Collection, Use, and Care of Historical Photographs

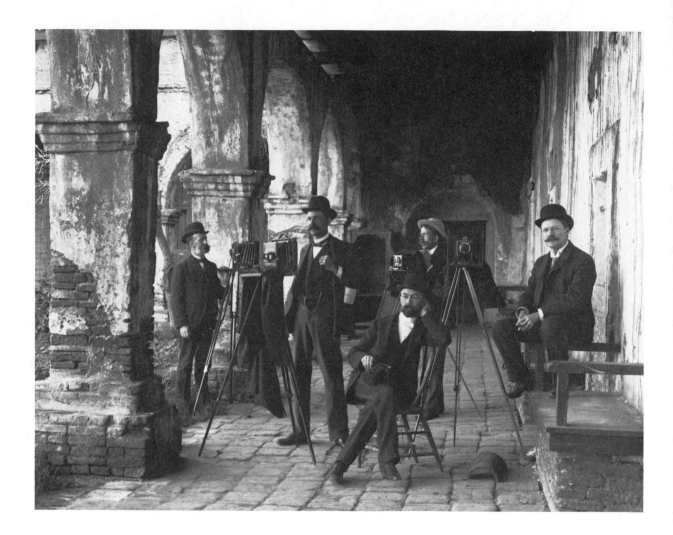

Collection, Use, and Care of Historical Photographs

Robert A. Weinstein
and
Larry Booth

American Association for State and Local History
Nashville

The authors and AASLH would like to acknowledge the generous support of the Council on Library Resources in the preparation of this book.

Library of Congress Cataloging in Publication Data

Weinstein, Robert A
 Collection, use, and care of historical photographs.

 Bibliography: p. 211.
 Includes index.
 1. Photographs—Conservation and restoration.
2. Photographs—Collectors and collecting.
I. Booth, Larry, joint author. II. Title.
TR465.W44 770'.28 76–27755
ISBN O–910050–21–X

Printed in the United States of America
Second Printing, brought up to date and corrected, 1978
Third Printing 1982

To the many men and women
trained and untrained
who maintain and preserve the
innumerable collections
of historical photographs
that are so significant
a part of our
national graphic heritage

Contents

Preface

Carved stone endures for thousands of years. A potter's fired clay may bear the imprint of the maker's thumb through hundreds of generations. When a photographer's work is done, however, it immediately begins chemically to self-destruct. And this process finds willing helpers in fungi, moisture, residual chemicals, molds, fumes, insects—and too often in the well-intentioned but uninformed mishandling by man himself. That is the reason for this book.

There are many dedicated individuals in the world who find themselves struggling to preserve historically significant photographs and to use them wisely for society's enrichment. Commonly their efforts are hampered by the lack of money, by willing but inadequately trained staffs, and by deficiencies in equipment and suitable storage.

Certainly, no book can solve these problems. What's more, the complexities of advanced restoration techniques would fill another book and be helpful only to the trained conservator. A surprising number of snares and stumbles await the inexperienced collector, restorer and user of historical photographs. Despite these difficulties, however, museum and historical society workers ought not feel intimidated. This book details many of these difficulties and pitfalls, a surprising number of which will seem to be almost elementary to the thoughtful reader. And the simplicity of so many of the critical precautions is precisely the point to be made here.

Remember, the road of "Good Intentions" is paved with shattered glass plates, thoughtlessly discarded data, and fragments of collections the bulk of which disappeared at the owner's death. In short, think and plan before you act. When in doubt, check it out. Go so far as to risk being called a "fuss-budget." Old photo materials are tragically fragile, and an ounce of preparation is worth a pound of remorse.

From the time you first hear about a collection which may be available to you until the last copy negative rests safely in your files, take nothing for granted. Problems begin even before you acquire the material.

In the pages that follow, there are common-sense suggestions, basic information, and explanations that any nontechnical person can employ. Hopefully they will help one to decide what should be done with historical photos entrusted to one's care: who should do it, what it will cost in time and money, and what facilities and equipment are necessary.

Most important of all, the reader will learn how photos can be ruined unintentionally by mishandling, experimentation, and improper storage. He will learn to avoid these costly mistakes by using the prescribed precautions; but he will avoid even more by keeping one cardinal rule in mind as each problem arises: *When in doubt, check it out*. Consult an expert—avoid remorse. This book safely expands knowledge of what problems exist and what degrees of skills are needed to solve them. By arming you with this broad knowledge, this book guides you to make responsible, informed decisions about what can be done and by whom; much can be done by serious, dedicated workers, but some jobs *must* be left to trained conservators and technicians.

<div align="right">

Robert A. Weinstein
Larry Booth

</div>

ACKNOWLEDGMENT

The foresight and understanding of two men
in particular are responsible for the appearance
of this book: Dr. William T. Alderson, Jr.,
Director, and the Council of the Ameri-
can Association for State and Local History,
who long ago recognized the urgency of this
problem, and Dr. Fred C. Cole, President of
the Council on Library Resources who au-
thorized and funded our labors. Many gener-
ous friends contributed greatly to its creation.
They each deserve a part of the credit and have
earned our gratitude, an obligation we are
happy to acknowledge here. For the inevitable
omissions and errors that will be found, we
alone bear the responsibility.

Introduction

THE discovery of means to make images formed by the *camera obscura* more or less permanent is only one hundred and thirty-seven years old. The little we have learned in that time about how to collect, restore and preserve photographic images has proved inadequate. As there have been few collections and fewer collectors until recently, the lack of such knowledge hasn't mattered very much; these problems became the near-exclusive concern of a tiny group of individual and institutional collectors. Virtually alone, they were unable to mount a major effort to learn how to care for old photographs.

If the nineteenth-century photographs now being collected are to survive, their care and preservation is our major problem. Immense in their numbers, bewildering in their technical complexity, fiscally demanding in their endless archival and research requirements, the dilemmas posed grow more pressing. Enthusiasm for historic photographs is high now; almost overnight, in the world's marketplaces, it has transformed photographic artifacts into objects of value, awakening new interest in their care and use. Required techniques and procedures for their care are being developed, in fragmented fashion; many needed solutions to the problems of photographic conservation still lacking a coordinated effort. Untested advice in place of solid knowledge, misinformation and ignorance—all are freely available, even without asking for them.

The serious collecting of historical photographs was for a long period very casual, until some accumulations found their way into the libraries of the nation. Librarians, untrained then in caring for photographs, did the best they could. They incorporated these images for the first time into normal library cataloging and retrieval procedures. They sorted, organized and housed the photographs so they could be used. They surrounded the photographs with large collections of reproductions clipped from books, magazines and newspapers, forming picture collections of major importance; the collection at the New York Public Library under the direction of Romana Javitz is a notable example. Their contributions at that time were live-saving for photograph collections and we are all indebted to them. Their loving care in most situations bought valuable time, but unfamiliar with proper archival procedures required to preserve old photographs, their attentions proved insufficient. Photographs in their custody faded, were often abraded, bent, torn; sometimes priceless original prints were lent to the uncaring public as casually as if they were current magazines.

Evident gaps in reliable preservation procedures encouraged the gradual entry of professional archivists and special collections librarians. It was well, for the help of many different specialists was needed. Only conservator-technicians could provide the trained expertise necessary for archival preservation of photographic images; art historians, the aesthetic leadership needed to interpret and evaluate; and the professional curator to explain and develop mounting, storage and viewing requirements. Experts in each of these fields were found and sometimes put to work; their research provided some answers but fell short, still, of affording a coherent view of the whole problem. To many sympathetic observers, the parable of the blind Indian fakirs —each feeling the newly discovered elephant for themselves—seems tragically applicable. Incomplete answers to complex problems, a degree of harmful advice, and an eagerness for quick solutions to vexing problems still substitute for patient research. Consequently we

continue to publicize certain hasty efforts and practice unsatisfactory and dangerous techniques. The single specialist's work is by itself continuing to prove inadequate, underlining the need for larger horizons of understanding. This book is intended to help establish new horizons.

Serious inquiry is growing and conservators have begun to report their research findings, stimulating further work from other specialists. Sometime in the foreseeable future conservation techniques will be developed, evaluated and disseminated by the George Eastman House, the Library of Congress and other national and regional conservation centers.

Still locked in the experience of scattered individuals are many useful bits of information, too little of it recorded or disseminated widely. We have offered here some of those experiences and our own work in this field. More will be discovered and published, for more is still needed. We trust this book will be used, amended, questioned, and in time, replaced; we welcome such a course. Nothing can replace the endless research and serious study required to care for and preserve our photographic legacy.

Part One

Collection, Use and Initial Care

1

Historical Photographs: Definitions and Descriptions

WHAT a difference there is in the museum treatment accorded a hundred-year-old painting and a photograph of the same vintage! Photographs are still regarded rather casually these days, and unlike paintings or rare manuscripts are looked upon in too many cases as commonplace objects. For most people esthetic consciousness does not yet extend to photographs as it does to paintings; photography limps along as a lesser art, if it is accepted as an art form at all. The ease of producing photographs now, with almost foolproof equipment, inexpensively and under most types of light, has transformed Everyman into an apparently successful photographer.

Descriptions

Every aspect of contemporary life has been defined, enriched and altered by photography. Few persons fail to acknowledge how much our existence depends upon images in a world bound together by visual communication, a reliance upon "pictures" for information we could understand better if we were suddenly deprived of these familiar images. Any casual attitude about our functional reliance on photography is a tragic misunderstanding of its real significance. Scientific breakthroughs anywhere can now be visually verified. Almost any visual miracle seems possible for the roving lens. Mankind can not only see the daily news of its time, but so immediate is its transmission, they are offered repeated opportunities to participate in its making. Who can forget the dramatic shock with which the murder of Lee Harvey Oswald by Jack Ruby was accepted by everyone who saw it on television in their own living rooms.

In scarcely one-hundred-odd years, photography has become a predominant medium for world-wide information exchange. Sophisticated and automatic means for making and transmitting photographic images are being found with great rapidity. Automatic cameras for taking endless visual notes and automatic image processors to make them instantly available as magnetic-tape produced printouts may soon be commonplace in our lives. The next generation will make, use and depend upon photographs as naturally as we now take notes, write letters, store and retrieve written and copied documents. The end of such developments is unknown and unpredictable. What is clear, however, is the transforming character of the application of photography in the lives of men and women. Photographs, by their credibility, can illustrate our past, offer a widely accepted form of communication for the present; they are an important reference for the future. Photographic communication will become everyone's concern.

It was not always thus. Before the discovery of the chemical and optical means to make "sun pictures" permanent, trustworthy visual images of the world were largely unknown. Consider this: in the nineteenth century, let us say 1825, a Maine fisherman had no convincing notion of what his fellow citizen in Kentucky truly looked like. He could have been tall, short, thin or fat, bearded or clean shaven, as reported. None of this was known visually to the fisherman, or to his family, as facts they could see and trust. Their sources of visual information, when they could see them, were sparsely illustrated journals of the day. Wood engravings based on interpretative drawings by artists were diverting, if not altogether dependable.

Realize that in 1776 the actual likenesses of

4 many American revolutionary leaders of the day were unknown to most colonists living outside the Eastern seaport and commercial centers. For colonial Americans pioneering the west of Ohio, Kentucky, and Tennessee, little they could see, or had previously seen, afforded them the sense of security they needed to grapple with a geography and people largely unknown. In the absence of a photographic portrait of the Native American, a fearful image of the "savage" Indian lived on stubbornly in the popular mind. The anxieties and fears of a little-known world were real and crushing then to most people denied a comforting view of that day's reality—a visual luxury we, in our day, can regard as practically commonplace.

A remarkable set of colored lithographs lies in the vaults of the Bibliothèque Nationale in Paris. They were drawn by artist Louis Le Breton and are views of cities in the United States, produced to calm the fears of Frenchmen sailing in 1850 to hunt for gold in California. In several of the views of New York, Baltimore and Philadelphia, the buildings shown include minarets, Japanese pagodas, Greek temples, Babylonian palaces, even Egyptian Sphinxes and pyramids. The citizens shown are dressed in everything from top hats and tails to Turkish fezzes, East Indian saris, Chinese gowns and coolie hats. Street transport features rickshaws, sedan chairs, horse-drawn omnibuses, steam locomotives and floating, hot-air balloons. Wherever such "views" were available at that time they provided an accepted picture of the "unknown world."

It was into such a visually limited world that the daguerreotype, hailed as the "mirror with a memory", made its entrance in 1839. Pleasure at its appearance was high, for the satisfaction these daguerreotypes assured was enduring. Travelers of the day could now carry small lifelike portraits of their loved ones, and for the first time they were able to send back por-

traits of themselves and the new countries they visited. The evocative power of these new portable images was so great that for memories's sake even the dead were photographed. The great wonders of the nineteenth-century world—the Pyramids, the great waterfalls, the Eiffel Tower, the Crystal Palace—were all available in the new photographs which offered clear proof that these natural and man-made wonders really existed. They opened up for popular viewing the "mysterious" East and darkest Africa for those who had not or could not travel to see for themselves. It seemed that almost everything was worthy of being photographed and thus very little escaped the peering lens of one photographer or another. If the discovery of photography was too late to record the personalities and events of the American Revolution, it was on the scene for our Civil War, recording the bitter agony during 1861–1865 in now valued, deathless images. The neutral camera and the photographer's partisan perceptions have witnessed Americans in triumph and defeat for generations. Few mediums matched the photograph's verifying accuracy, presenting the way people and events appeared in the days and years of yesterday. Each photographer has left as his legacy an archive of such images, a near-bottomless accumulation we are just beginning to find and use.

Definitions

A *photograph* is a chemically fixed image holding a lens-produced pattern of light, an aggregate of space and a finite amount of time. A *historical photograph*, offering a believeable image of times past, is any photograph capable of supporting the study or the interpretation of history. The apparent reality of any photographed instant of time can be verified and illuminated by the historical photograph made of it. The moment after it is made it becomes a

visual artifact, although it is not always valued as a historical treasure. One need only consider the difference in archival treatment between a written manuscript and a photograph—each frequently being equally old.

For a world of strangers isolated in separate communities in the middle of the nineteenth century, there were suddenly, after 1839, pictures of this vast complex inhabited by humans of almost every description and mode of life. It is the images of that time and those that followed that we are anxious to recover and save so that we can use them to heighten our understanding now. The negatives, prints, records and photographic artifacts of every description that define the 137-year-old history of photography make up the largest share of the photographic collections in historical societies and libraries.

These materials represent many different types of images which can be divided into two broad categories: negatives and prints. Consider a negative as a printing plate and the photograhic print as the product of the plate. With the exception of the daguerreotype, the ambrotype and tintype, all photographic prints are produced from photographic negatives. The final product of the negative-positive picture-making process, the visible image, is called, in all cases, a *positive photographic print*—commonly referred to as a print. This distinguishes it from a silkscreen print, a lithographic or other type of graphic artist's print. It may be any size, hand-colored, black and white, sepia or any other color, mounted on thick board or thin; it may be on thin or thick paper, dull or shiny, be matted or framed, but it is always a photographic print. More precise descriptions of the several types of negatives and prints you can encounter in dealing with historic photographs can be found in the section on Care.

There are several broad categories of nineteenth-century photographic images which are products of different periods in the evolution of the medium. The earliest photographic process combined the negative and positive in one image. The first image of this category is the *daguerreotype*, invented in 1839. It is unlike any other photographic image in some of its physical characteristics; it is for example, the only one made upon a sheet of highly polished silver-plated copper. With the tintype, which is made on black-enamelled iron, the daguerreotype is one of the two photographic images made directly, without a negative, on a metal plate. The image side of the plate can appear to be either a negative or a positive depending upon the angle at which the light strikes its mirror-like surface. By tilting the plate in the hand and manipulating the angle of the light, the image may be made to appear as a positive for easy viewing. The negative/positive appearance of the daguerreotype is important for its identification, as it is true of no other photographic image.

The daguerreotype was produced in standard sizes and sold in handsome covered cases. It was matted with die-cut ornamental brass mat and covered with a piece of clear glass; the whole was then encased in a wooden or leather-covered shallow box. Its inside lid was often padded with colored satin and sometimes contained the daguerreotype maker's name. It is possible to find daguerreotype plates loose without their protective mat, glass and case. The mirror-like plate alone is easily identified. (See pp. 153–159).

Following the daguerreotype in 1854 was the glass ambrotype. Made for popular sale, it was more easily produced and cheaper than the daguerreotype. The *ambrotype* was a wet collodion negative on glass, made in the same standard sizes; the protective materials and cases were frequently used interchangeably for both the daguerreotype and the ambrotype. The ambrotype usually presents a positive image when viewed, but it can be seen as a negative image when light strikes it from a particular angle. The transformation of the

6 ambrotype—an almost transparent, thin glass negative into a recognizable positive image—is accomplished by putting a dull, black surface behind the negative, thus preventing the passage of light through the negative. Since the nonreflecting ambrotype is viewed through a clear cover glass, its image surface appears grey-green in color, unlike the highly polished, mirror surface of the daguerreotype (See pp. 159–162). If it is easier, think of the way the ambrotype appears, as a print on glass rather than on paper. The ambrotype was introduced three years after the 1851 discovery of the wet-plate collodion negative, which produced the more familiar print on paper (See below.)

The last of the images fixed and viewed on a single surface requiring no separate print is the *tintype*. Also called the *ferrotype*, or *melainotype*, the tintype was introduced a bit later than the ambrotype but survived in popularity until the twentieth century. The tintype is a direct positive image upon a sensitized iron base. The metal is quite firm, appearing to be painted black or dark brown on the reverse side of the image. The image itself is a dull gray, somewhat similar in appearance to the ambrotype. The surface is usually varnished for better viewing and for the protection of the image. Like the daguerreotype and ambrotype, the tintype has no negative and cannot be produced a second time (except, of course, by rephotographing the image and producing a printable copy negative.) Tintypes can still be found in many sizes from very small to fairly large, although the most popular was the size allowing its owner to slip it into a small pocket or wallet. They are sometimes found in daguerreotype or ambrotype cases and should not be mistaken for these other images (See p. 165).

Intervening historically before the wet-collodion negative was a paper print made from a waxed paper negative, known as a *Talbotype* or *calotype*. This image was the ear-liest forerunner of the modern photographic process of making a positive paper print from a negative. Although the calotype created great excitement and its success in England and on the Continent seemed assured, its discoverer unwittingly shortened its life by unwise rigid enforcement of his patent rights to the process. The calotype is marked by a noticeable lack of detail and vagueness of image due to the coarse fibers present in the drawing papers used to create both the print and the negative. As they are among the earliest examples of photographs on paper, they are very rare and valuable. It is unlikely that one will find many American calotypes, either portraits or landscapes (See pp. 165–166.)

The next major development in the evolution of photography was the development of a wet-collodion glass negative in the 1850s. This negative system doomed all single-image plate processes with its relatively easier production of multiple positive paper prints.

Let us immediately discard a few of the more commonly used erroneous synonyms for negatives. The most often heard are glass slide, slide or film. A negative is never any one of these three exactly. If it is made on a piece of glass, it is then a *glass negative*; if it be on cellulose nitrate or on plastic film, it is a *film negative*. There are certain broad distinctions between the two types of glass negatives. The earliest commercially used negatives made on glass in different sizes were individually coated by the photographer for immediate use in the camera, and were known as *wet-collodion negatives*. The name arose because liquid collodion, the binding agent for the light-sensitive chemicals, required the sensitized plate to be rushed into the camera for exposure while it was still damp. It was a cumbersome, demanding procedure (See pp. 174–176.) It is this wet-collodion negative that we commonly and correctly call a glass plate or a glass negative. When properly made, developed, and dried, it was used to make as

many paper prints as were desired. It was still used in the early 1880s when it was successfully replaced by the *dry-plate glass negative*, the other important variant of the glass negative. The commercially manufactured dry-plate negative was precoated and presensitized in a factory and was capable of maintaining its chemical sensitivity to light over long storage periods. Both types of plates were available in many different sizes, although increasing standardization in camera manufacture over the years tended to reduce the number of required sizes. The thickness of glass used by each manufacturer of dry plates tended to be uniform while the glass thickness used for wet-collodion negatives was quite variable. (See pp. 176–178.)

Most nineteenth-century prints were the same size as their negatives, as the necessary equipment and materials for making enlargements was not readily available until later on. These same-size prints, called *contacts*, were made by placing the negative and the printing paper in the closest possible physical contact in a printing frame, then exposing the frame to natural light for the time required to develop them. Many women were employed in printing establishments to do this work. The finished prints were fixed with gold toning, a process that imparted a distinctive warm brown color to them. Frequently found in historical photographs, this particular characteristic is a dependable aid in identifying albumen prints.

Prints made from glass plate negatives were often mounted on a cardboard backing for their protection and easier handling. Each size board had its own distinctive trade name. The most popular sizes are included in the George Eastman House list, p. 208. The wallet-sized carte-de-visite, the smallest of these mounts, usually held portraits and an occasional view. Intended for use with or in lieu of a calling card, the carte-de-visite was tremendously popular, as you will discover in compiling your collection. Mounts of various sizes were a form of successful advertising for the photographer and were embossed or printed, or both, with the name and address of the photographer. In many cases, the name and address on these mounts can be the name of the merchant who sold the photo, not the original photographer, so be careful. Often the mount will have printed on its face, or its back, certain identifying information about the photographer as well as a specific negative number, or a caption with the subject, location shown, and the date.

Stereographs, produced shortly after the Civil War, are well known and are rarely misidentified, although present-day viewers sometimes call them "3D" cards. (See pp. 187–189.) They are rectangular, cardboard mounts approximately 3 by 7 inches on which two nearly identical photographic images are mounted side by side horizontally and are intended for viewing in a stereoscope viewer. The early cards are flat whereas cards manufactured later are sometimes slightly curved across the horizontal axis from top to bottom. The cards almost always have hand-written or printed information on both sides of the card, and are thus self-identified. Originally they were issued by individual photographers in hand-numbered sets; later they were issued in printed sets by publishing or view companies.

Often misidentified in historical photograph collections are glass transparencies for viewing by projection. These are *lantern slides*, with a standard size of 3¼ by 4 inches. A glass *positive* transparency, either black and white or hand-colored, is sandwiched between plates of clear, thin glass—the whole secured by binding all four edges with black paper tape. They are frequently found in sets covering a single subject and are housed in stout, wooden lidded boxes, grooved within to accept each transparency separately. They are often confused with glass negatives, but there are several important differences. The most obvious

8 difference is that the lantern slide is a positive transparency, not a negative. It will not yield a positive print and it can only be projected as a positive image. As mentioned earlier, glass negatives varied in size, while the lantern slide was a uniform size. (See pp. 179–181.)

By the late 1880s, manufacturers had learned how to coat continuous belts of cellulose nitrate film with light-sensitive emulsions; this type of flexible negative material was introduced commercially by George Eastman and the Kodak Company. Known as roll film, it was soon produced in many sizes and shapes; its flexibility helped to pave the way for small hand-held cameras using the new roll film, tightly rolled onto wooden spools. This cellulose nitrate film is highly flammable and spontaneous combustion is still possible under certain circumstances. Such nitrate film, found in both sheets and rolls in photographic collections, poses severe archival and storage problems. (See pp. 189–193.) Eventually the introduction of plastic materials allowed the use of these plastics to supplant cellulose nitrate as a base for flexible film as well as for sheet film required by the cameras of the day. As all films currently produced are plastic based, their safety characteristics are very high.

There is a range of color film and prints of differing characteristics that we will discuss in greater detail in Chapter 7 in Care. Suffice it to say here that all known color materials are presently considered to be fugitive. This means simply that all color will fade over the years; and therefore color films or prints must be considered impermanent at the present time.

Detailed explanations of these negatives and prints as well as comprehensive instructions for dealing with their preservation and restoration will be found in Part Two of this book.

2
Uses for Historical Photographs

𝒪FTEN the last people to become aware of a revolution in progress are precisely those living through it; this notion holding a wry poignancy for those of us now living through revolutions in our own fields, disciplines or life-styles. Not the least significant of these is the ongoing revolution in the manner of human communication. None disputes the central importance of communication to civilization. Verbal literacy is taken for granted as being its most important medium. Hence society has required the mastery of those three skills demanded by verbal communication: speech, writing and reading. In fact, the mastery of any one of these disciplines has sometimes been considered proof of a "polite" degree of literacy.

The Historical Photograph:
Evidence Ignored

Since man has learned to speak, write and read, this tradition, the primacy of verbal communication, has continued virtually unchallenged. It is no longer considered sufficient to master the ancient skills; for literacy, both in today's and tomorrow's terms, now presumes mastery of the visual forms of communication. Today an old partner in communication has reappeared in gathering strength. Although slow in emerging, *visual* literacy is assuming its companion place alongside previously exclusive lexical literacy.

Since his earliest beginnings man has created pictures—of many kinds and for many purposes. Implicit in all these pictures has been his search over the last four centuries for a greater and greater sense of "actuality" of image. Men sought to increase the power of the image to command respect as a transmittable experience or statement, a power comparable in precision to the most skillful communication in verbal form. By the nature of man-made images, the credibility of all created images as documents was intrinsically subject to challenge until the introduction of photography in 1839.

Here at last was the proper vehicle for producing images truly incontrovertible in their ability to reproduce the actuality of the scene in front of the camera. William Ivins, in his *Prints and Visual Communication*, comments upon the capacity of the photograph to record the most concrete and precise particulars, without any of the limitations of preceding graphic techniques. The photograph has conditioned its viewers to consider it "a means to ocular awareness of things that our eyes can never see directly. It has become the necessary tool of all visual comparison of things that are not side by side, and for all visual knowledge of the literally unseeable whether on account of smallness, speed or time past."

Cornell Capa, Director of the International Center of Photography once wrote, "Photography is demonstrably the most contemporary of art forms; it is the most vital, effective and universal means of communication of facts and ideas between peoples and nations."

William Ivins points out that throughout the 500-year process of man's trying to make *exactly repeatable pictorial* statements with many different kinds of graphic processes, each was less exact than the photograph. Certain widely accepted verbal and pictorial conventions limited their precision and exactness. Only the photograph, relatively free of the deforming pressures of its own conventions, was and is able to make the exactly repeatable pictorial statement most exact. In this it supersedes the limitations of every preceding graphic process that could not avoid "obscuring, distorting, of

10 even hiding many things of the greatest interest and importance.''

John Kouwenhoven wrote in an article in *Snapshot* in 1972: "The cumulative effect of one hundred and thirty years of man's participation in the process of running amuck with cameras was the discovery that there was an amazing amount of significance, historical and otherwise, in a great many things that no one had ever seen until snapshots began forcing people to see them." Further he points out, ''. . . because snapshots often revealed impressive significance in things no earlier mode of seeing had enabled man to see, our assumptions about what matters have been profoundly altered. Before photography, reality was history and history was very largely something untrustworthily reported that happened long ago. Thanks, or no thanks, to the snapshot, we live in historical reality from the moment we are old enough to look at a Polaroid picture taken two minutes ago. Willingly or unwillingly we are participants in a revolution in seeing which began when the first snapshots were taken about a hundred years ago.''

Paul Vanderbilt, the noted photographic scholar, pointed out prophetically in 1958 in *Infinity*, American Society of Magazine Photographers, that a visual revolution was forming even then. "What happens to all the pictures?" he asked. "Suppose the sub-miniatures come into their own and get to be virtually automatic, so that just about everybody is pushing a button a hundred or more times a day or night, making camera notes of everything visual he wants to remember or pass along. It's entirely possible . . . the essence of this quantity production of pictures is upon us even now. Pictures are already as common as speech. Moreover, the revolution of photographic gospel hits more and more amateurs every week . . . photography won't just be the same, not merely because of the stepped-up quantity of pictures, but the photographic act and experience will be different, with a new

set of values.'' Vanderbilt goes on with remarkable insight, ''the acute eye sees thousands of potential pictures an hour, a weaving, constantly flowing fabric of stimulation, suggestion and symbolism. Suppose then that continuous automatic processing reaches its ultimate conclusion too, and quantity lab businesses on virtually a utility basis, takes care of everything for pennies a day. What is the trigger, and what is the end product? Where is photography going to end up, even if it just follows the present trend?''

Each of Vanderbilt's questions is answered in fragmentary fashion as visual literacy forces reexamination of much that had long been taken for granted. New confrontations occur and no field is immune. We need to see all the inquiries as aspects of a larger question: the role of visual literacy as a major communications form. Man's dependence on words for the communication of ideas and facts is long established. Systems for the reproduction, retrieval, storage and preservation of words have achieved high levels of excellence. However, in certain areas of science, philosophy and mathematics, words have already become deterrents to rapid and precise communication, and have been replaced by systems of conventional symbols. Communication based exclusively upon words is under successful challenge by diverse visual alternatives in which photographic methods and materials play a large part. Very few areas of our lives remain untouched by what photographs help us see and understand.

Trained to speech, writing and reading—to responding sensitively and critically to stimuli within these means of communication—most of us find it hard to learn to become equally sensitive to and critical of images. Besides lack of training, we have been inhibited by cultural resistance to looking closely and deeply at visual images around us.

But in today's world, demands for our visual attention and response are so many and com-

pelling that visual literacy has become a necessity to living fully. The youth among us accept and esteem photographs as a matter of course, while to many a professional mind the true value of photographs as primary documents and source materials remains more obscure. We professionals must all soon start to develop fresh attitudes that will help us to use photographs as effectively as we do the pages of a book.

Just as we have learned to perceive "between the lines" of a printed text, so we must now learn to scrutinize photographs critically, inquiringly and wonderingly. No longer is it enough merely to glance at a photograph. What a good photograph discloses to the appreciative eye and mind it will fail to disclose to the cursory look. Picasso once pointed out wryly, "To look is not to presume one sees!" Those who cannot use and appreciate photographs will be the semi-literates of the future.

Every field and discipline of historical work has been touched by these new pressures. To the historian witnessing vigorous challenge to outmoded ideas, a central question is whether the study of history remains an exclusively verbal field, or perhaps a visual one as well. If the burden of what we call evidence is no longer to be borne only by the written word, but includes the visual image as well (for the photograph requires we revise our belief as to what properly constitutes evidence) the implications of that possibility must be fairly and fully addressed. It is that important question, the role of the historical photograph as evidence, which those persons interested in history must ultimately decide. Not an altogether new idea for historians, it is one to which scant attention has so far been paid.

The question of what constitutes valid historical evidence has been revolutionized by setting aside the conventional limitation of evidence to exclusively verbal materials. In US courts of law, the fully documented photograph has been admissible in evidence for over a century. It is trusted as reliable evidence and stands high in popular esteem. As the data on an Internal Revenue tax form can be presented and accepted as evidence of wrongdoing, so can still or moving pictures of crimes being committed or forensic photographs be accepted as dependable evidence almost routinely at all trial court levels in the United States.

The compelling power of an occasion which the still photograph invokes has been proven countless times in the past, living on in images so powerful they survive as archetypes. Think of the tragedy in Alexander Gardner's immortal photographic portrait of the war-ravaged Lincoln, taken a few days before his shocking murder. Recall the way this nation was shaken by the photograph of the care-worn, in fact, the dying Franklin Roosevelt, cape-wrapped in his chair at the 1945 Yalta Conference. No one who has seen them can forget the pitifully abandoned, dust-shrouded homes of Oklahoma and Texas farmers, victims to nature's wild will and man's foolish greed. Pictorial evidence of a like kind rolls on in a flood of unforgettable imagery: the torn and twisted, youthful dead at Gettysburg; bearded twenty-year-olds recovering gold from icy California streams in 1851; defeated dust-bowl farmers stranded with their pitiful families on lonely western roads; striking workers on bloodied picket lines; and the many bitter faces of war, bigotry and hate. People have spontaneously responded to what they saw in such photographs, opening themselves so these images could involve them emotionally. They have accepted photographs as instruments of social change allowing themselves to be affected and moved by them, acting upon what they learned from these silvered images of life. Cornell Capa understands the power such photographs have as evidence that "images at their passionate and truthful best are as powerful as words can ever be. If they alone cannot bring change, they can at least provide

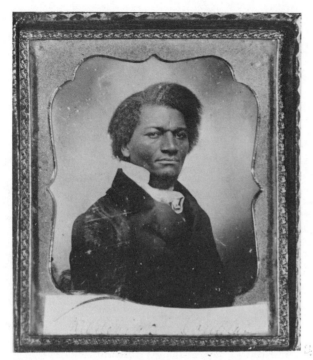

A daguerreotype portrait of the young Frederick Douglass—abolitionist, orator, journalist, editor and politician. (From a private collection)

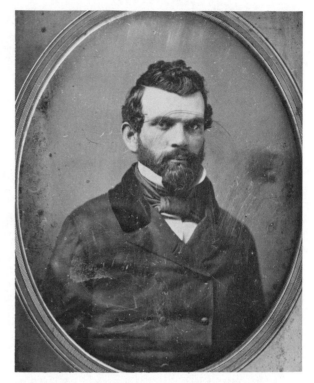

James King of William, intemperate newspaperman of Gold Rush San Francisco. His murder helped precipitate the formation of the Vigilance Committees of 1856. (Courtesy, Bancroft Library, University of California)

an undistorted mirror of man's actions, thereby sharpening human awareness and awakening conscience." This is not a new phenomenon. Many photographic images, the reproducible visual record of life, have been trusted and accepted as valid records from the earliest days of photography.

Early nineteenth-century photographs proved to be verifiers of decisive importance. Much of what we knew then about our infant country was vague and uncertain, supported only by ill-founded reports, speculation and outright lies. Tall tales and fanciful drawings were of little help for pioneers determining to build new lives in new territories among new and unfamiliar people; sure and certain knowledge was a necessity. Conclusive data from which plans could be made, dependable

information to help avoid unpredictable emergencies was urgently required.

It was needed to discover, for example, that Native Americans were believeable human beings with comparable human characteristics, not inhuman barbarians that could neither be understood nor coped with. Indian pictures by frontier photographers helped fill that need. The difficulties of crossing western mountains and prairies could be estimated more accurately if the traveler could but see them as they were, not as a romantic painter's biased vision might interpret them. It was the frontier photographer who once more provided the looked-for evidence: revealing camera pictures

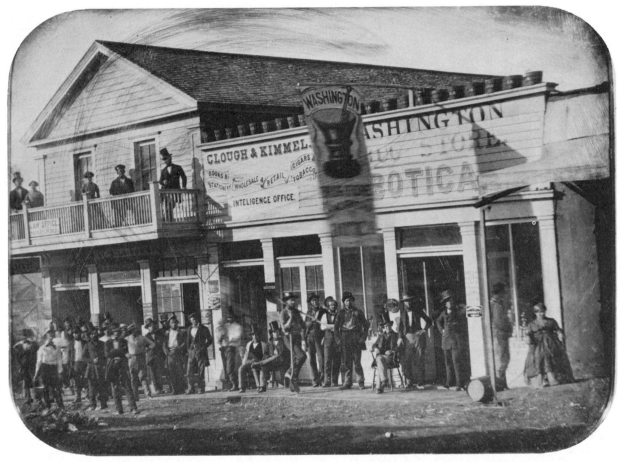

Most normal activity in California mining camps stopped for a visiting daguerreotypist—for a "complimentary town view"—as in this view of Sonora in 1854. It was an opportunity for everyone available to be photographed in the ensuing ensemble. It was quickly followed by individual portrait sittings until the "locals'" money for such purposes, and their vanity, was exhausted. (Courtesy, Wells-Fargo History Room)

that were confidently accepted. This new-found daguerreotype portrait of the great abolitionist, Frederick Douglass, adds additional stature to an already towering figure in American history. We have previously mentioned an unfolding panorama of newly revealed California Gold Rush images that enliven and demonstrate the turbulence of those vivid days. Here on one hand we can meet James King of William, passionate frontier editor, zealous reformer and martyred

crusader. On the other hand we can be witness to a single emerging small town metropolis and its Gold Rush dandies, a striking image of the Gold Rush reality. In an image captured by daguerreotypist John Plumbe in 1846, the national Capitol in Washington, D.C., stands in almost pastoral grandeur. Only thirty-odd years after its burning by invading British troops, the new building is eloquent testimony to the infant nation's determined reconstruction effort. Finally, we have the definitive

14

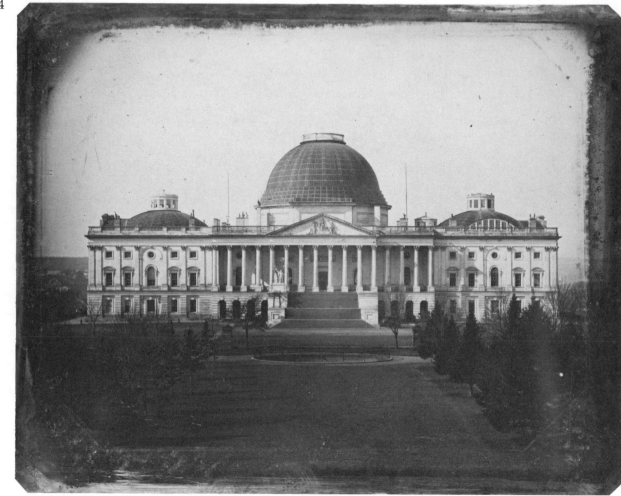

One of the newly discovered daguerreian views of the national Capitol in Washington, D.C., made in 1846. Taken by a prominent daguerreian artist, John Plumbe, it is a significant and trustworthy documentary image as well as an important photographic artifact. (Courtesy, Library of Congress)

view of a frontier photographer Henry G. Peabody, precariously perched with his eighty pounds of camera, tripod and plates on one of a thousand precipices—in this case the Grand Canyon of Arizona.

The photograph as trustworthy evidence replaced many nineteenth-century hesitations with increased confidence. What was accepted then as evidence by people who pitted their

safety and their lives against it, remains as evidence for us today, if we can but find and preserve this photographic record.

For the historian and photo-journalist, historical photographs as evidence can fulfill special functions. It is widely believed (although infrequently practiced) that a good historian should also be a literary craftsman; one for whom an accurate, rounded setting of physical

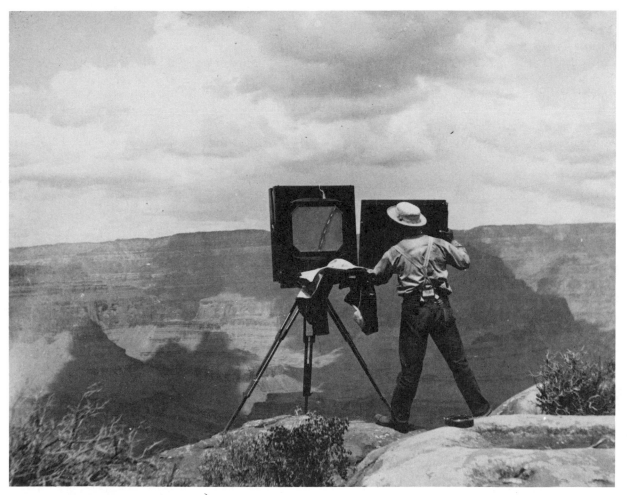

Henry Goddard Peabody, "outdoor man" for William Henry Jackson, is making a photograph of the Grand Canyon with his 20" x 24" glass plate view camera. This image typifies the frontier photographer at his active best. (Robert Weinstein Collection)

detail is a decisive point. The role of the "uncritical" photograph in providing the desired level of objectivity in reporting on the physical life of people—the accuracy of detail in object, an exact delineation of terrain—can no longer be disputed *if* the historical photograph is used with care, intelligence and taste.

To deal with present-day audiences already accustomed to photographic images offered by the communication media, to accept and respond to believeable pictures is to recognize many new opportunities in communication and in learning. If a goal of scholarship is to become directly comprehensible to audiences beyond one's colleagues, the intelligent and thoughtful use of photographs can make that goal a reality. The validity of the photograph's value as evidence of history has been summed up cogently by Beaumont Newhall, former Director of The George Eastman House: "If the

16 historian will be faithful to the photograph, the photograph will be faithful to history.'' Photographers have understood the powerful impact their work can have as representatives of reality. On one occasion the famed photographer, Irving Penn, asked in a TV interview why he took pictures, answered, "To touch somebody's heart." On the occasion of his ninetieth birthday, the photographer, Edward Steichen commented, "When I first became interested in photography . . . my idea was to have it recognized as one of the fine arts. Today I don't give a hoot in hell about that. The mission of photography is to explain man to man and each to himself. And that is the most complicated thing on earth and almost as naive as a tender plant." Finally, the novelist Willa Cather once defined history with perceptive brevity as, "the precious, the incommunicable past."

Our photographic heritage has the capacity and ability to touch the heart of man, to explain him to himself and to his fellow man; to offer the precious, the incommunicable past to mankind in forms that are believed, understood and treasured. Further evidence is the unprecedented success of the contemporary still photograph as news. The most convincing record of man's present-day scientific miracles have been photographs of the events themselves. Many have seen photographs of men on the moon's surface, probing under the sea, human life in the birth process, the passage of human blood through an artery or the human heart in ceaseless labor—all in natural color. No industrial process in its innermost life is safe now from probing, high-speed cameras. The planet earth itself can be photographed in color from miles away, high in the sky . . . even automatically if necessary. We are quickly approaching the era of holographs, lasers, and heat photography; "photographs" will soon be made without lenses, without light as a source, and without the necessity of chemical development as we presently know

it. There will be no limit to what can be recorded and almost no limiting conditions as to where or how. Secrecy and privacy may indeed vanish for mankind, even though for many the photograph's full significance has not yet been completely revealed.

As Margaret Weiss, photography critic for the *Saturday Review* recently pointed out, "Responding to the diverse demands of science, communications, and industry, the photographer's battery of equipment and expertise has extended the eye's limited range of vision and its fixed angle of view. . . . Anyone who sat transfixed watching the Gemini astronaut's color film-in-flight, or marveled at Mariner IV's interplanetary picture coup and the unmanned live TV coverage of the Navy Sealab project, can have little doubt about the camera as an eye-opener to wider horizons of experience. As an encyclopedic informer on everything from aquaculture to zoology, the camera has grown venturesome as well as versatile. With equal ease, it hitches to microscope, telescope or satellite . . . Though our age has not produced the Universal Man of the Renaissance, the man-made lens has given us a Universal Eye, one that exhibits a kindred, restless curiosity. . . ."

Science is not alone the exclusive beneficiary of this Universal Eye. The camera in the services of the historical record has produced an immense body of evidence. There are enough graphic images in hand to prove beyond doubt that the historical photograph, whether it is the daguerreotype of 1842, the albumen print of 1870 or the color transparency of yesterday, is indeed dependable evidence. For a new generation learning to trust photographs once more as reliable verifiers, using them as learning tools of a new kind, the need for their availability grows more urgent. We are learning to use photographs more intelligently and more responsibly and it is well for up until now the record has not been heartening.

The communication and media industries

routinely treat photographs without adequate recognition of their worth and their true educational potential. Television and motion pictures continue to use photographs in the dated traditions of classical book illustration. Newspapers and too many magazines do little better. Many educators, particularly those concerned with audio-visual materials, create and use them without the imagination and understanding appropriate to the power of the visual experience. They often transform outstanding visual materials into "visual aids", toys or useful "pupil-distractors", rather than into keen-edged learning tools. Publishers and graphic designers frequently treat photographs as merely an economic burden in their businesses; the photographs suffering accordingly. Too many scholars approach the use of photographs in their writings indifferently, seeming to exercise scant control on how they are used in their published works. Historians seem little concerned over the sizes of the reproduced photographs, their legibility or even their usefulness to their reader as source materials for learning. They often abandon the selection, identification and dating of photographs used in their work to unqualified publishing-house assistants. To ignore such powerful evocative images when they are at last beginning to be received with interest and with new enthusiasm can only be a tragic oversight. In spite of their demonstrated significance, notwithstanding any principled objections to the formal inadequacy of the photograph, their collection and efforts to increase their use and insure their preservation and restoration are at a low point. The continued lack of adequate public funds on any level to collect, restore, preserve and catalog the photographic resources of the country, both historical and contemporary, is a serious commentary on the lack of present public interest in the national graphic heritage. No knowledgeable person doubts that there are many significant and touching images buried in our depositories everywhere—unknown, uncataloged, unavailable for use. They *should* be cataloged, for local, statewide and regional listings of our collections are badly required. A National Union List of Photographs must ultimately take its rightful place in research libraries as a valuable and much needed bibliographical tool.

A familiar question, repeatedly asked by photo researchers, "Who knows where I can find this picture or that picture?" is too often answered imprecisely or not answered at all. It is in this fashion that too many familiar photographs continue to be used drearily, over and over again in publication, exhibitions and displays. These "old soldiers" no longer invite viewers attention, rather they succeed only in dulling our senses of wonder and interest. Fresh photographs are available. Thousands of unpublished images still lie unused and lost among each of our collections. Each day produces new finds, exciting and informative photographs, documents of worth and substance, suggesting riches yet to be mined if only we no longer ignore them.

Nothing will stem the rising tide of visual literacy, an idea whose time is ripe. Historical photographs are getting a new lease on life, signaling an effective role, a new position for them, in visual communication. The information they provide their viewers, the evocation they can recall of a time long-lost, the new-found trust of the scholar in their visual accuracy have earned them a growing level of public esteem. New values for photographs as conclusive evidence are at hand, their credible acceptance no longer questionable. We note with pleasure their emergence at last from a period in their history when it was believed they could be treated quite casually or safely ignored. It is clear now that visually literate mankind has made up its mind to depend upon photographs as learning tools. The tide is strong and running; nothing nor anyone can stop it.

A Selection of Nineteenth-Century Images

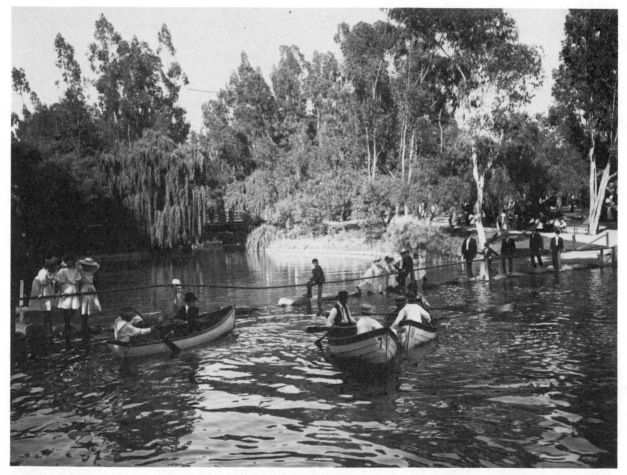

Between bobbing rocks that could be walked upon and bobbing rowboats that sometimes collided, encounters with Nature at Hollenbeck Park, in East Los Angeles circa 1900, proved unforgettable . . . and eminently photographable. (Courtesy, Natural History Museum of Los Angeles County)

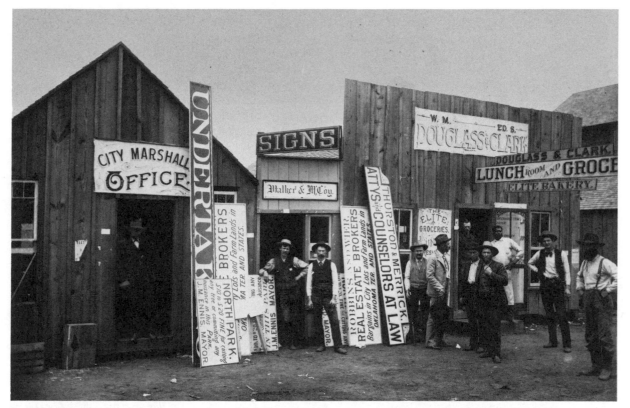

Sparkling in Plains sunlight, three-day-old Guthrie, Oklahoma is ready for business even if business is not yet ready for it. This image suggests the importance of the local sign painter—a herald of commercial enterprise. (Courtesy, University of Oklahoma)

At the turn of the century the private art gallery of Paul de Longpre's lavish Hollywood home, a sumptuous model of Victorian elegance, was a "must" for visitors to Los Angeles. (Robert Weinstein Collection)

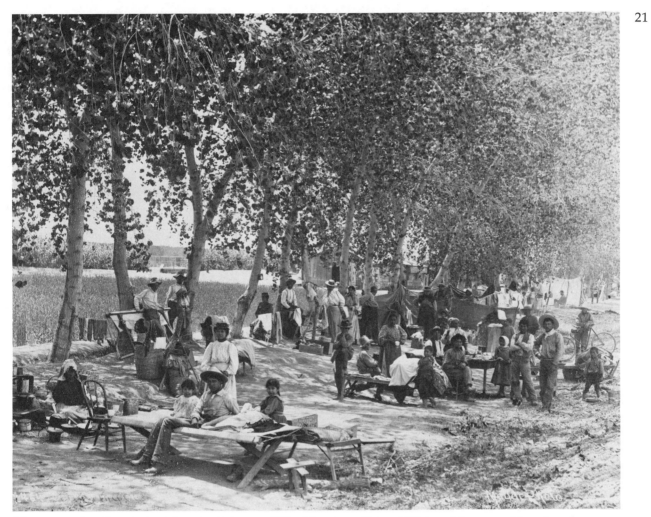

Mexican and Indian fruit pickers in Arizona, 1903. (Courtesy, Natural History Museum of Los Angeles County)

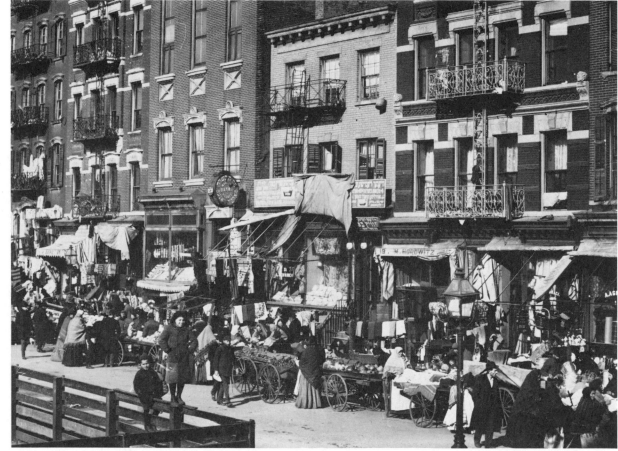

A teeming ghetto of the lower Eastside, New York City. (Courtesy, Natural History Museum of Los Angeles County)

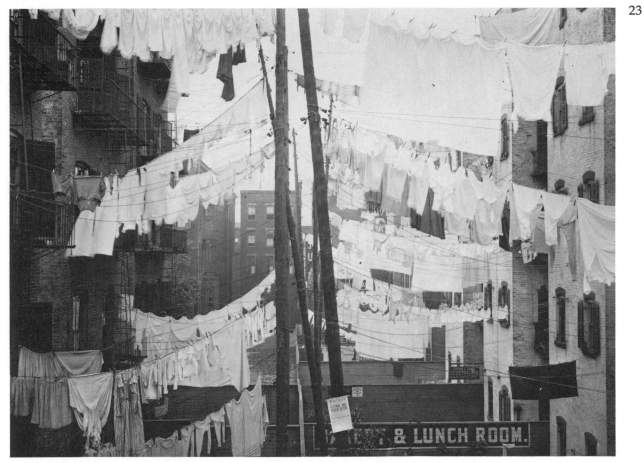

Everyone understood that wash day in New York City in 1906 meant hand labor and tired backs. The typical tools were a galvanized iron wash tub, a ribbed scrubbing board and a bar of yellow Fels-Naptha soap. The results: festoons of drying laundry, as immortalized in this photograph. (Courtesy, Natural History Museum of Los Angeles County)

24

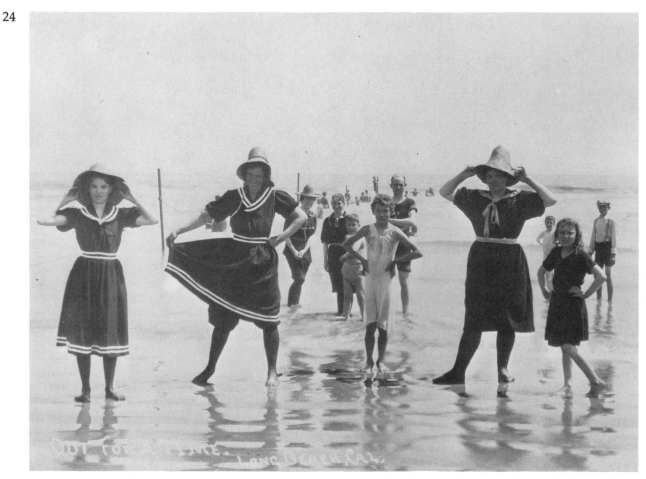

A glimpse of the days when going to the beach meant a dip in the briny, not a chance to be seen in near-naked glamour. (Robert Weinstein Collection)

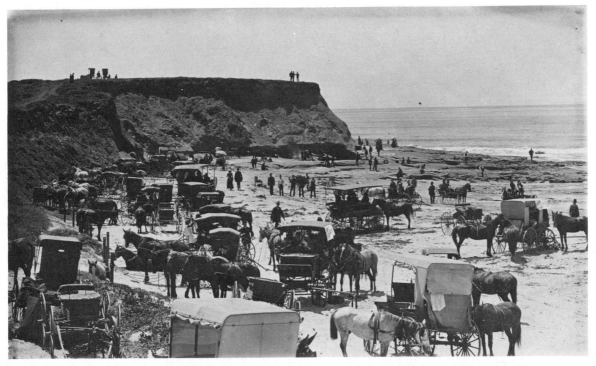

Vehicle parking at Ocean Beach, near San Diego in 1888, was free and unorganized—depending completely for its success on common courtesy. (Courtesy, Title Insurance and Trust Company of San Diego)

26

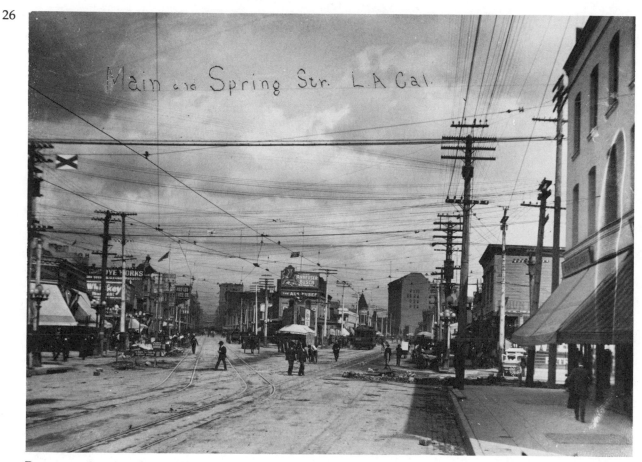

Downtown Los Angeles in 1908 offered streets paved with granite blocks, overhead electric wires in profusion, a general air of progress, and little elegance. (Courtesy, Natural History Museum of Los Angeles County)

Any photographer's "must!" A timeless view of the San Fernando Valley that so beguiled the Franciscan mission builders when they first saw it . . . much like this. (Robert Weinstein Collection)

28

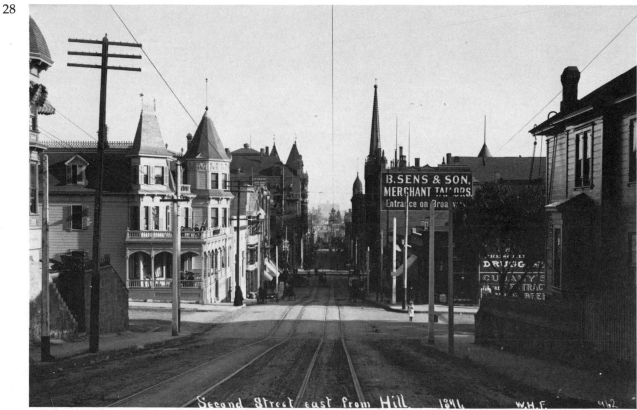

Among the attractions drawing Easterners to Los Angeles in 1904 were photographs of spires and minarets such as these gleaming in the sunny Californian twilight. (Courtesy, Natural History Museum of Los Angeles County)

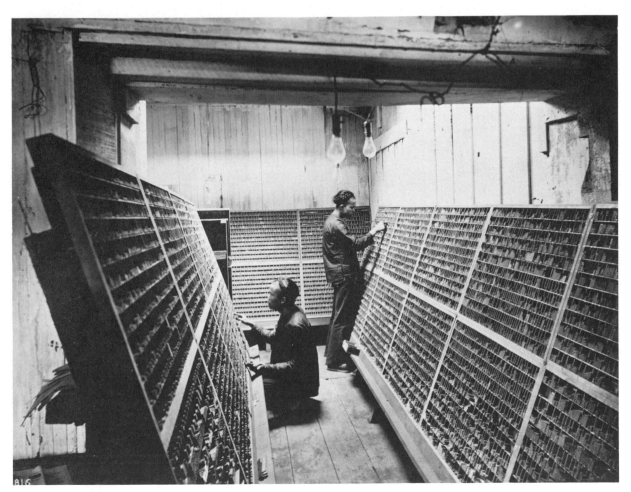

Rarely seen at the turn of the century by non-Chinese were San Francisco's pigtailed typesetters. Their skill made possible the daily newspapers their community needed. (Robert Weinstein Collection)

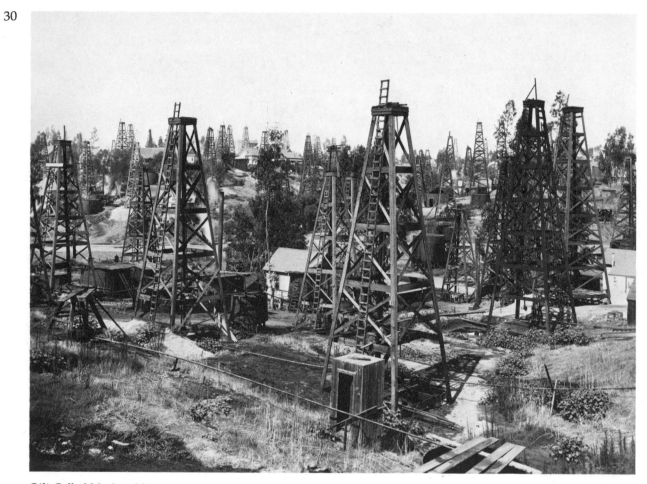

Oil! Called black gold in 1898, it was tapped wherever it could be found. No location was sacred—even here, the future downtown of Los Angeles. (Robert Weinstein Collection)

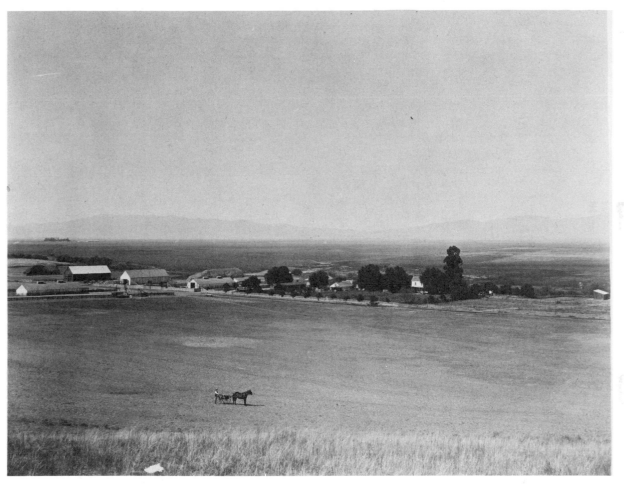

The bucolic glory of the great San Fernando Valley as the first land developers and subdividers saw it. Once they had arranged for water, they were sure this expanse might grow more money than crops. They were proved right. (Courtesy, Natural History Museum of Los Angeles County)

32

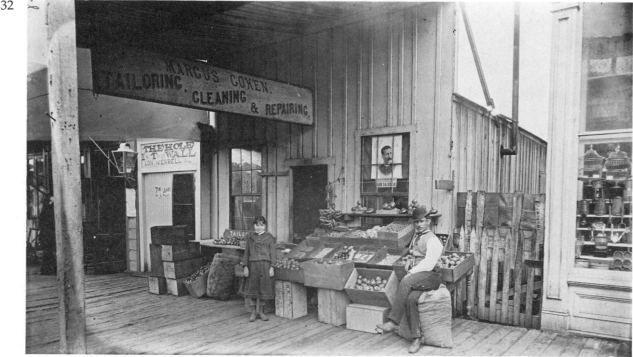

Lumber was king in San Diego in 1887. They used it for everything that nails could hold together. Stores, hotels, sidewalks, even the streets were wooden—and a serious fire hazard at the same time. (Courtesy, Title Insurance and Trust Company of San Diego)

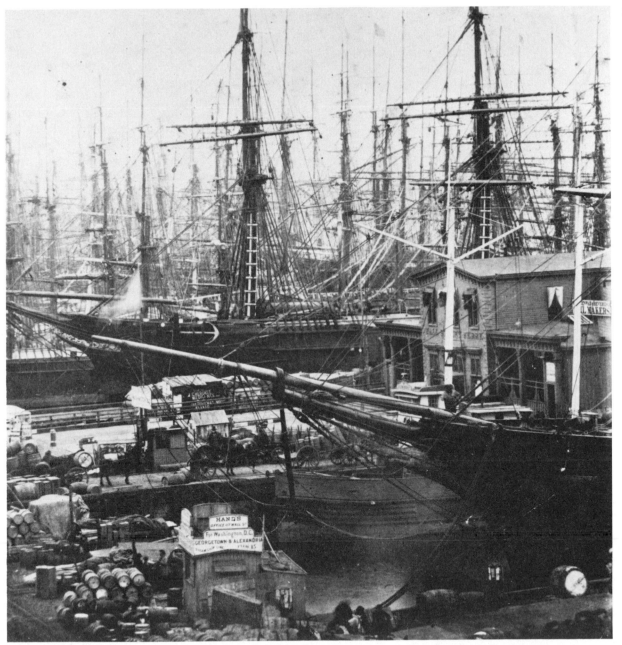

Almost lost among the forest of sailing ships' masts that was the East River waterfront of New York City in 1865, is the brick building housing the Wall Street Ferry. It was a dinky affair housing the ferryboats that brought the merchant princes to their Wall Street offices, across the Lower Bay, from their hilltop homes on Brooklyn Heights. (Robert Weinstein Collection)

Historical Research

The chief uses of historical photographs are for historical research, public display, as illustrations for publications and for the study of the history of photography itself, all illuminating and identifying a past inadequately comprehended. They are found presently in all media—books, magazines, newspapers, movies, television, audio-visual and similar learning situations. Public displays, exhibitions, trade shows and museum exhibits of every conceivable design often rely for their success on historical photographs. The identification, dating and intelligent interpretation of these images are a growing concern for many specialists, nationally and internationally. As yesterday's photographs are secured and their significance more deeply understood, we will come to regard them properly as precious documents, opening new visual windows to our pasts and enlarging our pictorial curiosities. The interest in these images is world-wide and growing. Historical photographs have already proven their ability to satisfy this interest. The existence of an increasing resource of photographs must alter the present-day attitude of the archivist, the librarian, the curator, and the historian about them. As these people become more familiar with photographs, adopt critical views about their significance, learn to recognize valuable and pertinent historical images, they must also develop the skills to preserve and restore old and new photographs in their collections. Photographs require constant care and will deteriorate if they are neglected; preservation, restoration and archival efforts cannot be delayed. Losses will occur and in the visually dependent world of today we can ill afford to lose the photographic record of our past, our present and the images that will help document our future.

Methods for Identification and Documentation

Identification is the keystone to the value of any historical image. From the time a collection arrives at an archive, accurate identification must become an ongoing activity. Perhaps because the photograph is a transfixed instant of time, the immediacy suggested by a photograph has encouraged the belief it need have no after life, and thus a written record of its meaning need not accompany it. Whatever the truth of the matter, too many nineteenth-century images, both negatives and prints, have been left to us without any identification or dating. An equally present nuisance of this legacy is misidentification; prevalent inaccuracies are too often accepted and offered with equal abandon and indifference. The necessary process of identification, a type of patient detective work, is ever fascinating but arduous.

Photographs may arrive with absolutely no identification of any kind except the acquisition number you assign to it. Useful as that number will become, it cannot substitute for solid information. At the same time as you receive the photograph, begin to assemble whatever information about it is available. Save every bit you can secure; what the donor or seller says about it, what may be indicated by the old packaging, what related, identified photographs can contribute. All are important, as they allow you to play detective, to begin the process of piecing together the story of an identity. If a written log has been faithfully kept from the start, every little bit and piece of that record will prove helpful in constructing an identity as further facts accumulate. The process of identifying and dating pictures is like putting together a giant jigsaw puzzle, only instead of being given all the pieces, you have to find the missing ones. With patience and research, it is usually possible to find enough pieces to complete the picture. One

cannot successfully manufacture an identity, one can only slowly accumulate facts that reveal it. It is very gratifying and exciting to succeed.

Internal Evidence. In difficult cases of accurate identification, the most useful source of dependable data can be internal evidence. We strongly recommend a thorough scrutiny of the image, both negative and print, with a sufficiently powerful magnifying glass. If the searcher is familiar with the subject matter of the unidentified image, it is possible, often easy, to decipher signs, posters, name plates, numerals, advertisements and other dependable clues. Equally valuable can be precise details of building construction: for example wood versus brick or sawn lumber versus logs, opened windows or shutters. Any such clear information can assist in pinning down an accurate date or a confirmed identification. The ability to see many clear details of a Brady view of the New York City waterfront in the mid–1850s made possible accurate identification of the only known photograph of the celebrated clipper ship, *Dreadnought*. Being able to read certain painted signs in the photograph clearly identified the location as the Wall Street slip at the East River, and a sharp image of the figurehead on the sailing ship in the foreground—a dragon with outstretched wings—was definitive proof of the identity of the famed *Dreadnought*. Identification and dating through careful examination of a photograph's internal evidence is widely used and should be your first step.

We have found that holding certain prints in front of a strong light for a short time will render the detail in prints more clearly. To assist this kind of identification, use a light box of the type used for viewing and examining negatives, one large enough to allow an 8" x 10" plate to be viewed on it comfortably. Used together with hand-held magnifiers, such illumination adds to the detail that can be ob-

served by the naked and inquiring eye. Magnifying glasses come in a variety of enlarging powers and are manufactured in many sizes and shapes. Select a size and style that you find most comfortable to use; remember, you may be using it for a long period of time over a strong light, so your comfort is hardly unimportant. Negatives are best examined by transmitted light as this allows use of a powerful magnifying glass for their examination, one 6x to 12x power. You will find each type of glass marked to identify its magnifying power. These glasses should be the high quality, triplet type. In some specialized situations, higher power glasses, as 20x or even a low-power microscope can be used to advantage, especially if one needs to read in a negative with very high resolution and fine grain or a very finely detailed image, a face, a sign, or a calendar. The denser or darker a negative is, the stronger the transmitted light must be for reading detail. But be careful not to hold a negative too close to high-intensity light long enough for the heat to damage it, especially nitrate-base film. Prints generally have less detail and less resolution than do original negatives, or copy negatives, and thus require a lower-power magnifying glass, 4x to 8x. Too powerful a magnifying glass will often so enlarge the fibers forming the grain of paper that it can be difficult to see clearly the photographic image printed on it. Since the print must be examined in most cases by reflected light, it is convenient and less tiring to the eyes to use a quality magnifying glass with a built-in light source. They are readily available.

Comparison. A most useful way to identify a photograph is to compare it with a similar identified image. Such comparison with known and identified views is highly recommended. In time many researchers and "picture people" become astonishingly intimate with their specialty and develop a sense of recognition of the terrain, its objects, and its

36

A lesson in seeing
An apparently unimportant photograph is transformed into a resource. A magnifying glass reveals the Transcontinental Hotel, a baby carriage on its porch; a makeshift Billiard Saloon (and other sinful pleasures?); Mr. Hathaway's commercial enterprise; and Kenniston and Brazelton's Livery, Feed and Exchange Stable. Such precise information otherwise unrecorded might thus be lost forever, but for the verifying historical photograph. (Courtesy, Title Insurance and Trust Company of San Diego)

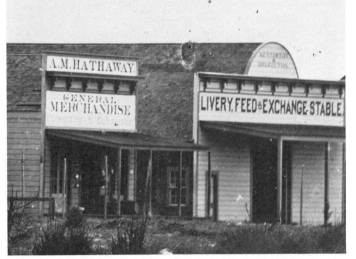

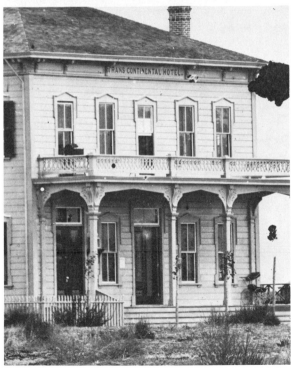

38 structures, that materially help identification and dating. Try to develop your own sense of recognition of the prominent landmarks in your area that will help fix locations and approximate dates, for you will rely on it often in identification of your photographs. Photohistorians rely greatly on such landmarks, learning to recognize the view from well-known and widely used vantage points from which photographs have been made. In a recent book, *Gettysburg* by William Frassanito, the author adds substantially to our knowledge of the photographers who recorded the immortal battlefield after the fighting had ended. A long-time student of the battlefield and intimately familiar with each fold of the terrain he has provided new and valuable identifications to photographs long accepted as originally identified, even though they were altogether erroneous. His book is effective validation of his method, a technique based on detailed knowledge of his subject. Learn to find such important points yourself in your own territory. They can be church towers, tall buildings, bridges or the other kinds of elevated platforms photographers used repeatedly in making such views. Don't overlook water towers, barns, windmills or two-story railroad stations; all were used by nineteenth-century photographers to take impressive "long shots." Collect and organize postcards! As postcards are almost always accurately identified and dated, such photographic views of cities and the countryside are especially valuable for confirming otherwise unidentified photographs. Organize your postcard collections by subject headings for cross-reference purposes. Postcard collectors can provide information about the manufacturing date of most cards and about the photographers who provided the original negatives from which they were printed.

If you find an unidentified view, compare it with an identified scene that is similar among your postcards for photographers always took more than a single image of a portrait sitting, a view or event. In addition to postcards, corollary images such as stereographs, lithographs, maps, drawings and similar accurately identified images are helpful.

Printed Evidence. Don't overlook any available printed or written documentation. Printed illustrations in contemporary books often carry captions or legends that can sometimes be used as information, although they are not always dependable, and should be used with caution as confirming evidence. Develop a habit of storing away in your brain all the bits and pieces of knowledge you can use to establish the accurate identity or date of a photograph.

Newspapers and magazines can be solicited to publish unidentified photographs so that readers might help establish accurate identifications. We know of cases in which the publications of such photographs are a continuing and popular feature. Soliciting community help to identify accurately photographs used in community histories has proven helpful. The verification or identification of historical photographs by informants being interviewed in oral history projects has similarly been of great use. It is a practice whose value will become even more apparent. Beware, however, of information ill-based in memory and uncertain in authority offered by some older citizens and accepted uncritically. Although the knowledge offered in these kinds of situations must be accepted with care, the photograph can trigger valuable associations and accurate memories worth recording. The historical knowledge of a community can be secured in additional, innovative fashions—a possibility well worth investigating.

Overlooked most of all as sources of confirmation and identification are the surviving business records of photographers. It was a normal procedure for nineteenth-century photographers to list the negatives they made in ledger books, describing the subject and as-

signing each exposure a negative number. Although their numbering systems can sometimes be obscure, much valuable information can still be gleaned from such surviving ledgers. Photographers' letters, diaries, account books, etc., can supply information that can often be matched with surviving photographs. The search for such records, and related ones, has been too desultory. New understanding of the value of such records requires increased efforts to find and safely secure them in available collections. Nineteenth-century newspapers are valuable sources of information as many early photographers were frequently mentioned in local news stories and because they might also have been valued advertisers. Sometimes news stories and photographers in your collection can be found that relate to each other.

Chronology. Knowing the chronology of the history of photography is another important tool for identifying photographs of the nineteenth century. Correctly dating the time a photograph or a negative was made can narrow your search. An accurate knowledge of the periods in which different processes were used to make photographs is significant as many processes were used during only a short time segment of three or four years up to twenty years.

Daguerreotypes, for example, can only be expected to have been produced between certain dates in certain places. The same can be said of ambrotypes, tintypes, wet-collodion negatives, albumen prints, Solios, etc. For further example, ambrotypes can roughly be bracketed between the years 1854 to 1870. Burnished albumen prints can be dated about 1878 to 1890 and Solio prints from about 1888. Daguerreotype and ambrotype cases, cardboard mounts and photo finishes developed for merchandising nineteenth-century photos are accurate benchmarks of when they were made and offered for sale. By correctly identifying the type of photograph under examina-

tion, one can determine approximately when it was made. The list in Appendix B reprinted by the kind permission of the George Eastman House, Rochester, New York, may help you in this regard.

The date of each of these artifacts taken together with information about photographers and their agents from city directories, tax rolls, and public records of different kinds can all help pinpoint the place, the date and the maker of specific photographs.

A further indication of the relative age of a photograph can be the negative number assigned to it by the original photographer. By matching it to a photographer's negative record ledger, the date may be fixed accurately. Even if you do not yet have such records, remember that as they do eventually arrive at

An example of a rare photographic curiosity—a pannotype. This piece of soft leather was successfully coated with light-sensitive chemicals and an image printed thereon. Such circular photographs were often placed in lockets and worn on a chain around a lady's neck. (Courtesy, Natural History Museum of Los Angeles County)

40 your archives, they can provide needed assistance in identification. Look at the negatives themselves, there is often critical information marked on them. Certain negatives of all types—including glass plates, nitrate-base and safety films—may have had photographer's numbers and legends lettered on them that have been obliterated or retouched by a later owner. For example, a photographer might borrow or buy another photographer's negative file and obliterate the old numbers, legends, or names so adroitly that no one would realize it by looking at a duplicate negative or print. However, as you examine the original negatives to record information about them, you may be able to see that such retouching has been done. Turn the negative at various angles to the light and you may be able to read the original information, providing more accurate data for identification of the photograph, its original maker and the date. Accurately identifying the maker of a photograph is proving complex and difficult for lack of adequate documentation. Too little knowledge about how nineteenth-century photographs were made and by whom, as well as the ways they were merchandised and distributed, have impeded the efforts of many scholars to unravel the truth. Great care must be taken in any presumptions made about a photograph until the evidence is based on a positive identification of its maker.

Combining the Evidence

Establishing the identity of a particular image is sometimes difficult, but arriving at an accurate date is the most difficult job of all. Larry Booth has used a method for identifying and dating photographs that can prove valuable to others with a similar problem. The procedure is simple in concept. Basically it requires bringing together all of the information that might remotely help pin down the facts being sought. If your search includes a wide horizon of existing sources, the problem can be solved. To illustrate with pictures of New Town, San Diego, three things were done:

1. A rough chronology was established of when a particular type of film, camera, print, and other techniques were used. Using this information narrowed the date of most of the photographs to within a ten-year period. In this case, knowing from documentation that wet-collodion negatives were used in San Diego up to approximately 1883, the plate under examination could only have been exposed *before that date.*

2. Only two photographers, Parker and Fessenden were in business at that time in San Diego's New Town; from the newspapers of the day and the photographer's own advertising, it was possible to verify the two photographers' business addresses and the years they were used.

3. Again, using contemporary newspapers, it was possible to assemble a series of key landmarks in San Diego as well as the dates that were applicable.

Newspapers provided sufficient stories about the two photographers, Messrs. Parker and Fessenden, indicating sales of businesses, change of gallery addresses, joint photographic ventures with other photographers—enough information to assure that any picture with Parker and Fessenden's name on the back had to have been made within a specific five-year period.

The technique that proved to be the most helpful was assembly of information about key landmarks, including a list of prominent buildings with their completion dates and a list of services and when they were first available. A similar list of verified dates for key buildings was invaluable in pinning down the completion dates of structures at known locations. For example, in San Diego the first community gas lights appeared in 1881; first electric arc lights in March, 1886; horse cars, July 4, 1886; electric railway, November, 1887; cable cars, June

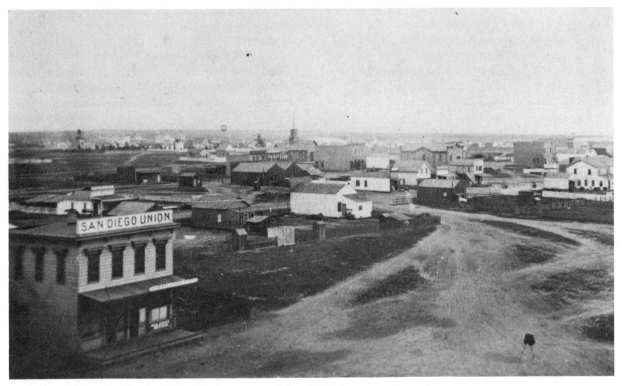

(Courtesy, Title Insurance and Trust Company of San Diego)

1890–January, 1892; telegraph poles, 1870; sewers, July, 1887; fire alarm bell, 1878; and so forth. The value of such information in the search for accurate dating is readily apparent.

The process of dating of a photograph accurately consists essentially of narrowing down the unknown by verifying the known elements. For example, we once had a view of the Horton House, a well-known hotel in San Diego, under examination; without the Commercial Bank Building in the same picture, we were sure the photograph was taken between 1870 and 1873. Many times landmarks will appear in some stage of their construction. In such fortunate cases the photograph can often be then dated accurately within six months. In a photograph of the Horton House, for example, taken between 1870 and 1872, it was possible to discern with a magnifying glass that

the east wall had not been completed; the construction scaffolding was still in place. Since the opening date for the hotel was October 17, 1870, the photograph was probably taken in June of that year.

Knowledge of well-known landmarks can also help determine the vantage point that was used by a photographer. For this purpose, it is useful to mark a copy of a city map of the period you are interested in with the locations of the various key buildings that form your landmarks. On the map, line up one known building in the foreground of the photograph with one known building in the background of the photograph. Repeat the same process in a different segment of the picture. On the map, draw straight lines connecting the pairs of foreground and background points. Where they cross and intersect is the spot on which

42 the photographer stood to take the picture. This can be cross-checked by looking for a high-vantage point such as water towers, hills, roofs of buildings, etc., in that intersected area. Moreover, once a picture is identified, it is then useful in identifying and dating other pictures of the same area, even if taken from entirely different directions. As a type of Rosetta Stone, it allows you to spread out from that identified location, the known point, to other unidentified areas, the unknowns. For the photo-researcher, the historian and for many journalists, let us repeat Beaumont Newhall's good advice; "If the historian is faithful to photography, the photograph will be faithful to history." The implication of care, of respect for accuracy and patience in Newhall's remark underscores the ground on which this problem of accurate and thorough identification rests.

A word of necessary warning. To be sure of identification and date, base your final opinion on more than one piece of evidence. It is too easy to come up with the logical but wrong answer based on false information. For example, construction of a building could be confused with remodeling. Some buildings have been moved or turned ninety degrees on the same lot, facing a different direction than their original placing. Some have been altered more than once; be careful! Newspapers have been known to make typographical errors, reporters and editors can and do err, negatives have been printed in reverse, pictures have been retouched. Examine everything with a reasonable doubt.

Finally, we want to emphasize the value of in-depth expertise. The ability to view photographs with specialized knowledge, interest and ferret-like enthusiasm is invaluable in examining internal evidence. The specialists who will do this far better than anyone else must be cherished! They are likely to be coming to your archive to carry on their own research; call on them to help you as well, they may contribute helpful suggestions about the dates and the identity of unidentified images in your collection. These experts should be encouraged to browse, for their "know-how" is needed to complete identification of your photographs. Nothing can replace the informed specialist's detailed knowledge of architecture, hair and dress styles, trains, ships, manufacturing processes, firearms, vehicles, etc. We are endlessly indebted to them for finding bits of crucial information that have escaped the scrutiny of the casual observer. We have seen the value of submitting unidentified photographs to experts in their relevant fields often. We recall a railroad buff of our acquaintance pointing out that a photograph of San Pedro, California, long unidentified, was taken in a particular year. In the corner of our photo was a Southern Pacific Railway locomotive numbered on the side of its cab. That number told him exactly when that locomotive was in use in San Pedro and for how long. Amazing, isn't it? If you find a single photograph, itself a segment of a multiple-plate panorama, look for the additional images intended to be joined and viewed as one. Try to find the additional matching images as well as the proper joints that will make the panorama whole. Such panoramas were popular and are often found in collections. When the civic pride of villages and towns in the process of their transformation into cities and suburbs was high, citizens frequently subscribed en-masse to pay for such self-serving "scenic panoramic views."

It is the easiest thing in the world to destroy or discard unidentified images. We urgently recommend that you keep them. Their identification might be found at any moment. Too often similar significant images have been destroyed or overlooked because no one saw any good reason to value and keep them. Remember, today's unknown image can easily be tomorrow's great treasure. Identification is the transforming key. Solving the problems of identification and dating can uncover further

priceless additions to the national graphic heritage.

Documentary Publications

If our collective past is to become credible and of use in the lives of all of our citizens, then the proven value of photographs used intelligently in public presentations of history require they be collected and be available for such uses.

The recognition of photographs as resource documents increases slowly. In their wake a new form of historical tool is emerging: the carefully-researched, well-written and finely printed pictorial history book. Their numbers multiply each year. Not long ago, the American Heritage Publishing Company published such a book entitled *American Album*, a large format book presenting several hundred black and white photographs of the nineteenth century in the United States. As an example of pictorial history, we believe it will endure and become a source of study by future students. Unpublished images from depositories all over the United States have been reproduced with care as full-page bleed pictures allowing the most detailed examination. A minimum of text exalts the photographs' eloquence adding to the book's visual power.

Three other books deserve special mention for their excellence. In 1971 the Chicago Historical Society published *The Great Chicago Fire*, a small book of 122 pages. Paul M. Angle wrote the introduction and notes while the pictures were selected from the Society's incomparable collection by Mary Frances Rhymer. The book combines seven letters written by Chicago residents, first-hand observers of the 1871 catastrophe, and photographs of the fire and the post-fire rebuilding. The photographs convey, as words cannot, the extent and the totality of the devastation. Together the images and the words provide a shocking, but believeable reconstruction of the

tragedy. For the viewer, the sense of immediacy invoked by these images is involving; photographs have rarely proven so eloquent. *Portrait of the Past*, a photographic journey through Wisconsin, has drawn heavily on the photographic collections of the State Historical Society. In 176 well-printed pages, the editors have assembled a succession of images, sharp, clear and detailed, of nineteenth-century Wisconsinites. Ranging through villages, growing cities, lumber camps, the new-found leisure and what the editors call, "the fabric of life", each picture leans heavily on busy people, rather than on standard views of landscapes, machines and structures. The informality of these photographs lends greater credibility to images of Wisconsin's nineteenth-century life than any other we have seen. The book is a superb presentation of graphic history, a model for future imitation.

The third book, *American Odyssey*, is a different sort of book entirely. The work of one man, Ingvard H. Eide, the photographer and editor, it attempts to rephotograph in 1969 the trail west of the Lewis and Clark party as recounted in their published journals. Eide followed in their footsteps where he still could; and he found terrain for his photographs, so closely matching their original descriptions, as to be astonishing. This book encourages the reader to move back in time, look through Eide's vision and his camera's lens, at the land almost exactly as the Lewis and Clark party saw it for the first time.

Nothing so well fleshes out the brevity of the original journals as these telling images of the land, the great rivers and the sea. The exploring party's struggle against the land can take on believeable form for the reader, so matchless are the photographs to the journal; they underscore once more the power of the photograph as historical evidence. What else recaptures so credibly the accurate look and feel of a time history has passed forever? Historical publishing in the future will be mod-

44

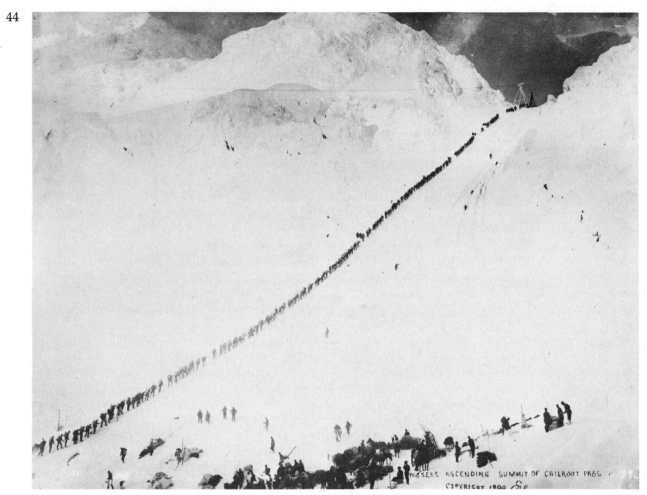

PACKERS ASCENDING SUMMIT OF CHILKOOT PASS
COPYRIGHT 1899

No one who had dared the Chilkoot Trail in gold rush Alaska could forget the brutality and horror of its icy passage. Even in this photograph—a vivid reminder of the struggling line of near-frozen men, suspended like flies on the ice—the reality is only suggested. (Courtesy, University of Washington, Special Collections)

eled on this type of creative graphic presentation, and will need every available graphic image in our arsenals. A. B. Guthrie writing in the introduction says of Eide's work, "His determination has been not only to capture in recapitulation the season, the very time of the day, the very state of the weather and the very shades of the light, but also the moods that such circumstances induced . . . he has seen what its members saw and felt as they

felt . . . and has brought sight and feeling to us." The worth of such images is beyond dispute.

For the scholar, author and journalist, few documents can be used to greater effect as representation of past events as the historical photograph. Both social and art historians are increasingly using historical photographs for their work and study of the history of photographs itself requires greater archives of im-

ages for scholarly examination. Numbers of important researches by both private and professional scholars already enrich available bibliographies of photography. Printers are pointing with pardonable pride to their ability to reproduce earlier photographic prints with increasing fidelity. The tempo of significant research and publication accelerates, all of it dependent on the priceless image documents already available in responsible hands.

The impact of the photograph on the popular mind has rarely been more compelling. Nothing has so authenticated, for example, the man-killing climb over the Chilkoot Pass in Alaska as photographer Hegg's enduring image of Alaskan goldhunters, suspended in space almost as flies upon a piece of milky glass. Only a cry of their pain could more faithfully etch the agony of Hiroshima's citizens than the pitiful images seen in the photographs of their atom bombing. John De Visser photographed the fishermen of Newfoundland, presenting their indomitable hardihood in black and white images as powerful and weighty as the brooding sea and chilled granite in which they endure. Such photographs can establish for audiences the topography, the character and more of the feel of a setting than any other type of document that is available. In Los Angeles, the Natural History Museum owns a daguerreotype portrait of a celebrated Californian, Don Andres Pico, dressed in silver-mounted charro costume. This particular portrait, charged with the imperious vitality and style of its subject, carries with it to the viewer, the challenging vigor of the real man. We know of few images defining the look and feel of the land-owning California Dons that are more believeable. We remember gold-toned daguerreotype views of California gold miners establishing beyond question the callow youthfulness of the bearded argonauts, mere boys from the East, working to recover gold in the icy streams of the Sierra foothills. These images faithfully present and verify the

Evidencing the certainty of his pastoral success and secure in his provincial power, this gente—caballero principal El General Don Andres Pico—sits in this vigorous portrait for the kind of visual posterity only the daguerreotype could then assure. (Courtesy, Natural History Museum of Los Angeles County)

brutal, man-killing labor that was the truth of gold recovery, the endless washing of mountains of hoped for gold-bearing rock. The joy in these precious images is the wealth of precise and accurate information that can be gleaned from careful scrutiny. One can discover the most remarkable examples of sartorial splendor, fashions in mining-camp architecture, curious arrangements for transport, and most of all the displayed characteristics of men, women and children of the times. As their images gaze in quiet solemnity from the

Bearded or otherwise, these tyro goldseekers, youngsters to a man, share an immortal moment with a visiting daguerreotypist from the City. Most such daguerreotypes were hastily despatched to anxious families at home, eager for news and views of their wanderers. (Courtesy, Bancroft Library, University of California)

fragile pieces of paper and metal that represent them, they seem to feel secure in the photographer's ability to present them to their world exactly as they saw themselves, trusting completely in the magical camera, the agreeable sun and the enchanting skill of the photographer. If we wish to see the faces of the nineteenth century we must turn to the photographs produced at the time.

Educational Use

One should not overlook innovative horizons emerging in the educational field. With greater dependence now upon visual materials of all kinds, the use of historical photographs as aids for teaching takes on more serious importance. Where the teaching of state history is obligatory, as in Wisconsin, the photograph

collections of the State Historical Society play an effective part in a many-sided series of programs created and used to aid schools and their teachers. Photographic exhibitions are unfailingly popular whether stationary in public buildings or displayed in appropriate vehicles as traveling shows. Such traveling shows, together with selected albums of historical photographs, can be offered for rent, lease or free to the public. Photographic essays to increase public understanding, as effective propaganda, are increasing in popularity. Some are making exciting use of photographs as posters. Photographs are finding uses on new items being sold each day. Students should be encouraged to attend seminars or workshops on historical photographs, where possibilities exist for careful study. Don't overlook oral history. Historical photographs can be helpful in several ways during interviews; they have already proven to be "memory stimulants" and successful aids for effective oral history interviews. The person being interviewed can be asked to verify photographs; the interviewer can offer them to jog a fading memory. Browsing through a photo album with a subject can open up unanticipated lines of inquiry, as well as other useful relationships.

Photographic Essays

The historical photograph essay has become so popular that it is virtually a standard fixture in an increasing number of historical and popular publications. Pioneered with notable success by *American Heritage* and *American West* magazines, it has been imitated countless times, a tribute to its popular impact. Such an essay frequently takes the form of eight or sixteen pages with a suitable number of photographs, perhaps twenty or twenty-four. This format allows proper space for the images as well as adequate room for captions or a continuous narrative. We recommend the use of large reproductions; avoid pages of tiny im-

ages that can hardly be seen, let alone "read" intelligently. So widespread is the success of this pictorial form that it is difficult to single out those worth special consideration, although one such pictorial treatment recently printed on frontier women in *Montana Illustrated* struck us with particular force.

Creating a file of photo-essays that win your approval can stimulate your own efforts. Such essays win the attention of those persons who may not read a publication but will "look at the pictures." It is an effective showcase for an institution's prize images often attracting the attention of publishers, television producers and other potential users of historical photographs. We recall one particular Gold Rush image, first used in an essay in the *American West* that was used not only in a larger book by another publisher, but figured in a group of western photographs used as a title for a television show. The essay can be innovative in treatment. A particular pictorial created for the quarterly of the California Historical Society is an example. The subject for the essay, a seven-plate daguerreotype Gold Rush panorama formed a continuous horizontal image some 27 inches long—requiring special folding as finally reproduced. Had this impressive image been compressed into the width of the journal's page, a mere six inches instead of the panorama's twenty-seven, the pictorial excitement of the original would have been impossible to reproduce satisfactorily. In printing such a photograph across two pages, it proved better to allow a quarter to a half an inch of white space at each gutter rather than running the photograph itself completely into the binding edge gutter of the publication.

Museum Exhibits

The widespread use of historical photographs in museum exhibitions and displays of every kind hardly needs comment, even though we are seeing only the infancy of an

48 expanding development. We recall the newly built Centennial Museum in Vancouver, B.C., which used mural-size enlargements of historical photographs to offer the viewing public convincing, supporting environments for their displayed reconstructions of early-day Vancouver. They are powerful and compelling exhibits using dramatically lit photographic enlargements, supported by carefully chosen artifacts and text. Robert Weinstein watched visitors passing these displays noting many expressions of pleased surprise and appreciation. It was a pointed example of the power of an enlarged photograph to draw its viewers into the environment of the photograph itself; it was as though the photograph were a successful exercise in space, rather than a flat, one-dimensional plane. We have seen other examples of effective use of historical photographs, in a series of display backgrounds in the Jocelyn Museum in Omaha. The curators there created exhibits of a reconstructed late nineteenth-century Omaha, Nebraska parlor, living room and kitchen to show the changing styles in dress and home decoration. Behind the windows, well-selected photographic enlargements offered spectators the changing vista of the Missouri River over the time span involved. It was brilliantly convincing! A series of photographic enlargements in the Whitney Museum at Cody, Wyoming, dramatically transform displayed costumes and the working gear of cowboy life into living artifacts. In planning public exhibitions, it is a tragic error to ignore historical photographs, so easily are they accepted as truth.

Slide Shows

The ever-present and widely-popular slide show, the standby of seminar and workshop, is a natural use for historical photographs. Their appeal seems never to fail. While the number of available historical images is large, too few slide presentations make effective use of the best of them. Others can tell you in detail how to organize a successful slide show, but we urge you to find new, unpublished images among the wealth of available historical photographs. They will make your presentation exciting and unforgettable. We know of a couple, photograph collectors in Colorado, who put together an immensely successful show using two projectors and two sets of slides, shown side by side at the same time on two screens. Each pair of slides offered before and after views of the same locale, or the same community, usually showing the difference over a good many years. At the conclusion of the slide show, a request is made of the audience for gifts of like material to add to existent files of such photographs. The record of this couple is that every showing produced its crop of additional gift photographs. As historical photographs are seen infrequently by most audiences, they are received with enthusiasm and an effective commentary to support the projected images makes for memorable presentations. In every case where we have spoken about photographs publicly, we have never failed to show a suitable group of slides with commentary. We are convinced that slide images made our various points more powerfully than anything we were able to say. We would urge in showing slides to use a zoom lens or any other lens that will enlarge the image; always use as large a screen as you can get. The larger the image seen, the more directly involved the audience seems to become. Try it yourself; the power of an imaginative slide is still vastly underrated.

Commercial Use

Historical photographs have been used imaginatively and excitingly on television for years in a succession of documentaries produced by Project 20 for the National Broadcasting Company. They include "The Real West," "Mark Twain," "Abraham Lincoln," among

others, making convincing use of nineteenth-century still photographs by Daniel W. Jones, Research Director, a brilliant workman in this field. Similar images now seen repeatedly in movie and television productions of every kind verify the impact of the still photograph used in this innovative fashion. The merchandising and advertising media have not been slow to use historical photographs successfully, reflecting the taste for nostalgia now sweeping the nation. The vogue today for another look backward shows up in the current public taste for nineteenth-century clothes, furniture, lighting fixtures, even the very "look" of hair-dos, mustache and beard styles. Posters using photographs of vanished Indians, cowboys, Civil War leaders and others continue to sell in astronomical quantities. Few areas of current taste have not been affected by what the nineteenth-century photograph has so accurately revealed.

One must further note a greater concern now by business and service organizations for public service activity among community organizations. These activities include visual presentations of every type; those featuring community growth in presentations of historical photographs have proven particularly popular. In San Diego, a Title Insurance company possessing a valuable historical photograph collection has a public relations program relying on the type of pictorial displays we have suggested above. They offer a variety of prepared displays to requesting organizations and in selected cases, will prepare displays to suit specific needs. In Los Angeles, a savings and loan organization named Lincoln carried on a successful sales campaign for a number of years utilizing every type of artifact it could obtain relating to Abraham Lincoln. The many photographs of Lincoln readily available played a large part in their success. In the same vein, the Wells Fargo Bank has maintained for many years a highly popular History Room in San Francisco under the leadership of

Irene Simpson Neasham, now retired. Built around displays of artifacts and photographs as well as clothing, firearms and a handsomely reconstructed stage coach, the History Room has become a national attraction. It owns an expanding photograph collection making its use easily available to any interested patron. Its activities are marked by understanding of the photographic image as an entertaining learning tool. A bank in Chicago is building a small but carefully selected collection of historical photographs. Every story of the successful public use of historical photographs cannot be recounted here; and yet any single story, or all of them, would reaffirm increased understanding of their value. The possibilities for even greater acceptance is at hand.

Reproduction of Photographs in Printed Form

Because the use of photographs in publication is so widespread now, some information on how to secure their successful reproduction may prove useful. Consider your reader's eyes and interest; don't reproduce photographs so small they cannot be adequately seen or understood by their viewers. It is a cardinal sin, avoid it! This is equally true for photographs badly reproduced or poor photographs reproduced only as well as they could be. The problem is not only an editorial responsibility; photograph curators can help by being aware of what to do to help limit poor reproduction and, most importantly, what kind of photographs they should provide to assist first-rate reproduction.

The most popular printing process for the reproduction of photographs is the halftone process. It was developed in the United States in the late nineteenth century and it remains today, highly improved, a successful method for reproducing photographs. It is in the technical sense a skill of its own, a complex process with its own specialists and its own

50 specialized literature. In so short a space we can't make you into a specialist, nor do we want to mislead you into thinking yourself an expert when you do discuss the process with your printer. We do want you to know a few of the things that can help you secure worthwhile reproduction of photographs. In all mass-production processes, taste takes time and time costs money. It is fair to point out that the more care and time taken in preparing and printing halftone plates, the better result you can expect. Budget can mean choosing a better grade of printing paper, more care and individual handling in the making of halftone negatives and plates, and more attention for the pressman as he attends the lithographic printing presses. Thus, the first consideration is recognizing that your budget, and the skill and experience of the printer you use, will make all the difference in the final result.

As an initial step, carefully examine the photographs reproduced in a book, in your library. Look at them with a powerful magnifying glass. You will notice a pattern of "spots" or what printers called screened dots. The original photograph which had no dots was photographed through a piece of glass or plastic having a pattern engraved on it of closely ruled horizontal and vertical lines. These intersecting lines form a pattern of dots, or a screen, designed to allow each resultant dot to carry a bit of printing ink. Responding to the amount of light and dark area in the original photograph, the size and closeness of the dots will vary, forming the halftone reproduction. When printed carefully, the pattern of dots will reproduce the photograph apparently in facsimile. We say, apparently, because it does not accurately reproduce every tone in the original photograph, but rather most of them, giving rise to the name of the process, *halftone*. The process can do no better than the quality of the original photograph provided. Thus, your primary concern is providing a well-printed,

sharp, full-tone photographic print for reproduction. A faded, out of focus, uncontrasty or flat print, one lacking in tone will produce the gray, murky, muddy reproductions that everyone despairs of. Most photographers can quickly teach you what a photographic print suitable for reproduction should look like—a point of view you should learn as quickly as you can.

The halftone process, properly executed, will add about 10 or 15 percent contrast to a reproduction in the printing process. *Contrast* means the degree of difference between white and black or dark and light. Thus, a photograph in which the whites are near blinding and the darks absolutely black, a photograph in which grey or middle tones are markedly absent, is very contrasty. A photograph in which there are no clean whites or sharp and dense blacks, but predominates in an overall total grey or middle tone quality, is lacking in contrast and is known as a flat print. Both flat and high contrast prints should be avoided for reproduction. If there is high contrast in the original photograph you provide for reproduction, the halftone process will only add further contrast. To put it another way, a well-printed photograph made for public display in an exhibition hall is usually too contrasty for maximum reproduction. Photographic prints that are a bit less contrasty than full-scale tonal value prints, a bit more flat than would be used for exhibition prints, are the best to offer for reproduction. If you have access to a good printer, and if your photographer does not already know what we have just said, then a meeting between the two of them will be to everyone's advantage.

A printer tries to produce halftone negatives and printing plates that he can print well easily and speedily. Remember, time costs money. Thus, the printer's effort is aimed at producing what he may call balanced halftone negatives that capture as wide a range of

middle tones as possible, deliberately sacrificing some of the brilliance in contrast between clean, crisp whites at one end of the tone scale and dense blacks at the other end. This "balanced" technique can transform crisp, contrasty photographs into lifeless, flat reproductions. Discuss with your printer your desire to avoid such reproduction. Try not to reduce an original 11" x 14" photograph to a 2½" x 3½" halftone reproduction. Making photographs smaller reduces the amount of observable detail, the halftone process adding further to the problem. Where it is possible, it is best to provide the printer a photographic print the same size as it is to be reproduced, or else a print just a bit larger than its final reproduction size.

The printer's camera is a very precise and accurate recorder and will pick up every blemish on the surface of the photo you provide—including certain gouges, indentations, greasy fingerprints, etc., that may escape your attention. Keep all the photographs you intend to reproduce in an evelope of some kind until they go to the printer. Be sure they are always handled with great care. Finally, although fine printing is a matter of individual taste, it is universally agreed that a halftone reproduction almost always looks best when printed in black ink or a very dark ink as sepia, dark gray, etc. Printing them in a colored ink alone, as blue, green, orange, yellow, etc., should be avoided. It tends to wash out the contrast and render the photograph pallid in appearance.

Montages are a collection of pieces of photographs pasted together to form one coherent image. We think they are rarely seen by the reader as planned by a designer and we disapprove of their use for the presentation of historical materials. Our main objection is that all the edges of the separate pieces of photographs appear to run together and the juncture of the many pieces only increases visual confusion. We think if you mean to use them, try to avoid many small, individual images and con-

centrate instead on a fewer number of images that stand by themselves. So they can each be "read" clearly, we advise separating the individual images by a black or white line, wide enough to insure a clear separation. Another popular sin of inexperience that confuses the clarity of a photograph is the practice of reproducing a few lines or page of type over it. In most cases we have seen, they effectively cancel each other out so that neither can be understood. There are cases where this has come off successfully by the use of a second color or by the choice of a photograph of very low contrast. Usually the fine hand of an experienced graphics designer has been at work in such successful instances and the amateur should try to avoid the danger. If you need to print type on the face of a reproduced photograph, beware of two pitfalls. The first is making certain that if the type prints in a dark ink, the background of a photograph must be light enough for the type to be legible. The second precaution is exactly the opposite, in that if the type is to be white against a dark background, the only way it can be read is if the background of the photograph over which it is printed is dark enough.

Remember, if you plan to *bleed* the photograph, or run it to the outer margins of a printed page, you will have to allow for photographs losing at least an eighth of an inch from their outside edges in the final trimming of the publication. This does not occur when the edge of a photograph is printed so it touches the inside edge binding, or the gutter, of the printed page.

In using photographs for publication, it is often desirable to use only portions of a photograph. The submitted photograph is not then actually cut to the desired proportions but written instructions are usually given to the printer to use the photograph, without harming it, to such an end. This process of appearing to cut or trim a photograph as needed is

52 known as *cropping*. In this fashion a complete photograph may be trimmed at its edges as needed, or a portion may be selected from within a photograph, creating a new and separate photograph.

You must be certain that cropping does not remove essential parts of the photograph, impairing its ability to transmit information or feeling. A most apparent error is the wanton cropping of the tops of people's heads, or portions of hands, or a bit of chins or something similar. In the case of objects, equally harmful croppings can occur through ignorance. The brownline or blueline proofs of halftone negatives given to you by the printer should be used to determine or check planned cropping so the picture may perform as planned. Try always to assure that any planned enlargement of a photo, or cropped portion of a photo, is not so great as to reproduce a blurred or grainy image in consequence. Remember that you are dealing with a series of dots; too great an enlargement will reveal the dot structure, not the photograph. Again careful examination of the brownline, or the blueline will reveal this problem. In providing the printer with the instructions he needs to use your photographs, offer the needed information on a separate sheet of paper that accompanies the photograph; *do not* allow anyone to mark instructions on the white borders of the photograph or on the back. The photograph can be seriously damaged in this fashion and the enforcement of a strict prohibition in this regard is very desirable.

There is no encyclopedia of how to use photographs well, for new ways are being found every day by innovative minds. We think you can only present convincingly what you find in photographs and what you believe about them. They can be used alone, without words of any kind, or they can be combined with words with great effectiveness. One of the more eloquent such combinations in our memory is a little-known book, a pictorial

homage to the totem pole of southern Alaska and to those who carved them. It is called *Out of Silence* and in itself, perhaps, sums up many of the feelings we have about the still unexplored possibilities of the visual image. We are convinced that all that we have seen thus far is but a foreshadow of the truly impressive pictorial works to come.

Retouching

Photography, newly discovered in 1839, leaped upon the centuries old traditions of painting that had preceded it. Painting had formed the way people looked at things and at one another. The flattering perceptions of the classical portrait painter were widely accepted as a "beau ideal" for the way one should appear and the new portrait photographer could find no way to escape the impact of this convention. The difference between the painter's portrait and the "truth" the photographer's lens returned to its subjects was unbridgeable.

Retouching was developed in the nineteenth century to help portrait photographers feed the vanity of those of their customers who felt offended by Nature. Far from pleased with what the photographic lens gave back to them in their portraits, certain customers asked for "artists" to make themselves look "better."

The photographic profession developed a variety of methods to satisfy this need. A popular one, retouching, was done on both negatives and prints and although the results were not always esthetically pleasing by present day standards, it was enthusiastically accepted in its day. Many examples of it can be found in historical photographs. The tradition for its acceptance is deeply rooted. Where the "selling" qualities of photographs are believed to be capable of improvement by skillful art work, retouching is still used. Commercial firms presently use retouching in advertisements to improve the attractiveness of their photographed product. Present-day devices

and techniques have greatly improved the art of transforming photographs and in certain cases the techniques have achieved results which seem nearly miraculous by business standards.

There is a growing satisfaction these days in presenting and seeing things as we think they are or were. For such vision, retouching is useless. The results of retouching, even skillful retouching in many cases, appear artificial to many persons. The retouching artist is unable to exactly match the random character of natural textures, nor can the artist accurately duplicate natural lighting. This combination of the real and the artificial in photographs is unacceptable to many enthusiasts of photography. Others believe the integrity of the photograph is harshly violated by retouching, no matter now expertly accomplished. These considerations must be taken into account in determining to retouch a photo. If one is decided upon retouching, it is well to know that the most satisfactory approach is defined most succinctly as "the less the better."

Retouching used as a repair or as a restorative for reproduction of photographs is a wise procedure if it is handled skillfully. The visual effects of a cracked negative can be repaired by retouching, as can the consequences to the view of gouges, embedded or surface dirt, or abrasions, especially in a blank sky. Highly detailed areas of a photograph requiring artistic rebuilding must be treated with the utmost judgment and ability. Certain kinds of damaged photographic images intended for public display can be improved by judicious retouching and such work deserves the effort.

Some of the more important Don'ts are:

Don't *ever* retouch an original print
Don't retouch a large area
Don't retouch with a heavy hand
Don't retouch over the glued joint of two edges of a photograph

Don't redraw a portrait; don't put young eyes on an old person . . . or vice versa
Don't be sloppy . . . it will all show.

And now a few important Do's:

Retouch only where *absolutely necessary*
Be scrupulously careful in your work
Do only what you can undo—if necessary
Be true to the subject, be utterly faithful
Be light of hand and free of heart.

In general, Nature is infrequently improved upon by Man and this caution can well apply to retouching. If an artist rebuilds or redraws a damaged photographic portrait, *remember* that however skillfully it is done, it is no longer simply a photograph, it is a retouched, a redrawn photograph, not a drawing, not a photograph . . . but a mismatch of the two arts.

Making Your Collection Available Responsibly

It has been wisely said that a collection neither available for use nor used is hardly worth the effort to accumulate it. The active and informed use of a photograph collection should, of course, require no justification; yet use carries with it a wide variety of unavoidable problems. The essential problem is that Man, whether through indifference or ignorance, remains the single greatest source of danger to photographs. It is a risk that archivists, librarians and curators must accept, as there seems no way to avoid it. If photographs are used, they will be damaged and deteriorate; if they are not used, why bother then to collect them?

In general, the transient nature of patrons, their ignorance of the necessary care in handling photographs and the dangers of theft, all real risks, define the problem. Some control over the activities of your patrons is obligatory

54 if the consequences of their rough use of the photographs in your collection are to be minimized. A successful way to guarantee greater physical security of photographic images is by establishing and enforcing effective rules and procedures for handling them. Such rules and procedures must be clearly understood by all, be in force at all times and be uniformly applied to all persons working in your collections. It is unwise to allow a curator or an assistant to make up new procedures each day or to allow anyone to breach the required procedures lightly. Certainly no patron, no matter how important, should be allowed to create personal rules for handling photographic materials. Whatever requirements are agreed upon should be enforced faithfully, and revised and upgraded as the collection grows larger.

Patrons will arrive with different needs and different levels of experience in using photographic collections. Some flexibility in the application of your basic procedures may be warranted. Defining the type of patron needing service should be a major first step in deciding what leeway you will allow. They can be divided into two broad groups: the first, a small minority, consists of professional photoresearchers, picture people like yourself, specialists and serious amateurs. The second, the majority group we call "browsers," dominate the field and include many persons from publishers, movie and television studios, and newspaper offices. They are predictably unskilled in handling photographs and are usually not anxious to learn.

You have most to fear from the browsers, and run far fewer risks of mishandling from the professionals. It is not hard to spot them; you may already know these professionals by reputation, or they will arrive having been recommended to you. Discussion with them will quickly reassure you as to their professionalism. Because their expertise can frequently help you and because they can usually be trusted to handle your fragile and valuable items properly, little in your collection should be withheld from them. The curator or your librarian of photographs ought to prepare a list of photographs considered to be the great images in your collection. Every institution has such photographs; they can include well-known, little-known and as yet, publicly-undiscovered images. Original albumen prints, rare daguerreotypes or ambrotypes, fragile images, special problems in identification that have puzzled you—each of these is the particular province of the visitors we call "professionals." Their specialized knowledge is needed to increase the value of the images in your custody and every effort should be made to secure it.

Who are our browsers? They can be authors, artists, researchers, students, journalists, exhibit and display designers, picture editors, television and motion picture researchers, historians, teachers and publisher's representatives. They will each come to your archive with a personal point of view about photographs and their requirements will be equally personal. Discussion should establish the degree of interest, knowledge and qualification of your browser. What they tell you they need can alert you to the risk their search may present to your collection. Your job is to both serve and protect. To do both, to serve your patrons on one hand and protect the materials in your collection on the other, demands you assess patrons carefully. The depth to which you allow a browser to penetrate into your collections should depend on the quick judgment about each of them *you* must make. This moment of truth can hardly be avoided if you are to insure the safe handling of your photographs and negatives.

You must be assured that your patrons will treat photographs with required consideration. The perfunctory searches made by most patrons for photographs underscores the low regard in which many still hold historical photographs; they seem not to consider them as his-

torically valuable documents. Although it does not happen often enough, it is both rare and refreshing to find a browser really "flipping out" over eloquent images or a historic "find" of substance. Any examination of your collection in depth requires ample time and few browsers seem to have such time to give their searches. Haste on their part will absolutely produce neglect of the proper procedures, and with it some abuse of your material.

Patrons ought to be told of collections of unprinted negatives, uncataloged albums, and uncased daguerreotypes and ambrotypes in your collections. The willingness of researchers to spend the necessary time looking at such material is frequently a test of their interest in images. Having determined the browsers fitness to use your collection, your next problem is how they use it. What exactly do they want? They do not come often, as photo-historians, they come as a form of messenger trying to do a job as quickly and efficiently as they know how. Sometimes they come for a particular photograph they know you have and nothing more. They will not want to look at pictures, discover any new images, or even enjoy looking at old photographs. None of these will interest them. Sometimes a browser may ask to see everything you have on a given subject, not realizing how impossible that can be. Others come seeking illustrations for an article, a photo essay or a book—and they may ask you to tell them what they should examine. On occasion, they or their editors believe you have a photograph that should have been taken, but wasn't. In the majority of cases, researchers want to be offered options; they will make a choice or choices of pictures, even though their time is often limited and their interest in images mild. What they need most of all is to see pictures. Ideally, they want to see them grouped according to their choice of subject. They hope they will all be accurately dated, thoroughly identified; they want all the images the same size and all of them beauti-

fully printed. Most of all they want them to be available instantly. In every case, they perceive their needs as real and pressing.

In many cases we can recall, the photograph chosen was needed desperately, the very day it was found. The varied needs for photographs are near endless—as are the kinds of people coming to request the use of them. A specialist may appear to discover or confirm new aspects of photographic history or a photographer may appear requesting permission to photograph images for study and for later orders. Historians may come to find illustrations to accompany their projected publications, to discover material they might use in lectures or seminars as slide shows or to enlarge their own knowledge on some point of geography, dress or construction. Exhibit designers will come for story-telling photographs that will document and enliven the public or commercial displays they are planning. The moviemaker or television researcher will come hoping to discover still photographs that can be used in documentaries. Genealogists will come looking for photographs to support their findings, inquiring for individual portraits of persons, towns, villages, businesses, and homes, or even seaports, trains, ships and out-of-the-way localities. In some cases, their concern may be your particular locality, a specific structure or even a gravestone in your local graveyard. Requests to use your collection can come from newspeople, government employees and attorneys. We recall an insurance adjustor once looking for aerial photographs of a specific locality he needed as a key exhibit in a lawsuit involving home damage from slipping terrain. The point is that *verification* of some particular fact emerges constantly as the justification for using photographs. Each of these browsers can have something to offer that may help your collection. They may know of additional materials, or better examples in other institutions. Ask them for their help, it can prove to be valuable.

56 Many persons requiring photographs have proven unwilling to search very deeply for precise *images*. Often some photograph generally representing their need is satisfactory. For many patrons who fit that description, a master file of prints from your collection's principal holdings will suffice their needs very nicely. Your best known and most popular photographs by subject categories should be offered to most patrons as the first step in their searches. However, to describe this master file more carefully: suppose you own 350 photographs of the period 1880 to 1900, all of them showing the growth of your community. Carefully select twenty-five or fifty crisp, publishable views that previous browsers have chosen most often, or those unique photographs that seem to say it all; you will have assembled a sizeable group of popular images. They will answer the requirements of most of your patrons looking for that particular category of photograph. If you were to repeat such selections in each of your most often called-for categories—churches, schools, transport, farming, mining, lumbering, harbors, shipping, etc.—you will have created the kind of master file we have in mind. It is surprising how often the needs of most patrons are completely satisfied by such a master file, requiring them to do almost no further browsing. As these popular prints may be subject to steady requests for immediate sale, it would be best to print them in small quantities for current needs and replenish them as the stock diminishes.

Uses for Xerox Prints

A primary principle of image retrieval in cataloging and indexing is the inclusion of an image as part of the filing system. Because of the great expense involved, such procedures have been beyond the resources of most institutions. Now paper copy prints can be included in many types of filing systems at low cost, saving wear and tear on original photographic prints.

The new generation of Xerox-type copy machines, now called plain paper copy machines, are capable of making same-size reproductions of photographic prints well enough to serve many purposes in cataloging, indexing and reference use. Plain paper copy machines such as those made by IBM, Copy Master, Royal Bond, Canon and others can make these surprisingly good copies from original photographic prints at a cost of only 5 cents to 10 cents per copy. The paper used in the machines is usually no. 20-pound bond. The image is formed by carbon particles which are fused to the paper base by heat. The permanence of the copy image should be as good as the paper base. However, these copy prints should not be stored in contact with original photographic prints.

Print quality from these plain paper copy machines varies not only with the different manufacturers, but also with the condition of the individual machine. Before deciding on one particular machine, visit a number of distributors of competitive machines to have copies made from the same test print.

Copy exposures are made by high-intensity light, but the exposure time is short, about one-half second. The number of plain paper copies made from a valued original print should be tightly limited to a few for two reasons. First, the repeated exposure to ultraviolet light, albeit short, can be a life-shortening, fading factor. Second, any handling of an original photograph during the copying process causes wear and tear and physical damage. We urge that any plain paper machine copies be made by your own informed staff person. Do not subject valued original photographic prints to careless uninformed handling by copy service personnel.

Plain paper copy prints can be used in many ways as visual aids in cataloging and indexing, and as stand-ins for the original photo-

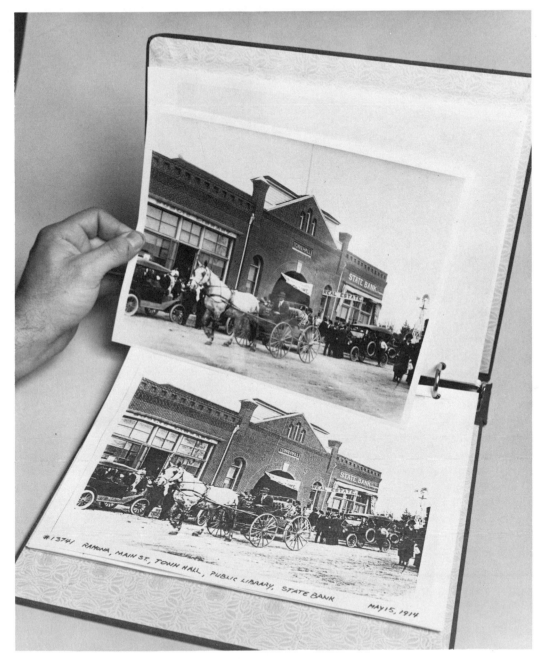

#13741 RAMONA, MAIN ST., TOWN HALL, PUBLIC LIBRARY, STATE BANK

MAY 15, 1914

Shown here is an original print (held in hand) compared to a plain paper copy print (below) made on an IBM Copier II. The loose-leaf notebook represents a collection of 150 related copies made by this inexpensive method at 5c to 10c per copy. Plain paper copy prints can be used in a variety of ways such as cataloging, indexing and cross-filing. (Photograph by Larry Booth)

58 graphic print. They can be used to make catalogs of any subject that suits your filing needs such as the work of one photographer, one donor's collection, or a grouping of like subjects. We have seen them used in subject folders in vertical file drawers. Sections of plain copy prints can be cut out and mounted on index cards as an enrichment to a standard file card system. Multiple copies, because of their low cost, can be made for cross filing in any system. As plain paper copy prints are not suitable for display or illustration, they are less likely to be stolen. Damage or loss of them is easier and less expensive to remedy. For most research perusal and identification use, these copy prints are quite adequate, eliminating wear and tear on originals and work prints. They can easily be written upon, on their faces, so detailed identification or extended comment is now possible where it is immediately visible. One need no longer turn over a photographic print to read what may have been written on its back side. Because plain paper copy prints are thinner than photographic prints, many more images can be stored in the same space. It has been common practice to send Xerox prints of photographs for identification purposes when requesting prints by mail for reproduction or illustration. It makes sense to expand the use of paper copy prints wherever they can eliminate handling damage to original photographic prints.

Preparing a Useful Photo Catalog

What kind of catalog should be available to help your patrons find photographs? There are many well-described systems already in operation with many useful features in each of them. We have noticed useful ideas that have been overlooked and we offer them to add to your own systems.

Most patrons will consider your catalog somewhat akin to a magic key instant guide to The Picture they know is in your files if they can but retrieve it. They want your catalog to be an instant, accurate guide to the image they and/or their editor have seen reproduced, the one whose retrieval has brought them to your files. Others wishing only to browse among available photographs, will regard your catalog as a regrettable annoyance. We recall one institution in which each individual image could be seen only by filling out a specific card request each time a picture was desired, more than one patron's idea of a bad dream come to life. Reasonable patrons expect your catalog to be an understandable, reasonably rapid aid to finding what they want, a complete listing of your available holdings allowing speedy retrieval of the image they need. Your patrons naturally hope for the best and would like you to offer them a sheaf of *exactly* the type of photographs they require. Even more frequently they hope to tell you in words what they are looking for and hope you will produce the matching photograph immediately, letting them get on to better things. There will be patrons who are impatient with catalogs of any kind and resent the time involved in having to look at the catalog at all. The largest number of your patrons, however, expect that your catalog will be more exact and more thorough than they will find it. Although patrons hope to find each of your photographs accurately cataloged by subject heading and date, the limitations of many catalogers' knowledge and interest in photographs often frustrate this reasonable but often unrealistic expectation. Due to changing needs and unforseeable requests it may prove impossible to provide total access to your collection; patrons must understand this. In the absence of an opportunity to offer them a visual image to examine, your patrons hope you will provide as great a range of accurate information for his guidance as is possible. Where it is known, portraits should be thoroughly described and cross-indexed as well as listed alphabetically. Cross-indexing should indicate the images of well-known and

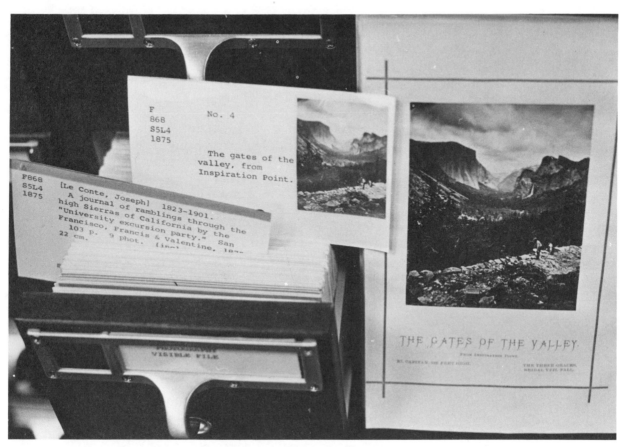

Shown here is a recommended approach to photographic cataloging which affords the patron a photographic image to examine. On the right is a book illustrated with a tipped, original photographic print. On the left is a normal catalog card required to find the particular book. Above it is a photographic catalog card using a miniature print of the tipped photograph in question. (Courtesy, Special Collections, UCLA. Photograph by Linas Bauskauskas)

significant photographers as they should also indicate lesser known photographers by name: for example, men and women like Vroman, Soule, Frances Johnston and others, unknown yesterday, but important today. Categories of photographers should be indexed by their specialties in photographing important historical events as the building of the transcontinental railroad, the digging of the Panama Canal, the voyage of the Great White Fleet, etc. Your catalog should also offer information that a book or manuscript catalog would not offer.

For example, your patrons ought to be able to know that an original or a copy negative is or is not available for printing. Your catalog should indicate by cross-indexing that similar and related photographs are available among other photographic materials as stereograph cards, carte-de-visites, daguerreotypes, ambrotypes and tintypes or other cased images. The catalog should index other items often overlooked by catalogers such as oversize images and available framed pictures. Cross-index negative collections worth examining by

60 patrons, as well as photograph albums in which they could expect to find specific images of interest. The inclusion as catalog entries of books illustrated with tipped-in original photographs would provide even greater help than a catalog normally provides. Another feature rarely found in contemporary photographic catalogs that would add more to their value would be some indication of the quality of the photograph described. It could save time and disappointment for researchers to know that the photograph described on a file card is a fuzzy, out-of-focus image or a poor print from a bad copy negative or a print made from a picture copied from a newspaper or a very contrasty or muddy print with very little definition. It is doubly disappointing to discover this after a researcher has spent money ordering a print and time for its use has narrowed down severely. Your catalog ought to distinguish the image category described, whether a color slide, a black and white positive slide for projection, or a photograph of a drawing or of a lithograph; it should indicate a wet-collodion negative, albumen print, stereo negative, etc. Such time-saving information can be very valuable to researchers.

Even more helpful to interested patrons if possible, would be an available printed guide to your collection. It could detail the different types of images you have, accessibility and degree of cataloging available, condition of the materials, restrictions on use, etc. It would be a great help if it would indicate the strengths in your collection—notable collections you possess by name as C. E. Watkins, Muybridge, Taber, Kinsey, etc. Note major subject holdings, unique images and any especially well-known archives as Alaskan Gold Rush, Civil War views, etc. The catalog should aim at providing the special kinds of information peculiarly needed to make the best use of the images in your custody.

What we have described as useful features for a photographic catalog, together with your own basic cataloging system should fill many needs; it will come close to what many patrons think a photographic catalog ought to be, meeting most of their aspirations. It would be far better than anything presently available.

The criteria suggested here should be considered only as goals for the future . . . even if that future cannot be soon. There is no need for despair. Too many well-known, day-to-day problems as identification, filing and refiling, pictures out of the file in use by patrons, lack of available duplicates, preservation and archival measure, insufficient personnel to maintain operating requirements, and inadequate funds still force many institutions to offer yesterday's solutions for tomorrow's problems—problems shared and understood by almost everyone.

Inevitable decisions have to be made about what to file, what not to file, and what to dispose of, even though a conservator or a dedicated archivist might hope to file every piece of a collection. If you have the knowledge and authority, go through a collection before it is filed and weed out duplicates and otherwise undesired pieces that can be used for trade, sale or technical experimentation. Do so, but with caution, remembering that your guiding principle is to protect all valued original historical photographs. As they are artifacts of their time and of special interest to scholars in general and photographic and art historians in particular, these original photographs should be treated with special consideration. As examples of long-vanished processes, their singularity requires their careful preservation. Their visual qualities can no longer be exactly duplicated and thus they can provide through careful examination, greater information than copy photographs. Even if you can afford to duplicate and make work prints of all your material, save and care for the originals. Severely stained and faded originals can be put away until they can be restored. Many techniques for restoration are in use today and ad-

ditional ones can be expected in the future. Some original prints hopelessly damaged by fungus, insects, nitrate-base film contamination, etc., may be worthless, only useful to a conservator-technician for experimentation. Discard them of course, but be *sure* they are altogether worthless before you let them go. This may be equally true of certain negatives, and our advice is the same. Be sure! Hopefully, what you learn in this book will give you the knowledge and the wisdom to make such judgments correctly. Paul Vanderbilt said it very well, "Finally, we would inject a word of theoretical caution. Do not confuse the issue of your own institution's immediate file problem, which we assume to be limited, with the general problem of access to picture resources. The use of pictures is in active transition. Total access is impossible except on some specific basis such as the geographical approach to mapping or the title-page approach to published books. The world of pictures is now almost as large as the world of words, and rather more diffuse. The only thing easy to find is an item or a unit already assembled, packaged and keyed in precisely the same terms as the inquiry. If you aim at a limited and local perfection, you run the risk, perhaps calculated, of completing a great labor in terms of demand standards just as those standards are being changed through evolutions in publication."

The important thing, therefore, is that existing and historically valuable photographs and negatives be collected, preserved, identified, and so arranged that they can be used, now and in the future, to add a greater dimension to our understanding of the past.

Thoughts on Charging Use Fees

This problem, whether to charge or not to charge certain users of your photographs is a thorny one; debate about it continues to rage. As yet, no one has offered a definitive solution meeting all contingencies. Our opinions and

the reasoning that forms them are offered here only as guidelines. Different opinions than ours, strong views held by equally sincere and concerned persons, should not be overlooked. No one can examine the organizational budgets of most institutions and the priority accorded the preservation and restoration of old photographs and fail to wonder how the necessary work will be carried out. The fact is that funds and staff for acquisition of photographica in most organizations is minimal and the availability of resources for archival and conservation needs are even less. The lack of any type of national or statewide preservation effort or funding in this area underscores the deficiency even more strongly. It is this frustrating dilemma that drives us to our position.

Faced with pressure for needed funds to maintain the work, we hold that those patrons who use photographs with the clear intent and hope of selling their product for profit, have an obligation to share that profit with the owners of the photographs supplied. We are less interested in the precise form in which the profit, or the amount of it is shared with the holding institution. There can be many acceptable forms of payment. We hold that the practice of repayment in money for such an obligation is moral, fair, and practical; we urge its observance. Those who use photographs for profit have no more right to expect their free use than they have to expect an author, a printer or a trucker to provide services free of charge. The obligation to pay for services rendered is beyond dispute, both in law and in usage. There is one area that does require clarification, however. Any institution supported by public funds faces some sort of conflict between charging for services and the right of free use; it must examine its position on any charges very carefully. The essential principal that all taxpayers—or in effect each taxpayer—deserves equal value from the use of those taxes is firmly founded in practice and in law and cannot easily be dismissed. Equal

62 value in this case means equality of access to all who wish to use publicly owned materials. Notwithstanding, the right of public bodies to engage in the selling of certain services has been upheld in law and is in widespread practice, for few observers dispute the urgency for public agencies to generate badly needed support funds from their activities. One need not look too far to find such fund-raising activities. Which public institution does not support money-making book shops, gift shops and restaurants in its buildings? Which museum or state-supported university fails to offer profit-making tours to its various friends and members? Which public, tax-supported institution does not organize profit-making sales, raffles, auctions and assorted fund-generating activities? Each of these activities underscores the urgent need now for additional support funds of publicly supported, public service agencies. In the same spirit we believe a photographic archive, by providing saleable items to businessmen, has the moral and legal right to expect a portion of those expected profit in return.

Moreover when publishers, for example, require photographs from commercial sources they expect and do pay handsomely for the right to use them in their publications. We know that the current normal practice among publishers is to pay established use fees to the owners of photographs for the right to reproduce them "one-time" in their publications. We cannot conceive of a manufacturer expecting to receive the staff time and research skills of scientists at a publicly supported university free of charge; we cannot similarly see the right of another businessman requiring the services and the products of another publicly-supported facility without a payment of some sort.

Our position is simply that photo archives ought to charge a fair fee for the making of any photographs, copy negatives, transparencies, etc., and that a schedule of use fees ought to be set up to be paid by publishers for the one-time use of such photographs. Use-fee schedules should be noncompetitive with commercial stock photo firms and the fees charged should be significantly lower than current commercial rates.

We think that for such fees the holding archive ought to provide a first-class photographic print, fulfilling normal requirements for suitable reproduction and that reasonable amount of staff time for search be included. We think the using organization has the normal obligation to acknowledge credit for the source of the photograph and the lending agency should provide suitable copy for that purpose.

We think that the using organization should provide the lending organization with a schedule of its normal use fees for guidance. In all cases of loan, the photograph should remain the property of the user purchasing the right to reproduce it, restricted by the agreed one-time use of the photo and the prohibition against further resale by the purchaser.

Adequate legal notice of restrictions on the uses of a photograph may be summed up in a simple statement as: "This photograph may be reproduced for black and white, *one-time only use*. Any further commercial uses require written permission of the owner." A written request for a credit line should accompany every photograph released for public use. It can be a straightforward, The So and So Historical Society. Requiring a credit line every time one of your photographs is used should become a firm habit; it is a profitable one. Any suitable waiver that you may wish to issue can oblige a particular patron.

Governmental bodies, public service agencies and other clearly nonprofit organizations ought to be able to request the use of your photographs for only their production cost. Students needing photos for scholarly work

can either be given them free or for the same minimal production costs or less. Where public service and profit-making are combined, negotiations ought to be carried on to benefit both parties.

We may discover more equitable ways to handle this problem in the future, but life will not wait for an ultimate solution. The problems of photographic preservation and restoration are with us now and their attrition must be halted. We pay a high price in continued ignorance for delay. What must be acquired and preserved needs funding now and the expectation of sharing openly in a profit-making venture seems to be prudent, moral and keenly urgent.

3

Thoughts About Collecting Historical Photographs

*T*HE negatives, prints, records and photographic artifacts that define the history of photography in the nineteenth century make up the largest share of the photographic collections of historical societies and libraries. Their effective preservation and use is our principal problem. But some ask, Why bother? Why spend the effort and the money to collect and preserve them?

It is not hard these days to believe that everything in the world is being collected by someone or some institution. The markets for "collectibles" expand steadily, the variety of interests they embrace endless. The growing interest in and the prices currently paid for photographs for example, have reached astronomical heights, and the end is still not in sight.

With such high-priced competition for images, the way ahead for professional institutions seems less and less clear. One is tempted to ask what will we lose if historical photographs are not collected responsibly? John Thomas, a British photographer, in 1891 offered a sensible answer in the *Proceedings of the Royal Geographical Society*. "We are now making history, and the sun picture [photograph] supplies the means of passing down a record of what we are, and what we have achieved in this nineteenth century of our progress." He has well defined what we will lose, "a record of what we are and what we have achieved."

Why Bother?

We would all be poorer without such a photographic record, for few persons dispute its value today. Yet, popular mistrust of photographs grows side by side with renewed interest, a paradox rooted in the development of photography itself. In the short space of time photography has served us, it has become a commonplace feature of most of our lives. The proof is hard not to see. With advertising, journalism, publishing and television, the demand for our visual attention is unceasing. Something has had to give under this pressure—and it is our visual attention span that has given way. Few of us really look at anything any more. We are being transformed from a nation of lookers into glancers, having time only for a hurried peek; we look more often and see a great deal less. The acceptability of the photograph is stretched to damaging limits under such tensions. Our abilities to manipulate successfully the photographic images on the enlarging easel, the drawing board, in the editorial offices and on the printing presses, all have further lessened public trust in their truthfulness. Such evidence is falling to a new and threatening low. Certain memorable exceptions remain of course. Recall those few: the hard core of the credible evidence surrounding the assassination of John F. Kennedy in Dallas, Texas, rests almost solely on a brief, chilling loop of 8-mm film taken that tragic afternoon by Abraham Zapruder, a casual spectator. The most popularly accepted verification of United States and Soviet moon landings are photographic images of the feat. Color photographs taken by moon visitors with hand-held cameras and television images were relayed back through space as electronic impulses—truly a near-miraculous accomplishment. Finally, the television coverage of the Viet Nam war allowed viewers to see modern war, almost live, in their living rooms. The only missing ingredients were the din, the stench and the pain of the real-life battlefield. Here is participation in history on a scale and involving numbers of human beings never thought possible by any person—proof

enough for anyone. Remember, it is the photograph, moving or otherwise—not solely the spoken or the written word, not a drawing or a painting—that involves millions of television viewers daily in history. This convincing photographic record, unlike any other previous form of communication, is the material we have an obligation to find, preserve and make available for use. Listening to computers whirring away and watching the flashing lights of copying machines is convincing proof of the near-mania we presently attach to the value of records. Although we esteem the assistance of photography in preserving a record of our own contemporary concerns, the care, collection and preservation of that photographic record itself has been slighted. It requires greater attention. A paradox is again at work here, for in spite of the persuading credibility of the photograph, far too little serious attention has been paid to its preservation and collection. Over the last 125 years in the United States, significant portions of the photographic records of our past have been ignored, refused a suitable home or adequate archival care, and, all too frequently, have been destroyed. It is sadly possible that such a story of neglect and indifference could easily continue into the future. So important a visual heritage ought no longer to be ignored. Why is this so?

Acceptance of the Photographic Record

The traditional reliance of historians on the written and spoken word remains. The struggle for greater acceptance of the historical photograph as a valid document offering dependable evidence is still new; and the shift from indifference for the visual document to understanding of its significance lags still. The study and uses of images as documents is just beginning, and funds to accomplish what is needed are in short supply and low on lists of priorities. Saving the images that still remain is a problem deeply rooted in traditional at-

titudes about photographs. Were we so blessed as to enjoy a national enthusiasm for historical images, there would be less to discuss. It is not easy to save photographs and care for them now. The national attitude is a diffident one at best, a take-it-for-granted posture that too many Americans hold about the value of preserving our photographic record. Let us look at how this attitude developed as photography itself developed.

Photography's brief record is impressive. It burst upon a world of 1839 impatient to receive it. What mankind knew of the world then beyond its own experience was limited to what the writers and picture-makers of his time could tell him and her, at least to those who could read and had access to books. The limitations of the artist and the writer established the limitations of their audience at the same time. Photography changed that instantly. No longer did the artist serve as the only interpreter-communicator between man and direct experience. The power of the photograph as visual experience was widely hailed with appreciation immediately and even looked upon with some awe. Man's eagerness to "see" through the photograph and to believe what could be seen in it took on frenzied proportions. The new "sun" picture made it possible for man to participate in an unfolding world beyond his limited vision and beyond the reach of all previous experience. Thoreau's perceptive insight, "You can't say more than you can see" had been given life by the photograph, adding a new dimension of visual experience for mankind.

The camera's familiar images were reassuring, corresponding with apparent reality in infinite detail. Photographs were accepted because they verified this apparent reality. The world that lay beyond immediate experience suddenly became at least visible. The unfamiliar transformed into the perceivable was soon believed. The long awaited ability to pass on both simple and complicated knowledge by

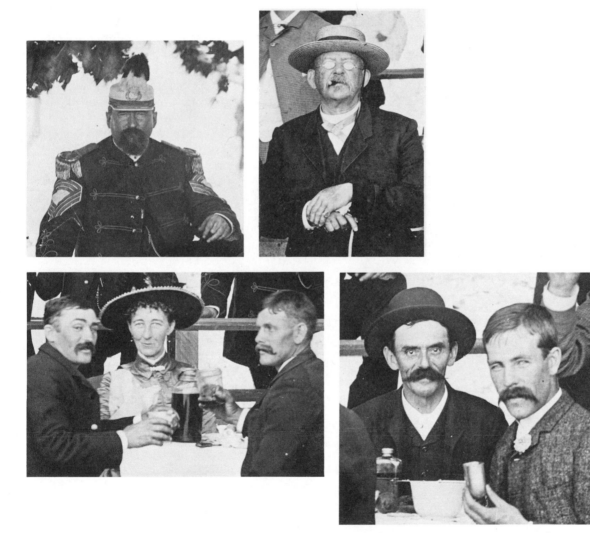

Finding pictures within a picture. This commonplace photograph of a San Diego picnic conceals a number of revealing individual pictures as well. They can be found by recropping each one of them from the parent picture as we have shown. Although it requires an inventive and probing eye to see them, the display possibilities of this technique are evident. Few presentations more effectively dramatize the value to the casual observer in looking more searchingly at photographs than this. (Courtesy, Title Insurance and Trust Company of San Diego)

68 visual means had at last become easier through photography. The potential for human learning was broadened and was for the first time realizable beyond previous imaginings; the reproducible photograph and the printing press would see to that.

Not the least of photography's wonders was its ability to verify both the similarities of mankind around the world and their real differences, replacing stereotypes with trustworthy evidence. The photographs could prove that "strangers" were familiar in most significant aspects, variant in some others—all of mankind providing examples of a common, multi-colored human species. Men and women from other lands might now be more easily accepted and trusted once credible photographic images of them had been seen. The photograph could provide that much needed reassurance and comfort.

The dependable photograph was in widespread demand from the very first day its availability was announced. Its popularity was predictable, but the speed of its wide acceptance surprised the skeptics. Photographers, their patrons, and their products, mushroomed like growing weeds in a field. Travelers demanded, bought and carried daguerreotypes over almost the entire known world. Every traveler who could, carried the photograph of a loved one. These accurate images provided sweet reassurance when it was needed, hundreds or thousands of miles away from home, a satisfaction unknown but not undreamed of before the development of photography in 1839.

A major test of the new daguerreotype process in the United States took place in 1848, a scant nine years after its announced discovery in France. It was called upon to produce images of the California Gold Rush, to cover a news event as we would term it today. Daguerreotypes taken successfully out of doors, in the fierce blaze of the naked sun were few; it was believed that the new process could not respond to that challenge, that the making of pictures out of doors was beyond its capabilities. The process certainly didn't have the capacity to take what we would now call "action shots." Candid pictures were altogether unknown then. In spite of the terrain, wilderness, and the inclement weather, tyro daguerreotypists in California produced thousands of successful plates. They ranged from individual views to panoramas made up of as many as seven plates. They photographed Gold Rush ships rotting in San Francisco Bay, the mining camps, the foothill mines, the city itself—with its merchant princes and its civic rascals. They photographed newly arriving miners in great abundance. Daguerreotype portraits of hardy and newly bearded 19- and 20-year olds are eloquent reminders of the type of endurance required for the mining life. Already proved in California, the daguerreotype apparatus was taken everywhere. To provide accurate details for colored lithographs intended for popular sale, John Stephens, a New York lawyer, and his colleague, Frederick Catherwood, took their daguerreotype camera into the Yucatan jungles. There in blinding light they made plates of the Mayan temple ruins at Chichen-Itza. Images of gold rushes in Australia were captured in daguerreotypes in the same fashion—some by the same workers as had been in California. On his historic first visit to "open up" Japan, Commodore Matthew G. Perry included Eliphalet Brown, Jr., a pioneer daguerreotypist, in his official party. Brown made over two hundred plates, most of which were presented to their Japanese hosts. The silvered mirror images captivated the Japanese and were used, engraved, in Perry's official report; they provided many persons their first, credible view of this virtually unknown country and its people. In the United States, John Charles Frémont, adventurer, took Solomon Carvallho, painter and daguerreotypist with him on his fifth expedition to create a photo-

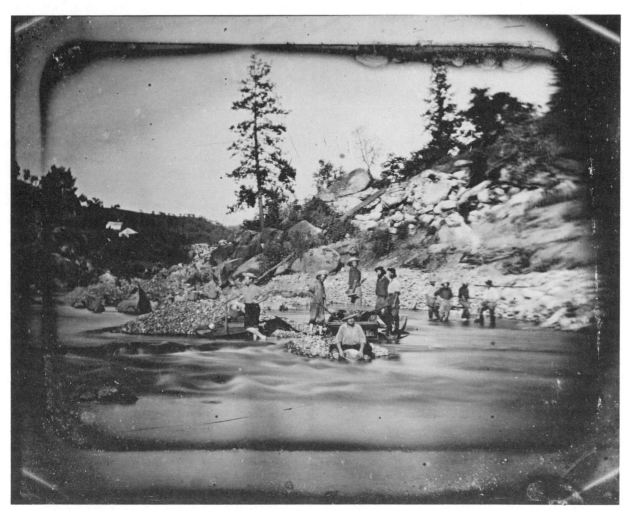

The natural grandeur of gold seeking in California, and the brutal labor required to recover the precious metal, are equally visible in this daguerreotype view of a foothill mining placer. The inability of the slow daguerreotype plate to stop motion has transformed the fast-running mountain stream into languid ripples. Piles of gold-bearing gravel were endless; and the labor of shifting them, shovelful by tiring shovelful, broke the backs (and the spirits) of many young Argonauts. (From a private collection)

graphic document, evidence of their Rocky Mountain explorations. The convincing Western views they produced and published as engravings helped to diminish understandable hesitations many city-dwelling Easterners had about further colonization and exploration of the region. John Mix Stanley, one of our earliest Western photographers, made daguerreotypes among the American Indians in the 1840s.

To see and believe in the world presented by the daguerreotype, a world known previously by the written or spoken word, proved more satisfying than was anticipated by anyone.

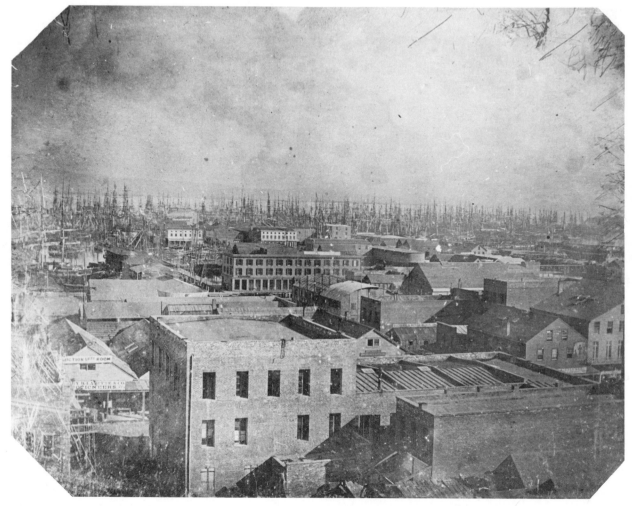

This classic image of Gold Rush San Francisco, a whole-plate daguerreotype, is part of a two-plate panorama. Nothing so convincingly verifies the *look* of Yerba Buena cove, choked with abandoned and rotting vessels. Left in disorder by their gold-hungry officers and crew alike, the sad hulks were used as temporary dwellings, warehouses, business establishments and even city jails. (Courtesy, Bancroft Library, University of California)

The challenge to look at these images more thoroughly and believe what could be seen there became a popular passion. The ever-present photographic album, the carte-de-visite and the stereoscopic viewer of the nineteenth century were the equivalent then for the contemporary moving picture and television.

Saving the Record of the Past

Prized and popular, images were collected and the visual experiences they offered eagerly accepted. The nineteenth-century world grew older believing in the photograph. William Ivins has noted that at the start of the nineteenth century, mankind believed that

whatever seemed reasonable was true; and it ended the century believing that whatever was photographed was true.

It was natural for the photograph, as it improved, to take some part unwittingly in the task of recording images of history. It was soon recognized that there were certain kinds of information photographs could present easier, quicker, less expensively and far more accurately than painted pictures. Its many sided, rapid development, both as a worthwhile business investment and as a prestigious skill, if not as an art, was eloquent testimony to photography's impact on the world. The production, sale and ownership of packages of stereographs—the earliest form of three-dimensional visual image produced after the Civil War—was widespread in the nineteenth century. It was rare to find a home that could afford it without at least one set of stereographs. No item of life was overlooked in these stereographs; everything from nature's wonders, the major news events of the day, to all too often bigoted local humor, were their subjects. They presented historic structures, battlefields, art galleries throughout the world and their famed contents, portraits of kings, queens, statesmen and distinguished individuals. Theater and stage personalities abounded, as did photographs of current news events—covered in exhaustive detail. Stereographs provided information and diversion in abundance for large audiences and were esteemed highly.

Larger photographs of every type were also available, occupying treasured places on the walls of homes, while albums of cartes-de-visite were much in evidence on sitting-room tables. The craze to see, to examine and to expand one's visual experience was immense. Photographs provided people opportunities to discuss the world they could see, its wonders and its events. The could and did use such discussions as substitutes or as supplements for the examination of history as they knew it.

The dawning of the twentieth century witnessed the emergence of photography as a major hobby for many Americans; the roll-film and George Eastman's Kodak saw to that. Almost anyone who wished to and who could afford it could now make pictures. The popular slogan then was, "You push the button, we do the rest." It seemed that almost everyone owned a camera, the ever-popular Brownie, and took pictures. There were few persons who had not at least had their picture taken. Such ease in taking pictures was making the skill commonplace. The photographer as specialist was beginning to be less highly regarded. The magic connected with taking a picture had begun to disappear for the average citizen, and the awe with which photographers had been formerly regarded started to disappear as well. It wasn't that people stopped taking pictures; if anything, they took far more. They made good ones, bad ones, and an uncommon amount of remarkable ones. The images they produced quickly numbered into the millions and the previous trickle roared on to become a raging flood of billions. It is *this* flood of images, or at least the most important among them, that we are trying to collect, preserve and use in the national interest. As almost everyone who wished to could make pictures, many Americans tended to regard the photographs more indifferently. The period of this lack of regard was a long one, hardly over yet, and in that space of time many valuable historical images have been lost. This indifference serves only to make the saving of photographs more difficult. We have not yet made the saving of old photographs a national priority on any level; consequently scarce public funds are alloted to projects considered more worthy and urgent. The belief that we ought to and can afford to save our photographic heritage is in doubt and thus the job is a more difficult and lonely one.

Most knowledgeable persons consider that the next few decades are *the critical time* for securing historical photographs. In that time

72 much of what is remaining will, if it is not properly collected and preserved, be destroyed as we rebuild the face of the nation. Where are these historical photographs? Where can they be found? Part of our problem is that no one source knows all or even most of the thousands of hiding places. The greatest bulk of the images that concern us were taken in the period 1839–1900. Almost none of the men and women who took them are still alive, although many children and grandchildren of these pioneer photographers are still living. It is they to whom parents and grandparents entrusted the precious images taken at that time. It is these men and women, now in their 70s and 80s, custodians of important photographic materials, that must be found. These old people whose time with us is too short, are invaluable in helping us identify and verify old photographs as well as locating further sources of needed information. They are passing away, these caretakers, and with them goes their accumulated heritage of historical photographs and lore. To fail to seek these people out, to ignore the knowledge they have to offer, is to leave our collections inadequately supported, misidentified and seriously lacking the accurate details of information we need desperately. The next ten years in respect to these people are frankly crucial. Our task will become much harder, as we inevitably lose each one of them. The houses in which they spent their lives must become prime targets. These depositories of the images we are trying to find are being torn down, disappearing every day. The old photography studios, another major target for us, are disappearing as well. Urgency on this front is the watchword as the tempo of our losses mounts.

The picture is not all gloomy, for many caches of valuable material remain to be found. Although organized institutional collecting of photographs has been insufficiently supported, there are indications today of new attitudes. Yesterday's indifference about the collection, care and use of historical photographs, is being replaced with new concern. Serious interest is increasing in some localities as are fresh evidence of limited financial support and new opportunities to discuss sympathetically further support to collection and preservation efforts. Useful work is going on in many quarters and certain limited successes are apparent: for example, an enouraging number of new photographic societies in many parts of the nation are flourishing, adding members, publishing journals, newsletters and reprinting needed manuals and books. New collectors' organizations are forming which cater especially to image collectors, photographic equipment collectors, postcard collectors and those who specialize only in stereographs and in viewers. These people are contributing to photographic history with carefully researched articles of merit. They have already contributed greatly to the endless job of more accurately dating and identifying photographs. The journal of the stereograph collectors, *Stereo World*, has been publishing useful biographies of important photographers as well as numbered negative lists of their stereographs. Many of the new societies have organized successful seminars, workshops, meetings, auctions, demonstrations, exhibits; they have engaged speakers and well-known experts for the guidance of their members and friends. A major conference on photographic preservation was co-hosted not long ago by Walter Clark, a Kodak researcher, and the Smithsonian's curator of photography Eugene Ostroff—a meeting well attended and enthusiastically received. It is impossible not to take heart from such encouraging reports.

Most importantly, new concern about photographs is coming from historical agencies and societies of every description. It is proper that they should care, as theirs is the greatest responsibility for carrying on the work of col-

lecting and preservation. They are often the closest point of personal contact with the custodians and owners of old photographs in private hands; it is vital that they secure them for their organizations. The pictures they are looking for can be found almost everywhere: abandoned and ignored in the storerooms and attics of people living yet in villages, cities, and communities great and small. The search for these images will have to be carried on by the local societies, for the professional historian has not bent to this task. They do not consider it part of their professional responsibility to rummage in dusty attics and old trunks for the documents and the photographs they must have to do their work. The sober truth is, that harassed and inadequate as historical societies or agencies might consider themselves, the job of collecting historical photographs is almost theirs alone. Few other people have done it, with the exception of the private collector, the enthusiastic amateur and the dealers. If the societies fail the job may very well not be done. To repeat, the only serious competition now is the dealer in old photographs and the avid amateur collector.

Lately, there has been a mercurial jump in the sale of photographs of every kind. Private collectors and some few institutions around the globe have been paying increasingly inflated prices for photographs and photographic artifacts, items that could hardly have been sold at all only yesterday, making acquisition of like materials for deserving institutional collections nearly impossible. Every possible source of photographica is being assiduously scoured by dealers and collectors alike and the public outlets, formerly rich in valuable items, are beginning to dry up. In the end, what these collectors and dealers find may eventually wind up in some public collection; it is only that institutions will have to pay far more for these items than if they had found them or bought them originally.

It is time now to turn to some of the nuts and bolts of collecting historical photographs. Where can such materials be found and how can they be gotten for your own organization? We could not list here *all* of the public and private depositories wherein historical photographs might be found, even though such listings are desperately needed. Limited successful efforts to provide such listings are already in progress and one useful result is a book entitled *Picture Sources* now in its second edition, published and sold by the Picture Division of the Special Libraries Association in New York City. We will suggest some sources where searchers for historical photographs might profitably look and make inquiry.

A major recommendation is to search in the depositories, large and small, all across the land—the many museums, libraries, agencies, private societies and organizations that hold such collections. Even at this late date, too many such accumulations of photographs are unknown or little known; in too many situations they are quietly deteriorating for lack of proper archival techniques. Numerous real problems including limited staffs and insufficient budgets bear upon these holdings, delaying urgently required help and attention. These collections contain four kinds of negotiable photographs that should interest any searcher. First, there may be large stores of duplicate photographs. Second, there are many items not directly concerning the interests of the institution that owns them: out-of-state photographs or out-of-period views, for example. Most important are photographs of subject matter far afield from the holding institution's areas of interest. Finally, there is a vast range of unidentified material, photographs that are thought to be of small importance. All four of these categories allow opportunity for equitable exchanges or purchases or

even in some cases, indefinite loans. We believe that if all of the kinds of material noted above were listed, organized by subject matter and date, and offered for exchange or sale, there would be a new treasure house of available historical photographs.

Inexpensively priced prints of important historical photographs can be purchased from the Library of Congress and other public agencies as well. It would pay most photographic librarians and curators to be aware of what is available from such sources. There are few publicly financed organizations throughout the country that do not make and maintain voluminous photographic records of their work. This overwhelming series of archives, cataloged in some cases, should be given very serious consideration as a continuing source of photographic documents. It is not possible, for example, to estimate accurately the literally billions of negatives and prints made of building, construction and destruction throughout the United States by untold Departments of Road and Public Works on every governmental level. Very few hamlets, city squares, few farming communities in transition to urban suburbs have escaped detailed pictorial recording of their various transformations. Virtually every public building, bridge, airport, railroad crossing, every sewer installation has a thorough photographic record of its life and, sometimes, its passing. Such pictorial records frequently lie in storage, decaying and deteriorating; in too many cases, they are believed to be taking up limited valuable storage space. Their safety and future existence is in constant jeopardy. Numbers of important photographs have been discarded and many others presently face a similar fate simply because the space they are occupying in storage is believed needed for records of momentarily higher priority.

Private businesses, particularly the larger ones, such as oil companies, automobile, steel, shipping and airline companies, banks and department stores, and a vast layer of medium-sized businesses, maintain extensive and valuable photographic records. They document in great thoroughness the growth of the businesses, as well as the sometimes sweeping technological changes their producing history reflects. Trade organizations of every type have likewise built up large bodies of photographic images of interest. The numbers of such photographs is often quite staggering; portions of them or in some cases all of them, are imperiled as information requirements, public relations and management ideas outweigh their significance as historical photographs. A considerable number of newspapers and magazines are simply sitting on outdated files of negatives and prints. Often these materials go back to the turn of the century. In some cases, important portions of such files are so isolated in storage facilities that they are utterly useless to researchers. For example, in Los Angeles, a major newspaper maintains over two million glass negatives, the photo files of their early years, in a warehouse completely unavailable to anyone. The same is true of certain television companies whose research files are constantly being upgraded at the expense of outdated but historically valuable photographs. This constant upgrading forces obsolete images into dead and useless, practically unretrieveable storage. Almost every public service organization and many private ones maintain in-depth photographic records of their activities. Frequently, the *historic* importance of such negatives and prints is virtually ignored. These images are also almost completely unavailable for scholarly use, publication or display. It is well to remember that a very large part of the surviving photographs of the immortal Lewis Hine were the property of a National Child Labor Committee that had hired him. These organizations in almost every case are little acquainted with local history programs and do not realize that their photographic records can

still be used and will be welcomed into your society's collections. Too few businesses and public institutions yet arrange for periodic transfers of their outdated but useful photographic files to organizations like yours that can preserve and use them. While the storage of such a volume of photographs presents real problems, the value of such a gift is well worth the difficulties encountered. Very often as a result of the sharply focused nature and interests of the organizations that produced the photographs originally, the resulting images are unique and certainly irreplaceable. Without a suitable home that can protect them, dead storage or destruction will be the fate of these valuable archives. Therefore, we suggest to you readers: *ask for them!*

We recall an instance in which a failing metropolitan newspaper in Los Angeles was faced with the sudden need to find a responsible home for the files of its early years. Successful arrangements were quickly completed to transfer the material to a large university library nearby; and although the library's storage facilities were already strained, the collection was received and stored. The photographic part of these files included thousands of glass plate negatives of the early 1900s and film negatives from the 1920s and 1930s, all topical and absolutely impossible to replace. This photographic collection was blessed with a careful and exhaustively thorough card index file of all of the negatives and prints. It provided accurate identification and dating of each image. This catalog, allowing quick retrieval and accurate refiling of each item, has transformed the collection into a significant research tool.

Photographic collections that serve public institutions and large private businesses are often similarly cataloged and identified. Sometimes such a high degree of cataloging and identification facilitates the ready utilization of computer capabilities for the storage, cataloging and retrieval of the collection. Such was

the case with a large collection of photographs accumulated, cataloged and carefully organized by the United States Forest Service. The National Archives, which received the collection, integrated it into their machine records system, making innovative and successful use of computer assistance.

Where to Look

Let us consider further sources for historical photographs. Important collections and many individual items of worth are still found among the contents of old houses in the process of demolition. Both commercial house and building wreckers, and the second-hand furniture dealers they sell to, often come across a wooden box full of pieces of glass. Their oft-heard query, "What will we do with this junk," is too often answered by no one. One ought to cultivate professional relationships with house-wreckers, moving men, and storage companies as well as land developers, second-hand furniture dealers, and building contractors. Their work places them directly in the path of caches of photographic material long forgotten in abandoned nineteenth-century homes and buildings. Making them aware of the value to your organization of old photo albums, framed pictures, boxes of glass plates, old photographic equipment and records, could assure at least one and, likely, many more windfalls. Acquaint them *in detail* with what you are looking for and describe, or even show them samples to be sure they can recognize what you want. Ask your more influential members and friends to open up and strengthen advisory relationships with probate judges, tax attorneys, accountants, probate lawyers and estate and trust officers. At tax time the society or institution you represent should try to receive its legitimate share of help from those most able to provide such assistance.

It is often true that wealthy families, large

76 business institutions or their advisors are simply not aware that certain items such as photographic albums and photographic files are gifts of significant historical value. They are sometimes unaware that such gifts can be tax-deductible as well. Remind them! Informing their business advisors is a wise and often necessary step.

Your organization should try to initiate and develop understanding relationships with various types of civic, county and state boards of public works, highway departments, harbor departments, aviation and airport, water and electric departments, police, firemen and others. The volume of photographic records maintained by most such departments is unbelievable and the periodic reduction of such a mass of photographs and negatives frequently becomes an urgent matter. Your organization should be at hand when such a problem requires resolution. It is almost impossible to describe the volume of new photographs arriving each day forcing the removal of yesterdays record. It can be a godsend for you . . . but only if you take the initiative. We cannot stress strongly enough the golden opportunities that exist in trying to secure outdated public and private records containing photographs. It is difficult to describe the overcrowding of such records in inadequate storage facilities that face most archivists or department heads. You must see them to realize the extent to which photographic prints and negatives abound in such files. Under such pressure you will find many officials anxious to be cooperative and helpful, providing rich opportunities for your organizations. Many local governmental departments move periodically into new buildings and must dispose of old records. You ought to be aware of such moves and ask for the material you can use in your archives. They *will not* be offered; you must show that you want them and asking for them is as good a way as we know.

Old Photographic Studios

Another important source of historical photographs is the studios of older photographers, abandoned in some cases, or sold and resold to newer owners. Such buildings and stores can be found these days in the older sections of cities, often in the path of urban renewal programs, and usually slated for early demolition. Oftentimes, the owners of such old studios are entirely unaware that boxes of old prints and negatives can still be stored away in odd corners or in unused closets. It is well worth tracking down the locations of such places from old city directories and ferreting out the treasures that may still be there. In Los Angeles, a well-known commercial stock photo firm, a business that sells photographs for publication and display, quietly purchased the contents of old studios from the families of deceased photographers. In this fashion, they had accumulated a number of important local negative collections. Robert Weinstein knew of these collections and knew the new owners were unwilling to sell them, believing they could sell enough prints from old negatives to justify keeping them. In time, dwindling sales of prints from the old negatives finally persuaded the owners to consider sale, affording him the opportunity to open negotiations on behalf of an interested local museum. There were long negotiations and predictable difficulties in convincing the museum's Board of Trustees of the value of historical negatives. The problems were ultimately resolved and the Museum purchased some 9000 8" x 10" glass plates and some 20,000 similar size prints; the collection detailed in depth the late nineteenth and early twentieth century in Los Angeles county. This body of images has proved to be of unsurpassed historical and research value. An additional value of this purchase lay in the friendly relations thus established between the seller and the museum. The museum was of-

fered a second valuable collection by the same seller a few years later. This second collection was purchased and together with the former photographs has become a major pictorial reference on Los Angeles for researchers. A bonus in both of these cases was a large accumulation of 4" x 5" copy negatives made from important historical photographs for which no original negatives remained. The seller had made them for his own use and they were given to the museum to "sweeten the deal". A sad note is our certain knowledge that similar valuable Los Angeles images have been lost in the past for lack of sufficient community interest. The same seller, for example, had offered prints from the same collection, free of charge, to anyone interested enough to merely ask for them by letter, and there were no takers.

Photographers

Try to discover the remaining family of former photographers; they might still be in possession of valuable images, surviving business records and correspondence. One of Robert Weinstein's most important finds, a large archive of the work and correspondence of Henry Goddard Peabody, an eminent photographer and "outdoor" man for the famed William Henry Jackson, was located in just such a fashion. It all began with a chance comment overheard at a meeting that suggested to Weinstein that Mr. Peabody had ended his days in California and was survived by an only daughter still living somewhere in the state. Pursuing this meager lead took Weinstein through public records, business licenses, birth certificates, death records and finally probate records. The search finally produced identity of the daughter, her married name and a solid clue to her whereabouts. Further searching located the daughter living in California as was initially suspected. She

proved an engaging person, full of interesting memories of her photographer father, most of which she could recall in detail. She was able to add much needed information on Mrs. Peabody, her mother, and details of their family life. Repeated visits established the basis for a warm friendship, leading the daughter to offer Weinstein a large accumulation of surviving photographs, albums, invaluable business records and correspondence. As Peabody used every type of camera in his professional life, from daguerreotype to 35-mm color, his life is an archetype of the nineteenth-century photographer and therefore of special interest. Such a surviving body of material on one photographer is rare and forms a precious link with the past. The "kicker" in all of this is that in Weinstein's reading of Mr. Peabody's correspondence, he discovered a suggestion concerning the whereabouts of a valuable collection of wet-plate collodion negatives of Southern Plains Indians, taken between 1869 and 1874 in Oklahoma Territory. In time, Weinstein found them as well at the Natural History Museum of Los Angeles County, and published prints from the negatives in a book entitled, *Will Soule, Indian Photographer at Fort Sill*. It is important to emphasize here that without Weinstein's prior interest in old photographs, the likelihood of finding meaning in such a casual reference, and persistence enough to follow up the lead, the Peabody materials might have been ignored or lost.

Family Albums

A frequently overlooked source of historical photographs, a unique type of image found nowhere else, is the personal photograph or snapshot album. Don't overlook it! It seems that almost everyone who owned a camera likewise owned a photograph album. Such albums house innumerable personal snapshots, rich recordings of the endless trivia of every-

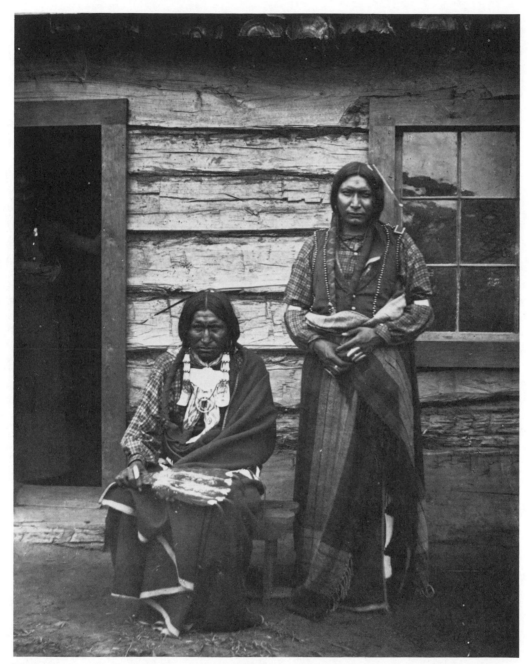

Photographs of Indians, as this one by Will Soule in Indian Territory in 1869, provided believeable visual contact, at least, between peoples for whom social contacts of friendliness and equality were well-nigh impossible. (Courtesy, Natural History Museum of Los Angeles County)

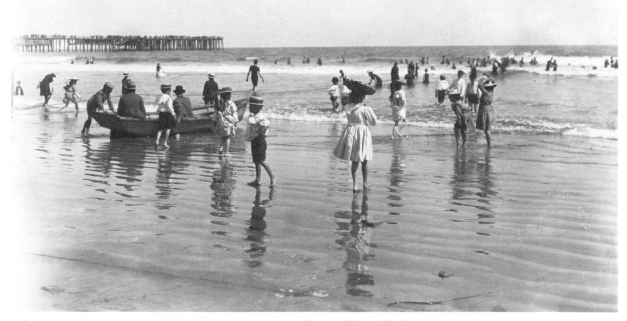

John Kouwenhoven pointed out in an article in *Snapshot* in 1972, "We do not yet realize, I think, how fundamentally snapshots altered the way people saw one another and the world around them by reshaping our conceptions of what is real and therefore of what is important. We tend to see only what the pictorial conventions of our time are calculated to show us. From them we learn what is worth looking for and looking at. The extraordinary thing about snapshots is that they teach us to see things their makers had not noticed or been interested in." Widely circulated photographs of sunny Pacific beaches as this one did much to fasten the notion of California's golden attractiveness upon a nation searching for affordable utopias. (Robert Weinstein Collection)

day life, minutiae we are now enjoying discovering anew. Because they are unprofessional photographs, merely a projection of the amateur's vision, the album pictures often reveal a broad range of human activities usually overlooked by the professional as trivial and unimportant. Every seemingly inconsequential motion and activity was photographed and such snapshots as fill these albums are replete with fascinating human details. Do you want to see the silly stunts attempted by young men to impress their dates on the beach in 1925? The snapshots in the old family album will show them to you. Do you need to study some

80 of the awkward postures in which new young fathers cradled their infant offspring? Only the snapshot in the family album will show you that. Have you ever wished you might examine exactly what the housewife wore at her work in the home? You can see such photographs in the family album, but only if you collect them. People don't keep family photograph albums now in the quantities they used to; even though albums are still around in abundance, they are mainly found in private hands. Far more photo albums are being lost through indifference and neglect than are being saved and preserved successfully. Reconsider their value and ask for them for your society's photograph collection.

A number of years ago a university in Los Angeles purchased a very extensive collection of snapshots and pictures, all of them mounted informally in a hand-made photograph album. The photographer, a telegrapher, had photographed all of the commonplace activities, events and personalities in Los Angeles beginning with the 1880s and on through the 1920s. His son continued the effort combining their pictures, so they produced between them a vast photographic record typical of one family's pursuits, birthdays, picnics, outings, early automobile trips, beach parties, vacations—literally nothing was overlooked. These are not the kinds of pictures one would expect to find in commercial photographers' files for they were thought unsaleable. Who, after all, would buy them? In such photographs we can glimpse on-duty policemen riding bicycles, Los Angeles citizens preparing to welcome President McKinley, and the arrival of Teddy Roosevelt's Great White Fleet in Los Angeles Harbor at San Pedro. The collection proved of unique and slightly risqué worth when the author of a small work on the "easy ladies" of Los Angeles, discovered among the negatives otherwise unobtainable photographs of the women taking their sunny ease among the cribs of the redlight district. At its best, the snapshot was the candid photo of its day; when we look for compelling "people pictures" of that time, we must turn to the snapshot and the family album.

One must be innovative and imaginative in anticipating the many hiding places of photographic items. Robert Weinstein is keenly interested in Pacific Coast maritime history and constantly looking for new images of West Coast ships, men and ports. He recently received a copy of an interview with an old seaman that contained the following remembrance. "Coming back from the islands (Hawaiian) we brought a class of Mills College girls. Twenty eight in all, including their teacher. They squeezed three into a cabin to fit aboard." It suggested to him the possibility that one or more of those twenty-eight college girls, or their teacher, might have taken photographs of their trip on a sailing vessel. Spurred by the thought he addressed an inquiry to the Library at the College, hoping that such pictures, either loose or pasted in an album, might be part of their collections. He also inquired whether any members of that class were still alive and were there addresses at which they might be contacted. The outcome of this query still awaits action by the College Library, hopefully it will be a rewarding one. Specialization of interest is often the "extra" incentive that will help a person find and pursue leads that might ordinarily be ignored or overlooked. As another example: it has been accepted archival practice for collections of personal or public papers to be cataloged and stored as a body regardless of any photographs, prints and/or negatives it might contain. It is equally common for such collections to include stores of photographs or other significant varieties of graphic materials. The Lyndon B. Johnson Presidential Library in Austin, Texas, is a prime example with its almost unbelieveable archive of photographs included among his many papers. It should become standard practice upon receipt of a collection

of papers to examine it for photographs and then make some decision about recording the existence of the photographs, or to separate them from the papers, whichever accords with archival policies. In the case of glass negatives or of nitrate film, there is an added urgency for separation and safe storage.

Collectors

Another somewhat untapped source for many organizations can be the private individuals and amateur photograph collectors in your communities, as yet unknown to dealers and other commercial outlets. Often their collecting enthusiasms are very narrow. For example, we know an important daguerreotype and ambrotype collector who is interested only in Civil War portraits. Such people are anxious to trade out-of-field materials they own that are of little interest to them. They can be found among the memberships of newly-forming collectors societies and they should be sought out and cultivated. They ought to become a central target for your collection efforts. Although the growing number of dealers in photographica inexorably reduce the available supply of worthwhile items, they cannot get everything nor do they. There are still opportunities for those looking for photographica. Many enthusiasts are actively searching for such material and many items will be uncovered by their efforts. Even though the recent "prairie fire" popularity of photographs and photographic artifacts has created prohibitive price levels, antique dealers and collectors, swap meets, flea markets and garage sales, and serendipity shops of every kind are still treasure houses of historical photographs. Collectors, both private and public, continue to swarm like locusts to such centers recognizing that the available market has not yet been exhausted. Let us cite a particularly dramatic example.

In northern California at a neighborhood swap meet, a dealer noticed a group of da-

guerreotype plates, all of them views of public buildings in an unidentified city in the United States. For a slight sum he purchased all of them to take home for study, and hopefully for identification and dating. In time, with the help of specialists, they were each identified and dated accurately. They proved to be among the earliest known photographic views of public buildings in Washington, D.C., taken in 1846 by John Plumbe, a distinguished daguerreotypist. The Library of Congress quickly recognized their great historical value and offered a bid to the fortunate owner. The owner accepted the Library's bid of over ten thousand dollars. The plates are safely housed now and are considered by the Library of Congress as honored archival images. They fill a major gap in the national graphic heritage. Two important points are worth noting. The first is that images of such importance were still available to be discovered as late as 1973. The second is the encouraging fact that the Library of Congress did value the daguerreotypes highly and was able to procure the large cash sum required for their purchase.

This growing number of private enthusiasts eager to buy, sell and trade their prizes, often items of serious historical interest, will increase and, as it does, new materials of worth will inevitably become available. It is important to develop wide connections with such people now, for they will afford your organization innumerable opportunities. It is not easy to locate these collectors. If it were easy, if the paths to their doors were well-marked, the dealers would have, and may yet, find them first. A key to finding them may sometimes be through those individuals, advisers and friends, who may in time have to guide the eventual disposition of such archives. Organizations can through their own civic prestige open such fruitful relationships with carefully selected persons—probate officials, trust officers, estate lawyers and accountants. Acquainting *them* with your organization's need for

82 photograph collections can help them decide where to place them as tax-free gifts. They can more easily discuss the disposition of such artifacts and the historical values of such items held by their clients in favor of your institution. Often such discussions are made long before the demise of the owner and that type of foresight may enable the donor to turn away the ever-wooing auction house or bookseller.

Ask for Them!

In answering the question of how historical photographs can be gotten, one response deserves to be uttered again and again. That answer is, *Ask for what you want. Be bold.* Its simplicity and its forthrightness says it all, summing up the required attitude. Be enthusiastic about photographs! Express your enthusiasm about them whenever and wherever you can. We have learned that there is nothing more persuasive and compelling than projecting enthusiasm about photographs. It will carry the day and more than make up for any lack of verbal eloquence. It is, in our opinion, the all-important element. There is a parallel between securing historical photographs and making money; you must start with a passionate desire to get either. The main supporting quality is your willingness to work hard at it. If you work at it your desire for historical photographs will become known in your community. People you have worked with or those who have heard that you are looking for photographs for your organization will pass along that information. They will popularize the fact that you will take them under almost any circumstances or come out to get them if that is necessary. Success is infectious! We cannot overemphasize the virtue of zeal in collecting photographs. It is the decisive cornerstone of any effort. Be bold as we said, be even bolder. You must come to believe that people want to help you find photographs, so help them help you. You may absolutely count on getting offers of photographs. We have never known it to fail.

When opportunity presents itself ask for what you want, forthrightly and right away, don't plan to ask the next time you return. If you wait for another day you might find there may not be another day. It has happened more than once. Ask right then and don't ask timidly or hesitantly; it only spreads uncertainty to your listener. If it is possible, it is best to take away what you want right then and there. Do it. Do not procrastinate.

It is true that many people attach little value to photographs and discard them as easily as throwing out garbage. It is vital, therefore, to establish in your community a sense of historical worth about such "pieces of paper." This sense of value does not yet exist and it is urgent that it be created wherever people now use photographs. It is a long and difficult task requiring patience and skill. The methods for generating information and interst in this area are essentially no different than those traditionally used in any other sector of the public interest. We need most to be convinced ourselves that this sense of value is important enough and is worth the trouble it takes to nurture it in the public esteem. What is crucial to such efforts is the ability to be "turned on" by photographs and by historical photographs in particular. Equally necessary is the ability to project the "turned on" feeling publicly, to convince audiences and to generate in them the enthusiasms you think and feel. Photographs are often lost simply because no one felt strongly enough about their worth to make a determined effort to save them. The first and most decisive step is to explain vigorously your own feelings about historical photographs at every opportunity. Your audience must come to understand that these images mean a great deal to you and to the popular presentation and understanding of history. They must understand that your organization wants to use and publicly interpret their elo-

quence and their verifying accuracy. They must share with you the belief that these are important artifacts of the national graphic heritage and they must be preserved as we now preserve our precious written documents. Stress the point that only adequate means and suitable preservation techniques will guarantee the existence of this credible record into the future. Explain that without these images our national past will be less intelligible to a nation growing more and more dependent on visual images as sources of information and learning.

Publicize Your Needs

You will learn that most people will help you and will freely offer valuable photographs as loans or gifts to your institution. It has been our constant experience that most people who own photographic images, and this is particularly true of older people, have almost no use for them except the legitimate sentimental attachments they hold for them as evidence of their past. We have often found in our experience that with prudent solicitation, many donors are willing to turn over their photographs to public institutions for safekeeping, study, display and publication uses. Every effort must therefore be made with them to negotiate for what you want with tact, honesty and sensitivity for the donor's feelings. It is true that a great many older people are anxious to find an organization that will provide a secure home for their treasured artifacts; they need only to be certain of the willingness, ability and the integrity of the organization and the people they are dealing with. That is what you must be able to offer them: offer carefully, but boldly! It is surprising how many older persons live in utter isolation with valuable family photos as prized possessions, unaware of their historical value and unacquainted with your organization's need for them. Any opportunities that may be offered to speak on old

photographs on radio or television should be accepted eagerly. Whenever you appear make a public plea for what you want. Television in particular offers spectacular opportunities to demonstrate the usefulness and the nostalgic charm of old-time photographs. Before and after comparisons have proven of special interest to many viewers, the then and now views of the same location taken many years apart. Such appearances have rarely failed to produce a gratifying number of responses. Don't worry about offers of photographs, you will get them. You may even be surprised at how many offers of support and help will be proffered, even though some offers may waste your time. All of them express good faith and interest and some will turn out to be of great value. Robert Weinstein recalls an interview on a radio talk show in Los Angeles. The producer wanted to be of service to the Natural History Museum of Los Angeles County and Weinstein was asked to speak in their behalf requesting old photographs. The responses to the talk resulted in a number of telephoned offers of old photographs to the museum in the next few days. Each one of the offers was followed up as carefully as possible. Two of the gifts were newspaper clippings not photographs. One donor had some useful colored postcard views of Los Angeles while another donor gave the museum a small and valuable collection of daguerreotype portraits of early Southern California residents. The prize offering, an unlooked-for bonanza, was a few letters of an early Los Angeles photographer, a man on whom the museum had scant information. They were eagerly accepted and soon the donor followed them with the gift of a voluminous diary detailing the photographer's life and work in early Los Angeles. It proved a rare item of great historical value and is a highly prized acquisition in the Museum's photographic collections.

Don't be dejected if you find, as we have, that a willing donor does not know the differ-

A. C. Vroman at Mission San Juan Capistrano (seated third from the left) with the little camera club of amateurs he founded. They toured the Southwest photographing everything that seemed worthy of their skill. (Courtesy, Natural History Museum of Los Angeles County)

ence between a genuine photograph and a newspaper clipping; many people can't understand that difference. Potential donors are often uncertain that what they own may be of interest or of value to your organization. In that respect, your knowledge and expertise can be of service to them. Give fate a chance to be kind to you. Answer as many bona-fide requests for assistance as you can.

The nationally important A. C. Vroman col-

lection, was secured by such a quirk of generous fate. Long after Vroman's death in 1916, his collection of glass-plate negatives was sold to the audio-visual department of the Los Angeles County Board of Education. After many years of use the collection was finally replaced by newer materials, boxed and placed in dead storage where it languished in obscurity. With a lead to its whereabouts from a former colleague of Vroman's, a university lib-

rarian and his assistant discovered the retired glass plates in the Board of Education storerooms. The Board of Education, forced a few years later to move the plates to more permanent storage, offered them by the merest chance to the Natural History Museum which accepted them as a transfer of County property. At the time of the transfer, neither the clerks at the Board of Education warehouse or the curator receiving them at the Museum, had any idea what the boxes of "glass" were. Certainly they had no idea they were photographic plates. How kind was unknowing fate in that circumstance!

Their full worth was soon recognized at the museum, where they received more careful storage. Exhibit-sized sepia enlargements were made and formed into a permanent gallery which included Vroman's camera and tripod, subsequently loaned to the Museum by his niece. His work has since appeared in a variety of publications and has firmly established him as a significant nineteenth-century photographer, the maker of a uniquely sensitive record of Southwestern Indian life at the turn of the century. The rescue of his work from its ill-deserved obscurity is only one of the more gratifying consequences of the revival of national interest in historical photographs.

The methods of procuring a collection vary immensely and call forth all the organizing ability one may possess. Again, Robert Weinstein recalls a particular collection of 8" x 10" glass plates of lumber-carrying sailing ships of the Pacific Northwest. They had been stored in the photographer's home in Seattle and when the house was sold the new owners discovered them packed away in wooden boxes. They wanted to sell them but had little idea of the value of the plates historically or financially. Their efforts to dispose of the collection came to naught and by chance Weinstein heard of its existence from a friend. He entered into negotiations by letter with the owners for its sale and the ensuing correspondence describ-

ing the plates more fully heightened his interest sufficiently to ask the owners to ship a half dozen of the glass plates to him for examination. They obliged, and upon receipt of the plates, he arranged to contact print them as carefully as possible. They proved to be excellent 8" x 10" negatives in first-rate condition, the contact prints from them providing vivid and exciting images. He now faced the problem of who should receive the collection if he could purchase it, and from whom he could get the money to purchase it. He decided to negotiate the final selling price with the owners by telephone rather than by letter, and succeeded in setting a mutually agreeable figure; he received a two-week option to conclude the sale. He then approached a particular donor, one he selected because of his well-known, long-term interest in the subject of the photographs. He showed him the prints, explained the complete collection, the price asked for it and the steps needed to purchase it. Securing the donor's agreement to purchase the collection and his desire to donate it as a gift to a museum, he contacted the proposed institution, the San Francisco Maritime Museum. After discussions with the donor, they proposed at the donor's request that acting as his agent, Weinstein go to Seattle, examine the collection thoroughly, purchase it if satisfied of its worth, arrange for its packing and transit, and ship it to San Francisco. All this was done and the collection now forms an archive of unduplicated material of significant research value. Mr. Weinstein is presently preparing a book of these photographs, the work of a young German named Wilhelm Hester.

Arranging for a purchase of a photograph collection, or for its donation as a gift, must take into account the self-interest of *both* the donor and the seller. One needs to discover the exact formulas that will satisfy the needs of everyone concerned. Although these formulas are many and all broadly similar, the subtle negotiating variations that differ one scheme

86 from another, are always engaging. Opportunities to discuss them with colleagues are stimulating and ought not be overlooked. The significant point now is to realize that the impact of the photograph's current marketability has sharply reduced the ease with which free gifts can be organized compared to an earlier period when historical photographs were considered far less valuable.

If sudden affluence strikes your institution, we recommend bidding at the photographic auctions that are appearing with some regularity throughout the country. Sotheby Parke-Bernet is one currently prominent house in this field. Although prices are near-scandalous, photographic items of worth are coming to light and superb examples are frequently available. Of special interest to photographic collectors ought to be the catalogs that accompany such sales and auctions. Lavishly produced and rather inexpensively priced, they provide illustrations and descriptions of many items as well as selling prices. They are valuable reference works for any photographic library.

Many collector's societies organize auctions assisting their members' efforts to sell and trade their materials. As they are mail-order auctions in many cases, catalogs of the available items can be purchased. They prove among other things the wealth of historically valuable items still in circulation and available for purchase and trade. They prove how rich yet are the "unknown" sources still being tapped by the amateur and professional collector. While it has grown more difficult and more expensive than a number of years ago, there is much evidence that there are still treasure troves of images around. We have told you of leads and ideas that will point you in the right direction. Happy hunting!

4

A Case Study in Collecting Photographs

We offer now a detailed case study in receiving a photographic collection, cleaning it, and preparing it for public use. In this step-by-step account of the problems you will meet, we are offering a compendium of the most useful information available, trusting you will use what is relevant for your situation. There are questions we would like to have asked each one of you: how much do you know already about preserving and using old photographs? Do you normally take care of a large quantity of such material? Are your normal, daily procedures somewhere between satisfactory care and no care? Are you perhaps, contemplating starting such a collection? Are you a museum director or a curator who, in addition to other pressing duties, must take care of your institution's photo collection? Are you a librarian, a photographer, interested in preserving old photographs, a history buff, a historian, author, or just a volunteer who "flips out" over historical photographs? Are you brand new to the job of caring for an existing collection? Are you a committee member of your historical society investigating the possibility of starting a photograph collection to preserve such fast-vanishing material in your locality, or are you a member of a business considering forming a collection for your public relations and advertising needs?

We can't know what each of you already knows but clearly you each have different ideas on what you want to do. You may even be clear on how you ought to proceed. For those who have questions, this case study seems a good way to tell you what you may really want to know. It is offered here in the hope that *anyone* interested in collecting and caring for historical photographs may find something of interest. Good luck!

Twenty Questions To Answer Before the Collection Arrives

Staking Out a Collection

Will the owner allow you to assess it values? Is it really suitable for your institution, or should you recommend placement elsewhere? What "talking points" for possession have you:
money for purchase, tax deduction;
preservation from further destruction;
public recognition for the owner;
benefit to posterity?

Arranging Acceptance of a Collection

Have you resolved all copyright questions? Have you resolved all transfer of ownership questions? Do you have documented all reserved rights of owner? Do you have discretionary disposal rights? Have you rights to related materials and records?

Taking Possession of a Collection

Have you scouted the present storage site? Have you recorded all pertinent data? Have you planned all your moving needs? Do you have a safe, prepared receiving area?

Processing the New Collection

Your workroom—are physical conditions right? Have you assembled necessary equipment? Have you arranged to dispose of contaminents? Can you handle all of the likely damage situations? How will you record incoming materials? Has staff been briefed for the task? Are workroom rules

88 posted and understood? Are the hazards of nitrate-base film clearly understood?

Legal Questions

Tracking down a collection of photographs requires close attention; it can easily be a project requiring many months or years of work. You could be aware of such collections or of individual items through conversations with museum colleagues, interested historians or collectors, potential donors or sellers or perhaps through a donor's agent or family. As a first step, arrange to meet with and talk to the owner of a collection. Try to see the material so you may determine whether its quality and the character of its coverage are an appropriate acquisition for your institution. This is an important consideration, because once you accept a collection, you have an ethical obligation to give it the best care possible and make it available for use. Since doing this will cost your institution money, time and storage space, the decision to take in a collection by donation or purchase should be considered very seriously. To be sure, accepting and simply warehousing a collection certainly is better than letting it be destroyed. We have heard of one collection that was purchased by plant growers who used the glass plate negatives as panes in the roofs of hot houses! But if your institution is not prepared to permanently house and display a particular photograph collection, consider directing it to another institution better equipped to protect it.

Unfortunately, old photographic material often becomes available only when its owner has died. There is one kind of person happy to see his photographs put where they will be well cared for and used, but other owners hold on to such material to the end. To its detriment, they feel the material embodies something so important and valuable they are unable to let it out of their custody. Such a donor needs assurance that your archives offer the proper facilities, experience and desire needed to care for their collection. Such assurances encourage the sale or donation of their photographs and negatives to your institution. Larry Booth recalls one older man who came to talk to him about his choice historical collection, describing it diffidently but obviously proud of it. Since the material was not relevant to Booth's collections, arrangements were made for the donor to meet the curator of Special Collections at a large university nearby. The university library already possessed examples of the materials in this collection and this collector's contribution would be a welcome addition. The owner was invited to visit, examine the facilities and was encouraged to donate his collection. Two good results emerged from this encounter. The man *did* donate his photographs. He has become a good friend of Booth, well-pleased that his collection has the best possible home and his interests have been carefully considered.

Before agreeing to accept a collection of photographs you ought to resolve *all questions* relating to legal ownership. First of all, you should try not to accept material for your institution under conditions that allow the donor to reclaim it at a later date. The risk of trouble with such an arrangement is great and we recommend *very strongly against accepting it*. Lien-free, full-title ownership ought to be cleared by a lawyer if possible. In a sale or partial sale, all of the documents required to establish complete legal ownership need to be executed thoroughly. Chief among these is a proper bill of sale in legal form. Search out and understand fully any copyrights on any of the photographs that may be outstanding; make clear, in writing, to whom such rights *will* belong after the completed sale.

Copyright

Rights and copyrights properly require professional legal opinions. Such opinions in the

application of copyright law to photographs are not yet altogether definitive since this copyright law is still being made in pending lawsuits and Congressional action. Certain tentative opinions can be offered, however. We are not lawyers nor copyright specialists. We offer our personal opinions based only on our own practical experiences. We have checked everything mentioned here on copyright with copyright attorneys and their paraphrased opinions provide a dependable basis for further necessary investigation.

Questions and Answers about Copyright of Photographs

Q. *Who has the final word on copyright questions?*

A. Although the Copyright Office of the Library of Congress can provide much information, the final word on all copyright questions rests with the courts. The guidance of a lawyer is strongly advised on all copyright questions.

Q. *What is copyright?*

A. Copyright is a public legal statement of proof of ownership of an artistic or literary property, enabling the legal owner to enter into legal agreements involving the sale, lease or other commercial uses of the property.

Q. *What does the term* assigned *mean in connection with copyright?*

A. *Assigned* is a legal term giving to someone other than the copyright owner legal permission to use or sell a legally owned, copyrighted property for some mutually agreed value. The owner of a copyrighted property assigns it to the person or organization intending to use or sell it. Royalty payments are often involved in payment to the owner for the use of their property.

Q. *For what period is copyright valid in the United States?*

A. 28 years with an option to renew for another period of 28 years, or a total of 56 years. It is then no longer renewable. The copyright expires after 56 years, placing the property automatically in the public domain.

Q. *What does* public domain *mean?*

A. *Public domain* means that a property is no longer protected by copyright law and it may be used commercially without paying the owner or the estate for that right.

Q. *How can I find if a photograph is protected by copyright?*

A. Upon written application on a printed form obtainable from the Library of Congress, plus a small fee, the Library will verify the existence of still valid copyright on one particular photograph. Each additional verification request requires a separate application and fee. The name of the photographer and a description of the photograph is required in each case.

Q. *Are most nineteenth-century photographs copyrighted?*

A. Most photographs at that time seem not to have been copyrighted. Perhaps the expense didn't warrant it. This is particularly true of lesser-known photographers. Some part of the work of the well-known and much-admired photographers then was copyrighted. Remember, their copyright, if renewed, expired in 56 years from the date of original application. As it was no longer renewable, the photos are in the public domain.

Q. *What about personal photograph albums?*

A. Very few, if any personal photograph albums were copyrighted. However they are automatically protected by the common law and if the owners or the descendants of the owners are still alive, their permission in writing must be secured for any commercial use of the photographs.

Q. *Is every photograph in the Library of Congress protected by copyright?*

A. No. Many photographs were never copyrighted and are thus in the public domain. The legal status of any photograph should always be clearly determined before any commercial use.

Q. *Who owns a photograph that has never been offered for sale or one that has never been used commercially?*

A. The photographer does. The common law

awards ownership to the maker of a photograph up to the point that the photograph is offered publicly for sale.

Q. *What happens then if the photograph is offered for sale?*

A. Ownership must be protected by copyrighting the individual photograph. If it is sold without copyright protection, then it is in the public domain and may be used commercially by anyone without payment to an owner for that privilege.

Q. *What protection is provided by the common law to a photograph?*

A. The common law provides that any property whose legal title can be proved cannot be stolen or used commercially for profit in any way without the owner's written permission, except at the danger of legal action for which damages may be awarded by a court of law. Even if the property is lost, the finder may not use the lost property without the owner's written permission.

Restrictions on Use

What rights then does an institution as a recipient and likely user have with respect to historical photographs? This question has several answers. The bill of sale for any photographs purchased by an institution should make crystal clear whether there are *any legal restrictions* to title. This means that if the seller transferred all existing legal rights of ownership to the buyer and had owned the material free and clear, then the institution may make use of the purchased property as it sees fit. However, suppose your organization purchases a photographer's negative collection of a hundred years ago, could you restrict the use for sale of any print that photographer ever sold in his lifetime? We believe the answer is No. If the original photographer, or his agent, sold a print without any restrictions, then the buyer may use that print alone, his property,

as he or she may see fit. If your group makes a new print from one of the negatives it now owns, sells it to a patron and says in writing that one-time use only is allowed and further resale is absolutely prohibited, then the buyer may do no more with that print than you have specified. Even though there may be ten copies in the country of the print your organization offers for sale, your particular print may not be used commercially, except with your permission and only under such conditions as you permit.

If a photograph belonging without restrictions to your organization is used commercially without your permission, you may sue and collect for damages. However, you ought to weigh the possible damage award against the expected costs of suit.

When a publisher reproduces your photographs in a book, it is common practice for your organization to receive a complimentary copy from the publisher or the author for your library. Such a copy should be inspected to assure that proper printed credit was given to your organization for any photographs you supplied. Remember that the printing of a credit line does not grant permission in any way for a publisher to use your property without your written permission. Further, granting a publisher's representative the right to make copies of photographs in your possession does not grant the photographer or the publisher any rights to use or sell those photographs without written permission. It is well to have the photographer taking such pictures sign a brief statement acknowledging the fact and describing the pictures he took in adequate detail.

In any event, whether the collection is a gift or sale, any wishes of the donor for restrictions in the use of the whole collection, or any part of it, must be understood clearly by all parties and should be put in writing. For example, a donor may restrict the use of the collection for certain purposes only: e.g., use in a museum

display and *not* for publication of any kind. The donor may not wish the collection to be used for a number of years after the gift, or such a time limitation might apply only to certain specified portions of the collection. It may be that in the event of sale, the seller wishes to have exclusive rights for a specified number of years to make prints from negatives in the collection and sell them. A variant use sometimes desired by a seller or a donor is the exclusive right for a period of time to himself create or complete a book from the photographs in the collection. In certain cases, the seller or donor may specify certain archival or storage requirements to be purchased or made available as a condition of the sale. For example, the collection might include many important nitrate negatives. Because of the many dangers involved in the storage of nitrate materials, the donor or seller might require them, or an agreed upon selection from them, to be duplicated on present-day safety film at the expense of the purchasing institution, and within a specified time. They might require the installation of special storage containers to promote the longevity of such materials. In other cases, especially in the case of a gift, the donor might ask for certain photographs in the collection to be copied and prints made for the donor and/or certain negatives be so printed. Or a donor or seller might require that only certain items of a collection be copied by the receiving institution, with the understanding that the original item will then be returned to the donor or seller for his lifetime. The possibilities are varied and it is well to be aware of *all* of them before securing full and complete agreement between donor or seller and the institution involved. Protect your institution from future disagreements. If the existence of copyright protection about any picture you may be considering for sale seems important, application to the Library of Congress is the only way it can be settled authoritatively.

There will be cases in which all or part of an incoming collection duplicates material already in the institution's holdings, or are examples of lesser quality. To allow maximum use of a part of a newly received collection for exchange or for sale, it is wise to secure written agreement for such purposes. Make certain that such arrangements are clearly understood by the donor and fully noted in the document giving your institution legal ownership of the material. A frequently used form is a simple statement allowing a museum, for example, to dispose of all or any part of a collection with another institution by trade, direct sale or gift at the discretion of the curator. Such flexibility is important as the collection grows and in particular as prints are replaced by better examples. A growing body of materials that can be legally exchanged or sold is a great help—especially if a donor wishes to be rid of a "storage" problem and insists that the receiving institution take "everything." Often a glance will uncover a great deal of useless material that would normally be discarded; a chance legally to discard worthless accumulations of damaged prints, negatives, artifacts, etc., ought not be overlooked. Finally, one can pretty well be sure that the donor or seller or a member of his family will eventually come in to check on the disposition of a collection. Have available copies of any agreement governing the care and disposition of the collection and be able to say definitely what has been done with the material. In the cases of both gifts and sales, there can be long-standing disputes within families over the ownership of such materials. We caution receiving institutions to be especially alert for any possible intimation or clue that might assist in untangling such difficulties when and where they appear. It could be costly to spend time and money on material of doubtful legal ownership.

The ownership of property may in a publicly

92 supported institution be restricted as to its use or sale by regulatory legislation. Clearly this is a specific legal matter and the individual requirements for acting under such legal limitations must be fully understood with the assistance of a lawyer. We know of cases that make it impossible for certain institutions and agencies to sell or lease the use of their property in *any* way. We believe that the right of public agencies to copyright public property is unresolved and will require legal guidance for resolution in the future. In the interest of good public relations with past or potential donors, the status and disposition of a particular body of photographs should be recorded so that it can be accounted for. If a collection has been dispersed in the master file, traded, sold, given away, or is on loan, it is particularly important to have records available to answer questions or objections.

We have confined ourselves to only a few legal rights and obligations, believing that such moral issues arising out of questions of ownership and sale are properly handled by the organizations concerned. For example, should a sister organization sell you a collection of photographs or negatives and fail to limit their use or sale in any way, then *legally* you may use them without restriction. We could forsee a moral question of propriety arising that could require resolution. Again, should an organization receive a negative collection from a private donor without any restrictions, although they might be legally free to use it for publication, it might require consideration for the sensibilities of the donor before doing so. Perhaps the point to make is that giving away a photograph or selling it without specifically indicating the limitations of its use is to extend such unlimited use into the future. All organizations involved should understand this fully in determining their photograph use policies.

Photographica to Ask the Donor About

More often than not, a collection will not be brought into your archives, you will have to go and get it. It is just as well that you do so, for this can be a courtesy to the owner and may also be to your advantage in assuring safe transfer of the photographs. It will enable you to know more exactly what you are buying or are being given as a gift. Frequently a collection may be broken up and may exist in the hands of a number of individuals, families or institutions. Every effort should be made to secure an entire collection where it is possible. Additional materials of worth include batches of negatives, daguerreotypes, ambrotypes, tintypes, books of carte-de-visites, framed prints, rolled circuit camera prints, photograph albums, the print books of professional photographers, all forms of business records and correspondence of such professionals. These materials could include documentation of relationships with supply sources, camera clubs, professional journals and publications and personal correspondence with fellow professionals. One should look for every type of photographic artifact such as cameras, lenses, film holders, tripods, head stands, posing chairs, scenic back drops, lights, darkroom equipment, business signs and placards, advertisements, handbills, calling cards, framed samples of the photographer's work, and any portable equipment for a traveling studio, as for a horse and buggy or an automobile or railway car. If you as an informed person can visit the owner and see the collection as it is then stored, you will be able to more clearly assess what arrangements are necessary to move it and what additional material might be worth taking along with it. If the job is left to a donor, seller or family, important material may be discarded unwittingly by them in the belief that it is not worth sending along with the photographs. By visiting the owner on location

you can ask about his memories related to the collection or its photographer and also seek out these related artifacts and records.

It would be well if all that we needed to know about photographers were contained in their surviving photographs. However happy an idea, it is far from the truth; the eloquence of their images alone cannot satisfy our need to understand the life and the activities of these workmen with their cameras. It is curious that the photographer on nineteenth-century American frontiers was allowed little social prestige, even less professional standing among his professional peers. He was often an itinerant, self-employed, underpaid working-man. Cut off from urban centers, his problems of supplies and professional contact were severe and the resultant geographical isolation often prevented needed relief. The many problems of running a successful business were often compounded by inexperience and inadequate capitalization. Merchandising was one of the most primitive sort and a steady day-to-day clientele was a glorious dream at best.

Our problem of knowing these men and women, understanding their trials and tribulations, is doubly vexing in that few people considered them significant enough to preserve the few records these photographers did maintain. What little we know of them now is too often based on memoirs by their colleagues, written when all concerned were old and disabled. It is precisely because reliable information about the early photographers is so scant that the need for diligent pursuit of formal documentation now is great. Their personal and business correspondence is filled with negotiations for photographic commissions, trips, request for supplies, hiring of assistants, alterations and building or rentals of studios and galleries, sales of business, etc. Correspondence of this kind must be sought, including business accounts and ledger books. Per-

sonal memoirs and diairies are needed as well as family recollections. Accounts by photographers who took over the business of their earlier colleagues can be of substantial help; accounts of related endeavors such as print-making establishments, photographic supply houses and members of founding regional camera clubs are equally significant. Governmental records are invaluable as are the files of professional organizations, major camera clubs, exhibiting organizations and Art Unions. Analyses and studies based on these documents, such as lists of photographers mentioned in business directories, are necessary—as are similar listings for photo suppliers, retouchers, print-making establishments and many others. Copies of photographer's advertisements are important as are collections of photographers' imprints found on the backs of carte-de-visites, cabinet and boudoir photos. We need collections of photographs of photographers at work and photographs of their studios, inside and outdoors. These early photographers can be found sitting in railway cars, driving in equipment-laden buggies, sleeping under large mountain overhangs and setting up their 20" x 24" cameras on Grand Canyon precipices. Similar images await the collector's discerning eye and each of these telling pictures will add to our understanding of the condition of their lives.

We have far too few photographer's diaries while the few we know of are gold mines of richly needed information about them. These documents provide vital commentary on the environment in which photographers learned their trades, worked and built their fragile businesses. Finally, we are desperately short of catalogs and guides identifying the locale of such records and materials. Available information must be found and shared. It needs to be organized, printed and made available to organizations that can use it effectively. For the history of photography itself this is still the

94 period in which *who, what, when* and *where* type of information must be gathered, and time is dwindling when we will be able to do so.

When you actually see the stored collection and talk to the donor or seller, you will be able to determine how many people will be needed to help transport the collection to your institution and what type of vehicles will be required. Estimate what to bring along on moving day: portable extra lighting, clothing for crawling around in dirty storage areas, gloves, maybe cloth masks for those who could be affected by inhaling so much old dust. Consider bringing moderate size boxes, cord, cushioning material, envelopes and wrapping paper for an emergency in case the old wrappings disintegrate when disturbed. Try to work in good weather but bring plastic sheets along to cover the material in case of rain. *Do not* take insecticide to spray around the storage area; the chemicals can damage old photographs. *Do not* stack the bundles or lean on them. If a bundle is too heavy to carry safely, divide the contents into manageable amounts to transport.

Try to find out whether the collection is complete. Does the owner know if it was divided previously? With whom? Where is additional material now? Did the photographer work with others? Under what names was his work sold? Was the collection sold long ago and merged with work of another photographer? Did that buyer put his own name on the photographs he bought? Be vigilant in your search for information and additional related material. Ask for permission to look in other likely storage places for additional things,

under the house, in the attic, etc. Ask if other members of the family are storing related material. Most photographers had sample print books to show their customers; acquiring these, which show some of the best work, is most desirable. If the collection being acquired consists principally of negatives, there may be original prints in the donor's possession that he may not have realized are related to the collection. It is possible that equipment may still be around, cameras, tripods, stereo cameras, lenses, printing frames, perhaps even an ancient enlarger. There may be a collection of lantern slides which fortunately were usually stored vertically in special boxes with grooved slots. Some photographers stored their glass plate negatives in similar grooved boxes to keep the plates vertical and apart. The photographer's family may have preserved albums of pictures made on his trips or albums of family members and close friends. Such personal story pictures and their related chronology contribute to the knowledge of his work and his time. Learn all you can about the photographers and his family and write it down immediately for addition to your archives; knowing some of the facts of his early life can help to identify and date his work. For example, we have found correspondence and family photographs of an early Southern California photographer, giving specific information about the time periods and locations of his stays in four different towns, which has led to positive dating and identifying of many of his photographs. In this particular instance there was another happy find—several rare photographs of the photographer himself in the field along with views of his gallery.

A Selection of Nineteenth-Century Photographer's Galleries

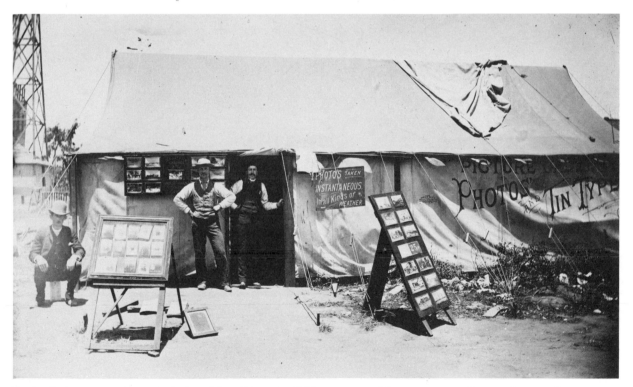

In the balmy air and steady light of San Diego in 1887, a tent could serve very well as a photo gallery, a darkroom and a sales counter all rolled into one. In fact, it often did. The square object in the left foreground leaning against the rear leg of the display rack is a frame for printing photographs by the sun's natural light—a common printing technique of that day. (Courtesy, Title Insurance and Trust Company of San Diego)

96

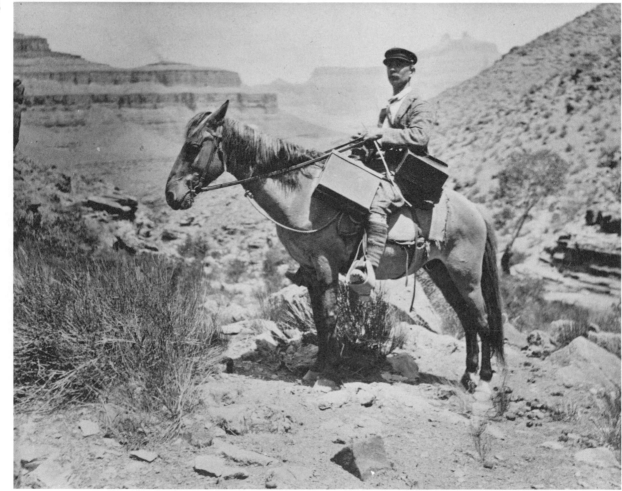

Henry G. Peabody in the Grand Canyon astride his portable "jackass" gallery. His heavy photographic equipment was transported in the field either by himself by hand, by his assistant or by the ever-faithful burro—in some cases by all of them. Dressed for the outdoors, he was the approved model of the mobile frontier photographer of the 1890s. (Robert Weinstein Collection)

A classic pair of photographic studio interiors, both the same studio, photographed in 1876 in Northern Minnesota. The left-hand view is the "shooting" gallery with its mounted portrait cameras, posing chairs and overhead reflecting screens. The right-hand view, the sales parlor with framed examples of the photographer's art, suggests the types of work available for purchase. (Robert Weinstein Collection)

Even in daguerreotype days, an enterprising frontier photographer couldn't afford to be a stay-at-home, stick-in-the-mud. Here a no-nonsense operator, Perez Batchelder has mounted an abandoned ship's house on wheels—journeying with it to the California mining camps to find customers, make and sell his much-admired plates. His hired daguerreian operator, young Isaac Baker, stand in the doorway of the erstwhile "studio-in-the-field." (Courtesy, Oakland Museum, History Division)

If such "ooh and ah!" photographs, common to Western frontier photographers, were not testimony to their enterprise, they did certify their determination and the touch of foolhardiness each of them needed. Yosemite shown here was accepted by all photographers as an exciting challenge. Few wild areas were safe from the outdoor man looking for new, saleable images. (Robert Weinstein Collection)

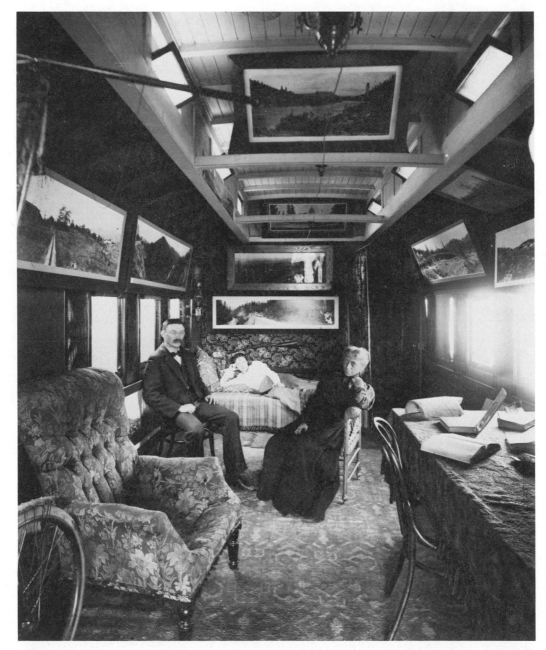

The frontier photographer often worked for railroad companies as a visual propagandist, living and working in a fitted railroad car. This example is revealing for the Victorian splendor enjoyed by this photographer and his family. The framed photographs are tribute to his skill and support the railroad's claims of the natural beauty of their right of way—conveniently for sale. (Courtesy, Natural History Museum of Los Angeles County)

First Examination

The collection itself is likely to have been arranged for storage in some general groupings long ago, probably in liftable wooden boxes, cartons, barrels or old film and paper boxes. Probably it was wrapped in newspapers at the time of packing and tied with strings, ropes, even rubber bands. These bundles may have been stored for many years in an attic, basement, garage or carriage house, suffering through dampness, heat, disintegration of packaging and insect damage. You are wise to get to the scene first and plan to move them carefully. Often the wrappings are ready to fall apart in your hands; small bundles can be unexpectedly heavy, especially if they contain old glass-plate negatives. Be aware that bottoms can fall out of containers and strings break easily. Try to keep together material that has been stored together, their juxtaposition might be a clue to their identity or date. Remember that tubes and cans may contain rolled up photographs such as circuit camera pictures, and the contents of each one should be investigated. If you find things like old rags, tomato cans with indescribable contents, evidence of rats and wasp nets in the storage boxes and packages, remember we warned you; smile and discard immediately. If the collection coming into your archives is of a later date, chances are that it will be cleaner, better stored and packaged. It probably will be easier to transport, but a little less of an adventure to bring in.

Plan to take the collection to an intermediate place, loading dock, shipping room, or hallway, to get rid of as much of the dirt and debris as is practical, to avoid taking so much dirt and so many contaminants into your workroom. Even during this preliminary intermediate cleaning, avoid careless handling of the photographs, especially negatives. Do not bring them into an environment dangerous to them, do not leave them on the floor, try to avoid paint, chemical fumes, heat, dampness, more dirt or sunlight or especially this kind of disaster. One man inherited a collection of glass plate negatives and prints from his grandfather, an early photographer. He stored the material "temporarily" in the service room of his home where the washing machine overflowed, saturating the bottom of all the cartons containing the collection. The water dried and the man thought nothing of the damage that might have occurred to the photographs. After he donated the collection to a museum, it was discovered that much of the material was useless, hopelessly stuck together or damaged by fungus and insects; a once very important and valuable collection was ruined through unintentional carelessness.

Keep the photographic material in your immediate dusting area only a very short time before bringing it into the safer and better managed archives workroom. If you cannot take the collection into the workroom immediately, but have to store it temporarily, do the best you can for it. Your guiding principle must be to store the photographs temporarily as safely as possible to avoid further deterioration while they are waiting to be assimilated into your archives. These precautions soon will begin to seem like a familiar refrain; store in moderate temperature and humidity conditions, ideally the same atmosphere as that of the archives; avoid storage on the floor, store away from airducts, dust, new paint, new wood, maintenance and cleaning supplies and other chemicals and their fumes. By the time the photographs reach your workroom for the assimilation work, you will have learned enough of the scope of the collection to estimate what materials will be needed, what work may be necessary, and the space requirements and approximate hours involved. If possible, decide which boxes and bundles to work on first.

The look of a real collection as you may find it in storage. (Courtesy, Title Insurance and Trust Company of San Diego)

Workroom Materials

Here is a list of materials that may be needed in the archives workroom.

Pencils, soft lead, graphite, numbers one and two; nonpermeable India ink, carbon typewriter ribbons and pen. Only pencil is recommended for writing code information on the back of a photograph. Pencil, India ink and carbon typewriter ribbon are the only recommended materials for writing on storage envelopes,

sleeves and folders. As other printing and writing materials may contain acids and harmful chemicals, they should not be used; even the recommended pencil and India ink should be used with care. Do not ever write on the face of a negative or a print. Do not write hard on anything. Felt pens should never be used.

Lintless clean cloths. As commercial tissues or cellulose pads are seldom really lintless, cotton cloths that have been well laundered repeatedly are best.

Circuit negatives in their tubes and glass negatives, lantern slides and business ephemera of the working, professional photographer as they may be found in storage. (Courtesy, Title Insurance and Trust Company of San Diego)

Q-tips, Cotton balls.
Single-edge razor blades
Clean camel hair brushes.
Solvents for cleaning. Have a bottle of distilled water, one of denatured alcohol and one of a good hydrocarbon commercial cleaner such as benzene and Kodak film cleaner. Note: Alcohols and hydrocarbons are dangerous if inhaled or used improperly. Observe all cautions and have good ventilation.

Sheets of single weight glass, 8" x 10".
3M acrylic tape no. 850, ½" wide.
Light box, 8" x 10", for viewing negatives and slides.
Disposable cotton gloves. Inexpensive disposable cotton gloves can be bought at photo supply stores and are used to keep finger marks off film. Ask people to scrub their hands and offer them disposable gloves if they handle original photographs. Hands must be scrub-

A Case Study in Collecting Photographs

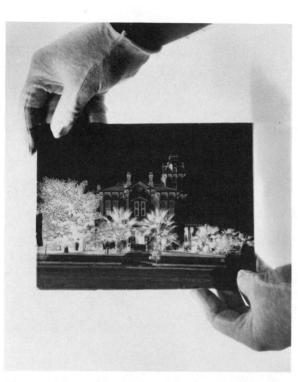

This method of handling a glass plate negative, by its top and bottom edges as shown, assures both control and protection from fingerprints and grime. (Photograph by Larry Booth)

A one-handed grasp, suitable for flexible film negatives. (Photograph by Larry Booth)

bed frequently, rinsed well and dried thoroughly. Hands that *look* clean can carry all kinds of contaminants—grease, acids, body oils, lotions, cosmetics as well as dirt and grime from old wrappings and other photographs. To protect photographs, make definite rules that there will be no smoking, food, beverages, nor dirty hands allowed in the workroom; smoking, eating, and drinking can be done elsewhere. Be especially careful with ashes and sparks from smoking for they can be a dangerous fire hazard, especially near nitrate-base negatives.

Storage envelopes, sleeves, folders and separating papers. The section on filing and storage offers detailed options for differing circumstances and budets.

Principal Preservation Aims

Before undertaking any work on your photograph collection let us restate the main goals that form the five principal aims of preservation efforts.

1. Consider your work a holding action, concerned mainly with the control of temperature, humidity levels and atmosphere to slow down any further deterioration of photographs.
2. Create a safe physical environment for photographs by using appropriate envelopes, sleeves and suitable storage furniture as cabinets, folders, cases and drawers.
3. Protect all images from abrasion, light, fungi and insects.

4. Remove prints from high-acid board mounts or ones mounted with certain dangerous adhesives. Remount them after rewashing on approved, buffered board mounts with recommended adhesives.
5. Reprocess historical photographs and negatives to remove residual hypo.

Points 4 and 5 are wet procedures requiring considerable judgment, knowledge and experience and should be performed by a qualified technician. As ruinous damage to both negatives and prints is possible, copy or duplicate the pieces to be worked on before treatment.

Initial Cataloging

Keep a log on an incoming collection; enter all the numbers given to the material and record each scrap of information from the packages and the wrappings before they are discarded. A log can be as simple or as extensive as your staff, funds and time permit—a journal type of book, loose-leaf book or simply on file cards. A log is a permanent, dependable record, an invaluable accounting of what has been received and done with the material. As a record of permanent acquisition numbers and related information it is of great help, but in no way a substitute for examining photographs themselves. The real advantage of keeping a log is that it represents a portable, complete record of each of the pieces in one collection. It will be used often for reference and will save unnecessary handling of photographs. If the collection being brought into your archives represents a few dozen or a few hundred photographs, the time spent on keeping a log and the complexity of keeping it are not formidable. If there are, however, several thousand pieces, you may well decide not to keep a log on the grounds that insufficient staff and funds make it impossible.

It is our belief that regardless of what kind

of system of cataloging, indexing, or filing is used in your archives, each photograph should be assigned a permanent number when it comes in. Given an individual collection and code number in the very beginning, it always can be accounted for and identified, no matter what is done with it—cleaning, repair, publication, duplication, display, loan or research use.

A simple but useful form for recording the data found on the wrappings of the photographs can be a series of carefully written memos to be filed for use in lieu of a log. Transfer all the information you think may eventually prove useful, try to overlook nothing. For example, such homely descriptions as "Papa's old home," "Trip to San Francisco", and "Aunt Sue's family", may be found scribbled on film boxes; record it, don't lose it! Utilize any system that will suit your needs so long as you will reliably know which photographs or negatives were so marked. Include the names and dates of the old newspaper wrappings in which you found the material; they may contribute to eventual understanding, identification and accurate dating. Transfer whatever information is available from old individual envelopes to your log or to new envelopes. Sometimes old envelopes show the photographer's original number, an important piece of information which should be definitely noted. Even if you do not have his day book or diaries, they may come to light in the future and help to identify and date the photographs by their old numbers. It may be better to put on the new envelope only such absolute essentials as numbers, dates and the briefest description. Keeping all additional information in a log or on index cards will make the information instantly available without having to handle the actual photographs to find it. Photographs can be dispersed throughout your archives and still be retrieved as a separate collection if a comprehensive log and/or index file with acquisition numbers is kept.

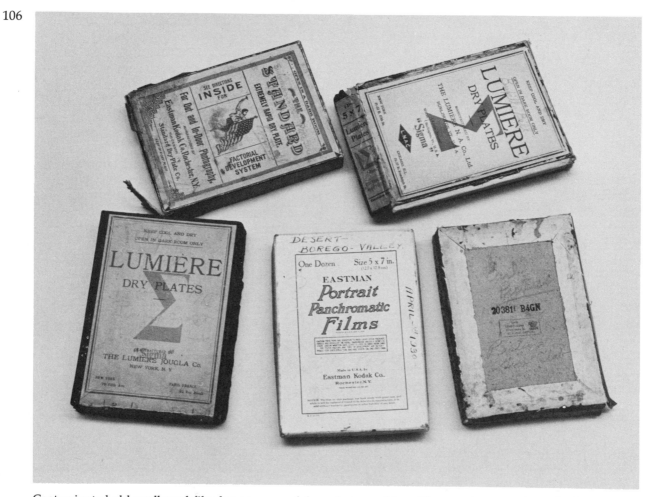

Contaminated old cardboard film boxes are useful as photographic artifacts, *not* as containers for historical photographs. (Courtesy, Title Insurance and Trust Company of San Diego)

Initial Sorting and Care of a Hypothetical Collection

By "walking you through" the procedures involved in sorting, logging, cleaning, numbering, diagnosing damage and recommending remedial work for some hypothetical incoming photographs, we hope to acquaint you with many of the facts one must know about taking care of these wonderful images of our history. Keep in mind always that our guiding principle is to keep and protect original photographs.

Imagine bringing in an old wooden Baker's Chocolate box marked Julian, California. In addition to a staggering accumulation of dirt and dead bugs, it might contain old film holders, a small 1903 folding camera, tintypes and a heavy bundle wrapped in disintegrating 1920 San Diego newspapers. One would log the information that these items arrived in a box marked, "Julian, California." This does not

necessarily mean that they all came from there or were even made or used there. If the fact is logged, the information won't be lost. As a matter of fact, this actually happened and some of the photographs in this particular box proved to have been taken in Julian during the short span of time the photographer, Vail, worked in that town. Often old plates and prints are stored in interestingly labeled early photographic plate and film boxes. If you want to preserve such old boxes, do so, but not in your photographic archives; these boxes have been collecting contaminants for years and should be stored elsewhere.

Before the actual work starts with the contents, cover work tables and counters with large sheets of newsprint which will collect dirt and debris as photographs and artifacts are unwrapped and removed from old containers. Avoid contaminating both the workroom and the photographs being worked on; as trash collects on these papers, fold them over gently and discard them without spilling, replacing with new papers. Then dust the tintypes carefully with a soft brush, assign numbers to them, log and make a new envelope for each one with its number, date and description. Remember, use only pencil or india ink! To write on an envelope with any kind of photograph in it is to risk damaging a delicate image, therefore, finish all writing on the envelope before putting the photograph inside, image side *away* from the envelope seam. Tintypes can range in sizes from less than a dime to about 8" x 10", with many variations in between. If one is in a daguerreotype case, keep it as it is, even though it may not originally have been put in the case. If one is mounted in a thin, soiled, and dog-eared cardboard mat with a cutout opening, keep it as it is, this is probably original with the tintype and should be preserved with the image. Most tintypes show varying degrees of aging and wear including some ridges from bending. Do not flex a tintype for the surface may crack at the bend.

Some tintypes are very dark and while it seems paradoxical to say that a tintype looks dark because it is fading, remember that it is really a negative image growing apparently darker as the black base shows through the fading image.

Turning to the wrapped bundle, open it carefully, for anytime a package or box feels rather heavy for its size, you should suspect it contains glass plates. Each plate must be handled with great care by its edges, regardless of its condition. It is critical in handling glass plates to distinguish between the image side, where the emulsion coating is, and the backside, which is shiny glass. As many people have difficulty in making this distinction correctly, we recommend that all persons handling glass plates in your institution be taught to recognize, without fail, an emulsion side from a nonemulsion side. One way to see the difference is to hold a plate horizontal, toward the light, about even with one's eyes, sighting along its surface. The emulsion side will have a luminous satiny film image on the glass, while if the glass is slick and shiny without a filmy image on its surface, you are seeing the back or nonemulsion side of the plate.

Most old glass plates can be removed from their old envelopes or wrappings and dusted gently on the emulsion side with a clean camels hair brush while the back, nonemulsion side should be wiped with a clean, lintless cloth moistened in water or grease solvent such as Kodak Film Cleaner or benzine. Stubborn dirt on the back can be dislodged with a single edge razor blade used with great care. Finally, as with tintypes, prepare a new envelope by showing the new number, an old number if there is one, date and description. Carefully slip the plate into its new envelope, emulsion side away from the glued seam and store vertically without pressure from other stored plates.

Although the ordinary tasks of unwrapping, cleaning, assigning number, transferring old

108 information to the new log or envelopes, putting the photographs into new envelopes, sleeves or folders can proceed at a rather calm pace, a worker must be prepared, like a fireman, to act immediately and intelligently when an emergency is found. Here is the first of the emergency cautions one must observe in dealing with glass plates. Some photographers painted masking areas on the back of plates and films, usually with red or black paint, to make them easier to print at a particular exposure or on a certain grade of paper. For whatever reason, the mask may still be found sometimes painted on the back of a negative. We recommend that it be saved. Before cleaning the back of a negative, therefore, make sure such a painted mask is not on it, because wiping will surely damage the paint. Merely dusting gently with a camels hair brush will be enough. Should the masking be done on the emulsion side, in most cases it should be removed to prevent the adhesive, varnish or paper from staining the emulsion. Leave the job to a technician, one better prepared to do it.

Your Five Most Immediate Problems

While all photographs must be handled with extreme care, it is imperative that those working with them know how to recognize emergency situations and act instantly and correctly. Willing volunteers and unskilled staff workers must be briefed thoroughly and taught how to care for photographs before undertaking this type of work.

The following five categories of photographs and negatives require instant, informed action to prevent further damage to themselves and similar materials and should be considered emergency situations.
1. Cracked and broken glass plates
2. Glass plates with lifted emulsion
3. Glass plates and films with stuck emulsions
4. Brittle prints
5. Deteriorating nitrate-base films.

Cracked and Broken Plates. Anyone sorting glass plates is likely to find some of them cracked or broken. It is imperative that you be prepared by first reading Cracked and Broken Plates in the Care section, Chapter 5, before beginning sorting. A worker touching these fragile photographs must understand that a glass plate which feels even the least bit *infirm* when it is lifted, is probably cracked or broken; it requires immediate special attention to prevent further damage. When you sense, see, feel, hear any of the tell-tale signals such as bending, lack of firmness, a grating, clinking or rustling sound, *instantly* lay the plate without flexing on a flat, rigid support. For such emergencies keep a supply of clean, clear, single weight, common size—8″ x 10″, 6½″ x 8½″, 5″ x 8″, etc.—glass plates stored within easy reach.

For our purpose the term *cracked plate* means the glass is partially cracked or even broken, but the emulsion is intact. There is a rare opportunity at this point to save the plate by making a duplicate that will show a minimum of the crack or break line of the original. Special lighting techniques are useful as well as special film.

Remove the envelope from damaged plate lying on the clear support glass, *not the plate from the envelope*, by carefully slitting around the paper edges and lifting off the exposed half to reveal the damaged negative for inspection. Use a second piece of support glass to flip over the damaged photographic plate as instructed to remove the remainder of the slit envelope. If the plate is cracked, any further handling must be done with the support glass under it to prevent tearing of the emulsion. The cracked glass plate should then be taped to a same-size support glass using a technique that will hold the pieces rather than causing them to part.

Broken plates means that the glass negative has been parted into two or more *separate* pieces with the emulsion no longer intact. If the plate is broken into separate pieces, the aim is to keep the emulsion along the broken edges from being rubbed off so there will not be gaps in the reassembled image. The glass side of the broken pieces should be cleaned and the pieces reassembled, emulsion side up, on a same-size support glass and held in place by taping edges with 3M 850 tape or with a cover glass (to form a sandwich—support glass, broken plate, cover glass) with the broken pieces taped in place. If it is not possible to complete this suggested assemblage, slip each broken piece into a separate envelope and store cushioned in a box until remedial work can be done. See the Care section, pp. 167–177 for details.

What to do about Lifted Emulsions. A glass plate with a lifted emulsion is another condition requiring emergency attention. Film emulsions are held to a base by a substratum adhesive referred to as subbing. The formulae for these adhesives and the techniques for using them have long been the carefully guarded trade secrets of individual manufacturers. Certain subbings, particularly of the early 1900 period, did not long retain their adhesive characteristics allowing emulsions to lift up from their glass bases and fracture. Protect a lifted emulsion plate immediately by laying a clean, same-size single thickness glass plate over the emulsion side of the plate very gently without scooting it around. One way of registering the plates without excess movement is to stand the two on their edges facing each other, toe to toe fashion, and gently bring them together. Seal two opposite sides with 3M 850 tape. At a convenient time the lifted emulsion can be resealed with a gelatin adhesive. See Care section, p. 178. When this repair is made successfully, the repaired emulsion can withstand careful handling in print-

ing and sorting. Depending on the success of the job, the plate may still need to be stored in a thin box or have a mask over it to minimize contact with its repaired surface, or again be covered with glass.

Fused Plates and Film. During sorting, you may find two plates or films stuck together, either one emulsion stuck to the back of another or two emulsions stuck together, face to face; do not attempt to force them apart. Gelatin that becomes wet from direct contact with moisture or from condensation, especially in high humidity conditions, becomes so soft it sticks like glue to whatever it touches. Pressure from plates stored tightly next to each other often further aggravates the problem. If you encounter this difficulty simply put the stuck pieces in new envelopes, log and flag them for future remedial action. Generally negatives with paper stuck to them can be saved through a careful process of removing the paper bit by bit. Negatives whose emulsion sides are stuck to the back of others have a good chance of being separated successfully most of the time. Negatives stuck emulsion to emulsion are more difficult to separate without damage to both images. Flexible films, either nitrate base or safety base, stuck emulsion to emulsion, to the back of another film, or emulsion to paper are treated in the same manner as are glass plates. The happy possibility is that their flexible backing makes it easier to handle and safely part them. Be careful that their flexibility does not lead you to hurry the job unduly. Put them carefully in envelopes and flag them for remedial action.

Brittle Prints. Imagine another hypothetical box containing an album, some daguerreotypes, some old prints of assorted sizes mounted and unmounted, a bundle of film negatives and a box of lantern slides; these could provide other emergency situations re-

110 quiring alertness. A print of the 1920s to early 1930s filed with its nitrate-base film negative in the same envelope is likely to be yellow and very brittle, damaged by the acid-forming gases emitted from the self-destructing nitrate film. Such a print can break or fall apart in your hands because of its brittleness. In time, the print's silver image also stains and fades. You may find prints with these damage signs and correctly surmise that they have in the past been close to nitrate-base film. If you find such a print, either separate or in one envelope together with its negative, place it immediately on a sheet of glass or other rigid support and carry it carefully to a place set aside for damaged material. Slit the envelope along the folds and lift it off to reveal the print and negative. Carefully slide a sheet of glass under the fragile print to lift it off without flexing. If the image is an important one, this print should be copied immediately. There is a procedure for placing such a sick print in a fiberglass carrier (like the ones used by conservators for reprocessing documents) and stabilizing it by reprocessing in the lab. Further information on this process can be found in the discussion on archival processing. Just as all nitrate-base films should be isolated from other photographs, prints damaged by contact with nitrate-base films, must also be stored separately.

Nitrate-Base Film. The next artifact to remove from the hypothetical box is the bundle of film negatives—another situation that may demand informed action. Nitrate-base film poses a very serious problem, forcing us to mediate our view on trying to restore and save everything. In fact, in most cases we recommend that suitable copies be made of the negatives, and the original film and envelopes in which they were stored be discarded. Nitrate negatives are a *very serious* fire hazard. They release fumes damaging to other photographic materials. Deteriorating nitrate film will quickly ruin any photographs stored nearby.

The closer the contact with adjacent film, the faster the destruction. Isolate nitrate-base film from all other photographs while holding them for duplication. They should be kept in paper envelopes and stored in ventilated metal cabinets. Temperature below 70°F and relative humidity below 50% will retard decomposition of nitrate-base film. This film with images that have yellow or orange stains should be duplicated on panchromatic film using yellow to orange filters most nearly matching the color of the deepest stain.

Typical Problems of the "Collection"

You will encounter other less pressing problems, which nonetheless warrant careful attention.

Daguerreotypes. If you can find some daguerreotypes, never touch the face or image. If you should open a case and discover that the daguerreotype within does not have its cover glass in place, take precautions immediately to insure the delicate image is not accidentally touched while it is waiting for a replacement cover glass. When the acquisition number of this daguerreotype is logged, note that this remedial attention is necessary and flag its envelope if one is made. A note can be tied around the case with clean, plain cotton string to warn the next person who opens it of the danger. Sometimes daguerreotype cases are worn and tattered to the extent that they have neither hinges nor clasps, or the existing ones are broken. Use cotton string to tie them shut before storing. As daguerreotypes, ambrotypes and tintypes are unique images, they should be stored in metal map cases compartmentalized so each daguerreotype can be laid flat in the bottom of the map case drawer, away from negative and print files. Each compartment can be easily marked for identification, retrieval and accurate replacement.

Original Prints. The old prints in the hypothetical box may have been jostled together in stacks, getting more scratched, rubbed and dogeared with the years. Some old prints may be so badly faded or damaged by fungus or insects or stains as to seem completely useless. Carefully examine each print to determine what kind of photographic technique was used to make it. This will help date it, assist in diagnosing the degree of deterioration, and determine the remedial action that will be required to restore it. Examine each print carefully and if there is anything that can be seen in even a hopelessly damaged image that will be of any use in your files, record it. Even though you may have to decide against adding this photograph to your archives, store it in a separate place to be used for experimentation by a conservator-technician. Such a photograph no longer useful as an image can contribute to our skill in saving other images, for new techniques are being developed. What seems utterly useless today, can be repaired or restored successfully tomorrow. After all, it was only a few years ago that Eugene Ostroff successfully made a photographic copy of a completely faded calotype by radiation exposure—a previously unheard-of technical achievement.

Writing on Photographs. Some conservators object to any writing on a print, and we think that they are right! If you do write on a print, never write in the center of the back. Put the print face down on a hard, smooth surface such as a piece of glass, and write lightly with *pencil* on the print edge only. Never write on the face, or the image side, of an original print. What we mean by *original* is a print made by the original photographer or at his direction, a vintage print. With a duplicate print—one currently printed from an available negative, study print or work print of any kind—one can be more lax about writing on its back. So long as the photograph is duplicatable, and not an original, one can mark on it

—although it is a poor habit to get into with photographs. We know of institutions that actually use rubber stamps on the front and/or back of original photographs; never identify an original print on its face with a rubber stamp, never! Do not use a rubber stamp of any sort on original photographs, their envelopes, sleeves or folders. This practice should be forbidden.

After unwrapping stored prints, do not leave them lying around too long unjacketed and exposed to light, as prolonged exposure to light, especially ultra-violet light, heat, or dampness, are damaging to prints and such neglect must be avoided. Store such prints in Kodak triacetate sleeves, recording any identifying information on a separate card or in your log, not on the prints themselves. We recommend that mounted photographs be left as they are except for archival reprocessing. Some institutions peel prints off their old mounts or trim the mounts down to the print's size, but this is not correct care of historical photographs. We have seen unmounted prints stuck on cardboard with rubber cement for filing convenience! Rubber cement leads to disaster! Never use it with photographs. Ideally, each individual print should be stored in a separate sleeve or folder to effectively avoid further abrasion and contamination from hands and from close contact with other photographs. If funds and expert technical help are available, consider having valuable old prints removed from their mounts by conservators so that both print and mount can be reprocessed to archival standards, then reassembled. If prints are very large, mounted or unmounted, or if they are framed, keep them separately in a special storage place designed to accommodate them. Prints should be stored apart from negatives because their paper base and mounts carry contaminants dangerous to negatives.

Albums. Albums of photographic prints represent a special problem of shelving and cataloging and must be considered either as a

112 group of individual pictures or as a unified body of images assembled by whoever chose them in the first place. Such a particular collection of images may have special historical significance and generally should be kept intact in our opinion, although extensive cross-indexing, itemizing the subject matter of each image, will make the album more useful. Important prints can be copied from albums and sometimes used to identify other prints in a collection. Because album glues and the high-acid paper used in album manufacture can contribute to the deterioration of images, you may consider having a conservator remove the prints, reprocess and remount them on deacidified pages. Although there is some risk of damage to the prints, this can generally be done satisfactorily by an experienced technician. This should be given serious consideration for important albums. Try to maintain the album as a unique artifact.

Lantern Slides and Glass Positives. Lantern slides often have the advantage of having been kept in special containers, grooved, lidded wooden boxes. We recommend that they continue to be kept that way if the container is available. A finished lantern slide is a glass plate positive with another same-size sheet of clear glass covering and protecting it. Often a paper mask, which sometimes has the identification or number or photographer's name printed on it, is sandwiched between the image and the cover glass, bound all around with black tape. If the tape has deteriorated to tattered shreds, remove it and the cover glass and clean carefully. Then reassemble the slide and cover glass and rebind with strips of Permalife paper and Jade 403 adhesive. Generally the covering and binding have protected the image from serious physical damage—although the most common problems are deteriorating tape or cracked glass. Hopefully, only the cover glass is cracked, not the positive slide as well; sometimes there is scum caused by condensation on the inside face of the cover

glass. Generally we do not recommend extensive refurbishing of old lantern slides unless the mounts are badly damaged or badly deteriorated. Another possibility is simply cleaning the positive slide and storing it in a Permalife envelope. The cleaned cover glass and mask should each be filed in a separate envelope and marked with the slide code number so the pieces would be available in future for rebinding. If the image on the slide is the only one you have of a particular subject, you may want to have a copy negative made from it for research use, display or publication.

If you should find a large glass plate positive transparency, say 8" x 10", treat it as a negative. If the plate is small, 3¼" x 4", it probably was meant to be a lantern slide. Larger transparencies were made as intermediate positives to produce a duplicate negative; for example if a photographer wanted to make a number of prints from a negative difficult to print, an adjusted duplicate was made of the original. For further example, a very dense original negative requiring an unusually long exposure time could be duplicated in such a way that the duplicate negative was able to be printed at a more normal exposure. This interpositive method was sometimes used as well to change the size of an original image, such as reducing it to the size of a post card. When you are able to find both the positive and negative of the same image, file them with simultaneous numbers or make a notation on the envelope of each one that the other exists and note its number.

Nitrate-Base Film. Learn to distinguish nitrate-base film from acetate safety-base film. (See Nitrate-Base Film in Care Section for detailed information.) The following signs are usually enough to identify nitrate-base film. The pungent odor of deteriorating cellulose nitrate is similar to the odor of nitric acid. Do not confuse it with the smell of acetic acid characteristic of decaying early acetate safety-base film. Other signs of nitrate-base film de-

terioration are yellow-brownish color of the film base and stickiness of the gelatin. Nitrate-base film can be very brittle, warped and buckled, but acetate-base film can too; so look for some of the other nitrate deterioration signs to distinguish between the two films.

A trained technician might do some restoration of nitrate-base film by floating the emulsion off the sick film base and readhering it to a new glass or film base and using chemical restoration techniques to eliminate the stains' effects. However, this is so difficult and time-consuming that only an extremely important and valuable image could be treated in this manner.

We believe that all usable nitrate-base film should be duplicated as soon as possible and the film disposed of immediately. To extend the life of nitrate-base film, it must be isolated and stored in specially ventilated files. It will also have to be stored in a fire-proof structure at lower temperatures and humidity levels than are necessary for other photographs. Unless your institution has ample funds for safely storing these unfortunate photographs, we feel that caring for them while they continue to deteriorate and endanger other photographs is not wise.

Safety-Base Film. In our hypothetical box, safety-base film has its problems too. This film made of diacetate was introduced about 1934 in cellulose sheet film form; it can be recognized by the words "safety film" preprinted on the border. It can also be identified by the float test described in the Care section under nitrate-film identification. In about 1952 this diacetate film was replaced by an improved safety-base film of cellulose triacetate. It is subject to the usual scratches and abrasion and stains from improper processing (developing, fixing, washing). Stained negatives should be flagged, as they are enveloped, for duplication. To subdue the stains' effects in the duplication process, use a filter the same color as the stain.

Early safety-base film, if it has been stored

at high temperatures and humidity, may show signs of deterioration somewhat similar to those found in nitrate-base film. The deterioration varies progressively, starting with a warped, cockled film base caused by dimensional shrinkage. What was once on 8" x 10" film may measure 7½" x 9½". Film at this stage should be flagged for duplication before the condition worsens. Next, the emulsion will show separation from the base in irregular patterns. There may be tiny bubbles trapped beneath the emulsion. The anti-curl gelatin backing may also be separated from the base. See Care section, Safety-Base Film, for details.

Negatives that show separation of the emulsion layer cannot be duplicated or printed without the separation pattern being produced too. An experienced technician can sometimes float the emulsion off its old base and transfer it to a new base of glass or film. We suggest that early safety-base film of this sort be kept stored at temperatures of 70° F or lower with controlled humidity in the hope that a more practical restoration procedure may be developed.

At this point, most of the people assimilating newly arriving photographic material into your archives should feel competent to handle most emergencies. Other materials that might come in with a collection can be hand colored prints, transparencies and negatives, microfilm and movies, most are fortunately younger, more easily handled and less likely to fall apart in your hands. If you receive old movie film, it may likely be nitrate-base film. Be especially careful with it for it is dangerous. Do not handle it or try to project it until you know for sure what type film base it is. There is much dependable information about microfilm and movie film available from Eastman Kodak Publications. There is more detailed information about how to take care of other photographs, black and white and color in Chapter 7.

Suggestions for Filing and Indexing Photographs

Our remarks here on filing and indexing photographs are based on the assumption that help and budgets are limited and that you have to decide how your money and time can best be spent. Starting with the minimum, we believe a log should be made listing the material in your collection and the pertinent information about each piece—a log as detailed as time and help will allow. Even if a collection cannot be assimilated into your archives immediately, at least the items will be accounted for by number and some description.

The minimum effort and expense *should* include much more than logging the material. It should provide physical protection for the photographs—sleeves, envelopes, folders and storage containers, plus some organizational order for locating things. If we were to choose between spending money and effort on physical protection or elaborate indexing, we would favor protecting the collection. Our plan for filing and indexing a new collection as inexpensively as possible is to arrange the prints by *subject* and the negatives by *number* with an auxiliary subject file. After you are familiar with the collection and have assessed its scope and potential uses, indexing can be done in stages as money and help are available. It is sadly true that in many institutions, a filing system works primarily because one person knows the material very well and is able to find almost anything fairly quickly. We believe you should work toward making a filing system that does not depend heavily on one person's memory. What we suggest here is comparatively simple and usable by many.

Original prints in the collection organized and filed vertically in file drawers under subject headings can be retrieved without any additional index. This minimum expense system will work reasonably well. The advantage is that there is less work involved in getting the photographs filed and ready for retrieval; the investment in time and money is less, and nothing is locked into an unchangeable system. Should you want to go into a more complex arrangement in the future, much of the organizing and preliminary work will have been done already. You can build from this system rather than start over. Elaborate on it as soon as possible to save wear and tear on the originals; set up an auxiliary work-print catalog and/or index card file that incorporates images.

The major disadvantage in filing original prints by subject is that they will have to be touched and handled in retrieval and refiling. It is essential that each print be protected by its own transparent triacetate or polyester sleeve. If the print is thin or weak, also provide it with a slip-in sheet of stiff 0.010" acid-free paper or Permatan. Flat storage in acid-free boxes can provide better protection for your most valuable prints. Each should be in a separate sleeve and folder. Photographic copy prints, processed for optimum permanence from valuable originals, can be used as stand-ins in the master vertical filing-indexing system.

Here is a system we have used. Original prints are sorted by size into groups according to outside dimension of print or mount. We use four sizes: (a) 8½" x 11" or smaller—prints in most collections will be in this size range; (b) up to 11" x 14"; (c) up to 16" x 20"; (d) anything larger and framed prints of any size. These prints, a, b, and c, encased in the protective sleeves, are filed vertically in metal file drawer cabinets or in acid-free boxes. The triacetate or polyester-sleeved prints in a particular drawer are all a similar size, with a sheet of Permalife paper or Permatan as the stiff backing where necessary.

The 8½" x 11" and 11" x 14" size sleeved prints can be filed vertically in letter-size and legal-size file drawers. Larger prints and framed prints too cumbersome to kep in file drawers can be stored on edge on a shelf or

rack. The unframed ones are separated by acid-free museum board. Remember that whatever storage you devise for these large prints, framed or unframed, should be dark and covered. We favor steel map cases and large steel cupboards with adjustable shelves.

Sleeves can be tailored to fit large prints out of 5 mil or thicker polyester and 3M double-face tape no. 415 (see section on Original Prints in Chapter 5). All larger prints and framed prints can be copied. Handier size (8″ x 10″) prints can be processed for maximum permanence then sleeved and incorporated into your more often used 8½″ x 11″ print file. If map cases are available, the large prints can be stored in them horizontally, protected by acid-free board. Flat acid-free boxes can also be used the same way.

Original prints filed under subject headings and arranged alphabetically will be reasonably accessible without a separate retrieval index. Although there are several books in our bibliography about filing systems for libraries that offer assistance in selecting *standard* subject headings, your ultimate choice of headings must be based on your particular collection and the anticipated needs of those asking to see your photographs.

By the time a filing system for your collection is started, you will already know something of its contents and be able to list some logical subject headings and possible subdivisions based on places, dates and so forth. In-depth indexing and classifying a photograph collection ought to be postponed until an understanding of its scope and use can be assessed. Prepare sheets of paper with letters of the alphabet down one side with space for several notations by each letter. As each photograph is examined, decide on a subject heading for it, pencil the heading lightly on its file folder and enter the subject on an alphabet sheet. Eventually these sheets will form the basis for the subject heading file of your collection.

Try to be consistent. If a residence is called a "residence" on the alphabet file, and other residences are called houses, homes, domiciles, dwellings or pads, there will be confusion. Settle on logical headings and stick to them. Several related subject headings such as cats, dogs, giraffes and aardvarks can be consolidated under a single heading, animals. But if this particular collection is heavy on a subject, subdivide the section as required to make specific prints easily retrievable.

This system can be enriched internally with cross-references to other possible subject headings under which related prints can be found, i.e., on a subject folder marked vehicles, write airplanes, street scenes, blacksmith shops, garages. Often an original print you decide to file under something like Methodist Church may also have in it a parade, a street car, water wagon, Ladies' Aid float, soldiers and Mayor So-and-So. On the log, index card or in the folder for each of these subjects, place a separate cross-reference indicating that the photograph filed under Methodist Church is the source not only of the church, but also of the other images. If you have duplicate prints, use them for cross-reference filing under other applicable subject headings. Inexpensive prints made on plain paper copy machies, new generation Xerox-type machines, can be used for cross-filing. Any thorough indexing and classifying must be based on local needs; probably many requests will be for local landmarks, views, street scenes, buildings, residences, industries, celebrations and dignitaries. When the subject headings for dividers in the print file seem to have been finalized, make copies of this master list for use by your filing personnel.

We suggest that prints ready for the files not be allowed to accumulate in stacks until all of them are available for sorting into subject divisions. The time involved in preparing a large collection for filing could be weeks or months. All the prints prepared for filing in one day should be filed at the end of that day. This can

116 prevent mishaps and damage that can occur when the material ready for filing is left stacked around the workroom. File small, manageable-size groups of sleeved original prints in subject headed folders. Do not grasp an individual sleeved print to lift it out of the file or put it back into its place in the file; lift out the entire folder of prints, carry it to a work surface where the folder can be opened and the desired print selected. Return the print to its folder the same way; do not jam it down into a group of prints. Use folders generously, fill them only with an inch or less of prints. Often the folders can serve as further breakdowns under subject divisions; but one of their most valuable functions is carrying prints safely in and out of the files.

Some of the advantages of this simple system for filing original photographs are that it can be expanded, further divided and cross-referenced internally, or elaborated upon with further outside auxiliary retrieval aids. The original expense and work in setting up the print filing system will not have been wasted, as nothing will be locked in. No print will have been altered, cut, mounted or changed irrevocably for the purpose of filing.

Original negatives are difficult to read by their very nature and acutely subject to potential wear and damage every time they are handled. They should be handled as little as possible, a necessary precaution that should be observed strictly. The only protection a negative has is its envelope, and the only way its image can be seen is to pull it out of the envelope and look at it. To prevent as much handling as possible, file the negatives numerically using a separate auxiliary retrieval system. If negatives made by one photographer already have a usable numbering system, retain it as a part of the identifying information with your master file numbers. We believe the work of a photographer should be maintained as a unit. Whether it is kept intact or whether it is dispersed in an existing file system, a

catalog should be kept of his or her work so it can be reassembled. One should feel a responsibility for preserving the identity of an artist's work; we suggest that your doing so will make your collection more valuable.

As the ultimate choice of an image must always be made by visual inspection, the ideal retrieval system is one that uses a photographic image. With budget limitations in mind, we suggest comparatively inexpensive versions. Use work prints, usually 8" x 10", filed under alphabetically arranged subject headings in the same manner in which we suggest original prints be filed. Internal cross-referencing can be done with multiple copies of the work print. Kodak transparent sleeves or polyester sleeves should also be used to house work prints for their protection. Use a negative code number as well as a subject heading on back edge of a work print to facilitate correct refiling.

Collections of negatives will have some repetition and duplication, some will be damaged or of varying photographic quality ranging from good to bad. If you made work prints of 30 percent of a collection, this might well answer the needs of 85 percent of those requesting photographs for display, publication or research purposes. This assumes that you have carefully selected the negatives to be printed for their photographic quality, variety, story-telling capability and suitability for the uses your patrons are likely to put them to. Even if you cannot set up a work print file for your negatives from the beginning, order extra copies to be used as work prints and cross-reference prints every time a print is ordered from a negative. If a negative file is used actively, these work prints will begin to accumulate and form the basis of a work print file that can save the original negatives from wear and damage. Using the print selection is so easy and fast that a great number of images can be examined very quickly. For example, a Time-Life researcher using such a system was able to

go through about 7,000 prints in a seven-hour period. By comparison, the time spent using a standard library card catalog system, no matter how elaborate and efficient, would have allowed examining far, far fewer prints. We favor images for photographic catalogs and think money and time are best spent on file prints, or some other file system which incorporates an image, rather than on ordinary card catalog files.

An *aperture card* is an index card that contains a positive microfilm image of a photograph. It is a convenient auxiliary aid for retrieving an image without one's having to search through the original negative file for verification. When made in reasonable volume, aperture cards with microfilm-image inserts represent one of the least expensive ways of incorporating an image with a simple retrieval system. Updating the cards with corrections or additions is easy; a new card can be indexed and the microfilm image readily transferred to it.

Aperture cards can be used with a microfilm reader to view the image. Some readers can make dry silver prints directly from the microfilm image. These prints can be used by your patrons for reference, but like stabilized prints, they should *never* be used or stored near your photographic prints or negatives. An inexpensive light box and suitable 2x to 4x magnifier can also be used to view microfilm images.

Other index card systems include photographic images; i.e., 35-mm contact prints adhered to file cards or double weight photographic prints cut to file card size. When volume and equipment budget permit, we favor the aperture for its smaller unit cost, versatility in cross filing, and ability to be added to or corrected.

In terms of priorities, it is more important to spend time and money to make the images of a negative collection available to view in some organized form instead of making index cards

that force one to handle the original negatives to verify an image. If your funds do not stretch for work prints, but you have staff and volunteer help, compose accurate and intelligently descriptive cards that can be filed alphabetically according to subject headings. This way of retrieving negatives saves wear and tear. It is especially important that a card catalog for negative retrieval be as comprehensive and informative as possible, including facts about a negative's physical condition (scratches, stains, broken, fungus) and its photographic quality (fuzziness, poor definition, good or poor copy, etc.). Using a card catalog to find a known specific photograph such as the flag being raised on Iwo Jima is reasonably simple when the language of the cataloger and the person requesting the image match. However, when a researcher looks for photographs to illustrate an idea, the meshing of the catalog subject heading and card writing language with that of the researcher can be difficult and time-consuming. The person assigning a subject heading to a negative and making its retrieval card must use logical and familiar words that a researcher is likely to understand and respond to when trying to locate an image. Photographic filing systems requiring the solution of more complex problems than we have dealt with will undoubtedly benefit from the advice of professional librarians and catalogers. Renata Shaw of the Library of Congress, Prints and Photographs Division, has already written in lucid detail on this subject with large and complex picture collections in mind.

Storage Information

In planning storage facilities for historical photographs, two considerations are decisive. Whether you are buying or building storage cases, file cabinets, open shelves or folders and envelopes select only those materials that will not add to the chemical problems already existing in films and prints. Second, remember the

118 overriding need to maintain acceptable temperature and humidity levels. Try, in selecting storage containers, to give ventilation to the materials stored inside them. Such commonly used materials as most woods, including various types of plywood, pressboard, and chipboard, many paints and lacquers including varnish and other popular sealers, adhesives and glues all generate harmful gases and fumes; they must be avoided where possible. Use storage furniture made of steel with baked enamel finish, anodized aluminum, or stainless steel. Epoxy paint is the safest finish for any other material, but allow any paint to cure for about two weeks, with adequate ventilation before using any newly painted area.

Decide what size envelopes, sleeves and folders you will need and buy the best quality you can afford. Get plain, unprinted ones, not envelopes such as those preprinted with NAME _____ DATE _____ DESCRIPTION _____ . *Do not use a rubber stamp with stamp pad ink* on any paper materials intended for use in storing photographs. In some archives, every item up to the 8″ x 10″ size, including odd sizes is stored in an 8″ x 10″ envelope; larger photographs are stored separately, usually in large folders. Other file systems keep like-size negatives together, storing them in separate areas. An advantage to filing smaller photographs in matching-size envelopes is that they will fit in smaller drawers, saving filing space. Another advantage to filing different sizes separately is that the actual handling during retrieval and filing is more convenient and safe for negatives, particularly glass plates. If a person is searching through a file drawer of enveloped glass negatives all of the same size, that person can handle them without the danger of levering a large one against a smaller one, cracking or breaking the larger one. If small photographs are stored in large envelopes in a large drawer big enough to accommodate them, space is being wasted. Safety-base films,

prints and lantern slides can be stored in metal file drawers or cupboards or in Hollinger file boxes with the happy advantage that they will not require so many dividers as do glass plates. We recommend that all photographs be stored in metal, baked enamel filing drawers or in Hollinger boxes stored in metal cupboards. Filing cabinets up to five-drawer size are of manageable height.

During the work of cleaning and preparing an incoming collection for filing, all artifacts are removed, given acquisition numbers, coded and stored in whatever manner is used in your institution. All damaged photographs requiring remedial action are set aside, flagged for special attention. All other items such as daguerreotypes, ambrotypes, tintypes, large pictures, framed ones, albums, print books, lantern slides, etc., are given numbers and code and stored separately, leaving what generally comprises the bulk of a collection, the average size original print and original negatives. Very large photographs are stored flat in acid-free folders in shallow metal map drawers or suitable acid-free boxes. If framed pictures are to be kept in their frames, consider storing them on edge, covered or in a closed metal cabinet. Some institutions store daguerreotypes, ambrotypes and tintypes horizontally in separate sections in large shallow-drawer steel map cabinets; each piece is thus protected from abrasion, weight and unnecessary handling in separate sections marked for identification.

Since glass plate negatives are so fragile, special precautions must be exercised in filing them. Glass plate negatives should be stored loosely in a vertical position without undue pressures in file drawers and/or Permalife boxes. In vertical storage, glass plate negatives should have rigid dividers (metal baked enamel) at intervals depending on the type of separator and size of glass plate. Plates 5″ x 7″, 5″ x 8″, 6½″ x 8½″, 8″ x 10″, are especially vulnerable to cracking and breaking in handling if

they are protected with too few rigid divisions. Typical office-type file drawer dividers that pivot forward and backward from a channel in the drawer bottom exert a vise-like action against the plates and can frequently cause their breakage. These dividers also have a tendency to get out of their channels and caught as the drawer is closed, causing further breakage. Rigid metal divider leaves should be placed about three or four inches apart so that only a few 8" x 10" plates can stand between any two of them. Not only should the spacers be no more than three inches apart, but glass plates should not completely fill that space. Hollinger-type boxes of a size to hold the glass plates in a vertical position, and small enough from front to back to hold a manageable weight of plates may be used for storage on shelves in metal cupboards. Drop-in rigid metal racks can be specially constructed to fit into the regular metal file drawers dividing them into small segments of about six inches for vertical storage of glass plates. They should be baked enamel on metal or aluminum, stainless steel. If other materials are used they should be painted with epoxy paint and allowed to cure for several weeks before use.

To store prints, use transparent polyester sleeves, or Kodak triacetate sleeves. These have great advantage of providing visibility with protection from abrasion, scuffing and handling contamination. We like the polyester sleeves from TALAS because they are ¼" larger all around than similar-size Kodak sleeves.

Our case study is finished. Everything we have told you about has happened; it is all true. The problems were all difficulties we have faced and the solutions are real as well. They are answers that have worked and have helped each of us in setting up and maintaining collections of photographs. In walking you through this case history, facing you with problems and answers, we hope we have given you information that will help you; there is something in here for anyone who is taking care of a photographic collection. Remember! This case study cannot replace Part Two of the book which provides more detailed explanations of the materials you are dealing with, the particular problems they may pose, and explicit solutions for their resolution.

Part Two

*How to Care for
Historical Photographs:
Some Techniques
and Procedures*

5

Preservation of Photographic Materials

CURATORIAL staffs of most libraries and museums that now collect and use historical photographs are far more experienced in preserving other art forms, such as paper and the written word in its myriad forms, than they are in practicing correct restoration and archival storage of valued photographic images.

For our purpose, we define *archival life* of historical photographs as one hundred plus years. We do not know of any established standardized definition for this term. When one thinks of archival life of most museum artifacts, it may mean indefinite time, several hundreds to many hundreds of years, depending on the individual artifacts and their care. Reviewing photographic processes of the past 137 years, it is obvious that most of those photographs that have survived until today are *not* going to last indefinitely.

Accelerated age testing of today's best photographic materials, properly processed and stored as currently recommended, indicates they have the potential for life of several hundred years. However, because a photograph is made of several components, silver, gelatin emulsion, base and adhesive sub-layer, it can be ruined by the failure of any part. With the difficulties of protecting photographs adequately from our polluted atmosphere, it is uncertain that today's photographic materials are going to last their potential several hundred years. Much research has been done on preservation techniques for books and paper, and comparable research for historical photographs is just beginning to catch up. Hopefully future technology of preservation will keep ahead of pollution and deterioriation to make potential long life a reality.

Original historical photographs that have survived commonly show at least some deterioration or damage. Some common problems that can befall photographs are tears, abrasions, scuffs, finger prints, dirt, marking with pointed objects, such as pens, pencils, paper clips, etc. Glass plates are broken, prints are bent and rolled, emulsions are cracked and negatives are scratched and soiled. Staffs must learn to handle photographs carefully and establish and enforce rules of procedure for the handling of photographs by patrons. As photographic artifacts increase in value, and as possibilities of organized and random thefts and vandalism increase, precautions are required.

Curators assessing deteriorating condition of photographs can hardly avoid the need to do something to protect them. Caution is urgent to avoid doing the wrong things in enthusiastic ignorance that can result in as much damage to photographs as can thoughtless neglect. There is a long list of things done to photographs in the name of conservation that may do more harm than good. Improper decisions concerning care and handling can result in irrevocable damage. Other decisions, though reversible, may require so much extra work to change that continuing with them may be a tragedy of wasted photographs, work and money.

Here are some horrible examples:

We have seen many original prints mounted with rubber cement or Scotch tape on whatever kind of standard-size cardboard was available in order to make them more convenient to handle and file.

Identification prints are sometimes pasted on the outside of envelopes of original negatives.

Glass plate negatives are often handled carelessly during sorting, sometimes stacked on uneven surfaces until the accumulated weight cracks the bottom plates or breaks off corners.

124 Often people have difficulty deciding which is the emulsion side of a negative and mistakenly damage it with cleaner.

Identification is sometimes written with a heavy hand on the back of thin prints with ball point or felt pen.

Impossible as it seems, many fine original prints are stamped with the collection name *on the print surface in indelible ink!*

Old envelopes are commonly replaced with new ones, but all their old information is not transferred.

Negatives and prints, both copies and originals, frequently are stored together in one envelope, allowing contamination from one to spread to the others.

Negatives often stored more than one per envelope in damp conditions will stick tightly together.

It is common to find negatives and prints bundled together with rubber bands, fastened together with paper clips, or stored in old cardboard boxes with old newspaper clippings.

These are only a few of the awful things people do to photographs while trying to care for them. Given these warnings, *learn what to do before doing anything; learn how photographs are damaged and how they are saved.* Each type of photograph must be identified to determine its conservation needs; be sure the measures you undertake are best for each photograph's particular circumstances. It is so easy to do the wrong thing in photographic conservation and so hard to correct mistakes.

Problems of Preservation

Margery S. Long, Audio-Visual Curator, Archives of Labor History and Urban Affairs, Wayne State University, has provided a concise and useful statement of the problems of preservation, quoting in the first two paragraphs from a call to a photographic preservation conference held in the Smithsonian Institution in Washington, D.C., March 5, 6, 7, 1972. It is a pleasure to reprint it here. We have deleted those sections which deal with motion picture film, microfilm and magnetic tapes in this reprinting.

"Their [photographs] life depends upon storage conditions, the care with which they are handled, and the chemical characteristics and peculiarities each has. They are extremely sensitive to their environment and vary in their resistance to time, temperature, humidity, contamination, atmosphere, illumination, handling and even the presence of humans.

They are made of potentially unstable materials that tarnish, fade, stain, discolor, grow fungus and are attacked by insects and gases. If they are in color, the dyes may fade, change color or bleed, destroying the color balance. The supporting material may become deteriorated and affect the images on them. Even the enclosures intended to protect them may contribute to their undoing.

Though film and photographs are fragile and perishable, if they can be kept in a chemically inert environment with controlled humidity and temperature and were processed properly at the time they were made, they could have a long, useful life.

Chemically inert environment means: They are stored in the dark when not in use. The ultraviolet rays of the sun and fluorescent light fade photographs and hasten deterioration of film. Relative humidity should be maintained at less than 50%. Humidity of 60% or more encourages the growth of mold on emulsions and layers of film adhere to each other. The edges of rolled film swell and flute and ripple, distorting the image. Humidity initiates a chemical reaction of color film that colorchanges the dyes. In black and white photographs the moisture will combine with any excess hypo or sulphur compounds. The print

will fade to a sepia shade, and eventually will fade completely away.

Films should *not* be stored in damp basements nor should they be stored in hot attics. A steadily maintained temperature below 70° is best. Film, negatives and paper prints are composed of a layer of emulsion supported by a base substance. The layer of emulsion and the layer of base will react differently to rapid changes of temperature, both chemically and physically. The emulsion will dry, crack and flake off. The base will shrink, become brittle and break. Temperatures rise well above 100° in an attic or on a summer day, only to plummet overnight causing condensation of the humidity. The emulsion and base expand and contract to extremes daily and eventually will separate.

If air conditioned storage is not feasible, dehumidifiers and efficient filters should be used in the storage area. Polluted air, with its ever-increasing levels of gases and particle pollutants is a threat to film. Paint fumes, hydrogen sulfide and sulphur dioxide are particularly deadly.''

What Margery Long has said here is true and reflects needs that cannot be ignored. At the same time one must recognize that many real difficulties prevent fully undertaking many of the fundamental steps outlined here. It is not hard to advocate optimum performance at every preservation and restoration instance, but it is most often fruitless.

Preservation of photographs is neither simple nor cheap; and no one knows how to reverse inexorable deterioration of these fragile images. Informed care, technical training, exact chemical formulae and specialized materials and equipment are absolutely necessary for preservation. And mounting expense seems headed for acceleration.

Because many organizations do not have adequate funds to do a really first rate job of preservation, we have devised a system of priorities, general guidelines to help you start immediately to save as much valuable photographic material as possible until you can proceed with the more sophisticated remedial work which you must do eventually.

Eight Steps in Protecting Your Collection

The eight steps for protecting your photograph collection are listed in order of their importance as we understand it. We believe these priorities are valid for most institutions and collections regardless of funds or immediate capabilities for extended preservation procedures. Geographic differences in temperature, humidity and atmospheric pollutants make the choice of an appropriate course of action an individual decision, one that might not necessarily apply to the care and preservation of a collection in another location.

The primary aim is to protect photographic material from external causes of damage without adding new ones and to slow deterioration from internal causes by controlling temperature and humidity. If all eight steps are impossible to accomplish, each one should be undertaken in the numerical order suggested, proceding from one to the other as funds, personnel and equipment allow.

1. Temperature and humidity are most important. Move the photograph collection to an air-conditioned area with controlled humidity. If temperature and relative humidity controls are not possible now, move the collection to a cooler, drier part of the building.
2. Identify nitrate-base film and separate it from the rest of the collection. Store nitrate-base film separately and safely while waiting to make duplicate negatives of originals, then dispose of originals safely or give them safe, separate storage. See pp. 189–193 for details. Nitrate-base film is flammable, capable of spontaneous combustion, a grave fire hazard. The gases that are slowly re-

126 leased as nitrate-base film deteriorates are destructive to *all other photographs.*

3. Negatives should be put into individual envelopes. We favor paper envelopes made to ANSI specifications. See Envelope section for details.

4. Original prints should be given individual protection of transparent plastic sleeves, paper envelopes, folders or boxes. Your choice will depend on filing system, print size and budget. See Print section for details.

5. Within a collection of photographs there may be some items with special problems that require emergency action to prevent further damage. We deal with these in the Case History and Restoration sections.
 a. cracked glass plate negatives
 b. broken glass plate negatives
 c. gelatin dry plates with emulsion fractured and lifting
 d. brittle prints, broken and torn prints
 e. prints or negatives repaired or labeled with Scotch tape
 f. wet collodion plates with aging varnish that is either sticky or fracturing.

6. Storage furniture for prints and negatives should not be made of materials harmful to photographs. In general this means using enameled steel cabinets and drawers instead of wooden ones (painted or not), and using acid-free folders and storage boxes instead of ordinary cardboard or corrugated ones.

7. The storage area should be free of materials that may give off harmful fumes, for example, fresh paints, janitors' cleaning supplies, other chemicals and solvents. See Case Study for details.

8. A photograph collection should be protected from harmful gases and dust in our polluted atmosphere. The incoming air in the storage area should be filtered to remove these materials. See Case Study for details.

Acquiring the interested support of professional photographers and conservator-technicians in the community is a major step. Such assistance guarantees up-to-date advice on changes in archival procedures as well as the skill and experience needed to execute preservation procedures properly. While we can all attempt preservation, the largest part of restoration *must* be left to technicians and conservators, the professionals, who have the necessary skill and equipment.

An important step in protecting a collection of photographs is creating interest in the growth and use of such a body of material among the people of your community. *They* can find funds and people to help solve problems as they can provide professional assistance, advice and encouragement. They can point out sources of new material to your organization and assist donors uncertain about contributing to your collections. They will form an invisible and effective shield that guarantees the concern and necessary means for continual healthy growth.

What a Photograph Is

In order to know how to protect a photograph for long life, be sure you understand what it is, how it is made, and how it deteriorates. A *photograph* may be defined, for our purposes, as a metallic silver image lying on a support base of metal, glass, paper or plastic film; but other materials have been used such as leather, cloth or wood. The silver image can be imbedded in the paper fibers of the support base as in a calotype, plated on to a sheet of copper as in a daguerreotype, or contained in a layer of albumen, collodion as in a wet plate, or gelatin coated on to one of the support bases. There are other types of photographic images besides metallic silver ones, but we will not be concerned with them here. In general, good archival practices applicable to storage of silver image photographs would apply to others.

Between a support base and a gelatin emulsion (silver halides are suspended in the gelatin) there is an adhesive sub-layer to make the gelatin stick to the base glass or film. A photograph can be damaged or ruined by deterioration or destruction of any of its components, the base, the sub-layer, the silver-carrying layer, or the silver itself.

In a discussion about the chemistry of photographs and their deterioration, there is no need to distinguish a positive from a negative, as the chemistry is the same. However it is wise to explain that in a positive image the light and dark areas correspond to those natural to the original subject. A positive image can be transparent, as in a lantern slide, or opaque, as in a paper print. In a negative image—nearly always transparent—the light areas represent the dark areas of the original subject, and the dark areas represent the light portions of the original.

Photographic images are formed through action of light on chemical compounds, light-sensitive silver halides, specifically silver iodide, silver bromide or silver chloride—they can be present in any combination. The action of light on these silver halides creates changes which form one of two types of image, either a latent image or a visible one. Silver iodide and silver bromide are more sensitive to light and will form a latent image that subsequent chemical development can make visible. This developed image is permanently fixed by a hypo solution, usually sodium thiosulphate, which dissolves any unexposed silver halides that would still be light sensitive. The photograph is then washed in water to remove remaining hypo. This type of photograph with a developed latent image is referred to as a *developing-out image*. It is the basis of nearly all direct camera photographs, positive or negative. Paper prints also are made by this process and are called *developing-out prints*. Developing-out prints became the standard of the industry.

The second type of photograph is one in which a visible silver image is formed directly by the action of light on light-sensitive silver halide, silver chloride. After exposure, the visible silver image is usually toned in gold chloride and then fixed in hypo which dissolves the unexposed silver halide, making the photograph insensitive to further exposure by light. A wash in water is required next to remove the processing chemicals. This type of photography, known as the *printing-out process*, was used to make paper prints until faster developing-out papers became popular about 1900.

Why Photographs Do Not Last

It is not possible to predict accurately how long a photograph will last, but most prints or negatives that have survived as much as seventy-five years show some signs of deterioration ranging from slight to serious. Many will have deteriorated so far as to be useless for display or reproduction. A photograph's life is affected by problems from *within* and from *without*, and the effects of deterioration are cumulative and frequently irreversible. The following ten conditions are the principal reasons photographs deteriorate, decay and destruct.

1. High temperature and high humidity
2. Pollutants in the atmosphere
3. Residual processing chemicals
4. Direct physical contact with harmful materials
5. Harmful fumes from nearby materials
6. Exposure to light
7. Fungi and insects
8. Deterioration of base and emulsion from internal or external causes
9. Disasters, fire, flood
10. Physical damage from careless or misguided handling

High Temperature and Humidity. Tempera-

128 tures above 80 °F and relative humidity above 60% sharply accelerate all the various harmful chemical actions that damage photographs. High temperature and high humidity also cause or promote softening of gelatin in emulsions causing it to stick to smooth nearby surfaces.

Pollutants in the Atmosphere. Pollutants come from both natural and man-made sources. Industrial areas produce a wide variety of harmful chemicals both solid particles and gases. Silver is especially sensitive to sulfur compounds, particularly hydrogen sulfide present in gases found in industrial, volcanic and coal-burning areas. Sulfur compounds can react directly with the silver photographic image. Certain other gases, sulfur dioxide and nitrogen dioxide, form acids in the presence of moisture which attack all parts of a photograph. Solid particles carried by the air may be chemicals that are directly harmful to a silver image or they may be abrasive, dirty or catalytic. In some areas salt from the air is deposited ultimately on photographic surfaces. Salt is hygroscopic, attracting moisture which accelerates other chemical action, a problem compounded in high humidity.

Residual Chemicals. The presence of residual chemicals caused by inadequate fixing or washing threatens a photograph's life. Hypo left in the emulsion will eventually cause the silver image to turn yellow-brown and to fade. Fading in prints is most apparent in the highlight areas where silver is less dense. Staining and fading are caused by residual sodium thiosulphate (hypo) which attacks the silver image, changing it to silver sulfide. In extreme cases, silver sulfide, given enough time and exposure to sulphur pollutants, will break down chemically to silver sulphate, making it impossible to restore the image by a chemical process. Silver thiosulphate compounds left in the emulsion from *exhausted* fixer will decompose forming silver sulfide, evident as a yellow-brown stain uniformly distributed over the en-

tire photograph. It will appear to be stronger in the *highlights*, the less dense areas of the print or negative, as the darker areas help mask the stain. In reflected light this stain may appear gray or bright metallic, sometimes with shades of copper. The term *dichroic* describes such stains accurately. Unexposed silver halide left in an emulsion by inadequate fixing will darken and eventually change to silver sulfide, causing a localized yellow stain in the *darker* areas of an image. Finally, silver halide emulsion sometimes has been pulled out of prints by the pressure of contact printing a negative during times of high humidity or as a result of chemical splashes on it in the darkroom. This will cause silver sulfide, a darkish yellowish stain, in areas of the negative affected.

Direct Physical Contact with Harmful Materials. In sorting, handling and display, photographs come in direct contact with or close proximity to many harmful materials. This danger even exists in materials made for photographic use, paper envelopes, mounting boards, cardboard, adhesives, rubber bands, printing inks, raw wood, fingers, newspapers, writing inks, some plastics, photo albums, unprotected steel and rubber cement, to name a few.

Harmful Fumes from Nearby Materials. As photographs are vulnerable to fumes and vapors emitted from many substances including building materials, paints, plywood, adhesives, resinous woods, cardboard, exhaust from motors, janitorial supplies, cleaners, solvents and insecticides, the use or storage of these materials around photographs should be avoided. Painted areas should be cured by aging about two weeks with efficient fresh air ventilation.

Exposure to Light. Exposure to any light has the potential to damage photographs, but two most common sources of light that damage photographs most are *direct sunlight* and *fluorescent light*, the ultra-violet end of the

spectrum being most harmful; damage depends on the intensity and length of exposure. Avoid direct sunlight (most serious) and use ultra-violet filters over fluorescent light where photographs are displayed. Limit the duration of display as prolonged or permanent display will surely result in severely damaged photographs. Ultra-violet light from sun or fluorescent light does not affect the metallic silver of the image, but damages photographs by speeding up the detrimental effects of other chemical action. It also directly deteriorates the paper or film base and the silver-carrying layer of albumen, collodion or gelatin.

Ultra-violet filters offer protection to photographs and should be used, but remember this protection is not complete and the filters lose their effectiveness as they age. It would be safer to use Tungsten-type lights instead of fluorescent. In some situations such as in a display case, Tungsten-type lights can present a new problem of additional heat. Proper choice of bulb wattage and good ventilation are necessary.

Fungi and Insects. Airborne microorganisms are everywhere and thrive on the surfaces of photographs in humid conditions; though they cause little trouble in relative humidity below 60%. Fungus growing on gelatin can distort its surface leaving an etched appearance, this is irreversible damage. Superficial fungus damage can be corrected by wiping with Kodak Film Cleaner on a cotton pad. Water or water solutions should not be used, because fungus can make the gelatin water soluble, making it capable of being wiped off its base in cleaning. Black and white prints can be treated with a 1% aqueous solution of Hyamine 1622, available from Rohm and Haas Company, Independence Mall W., Philadelphia, Penn. 19105. The best and safest method of protecting historical photographs from fungus is to store them in a place in which the relative humidity can be kept below 60%. The

effects of fungicides on the many different types of historical photographs during long term storage is unknown. Insects such as cockroaches and silver fish in search of food find it in the paper base, the emulsion gelatin, fungus, or in other airborne decomposition products deposited on photographs. Carpet beetles will eat the paper base, destroying the images on them. Insect excreta on photographs can both stain and fade the images.

Deterioration of Base and Emulsion from Internal Causes. The permanence of a photographic image is directly dependent on the stability of the emulsion and base which support that image. A gelatin emulsion may fracture and separate from its base as the adhesive substance binding the two together deteriorates. On glass plates this process is accelerated by drastic changes of moisture in the air. The collodion on wet-collodion negatives may decompose and flake off the glass base. The same is true of albumen coatings. As any of these vehicles for retaining silver crumble, the images will disappear as well. It doesn't make too much difference what the nature of the base is; they can all eventually self-destruct, whether they are paper, metal, glass or film. Paper, or mounting board will turn yellow and crumble taking the image with them. Metal will corrode, glass is likely to be broken in handling or in storage, a film base can get brittle or sticky or otherwise lose its integrity. Nitrate film will decompose. Now we know that even early safety film base will also deteriorate and destroy its image almost as effectively as a decomposing nitrate film base destroys its image. Adhesives, mounting board and even the paper base of some prints will slowly release chemicals, acids, sulphur and others that will stain and fade the images of prints. Adhesives may also attract moisture from the air in higher humidities; and moisture will accelerate all of the mentioned internal problems.

Disasters, Fire and Water. No one can pre-

130 dict when unexpected disasters will occur or the extent of their damage; but attention to common sense precautions may someday save your collection. In addition to normal fire safety planning, recognize and deal with the very real danger of fire from nitrate-base film. Even in areas where floods are not a hazard, plan ahead to prevent damage from water. Avoid storing photographs in a basement where water can collect. Store them at least six inches above the floor to protect them against damage from water from broken pipes and sprinklers. Photographs stored in closed metal filing cabinets will suffer less damage from sprinklers than those stored in open fiber containers. If a file of photographs does get wet, do not leave them to dry stuck to their envelopes. As soon as it is possible to reach them, start salvage procedures. With gelatin photographs the two principal problems are (1) they will dry too soon and be stuck inside their envelopes or (2) they will stay wet so long that the emulsion will disintegrate. Immerse the photographs, envelopes and all, in a plastic container of clean cold water, 65°F or below, to which formaldehyde has been added in the proportion of 15 ml per liter. The formaldehyde and cold water will help prevent the gelatin's swelling and softening. As quickly as possible, remove the negatives and prints from their envelopes and wash them in cold 65° F running water for fifteen minutes. Air dry them in a dust-free area hung from wire line with clips (negatives) or on fiberglass screens (prints). Try to save and transfer negative and print numbers and other information. After washing, Ektachrome transparencies should be rinsed one minute in Kodak Stabilizer, process E3 or E4. Two of our recommendations: that most information concerning a photograph other than identifying number, be put on a file card (instead of a storage envelope) in waterproof ink and that copy negatives be stored elsewhere, could be of real value in saving a collection under disaster conditions. If you are confronted with a large quantity of water-soaked photographs, it will be necessary to get a professional lab to do the reprocessing and drying. The photographs can be transported to the lab immersed in cold water with formaldehyde solution in plastic garbage cans (not metal ones) within twenty four hours if possible. Eastman Kodak Co. at Rochester, NY. did the emergency reprocessing for the Corning Museum after its devastating flood in 1972. It is estimated that modern black and white photographs could last up to three days in the cold water and formaldehyde solution before the emulsion separates from the base. Forty-eight hours is the estimated limit for color film. If a water-damaged collection cannot be reprocessed within those time limits, then it should be frozen until special recommendations can be made; however, freezing may damage the emulsion as the ice crystals are formed. There is a need to pool all useful information about conservation methods applicable to disastrously damaged collections. Many institutions such as the Corning Museum of Glass in New York and museums in Florence, Italy have experience dealing with sudden damage to large collections. We urge you to read the Library of Congress booklet, *Procedures for Salvage of Water Damaged Library Materials* by Peter Waters, GP 0885-461.

Physical Damage from Careless or Misguided Handling. Many damages to historical photographs as scratches, abrasions, breakage, mounting with harmful adhesives and spills that stain, are the results of carelessness and neglect; often irreversible harm is done by uninformed people seriously trying to take good care of them. Even with reasonably good care photographs used in the normal manner suffer wear and tear. There will inevitably be some damage to negatives printed over and over again. Filing, sorting, retrieving prints for show or research will take their toll. The aim is to learn to protect photographs and still be able to use them.

Temperature, Relative Humidity and Air Purification

We cannot exactly gauge the degree of danger to photographs from *all* sources (most contaminants being influenced by many factors) but we do know that high humidity (first) and high temperature (second) are two controllable environmental conditions that together accelerate nearly every form of harmful action to which negatives and prints are subject. Dampness and warmth promote the growth of damaging fungus on the surface of photographs; this encourages insects to eat gelatin and fungus, destroying images. Pollutants in the atmosphere are another major cause of photograph deterioriation. A photograph containing chemicals from any source, particularly residual processing chemicals, may last for many years in temperate, dry conditions, but may fade severely in a few days of heat and dampness. Creating a mini-climate in which the air is moderately dry, temperate and clean for storage of historical photographs makes good sense and diminishes the severity of many problems connected with archival care.

Air-conditioning equipped with modern filtering systems that clean the air of harmful dust and gases, maintaining a temperature of about 65° to 75°F (lower temperature is better but less practical) and relative humidity of 40% to 50% is the practical range. Older air-conditioning systems will need additional filters to remove harmful gases from the air. If a modern air-conditioning, air-purifying system is not possible, humidity control—in most areas of the country—is the next most important measure to take. Dehumidifiers are relatively inexpensive. One should be installed with a humidistat that automatically operates the dehumidifier to keep the storage area within a predetermined humidity range of about 40% to 50%. Water removed from the air by this appliance should flow automatically into a drain. Manufacturers of air conditioners also make dehumidifiers and can supply them with capacities to match storage room sizes. Compared to a central air-conditioning sytem, this appliance, a dehumidifier with humidistat, represents a fairly modest investment. An air-filter system for a small storage area can be installed for a moderate sum with a little ingenuity. The goal is to remove both solid particles and harmful gases. Specially designed filters for each specific purpose must be used. To remove solid particles, use any of the suitable filters made of fiberglass, cellulose, etc. Activated charcoal filters are used to remove gases. A regular activated charcoal filter will remove hydrogen sulfide, and a filter of chemically impregnated charcoal will remove sulfur dioxide and nitrogen dioxide. The effectiveness of these filters will have to be monitored and the filters changed as required.

The air-filtering system should be installed with a low-volume fan (squirrel-cage type) to pull incoming air through the dust particle filters first, then through the charcoal ones. This arrangement will create a slightly positive pressure in the storage area, insuring that most of the incoming air will pass through the filters provided doors and windows are kept closed. If none of these atmosphere controls are within your budget, at least avoid storage areas with special humidity and temperature problems such as damp basements and hot attics. Areas adjacent to furnaces, hot water heaters, photographic chemicals, janitors' supplies, paint and other building maintenance supplies all represent real sources of trouble. If control of humidity, temperature and air pollutants is impossible for all areas where photographs are involved, at least try to control them in the storage areas. When temperature and humidity are controlled only in storage areas, there can be some danger of condensation of moisture on photographs' surfaces when the material is removed from the storage area. Should condensation be a prob-

132 lem during hot, humid weather, it can be avoided by first sealing the material to be moved in polyethelene bags and allowing it to adjust to the higher temperature outside the storage area before opening (about 30 minutes or whatever length of time proves to be necessary in your situation). Control of temperature and humidity is one of the pricipal ways of preventing deterioration of photographs. It is also the most practical way to prevent or slow down damage from residual processing chemicals and deterioration of collodion on wet plates and of nitrate-base film. Drastically lower temperature and humidity are more effective; arriving at the exact figures required however, is complicated. Many types of photographs are on a variety of bases, metal, glass, paper or film and on different emulsions, albumen, collodion or gelatin. Some of these diverse bases and emulsions require different humidities. Flexible materials, such as movie film, have special requirements.

If people have to work in areas where photographs are stored, there are practical reasons for keeping temperatures at higher, more comfortable levels; so any recommendation must represent compromises. Where people work full time, temperatures of 70° to 75°F and humidity of 45% to 50% may be used; 65° to 70°F temperatures and 40% to 45% would be better for the photographs and is practical for storage. The most effective conditions for preserving photographs are a low temperature of 0°F and relative humidity of 25 to 35%.

Care of Negatives

Negatives should be cleaned of their dirt and dust and put into individual negative preservers. Cleaning is usually limited to dusting with a camel's hair brush, or blowing with a syringe. With glass plates be certain you know the glass side from the emulsion side. The nonemulsion side of glass plate negatives can be cleaned with lintless cloth. A single-edge razor blade used carefully, will lift off material that is stuck to the glass side. Kodak Film Cleaner can be used on the nonemulsion side of safety-base film. Any additional cleaning of negatives should be carefully considered because of the danger of damage to the emulsion. Gelatin negatives can also be cleaned by an experienced technician. The gelatin swells as it gets wet, allowing dirt to be washed out; then as the negative dries the gelatin shrinks, healing minor scratches and abrasions. There is always possible damage to a gelatin negative when immersed in any aqueous solution. Remember:

1. The wet emulsion becomes soft and is more easily damaged if touched.
2. The emulsion may reticulate—fracture in a network pattern. This is caused by differences in both room and water temperatures.
3. The gelatin emulsion of some historical negatives has deteriorated from some unknown cause; it will become soluble in water, just dissolving away when immersed. Two precautions are recommended: First, make a duplicate negative before any aqueous treatment. Second, harden the emulsion in Eastman Kodak Hardener SH-1 for two minutes before washing.

Our choices for negative preservers are Hollinger Permalife paper and envelopes, polyester or triacetate sleeves, polyethylene envelopes, and probably Tyvek. See the section on Envelopes. For maximum protection, place negative in a sleeve of triacetate or polyester, then in a Permalife envelope. Negatives should be stored loosely on edge in vertical file cabinets or in Hollinger record boxes stored in cupboards. A group of glass plates can be very heavy; take care not to overload Hollinger type boxes. In file drawers, use enough nonpivoting separators to distribute and limit the weight. For example, with 8" x 10" glass plates there should be a rigid separator about every three inches. As an additional protection from

dust, negatives can be positioned with the open end of the negative preserver to the side (right for right handed people). File cabinets, cupboards, shelves and support separators used for storage of negatives should be baked enamel, not wood or cardboard. Negatives should be placed in envelopes with the emulsion side away from the seam to protect the image from direct contact with the seam adhesive.

Negatives should be handled with finger tips by the border and nonemulsion side to keep fingers off the emulsion. Keep the emulsion side of a negative facing you in order to see that nothing damages this delicate surface. Although handling a negative by the edges (as opposed to the borders) gives greater protection to the emulsion, there is more danger of accidentally dropping a negative with this technique. A safer way is to hold the negative by the edge, border and back side. With emulsion facing you, support a negative from the back with three fingers, steadying it with the index finger on the edge and using the thumb on the ¼″ border of the emulsion as a grip. This method works well with one or two hands. Negatives placed in transparent sleeves can be handled without such concern.

Not only should each historical negative be protected by its own individual envelope or folder, we think each should also be separated physically according to type and size for good archival practice. Negatives of the same or similar size should be filed together and *not* mixed with different sizes. Prints and negatives should be filed singly in separate envelopes and stored in separate files. Prints are more likely to contain substances in the paper base, mount adhesive or in the emulsion that would contaminate negatives. Collodion negatives should be filed separately in cabinets that are adequately vented so that deteriorating gases may escape.

Gelatin glass plates should be separated from flexible safety-base film as a precaution

against careless handling. If a section contains only glass plates, a worker is prepared mentally to exercise greater care in handling them. By the same reasoning, photographs that are either especially valuable or fragile should be separated from the more ordinary or sturdy photographs.

An overlooked danger to negatives is improper handling and accidents in darkroom printing. *All darkroom chemicals left in contact with a photograph's emulsion are very harmful.* There is an ever-present possibility of chemicals being accidentally splashed on valuable historical negatives during the printing procedure. The darkroom worker who exposes the prints and also runs them through the processing solutions will inevitably retain some of these contaminants on his hands and pass them on to the originals if they are the next photograph he touches. Meticulous work habits and thorough washing and drying of hands are imperative. An examination of commercial photographer's negatives that have been repeatedly printed by many people over the years will show stains from contaminated fingers all around the edges. Negatives that have been contaminated with photographic processing chemicals, or suspected of it should be reprocessed. This means immersing them for two minutes in Hypo Clearing Agent followed by a 20-minute wash. With gelatin emulsions, to prevent possible edge frilling of the gelatin, the process should be preceded by a three minute bath in Kodak SH-1 Hardener and a three minute water rinse.

The same care and consideration that is used in filing and sorting negatives in storage should be exercised in handling negatives in the darkroom. Do not lay glass plates on uneven surfaces. Do not assume that the darkroom surface is clean, uncontaminated. Glass plates should be carried in a sturdy safe box with two handles. They should be kept in the box while in the darkroom in a vertical position with adequate support.

A transparent negative, the light areas representing the dark areas of the original subject while the dark areas shown correspond to the light areas of the original.

A photographic print, also termed a *positive:* an image in which the light and dark areas correspond exactly to those of the original subject. (Courtesy, Title Insurance and Trust Company of San Diego)

Envelopes

Paper envelopes have been used to protect photographic negatives from abrasion, dirt and grime during storage ever since negatives and positive paper prints became part of the photographic system.

Commercial grade kraft paper envelopes soon became available in all the popular negative sizes and have been used ever since with little change in design, paper or adhesive. These envelopes were made to provide the photographer with a commercial product to meet his more *immediate* storage needs, without consideration for chemical purity and paper durability for long term archival storage.

As collections of photographs found their way into the care and storage of museums and libraries, they have been rejacketed in new envelopes still of the generally accepted, readily available kraft type. Popularly called negative preservers, these envelopes did a good job of protecting negatives from abrasion and grime; as preservers in the archival sense, they are inadequate. Acids and other chemicals left in the paper by the manufacturing process as well as chemicals and moisture from the seam adhesive (seam was in center instead of at the side) contribute to staining and fading of the silver photographic image. They affect the life of the envelope paper as well. *Kraft paper envelopes are not suitable for long term negative storage.*

Glassine. Glassine envelopes have undesirable chemical characteristics similar to those of most kraft paper. In addition they contain plasticizers, to make them more transparent, that will volatilize in time and affect emulsions. They are physically weaker and more easily torn and creased. For these reasons they are unsuitable for archival storage. We believe they should not be used for short-term storage either; as envelopes made from virgin polyethylene (for example, Print File) are similar in cost and are superior in other respects, stronger, inert, more transparent.

There is no perfect negative envelope. There are some objections to any envelopes now available:

Some cannot be written upon easily.

Some build up static electricity that attracts dust.

Some can cause ferrotyping (shiny spots on emulsion.)

Some have seam adhesives that are hygroscopic and can contribute to localized deterioration.

Some tear very easily.

Some have fibers that stick to emulsion.

Some are improperly sized.

Two types of materials currently thought to be safe for negative enclosures are certain kinds of paper and plastic.

Paper. Paper envelopes have a number of advantages. They can be written upon with pencil or India ink. They are porous, so gases and moisture do not get trapped inside. This is an advantage in an area of high relative humidity where emulsions would suffer ferrotyping if enclosed in plastic envelopes. Hollinger Permalife negative envelopes are made of paper without the known harmful materials of ordinary paper. Highly purified chemical wood fibers and special sizing are used, and the paper is buffered with calcium carbonate to a pH 8.5. The side seam is a nonacid. Negatives should be stored with emulsion side away from seam. These envelopes are not preprinted with blanks for date, number, name, etc. Do not add your own blanks with stamp pad ink! In our investigation we have not found a similar paper that is not buffered. ANSI gives recommendations for negative envelope paper quality, alpha cellulose content, sizings, etc.; but we have not been able to find a source for such envelopes. Some conservators question the effects of calcium carbonate buffering with a pH 8.5 (plus or minus

the manufacturers' tolerance) on photographic emulsions. Any investigation also should include the effects on photographic layers of albumen and collodion as well as gelatin. We have not found any serious study of the possible long-term effects of buffered paper on black and white photographic emulsions or any evidence that buffered paper can harm silver image photographic emulsion, but skepticism must be acknowledged. Buffered paper is harmful to modern "stabilized" color film. Buffered Permalife paper does offer considerable long-term protection against the paper's drifting to the acid side. It is our decision to use Permalife paper envelopes in situations where paper seems more suitable than plastic. We are gambling the known dangers from paper envelopes that become acid against the unknown possible effects of buffered paper. We have discussed the matter with Dr. Walter Clark of the Conservation Center, George Eastman House in Rochester, and learned from him that this subject is one of the first ones that will be investigated by his laboratory. We await evaluation of these tests and others.

Plastic Sleeves and Envelopes. Several plastics inert to photographic emulsions are suitable for negative enclosures. Triacetate and polyester are used as film base and represent no more of a threat to a negative's emulsion than does its base. Clear, transparent sleeves have the advantage of permitting a negative to be inspected while enclosed.

Plastic materials act as barriers to prevent transmission of air and moisture. This same quality can be a disadvantage in high humidity conditions, as it can cause ferrotyping on a gelatin emulsion. The shiny surface of plastic sleeves does not accept carbon pencil or India ink, but a small area can be given "tooth" with an engraver's scraper to make identification with pencil or India ink possible. The smooth, hard surface of these plastics, first polyester, second triacetate, can build up static electricity

that attracts dust. Bits of gritty dirt caught between a negative's emulsion surface and the inside of a plastic sleeve can scratch the emulsion. Beware!

Triacetate sleeves. Triacetate sleeves are inert to photographic emulsions and safe to use. Eastman Kodak transparent sleeves are made from cellulose triacetate and are recommended.

Polyester sleeves. Polyester is an inert plastic material. Accelerated age testing indicates it has an extremely long life expectancy. It is physically superior to triacetate and somewhat more expensive. TALAS offers polyester sleeves in standard negative and print sizes which are made slightly larger than actual film sizes. For example, sleeves for 4 x 5s are $4\frac{1}{8}$ x $5\frac{1}{8}$ and those for 8 x 10s are $8\frac{1}{4}$ x $10\frac{1}{4}$. This is an asset because material can be inserted more easily without abrasion. Most companies have their trade names for polyester, for example duPont uses the name Mylar. There are disadvantages to polyester—it can build up static electricity that attracts dust. The duPont Company has announced Mylar-S which has been treated to prevent static charge buildup, though it is not coated.

Polyethylene. Envelopes made of virgin polyethylene are suitable for photographic negative storage. They are made by several suppliers. The Print File Company of New York, maker of one of the most popular polyethylene envelopes, states that results from an independent laboratory indicates that polyethylene used in their envelopes is free from harmful chemicals. Envelope seams are heat sealed. One side of these envelopes is optically transparent enough to allow the making of contact prints for working file purpose, without removing a negative from its envelope. Polyethylene negative envelopes are made in many sizes and styles, are pliable and less likely to contribute to abrasions.

Tyvek. Tyvek envelopes combine some of

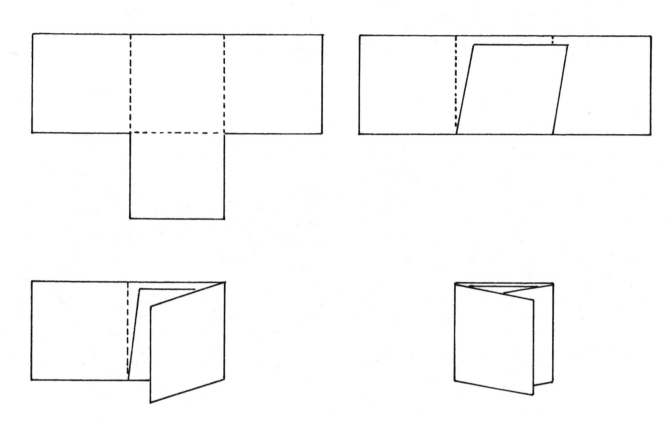

Making a Seamless Envelope

the advantages of paper with some of plastic. This is a duPont olefin made by spinning continuously interconnecting strands of polyethylene, bonding it into sheets with heat and pressure. It looks like opaque white paper, is porous, feels smooth, is very tough, and has a tooth which will accept carbon typewriter ribbon, carbon pencil (a little reluctantly) and India ink (a little untidily). Do not be tempted to use ball point pens; as the effects of their various inks on photographic emulsions are unknown and suspect. Envelopes of this material are available from Heco Envelopes Company, 4500 Cortland Street, Chicago 60639, and from Coast Envelope Company, 2930 South Vail Avenue, P.O. Box 2022, Los Angeles 90054. The seam adhesive is an emulsified polyvinyl acetate. Testing of the material for storing photographs has not been extensive. W. F. van Altena reports test and use of Tyvek envelopes for photographic negatives in the American Astronomical Society Bulletin, vol. 1, 1975. These envelopes seem to solve many problems, especially in areas where relative humidity is high and no control is possible. Tests indicate that ferrotyping of emulsions in high humidity is no problem. Tyvek takes a crease well, so it could be used to make the seamless envelopes for photographs worked out by UCLA. We believe the advantages of Tyvek make it a promising material for archival storage of photographic materials.

Seamless envelopes. The adhesives in envelopes have been of real concern to photography curators. Even in Hollinger Permalife envelopes a benign type of adhesive has been used; but there is the nagging thought that it would be better to have an envelope without an adhesive. The double and triple thickness of paper at the seam joints could cause additional localized pressure under some filing conditions.

An innovative seamless envelope has been developed by Hilda Bohem, Department of Special Collections at UCLA, under a NEA research grant for photographic conservation. This folded envelope, equally useful for negatives and prints, has no adhesive seams to attract moisture and contribute to deterioration. The envelope is made from acid-free paper such as 20-pound Permalife. Cut a piece of paper in such a way that it can be folded around a negative or print, diaper or wrap-around fashion, to give support on three sides and leave one end open. The basic pattern can be altered to fit different sizes of materials; and it is recommended that the piece of paper be measured slightly more than three times the width and twice the length of the photograph to be stored in the envelope. Allow just enough room for a negative or print to fit easily without moving around enough to be abraded. An additional end flap can be added to the pattern to make envelopes with greater dust protection.

The absence of seam adhesive in these envelopes eliminates the worry of being sure negatives are stored emulsion side away from the seam. To avoid the constant danger of fingerprints from careless handling, it is recommended that no cutout thumb hole be made. This requires the person using the envelope to buckle it slightly to see where to grasp a negative safely. Because two of the flaps can be mistaken for the correct cavity, one must be very careful to insert the photograph in the one cavity that has a closed bottom. Some distinctive cut, notch or mark on the two free flaps can help distinguish them from the ones that form the cavity.

If negatives are to be stored with a long side down, envelope opening to one side, adopt as standard procedure the habit of folding the upper flap over the lower one to make filing easier and catch less dust. Snagging the outside flap of this envelope during filing could be a problem. We suggest learning to hold it carefully in place when filing.

These envelopes can be ordered cut and prefolded to specification from acid-free paper

140

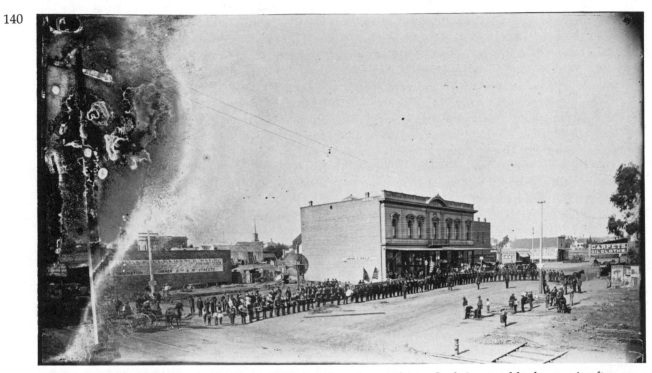

A print from a negative seriously damaged by fungi on the emulsion. Such irreparable damage is often encountered and can only be *prevented* by appropriate preservation procedures. (Courtesy, Title Insurance and Trust Company of San Diego)

supplier such as the Hollinger Paper Company. Or one can simply order the acid-free paper and cut and fold to suit individual needs. If staff and/or volunteers do the cutting and folding, be sure the work is done under clean conditions with clean hands to avoid contamination of the paper.

Air Circulation around Photographs. Occasionally the question arises whether it would be a good idea to store photographic material in an inert atmosphere, argon or nitrogen, instead of oxygen. We know of no research on the subject, but we recognize that use of moisture-proof envelopes and low-temperature storage described in Color Section may make it more feasible. Suitable buffering agents might also be used in this type "mini-climate" packaging to retard deterioration.

Some authorities recommend that all photographic materials be stored with air circulation. Under high humidity conditions, having a free flow of air will help prevent growth of fungus. Cellulose nitrate materials, nitrate films or collodion plates, must be vented to allow deterioration gases to escape.

Our experience with large quantities of different types of photographs stored in diverse ways indicates that restricting exposure of silver images to atmosphere pollutants retards staining and tarnishing.

Examples:

1. A daguerreotype with a cracked cover glass will be tarnished on its surface, reproducing the pattern of the crack.
2. Glass plates that have an overlay paper

mask used as a cropping device show more deterioration on the area unprotected by the mask (except where harmful adhesives have been used to fix the mask in place.)

3. Lantern slides that have been protected by masks and have cracked cover glass will show greater amounts of tarnish of the silver image in the area unprotected by the mask.

4. Negatives that have been stored for a long period of time, grouped together without individual envelopes will be tarnished more around their edges where air has been able to reach the emulsion. Negatives stored in envelopes do not show this same deterioration pattern.

We believe these observations, made from personal experience instead of from controlled testing, have validity even though storage conditions vary greatly. Protecting a photographic emulsion's silver image from the tarnishing effects of atmosphere pollutants in most storage areas is necessary. Negatives and prints should be stored in individual enclosures that provide the best possible barrier. Plastic sleeves of polyester or triacetate are better than porous paper but should not be used in cases in which humidity is high enough to soften emulsions (above 70% R.H.)

The Care of Original Prints

Our term, *original print*, means the one-of-a-kind, irreplaceable photographic print made with materials, chemicals and techniques of the same time as the negative from which it originates. Many collectors consider an original print to be one made by its photographer or under his personal supervision from his original negative. It is not always possible to specify that an original print was made by the same hand that made its negative. Many nineteenth-century photographers left the printing to their assistants or to printing establishments which also sold the prints widely. Frequently the printers were women. The per-

sonal control of a photograph from exposure of the negative to the finished original print, characteristic of many of today's photographers, was less important and less practiced in those earlier times. The meaning and value of original print in the nineteenth century clearly was different from our understanding of these words in relation to the one-of-a-kind product, itself an acceptable form of art today.

An original print should receive special handling and care commensurate with its value today. If its original negative has also survived, both are to be valued and cared for as one-of-a-kind artifacts. Duplicate negatives, copy negatives and prints made from them, or new prints made from the original negatives, serve to perpetuate the image and are useful for reproduction prints for file, study or working prints.

Original photographic prints should be protected during storage and handling with individual acetate or polyester sleeves. Horizontal storage in Hollinger flat boxes offers the most physical protection. Storage furniture for the boxed prints should be baked enamel metal cabinets. Many institutions will not be able to afford the greater space requirement of horizontal storage. In this event, we think the most practical method is vertical storage in baked enamel metal file drawers or Hollinger record storage boxes when the size of prints permits. Vertical storage demands triacetate or polyester sleeves to minimize wear in handling. Thin, unmounted prints may need additional stiffening material of Permatan or polyester sheets slipped inside their sleeves. If budget limitations make it necessary to file mounted prints in this type of storage *without* individual plastic sleeves, at least use triacetate or polyester sheets to separate one print from another to prevent direct contact and contamination.

You can make your own tailored-to-fit polyester folders with flap closures for prints. It is very handy to have a 100 foot roll of 0.005

142 polyester 24 inches wide, or a 100 sheet package of flat sheet stock. Cut enough polyester to fold comfortably over front and back of the photograph to be covered and include an extra ³⁄₈ inch to be bent over and creased as a closure flap. Use a bookbinder's bone creaser to make neat folds.

Fragile prints in particular can be more easily and safely put into these flap closure folders than in commercially-made sleeves. To keep the flap closure folders from flopping open in handling, especially those for large prints, secure flap with double-faced 3M acrylic tape no. 815. This is a variation on polyester encasement; instructions are available from the office of the Assistant Director for Preservation, Library of Congress. We suggest you get this publication to learn about techniques in handling and storing paper documents and fine prints other than photographic prints.

Mounting Photographic Prints

Curators cannot avoid the inevitable question, should original historical photographs be adhered on cardboard mounts or not. Mounting them has a number of obvious advantages, the print stays flat, the mount provides handling protection and it can be of a standard size, 8" x 10", 16" x 20", etc. The mounted print may be easier to display as well. Certain disadvantages to mounting photographs are also evident: the mounting board and the adhesives used may contain chemicals harmful to the print. If the board is broken or deteriorated, the print is likely to be damaged at the same time. Should remedial treatment such as chemical restoration be attempted, the print would first have to be removed from its mount—a process involving some risk of physical damage to the print.

One must deal with the aesthetic question of whether old prints should be mounted. Historical authenticity is important; to mount an old print permanently on a modern mat board is to risk destroying its original historical character. A sad example we have seen involves a large number of fine 1895 original views now mounted on 8½" x 11" fluorescent green cardboard with typed captions, all stuck fast with rubber cement! These uniformly mounted prints were then stored in a convenient cardboard soap box! These photographs were mounted and stored with the sincerest desire to protect them efficiently.

Adhesives

Most adhesives are harmful to the silver image. A good adhesive for photographic prints should have the following characteristics. (1) contain no chemicals harmful to the silver image or the paper base; (2) should not contain or attract moisture; (3) be removable without harming the print or mount; and (4) hold the print securely flat and neat. *Rubber cement should never be used for photographs. It contains sulfur which will inevitably fade or stain a print.* Starch paste comes close to being a good adhesive for this purpose except that starch grains are hygroscopic, attracting and holding moisture that can accelerate chemical deterioration from within a print. It also can attract insects in search of food.

Although dry mounting tissue has been considered safe for permanent mounting of original historical prints, the heat required for fusing it may not be suitable for some historical photographs, albumen ones for example. Dry-mounted prints can be removed with acetone; it is not a simple job, and the solvent may harm some types of old prints—such as collodion or hand-colored prints.

Certain of the synthetic adhesives are considered safe for photographs—for example Jade 403 from TALAS is a polyvinyl acetate adhesive. Another adhesive that can be made up as needed contains gelatin. This adhesive is hygroscopic but less so than starch paste. This gelatin adhesive is safe with photographs.

Prints mounted with it can be removed by soaking in water. For recipe see p. 178.

There is no ideal adhesive for mounting all types of photographic prints safely and easily. So many commercially-made adhesives have eventually been found to be harmful to photographs we have developed healthy suspicions concerning all of them. Because there is no ideal adhesive and the historical authenticity of original prints as artifacts ought to be preserved, we believe umounted original historical prints should not be mounted permanently on new mounting boards. Card-mounted prints should not be permanently adhered to new mounting boards. A safe method for handling and filing prints is to mount them in a nonpermanent way, *not exposing them directly to the possible dangers from adhesives and unknown mounting-board material* yet allowing the print to be removed, when the need arises, without risk of damage. Original historical prints should be put in Kodak sleeves, Mylar sleeves, Hollinger folders or mat boards with overlay covers.

Current contemporary prints can be handled the same way. If they are to be permanently mounted, use Kodak Dry Mounting Tissue Type II (for resin-coated papers) or Seal MT5 Permanent Dry Mounting Tissue (for conventional photographic paper.) Use museum-quality mounting board such as that sold by Hollinger.

When original historical prints are removed from their mounts for reprocessing, the adhesive to use in their remounting should be one that will allow easy removal when necessary, such as gelatin cement or heat-set tissue. These adhesives do require skill in handling to achieve a smooth job and the use of Teflon slip sheets and weights is recommended.

Heat-Set Tissue

An adhesive particularly suitable for mounting all types of original historical prints has been formulated by Peter Waters, Restoration Officer of the Library of Congress. It is a heat-set tissue for mending tears in semi-rare book and manuscript pages. This "make-it-yourself" heat-set tissue is applied with pressure at a fairly low temperature. A special tissue paper is incorporated on one side of this mending material. If this tissue paper is left off, the adhesive becomes a heat-set membrane simliar to a factory-made dry-mounting tissue. This formula is designed not to impregnate the print paper during the dry mounting operation. It can be removed more easily than can commercial dry-mounting tissue with denatured alcohol, toluene or acetone.

Mixture Recipe:
1½ parts Rhoplex C-72
1 part Plextol B-500
1 part distilled water or deinoized water.

It is important that the proportions be measured accurately by *weight*. The emulsion should be filtered or strained before use and a fresh batch made up for each make.

Acrylic emulsions:
Plextol B-500
Rohm & Haas Company GMCH
Darmsladt, West Germany

Rhoplex C-72
Rohm & Haas
Philadelphia, Pa.

This acrylic emulsion is applied to a clean, uncoated sheet of polyester film with a 5-inch Japanese handmade soft bristle brush. Lay down one even coat of acrylic emulsion using parallel strokes in one direction and an immediate second coat overlapping the first at right angles. This emulsion, when dry, is peeled off of the polyester sheet by lifting from one corner. Trim edges back ½ inch to remove uneven, irregular areas. This heat-seal membrane is used like regular commercial dry mounting tissue with a tacking iron and dry mounting press. Mounting time is ten seconds at 150°F.

144 The formula and procedure outlined above for a "do it yourself" heat-set dry-mounting tissue is recommended for mounting or re-mounting historical prints. Like commercial dry-mounting tissue this membrane will hold prints smooth and flat; but it can be removed if necessary. The low mounting temperature should be satisfactory even for albumen prints. This heat-set tissue is not hygroscopic and will act as a barrier to separate a print from its original mount.

A safer method for handling and filing prints is to mount them in a nonpermanent way—not exposing them directly to the possible dangers from adhesives and unknown mounting board material, yet allowing the print to be removed, when the need arises, without risk of damage. This can be done by using Kodak sleeves, mylar sleeves, Hollinger file folders or some version of mat boards with cutout over frames with covers. Two methods are offered here; by using these principles one can devise many other variations.

Example number one: Open a Hollinger file folder or map folder flat, one with dimensions at least 2" larger than the print to be protected. Place the print in the center of the larger (identification tab) section and make pencil dot at each corner of the print. Lay ¾" wide strips of dry-mounting tissue ¼" outside the line between dots at bottom and one side, and ¾" from the line between top dots. Tack the dry-mounting tissue strips in place with a hot tacking iron. Using one half of another print folder, make a frame with a cutout ½" smaller than the print to be protected, place it over the dry-mounting tissue strips and fasten down with hot iron or press. This makes a windowed pocket, open at one side, in which to carefully slide the print.

A sheet of polyester 0.008 thick can be placed over the print to protect its surface as the print is inserted into the pocket—*then the mylar is removed*. Note: the ¾" distance of the top strip of dry-mounting tissue can be positioned farther out in order to make clearance for a thicker print or its mounting board. These instructions are for a folder to be stored flat so that as the top cover is lifted the print is correctly positioned for viewing. For vertical storage with the open edge of the folder in the top position, the print should be mounted so that it is correctly oriented for viewing in that position. This special folder can be used for mounted or unmounted prints; it will protect the print in storage, handling and showing.

Another method suitable for larger mounted or unmounted prints is especially applicable for exhibition purposes: the print is affixed to a Hollinger Permalife musuem mounting board by mounting-corners leaving slightly less top margin than bottom margin. Triangular corners to suit the print size can be cut from 0.10" Permalife stock or 20-pound paper and mounted in place over the corners of the print with dry-mounting tissue and tacking iron. Tack ¼" strips of dry-mounting tissue on the two adjacent sides of each print corner. With the print in place, fit Permalife corners over the print and adhere it to dry-mount strips with a hot tacking iron. A cutout mat frame, with inside edges softened with an emery board, should be made from museum mounting board the same size as the back board, and cut to mask the print slightly, placed over the print and adhered with an inside hinge of mylar laminating film (Seal-Lamin Laminating film) 1½" x 1½". Place the frame board and the back board together, top edge to top edge opened flat. Lay mylar strips across the division between the two boards and affix with hot iron. A stronger hinge can be made by ironing corresponding strips of mylar laminating strips on the outside of the two boards.

Pressure Sensitive Tape

Anyone who has tried to remove old, yellowed, hardened transparent tape or masking

tape from photographic prints or negatives would hesitate to use any pressure sensitive tape on photographs. Occasionally, however, it will seem almost unavoidable. Here is an example: working prints sent out for publication must be accompanied by their captions, fastened on in a way that keeps them from being separated or lost. An easy and practical method is to type the caption on a separate paper and hinge it to the back of the print with Scotch Magic Tape. Do not use regular transparent tape. The caption paper should be folded over to cover the tape hinge to prevent accidental transfer of adhesive from the tape's edges on to other print surfaces. Pressure sensitive tapes can be removed with solvents (with good ventilation) such as benzine, acetone or toluene, depending on how ancient the tapes are.

Curled Black and White Prints

Some black and white prints become curled and difficult to flatten without damage when moisture content varies with the humidity of their environment. When the humidity is lowered both the gelatin and paper base dry out and change dimension differently, resulting in curling, usually concave on the emulsion side of a print. Loose, unmounted prints, not restrained by their envelopes or pressure from other adjacent prints, are the ones most likely to curl as a result of changes in humidity.

Most black and white prints that are curled are of the gelatin emulsion type, those produced after 1890. We have seen a few albumen prints afflicted with this curling malady, partly because most early albumen prints were routinely mounted on cardboard. Those which have been removed from their mountings for archival reprocessing, show almost the same curl tendency as they dry as do gelatin prints.

As photographic prints age, paper fibers lose strength; old photographs are more likely to have a weakened paper base than do more

modern prints. Paper fibers and gelatin become more brittle and more subject to cracking and breaking as the humidity lowers. Below 15% humidity, gelatin is extremely brittle.

Commercial photographers have dealt with the problem of flattening prints for many decades. The old-fashioned letter press has been widely used for flattening prints. The usual way to care for a *mild* curling problem in a fairly recent print is to straighten it, protect it with sheets of acid-free paper or sheets of teflon, and weight it down for two or three days to flatten it. Weights with handles made for this purpose are still available from photographic supply houses. If you should have many prints to flatten, consider these methods; but remember to interleaf the prints with acid-free paper to prevent spread of contamination from print to print.

An old curled print requires more careful treatment, because its emulsion and paper can be so very fragile. In many cases it may be necessary to humidify the print before attempting to straighten it out. If a print is curled so much that it cannot be flattened satisfactorily with weights alone, moisten the back of a print using an absorbent cotton pad slightly moistened with water. Sandwich the print between Kodak Photographic Blotters and flatten under weights or in a press for two or three days. Care must be used not to moisten the emulsion side of gelatin prints, because they can stick to the blotter surface. If more than one print is pressed at a time, each should be the same size and separated from others by blotters. Fresh, chemically pure blotters *must* be used to avoid contaminating a valuable print.

Copy Negatives, Duplicate Negatives and Copy Prints

The only practical way to perpetuate the image in an original historical *negative* is to make another negative, duplicating the origi-

146 nal. Three methods for doing this are (1) copy negatives made from prints from the original negatives; (2) duplicate negatives made from a film interpositive, itself made from the original negatives; (3) duplicate negatives made directly from the original negatives using Kodak Professional Direct Duplicating Film, SO-015.

Copy and Duplicate Negatives

The copy negative method most commonly used does *not* produce the best results. When a glossy print for copying is carefully made from an original negative and then photographed with a precision copy camera, the results can be satisfactory. *The special print made for copying should be somewhat lower in contrast and darker in tone than a print made for viewing.* Larger size copy negatives yield better prints and produce more versatile negatives. Dust and abrasions become overwhelming problems with small negatives that are frequently reprinted. Acceptable copy negative sizes are 8" x 10", 5" x 7", 4" x 5" and anything smaller than 4 by 5 should be limited to use as a *record copy* only. Superior duplicate negatives can be made by methods two and three, the interpositive method or the direct duplicating film method, provided skill and equipment of equal quality are used.

Our second recommendation, the interpositive method, consists of making a positive on film from the original negative either by contact or through an optical system, i.e., camera or enlarger. A duplicate negative is then made from this positive either by contact or again by an optical system. This way of making duplicate negatives offers the greatest contrast and density control in producing final negatives. It also has the advantage of yielding not only a superior duplicate negative, but also a film positive that may be stored elsewhere as a safety factor against loss or damage to the duplicate negative. While this interpositive nega-

tive system, made by contact in a vacuum frame produces the best possible negative without question, it is more expensive and time-consuming to use than either the standard copy negative or direct duplicating negative methods.

Our third recommendation, the Kodak Professional Direct Duplicate Film SO-015 negative system is probably the best compromise between cost and quality. Once this system is established, it will produce much better quality negatives as cheaply as the usual copy negative system. Duplicate negatives may be made directly from the original negative, without an intermediate positive, by using the new direct duplicating film. This negative can be made by contact or with an enlarger or camera—an optical system.

When an optical system is used, many variables control the final image. Not only are there great differences in lenses, but other factors such as focus, vibration, flare, alignment, etc., influence results. Duplicate negatives made by the optical method require good equipment and a high degree of skill if they are to be satisfactory. The great advantage of the optical method is that it allows making all duplicate negatives standard sizes, regardless of the size of the original. An enlarger works very well for making *enlarged* negatives, but the lens should be reversed when making reductions. For same-size negatives a process lens will give best results. Focusing for same size negatives is done by moving the enlarger head instead of the lens, because moving the lens changes the size more than the focus. This is an imprecise operation with most enlargers. Making duplicate negatives by the optical method allow the duplicate to be standardized. All original negatives can be enlarged or reduced to a preselected standard size, 4" x 5",5" x 7" or 8" x 10".

Contact printing systems can also be used in making duplicate negatives by methods two

and three. In contact printing the emulsion of the original negative is pressed tightly against the emulsion of the unexposed film. With usual diffused lighting, the sharpest image is produced by the closest contact between the two emulsions. This close contact can best be achieved by use of a vacuum frame. There is some danger of cracking an original glass plate with the pressure used in contact printing. To lessen the possibility of breakage, reduced vacuum pressure of ten inches of mercury should be used. Test a glass negative for flatness by rocking it gently on a sheet of plate glass. Warped negatives can be printed by the optical method or contact printed by simply laying it on top of the unexposed film, letting its own weight be the only pressure, then exposing with a point source of light.

Unfortunately, with direct duplicating film, the contact method invariably produces a duplicate negative with the image reversed. If it is important to make contact prints from duplicate negatives, this alternative ought not be used; the image would either be reversed if printed emulsion to emulsion, or the print would be unsharp if printed with the duplicate negative reversed.

In printing historical negatives, the light source used will affect the apparent sharpness and contrast of the print. In reproducing negatives through an optical system such as an enlarger the consequences of such differences are most apparent. An enlarger with a diffusion type of light source will produce prints of lower contrast and will subdue dust and scratches on the negative better than will one with a pair of condensers with a photo enlarging bulb. Condensers with a point source of light will produce maximum contrast and maximum edge sharpness. Point source of light will also maximize dust and scratches from the negative. Printing a wide variety of original historical negatives can best be done by using one of these three types of light source in

combination with paper developers of varying contrast characteristics and varying dilution of the developers for each specific situation—matching the negative to its purpose.

Standard Code for Reversed-Image Negatives

Copy negatives and duplicate negatives should receive archival processing. While you would not necessarily be doing the work yourself, you should know enough about the process to be sure it is being done correctly. For negatives this means using two fixing baths, replaced on a specified schedule, a hypo clearing bath and adequate washing. For maximum permanence the negative can be gold toned. These processes are readily available in Kodak booklet J-19 and the East Street Gallery booklet, *Preservation of Contemporary Photographic Materials*.

Processing prints for maximum permanence is more involved. For prints, two fixing baths and a hypo clearing bath are used. In addition, a hypo eliminator HE-1 is used followed by thorough washing. Gold toning or selenium toning is used for additional protection from pollutants in the atmosphere. The processed prints must be air dried to prevent contamination.

Reversed-image negatives are produced when a duplicate negative is made by contact printing on Kodak SO-015 Direct Duplicating Film. *Reversed image* means reversed left to right—that is, a mirror image. A print made from these negatives in the usual way (emulsion to emulsion) also will be reversed. When printing such a negative in an enlarger, turn the negative over (reverse it) to produce a correct reading print.

From discussion with many curators and collectors around the country about negative duplication, it is apparent that reversed-image duplicate negatives are being produced in large numbers and are being "remembered" or

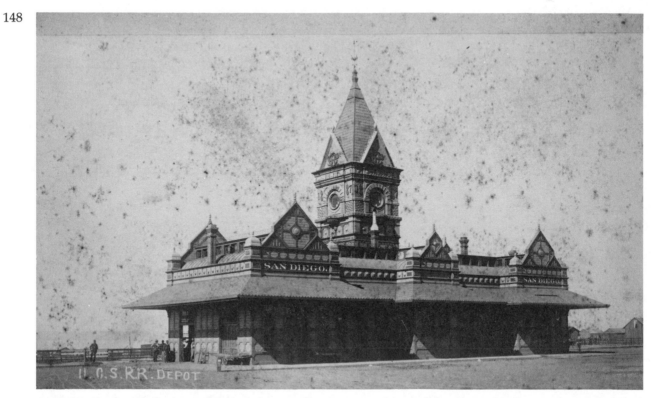

An original, chemically stained print *before* attempts were made to subdue the stains by copying and optical filtering.

labeled or coded by each individual in a different way. These reversed negatives will inevitably end up in the care of people other than those who produced them and probably will be printed reversed. The possibilities for confusion and historical inaccuracies are enormous.

What is needed is a universally accepted standard code for marking reversed-image negatives. We have alerted Eastman Kodak and ANSI to the problem and have asked them for support in establishing a new marking code. We think the code should be as follows: The factory emulsion notch is cut off and a new ¼-inch half-round notch is cut into the film on the adjacent corner (long side). Both cuts would represent the new code standard. Small pieces of film cut down from larger size

sheets can be marked with the same corner cut and half-round notch; although there would be no factory notch on any of the pieces except the one corner peice of film, an inexpensive paper punch that makes a ¼-inch round hole can easily be blocked off to produce a half-round hole.

Philosophy and Principles of Copying Photographs

Considering the many ways in which photographs deteriorate, it is apparent that both prints and negatives must eventually be duplicated if the images are to be saved. In archival reprocessing and chemical restoration, it is necessary to make copy negatives from original prints, and duplicate negatives from origi-

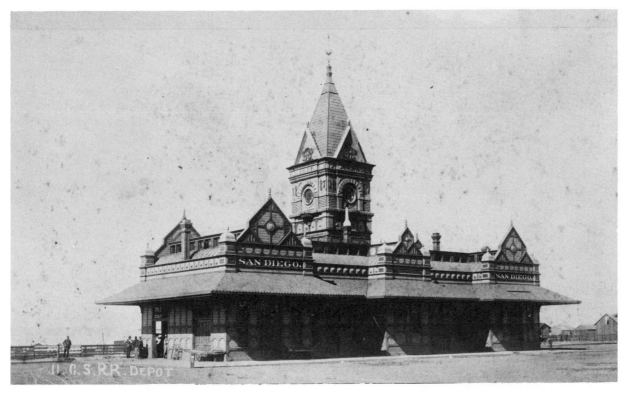

The *same print* after the stains have been subdued by copying it on panchromatic film, using an appropriate colored filter matching the color of the stain. (Courtesy, Title Insurance and Trust Company of San Diego)

nal negatives to guard against possible immediate loss of the original through damage.

In dealing with negatives, it is too frequently considered of small importance whether it is an original negative or a copy. Many museums mistakenly value an original print more than an original negative for the public sees only the print, not the negative.

In many cases, original glass plate negatives have been destroyed after copy negatives were made. We believe this is a serious mistake. With the exception of nitrate-base film, original negatives should be preserved for future use. Saving them is good insurance if something happens to the copy negatives. Perhaps some time in the future, better techniques will be found to reproduce original old negatives. In one unfortunate case, the film processing of

the copy negatives was so poor that the copies became stained and faded before the originals did. In another case an entire collection was copied on early safety-base film that had deteriorated beyond use within twenty years.

Original prints present other problems. It is obviously necessary to have high quality copy negatives and copy prints for the legitimate purposes of illustration, publication in books, magazines, etc., for which purposes it is neither practical nor safe to use the original prints. Before originals undergo archival reprocessing or chemical restoration, it is necessary to have high quality copy negatives in the event the original is lost in an attempted restoration. Copy prints are commonly used for retrieval filing systems, as study prints or as work prints. They may be compared to a

150 "stand in" in the movie business, in that they are used to save wear and tear on the star. In the case of photographs, the original print is our star—to be saved for important and necessary appearances only.

Many original prints are so valuable as historical documents that the need for copy negatives from them should be beyond dispute. Other photographs are very important because of the significance of their subject matter, but are especially valuable as unique originals. The daguerreotype portrait of Frederick Douglass on page 12 is such a photograph. Certain such daguerreotypes might be valuable enough to warrant limiting their display to selected occasions. Perhaps this situation would justify an exact daguerreotype facsimile made by the daguerreotype process. Rather than perpetuating the image through ordinary copying, why not reproduce a daguerreotype as accurately as possible—as a daguerreotype? It should not be a deception, of course, but simply a technical exercise to show more exactly what the orignal is or was like. A similar principle is used in displaying facsimile copies of the nation's most valuable documents and artifacts. Finally, there are prints prized so highly as artistic examples—a print made by Edward Weston personally, for example—that a copy negative of these for serious scholarly use might be ludicrous to some authorities.

Original historical prints, even with good proper care and storage, will eventually fade and deteriorate. To perpetuate such images, high quality copy negatives should be made, hopefully *before* serious deterioration takes place. Acceptable copy negatives for making prints for reproduction or replacement of the original print require larger size sheet film, at least 4" x 5", which allow a wide choice of film type and film developing. With equal quality equipment, the larger negative sizes will produce better quality prints, and the inevitable dust and abrasion problems will be less severe. We think 8" x 10" copy negatives, made with a precision professional copy camera with a process lens, will yield the best copy negatives. This is especially true with larger size original prints that are to be reprinted the same size or larger. Copy negative of 4" x 5" is the smallest size that should be used and is probably the best compromise for most institutions, although 5" x 7" and 8" x 10" copy negatives would allow less expensive contact prints to be made for most purposes. The greater initial cost of equipment and materials for 5" x 7" or 8" x 10" may not be justified, however, except in special situations.

A suitable photo copy system must include a precisely aligned copy camera and stand with polarizing filters over the lights and lens to eliminate reflections from the surface of the print. Best lights are strobe lights. They create no heat and because of the very short exposure time, eliminate vibrations. Reflection elimination is most important in copying historical prints with a matt finish surface. The lens should be a modern high quality lens designed to operate at copy distances. Colored gelatin filters can be used to eliminate or subdue stains on original prints. It would be helpful to include a gray scale and a ruler along side the original print to aid in printing and to establish the original print size automatically. Original prints should be enlarged or reduced to produce a uniform size on the copy negative in order to standardize subsequent printing.

A skillful worker can make very good copy negatives; the resultant print may compare very favorably with the original. Many defects in the original print can be at least partially corrected. Contrast *can* be increased when copying flat prints, stains may be erased optically by using colored filters to lighten or darken stains in the copy. Darkroom printing controls of burning and dodging can make further improvements. The aim of these improvements is to make a copy print matching the original as it was when first made. One thing copying *cannot do*, however, is to restore detail

in the faded highlights of an original print. A good copy print should have normal contrast, a good range of tones, with detail in the shadow areas and *without* muddy highlights.

Copies of historical photographs for record use only are usually made with 35-mm or microfilm copy camera equipment. A record print is used as *visual evidence only* of what the original print is like for retrieval or identification purposes; and for these purposes the print does not have to be a fine copy as for publication or display. Microfilm or 35-mm copy cameras can produce record copies in volume the fastest and most economical way. Using one hundred-foot reels of microfilm in a microfilm reader is a fast way to scan hundreds and hundreds of images. Multiple microfilm readers, located in different areas, can provide quick identification to a master file.

6

Restoration of Photographic Materials

Chemical Restoration

Chemical restoration of deteriorated photographs is a job for a trained conservator. Even in the hands of an experienced technician, a photograph can be destroyed during the complex restoration process, as uneven results and high mortality factor are real possibilities. Even when successful, chemical restoration may change the tone of a photograph—altering its historical authenticity. Stains must be identified accurately, the type of photograph determined, and toning process ascertained (if there is toning). Procedures that work on one type of photograph may ruin another. Gelatin emulsions are especially susceptible to damage in any wet treatment and more so in restoration. There is very little published on the subject. If you are interested in reading more, find a copy of Eastman Kodak booklet J-18, *Stains on Negatives and Prints*, published 1950 and 1952.

Staining and fading of photographs usually results from some of the silver in the image being changed to silver sulfide by external or internal chemical action, or from silver sulfide being formed apart from the silver image, in the emulsion. Removing these stains involves one or more of five procedures.

1. Remove stain with a silver sulfide solvent like thiourea and others.

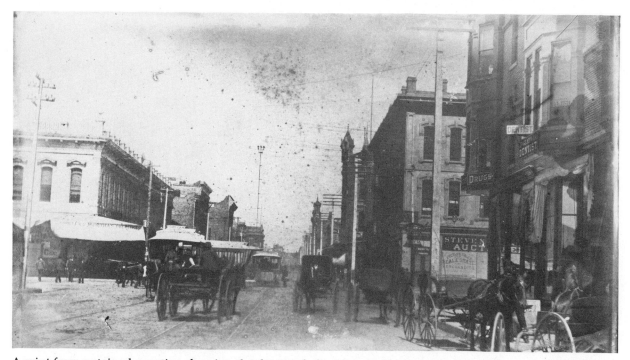

A print from a stained negative showing the damage *before* chemical restoration was attempted. The stains to be removed chemically can be seen most easily in the mottled sky.

2. Change silver sulfide stain to silver chloride, then change silver chloride to metallic silver by the bleach and redevelopment process.

3. Strengthen faded images by an intensification bath.

In Ralph Sargent's *Preserving The Moving Image*, two other restoration processes are mentioned.

4. An important improvement in the Bleach and Redevelopment method by Dr. Johann A. Keiler's "Process for the Restoration of the Silver Image of Black-and-White Films". German Democratic Republic patent 36078.

5. A method of restoring discolored negatives by a solution of iodine in alcohol. Dr. Edith Weyde, "A Simple Test to Identify Gases Which Destroy Silver Images", *Photographic Science and Engineering*, vol. 16, no. 4, 1972.

A paradox exists in deciding whether to restore photographs chemically. On the one hand, since chemical restoration is costly, only the best and most important photographs are considered for it. If on the other hand damage results because of this chemical restoration, it is the best photographs that are damaged. After chemical restoration, all photographs should be placed in clean new envelopes or folders and the old envelopes thrown away. A record of the treatment of individual photographs should be added to the card catalog.

Restoring Early Photographic Materials

Daguerreotypes

In the chronology of photographic processes, three of the earlier kinds of pictures were daguerreotypes, ambrotypes and tintypes. A

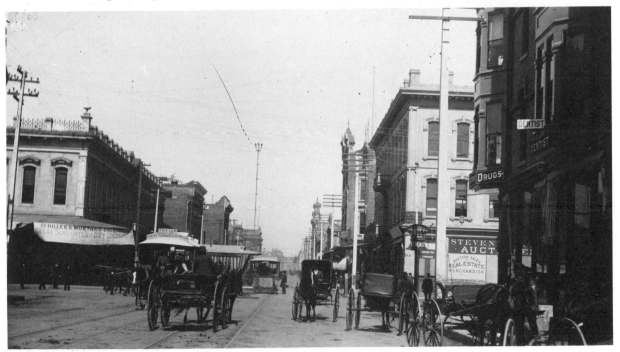

A print from the same negative *after* the stains have been removed chemically. The clear sky in this print proves the success of chemical stain removal in many cases. (Courtesy, Title Insurance and Trust Company of San Diego)

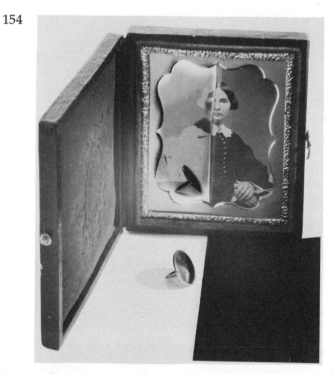

A daguerreotype in its hinged case, showing clearly both its negative and positive characteristics as well as its mirror quality. The angle at which the light strikes the highly polished plate determines whether one can see a negative or a positive image. (Photograph by Larry Booth)

significant common characteristic of each of these processes is that the light-sensitive material, exposed in the camera then developed and fixed, was the end product; each one was a unique image coming *directly from the camera* without having to be printed from an intermediate negative.

Daguerreotypes were the dominant photographic process used in America from 1840 to about 1860. Announced in France in 1839 by L. J. M. Daguerre, this became the most extensively used of all the early photographic methods. A *daguerreotype* is a silver-mercury image on a thin sheet of silver-plated copper. It was made by plating or brazing silver to a

sheet of copper, with the resulting surface buffed to a high polish. It was then placed in a fuming chamber and sensitized by the fumes of heated iodine and/or bromine or chlorine combining with the silver. The light-sensitive plate, exposed in a camera to natural light, formed a latent image which was made visible by development in mercury vapor (the plate was suspended over a pot of heated mercury.) The mercury vapor made a silver-mercury amalgam with the silver formed by exposure of the silver iodide-bromide, giving a higher density to the areas of higher exposure (highlights).

The visible image was then fixed in sodium thiosulphate, a hypo solution, converting the unexposed light-sensitive silver halides to a *soluble* silver thiosulphate. The plate was then washed and dried. The delicate image of the daguerreotype was protected by an ornamental brass mat and covered with a sheet of clear glass. This sandwich was sealed with paper tape, and decorative brass edging, called a preserver frame, was added. The assemblage placed in a hinged decorated case secured by a brass clasp for the smaller cases, and two clasps for the larger ones.

The original official daguerreotype camera produced a photograph 6½″ by 8½″ in size, called a full plate. Relatively rare exterior views were frequently this size, but portraits were nearly always smaller, a fraction of the full standard plate.

Full plate	6½ x 8½
1/2 plate	4¼ x 5½
1/4 plate	3¼ x 4¼
1/6 plate	2¾ x 3¼
1/9 plate	2 x 2½
1/16 plate	1⅜ x 1⅝

These sizes were not necessarily true fractions of the full plate, but were trimmed to maintain similar proportions to fit the cases. Except for the very earliest examples, daguerreotypes were toned in a bath of gold chloride. The gilding of the silver image with

gold increased the contrast of the daguerreotype, giving the image a rich, dark warm tone with shades of brown, purple and black. The gilding also helped to protect the daguerreotype from tarnish, giving it greater permanence. Gold toning of the daguerreotype, originating in 1840 in France, was soon adopted universally by most daguerreotypists.

Color was sometimes added to daguerreotypes by many complex methods. Shades of color were added to the delicate surface by galvanic plating with various metals. Cutout stencils were used to selectively position the colors. Both wet and dry pigments of various types were tried. Many galleries had their own "secret" formulae. However, the method used by most galleries was as follows. The image was coated with a solution of gum leaving a tacky, sticky surface, and then with a brush, dry pigment was applied by hand. When done skillfully, the subtle colors were very appealing.

As the daguerreotype is one of the more permanent forms of photography, some of the usual problems of deterioration common to other photographic processes are less severe or nonexistent. For example, unlike the paper and film base of other photographic processes, the sheet of copper with its bond of silver is quite permanent. The metal surface of the daguerreotype allows the hypo to wash off so completely, that residual chemicals are seldom left to cause deterioration. Its number one problem, however, is tarnishing of the silver—due mostly to sulphur pollutants in the atmosphere. The delicate silver image is very easily damaged when its surface is touched. Some of the mercury which is amalgamated with the silver can very slowly evaporate; as this evaporation is accelerated by heat, daguerreotypes should be protected from heat, kept away from radiators, hot water pipes and so forth, during storage.

Cleaning. There are two techniques in caring for daguerreotypes. One is remedial clean-

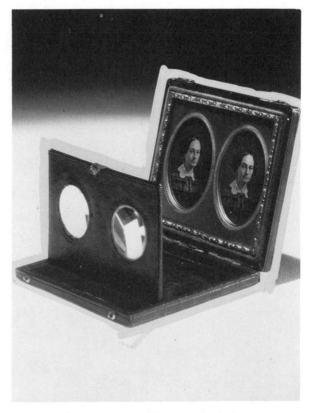

A stereo-daguerreotype. The case includes a stereo viewer so the two daguerreotype images might be viewed with the illusion of depth provided by the device. (Courtesy, Natural History Museum of Los Angeles County)

ing, the other is chemical restoration—removal of tarnish from the image. Remedial cleaning involves taking the daguerreotype apart, cleaning the several components and then reassembling it. To take a daguerreotype apart, gently pry the assemblage (cover glass, mat, daguerreotype plate and preserver frame) from its case by gently inserting a thin blade between the metal frame and the leather or cloth trim inside the case. Hold the daguerreotype assembly firmly together to avoid sliding the mat across the surface of the image, if the

An early daguerreotype view of Providence, Rhode Island. The valuable image apparently lost forever, it was practically worthless before the effort was made to remove the tarnish.

binding tape has ceased to hold them together. Movement of the mat can scratch the silver. Place the assemblage face down and pry open the back flaps of the soft metal preserver frame enough to remove it. Cut through the old paper tape that binds the assemblage and lift off the cover glass and mat from the daguerreotype. Carefully remove any old tape from its edges with a sharp blade. Cover glass can be cleaned with mild, soapy water, rinsed well and dried with a clean cloth. The results of this glass cleaning have to be seen to be believed.

Simply cleaning *both* sides of this protective cover glass can be transforming, near-miraculous. The accumulation on the under surface of this glass is often so great as to seriously obscure the image on the plate. To brighten the mat, wipe it with a clean cloth and brush it carefully with a jeweler's soft brass bristle (fine) brush. Do this work well away from the dissassembly area to avoid contaminating the daguerreotype. Photograph the daguerreotype with and without its mat, using a black cardboard shield with a hole in it fit-

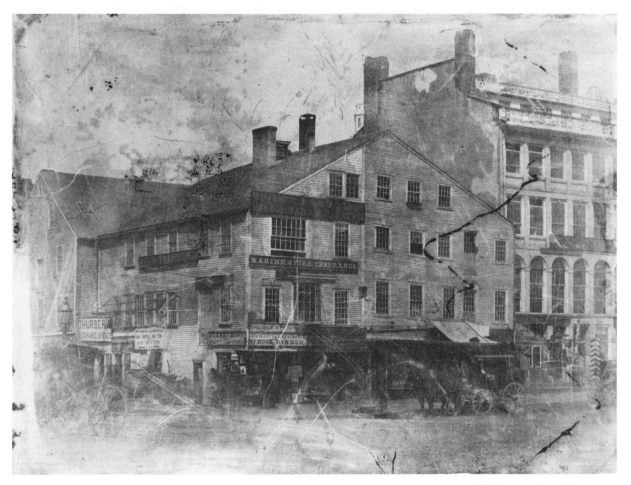

The tarnish removed, the rare image is successfully restored. The plate now reveals in its many surface scratches, evidence of years of neglect. Such scratches will not respond to any restorative technique presently in use or known. They are not affected by the tarnish removal procedure described here. (Courtesy, Rhode Island Historical Society)

ting over the camera lens to avoid mirror reflections in the copy negative.

Make a written description of each of the daguerreotype parts that will not be seen when reassembled. There could be some information, identification or dates or hallmarks on the back of the plate or written on a slip of paper. If there is no identification to be found, record this fact in your files to prevent unnecessary opening of the daguerreotype in future search for identification. Taking it apart

unnecessarily adds greater risk of accidental damage to the image, and the soft metal frame will eventually crack if flexed too many times. You are now ready to reassemble the daguerreotype sandwich.

As a daguerreotype's tarnish comes primarily from airborne contaminants and gases, edges of the assembled sandwich should be sealed with tape to slow the darkening. Components should be carefully reassembled and held together with two plastic clothes pins or

158

An example of the effectiveness of the tarnish-removal process. The upper left half of this daguerreotype has had its tarnish removed successfully, while the untreated lower half remains tarnished. (Charles Sachs Collection)

bulldog clamps. Place clamps opposite each other about midway but slightly closer to one end than the other. Have ready previously cut 20-pound Permalife paper strips ⅝ inch wide and ½ inch longer than half the perimeter of daguerreotype sandwich. Coat one side of one strip smoothly with Jade 403 adhesive and carefully stand sandwich on it firmly at center (between ends and between sides of tape). Lift up ends of tape and press straight up the sides of sandwich. Snip corners and press down edges of tape carefully, forming lap joints at two corners. Place untaped end of sandwich on second prepared tape and proceed to seal this remaining half, removing clamps, snipping corners and pressing down all edges and lapping ends of second tape over those of the first to seal.

A daguerreotype in a case fitted out with a low-power magnifying glass. The enlarged image thus available proved a popular feature for a brief period. (Courtesy, Natural History Museum of Los Angeles County)

After sealing the daguerreotype sandwich with paper tape, put it back into its preserver frame. For replacement of cover glass (broken or sick) use water white clear glass of similar thickness instead of ordinary greenish window glass. If the assembled sandwich and preserver frame seem too large for the case, do not force it in. Reform the preserver frame more snugly around the daguerreotype sanwich so it will fit more easily into the case.

Chemical restoration. This second technique can remove the tarnish from daguerreotypes. While daguerreotypes can be chemically restored more easily than other old photographs,

restoration should be put off until the image's tarnish is beyond acceptance. Some signs of aging are acceptable and expected on a hundred and twenty-five-year-old photograph. The restoration aim should be to bring the image back somewhat short of "like new condition". Although it is usually one of the less complicated and easier restoration processes, it is still a job for an experienced worker. The old system of using potassium cyanide has been replaced with a thiourea formula, one which is far safer to use for both the daguerreotype and the technician.

This restoration procedure is credited to Mrs. Ruth Field of the Missouri Historical Society and has been widely published and used. With some modifications it follows.

1. Wash daguerreotype plate in mild detergent solution (5 ml Ivory detergent in 500 ml distilled water) about 30 seconds.
2. Rinse in running water.
3. Immerse in following solution until tarnish is just removed—
 distilled water 500 ml
 thiourea 70 g
 phosphoric acid (85%) 80 ml
 nonionic wetting agent (Photo-Flo) 2 ml
 distilled water to make 1 liter
4. Wash immediately in running water about 1 minute.
5. Wash in Ivory detergent solution about 30 seconds.
6. Wash in running water about 1 minute.
7. Immerse in distilled water.
8. Immerse in 95% ethyl alcohol. (Use fresh solution each time).
9. Remove and dry in warm air (hair dryer).

After daguerreotypes have been cleaned, the same chemicals can be used to clean and brighten the brass cutout masks and preserver frames.

Reassemble daguerreotype sandwich as previously described.

Cautions.

1. A daguerreotype image is very delicate; the surface should not be touched during this procedure.
2. If a daguerreotype has been colored, the restoration process can remove the color. Consult an experienced conservator for help. Should you attempt restoration anyway, alter the tarnish-removing formula by reducing phosphoric acid amount to one half (40 ml.) Reduce time in this solution, and substitute a rinse in distilled water with Photo-Flo for the final ethyl alcohol rinse.
3. Thiourea has a powerful effect on photographic surfaces. It will fog unexposed film and react with silver images. It is very difficult to remove completely from hands by washing. We recommend using lab gloves during the restoration process.
4. The daguerreotype surface is extremely sensitive to residual spotting in the drying process. Use fresh, uncontaminated 95% ethyl alcohol which has been denatured with a solvent that will not add to the spotting problem—such as reagent grade Mallinckrodt. Avoid contamination of the alcohol by pouring it directly from the bottle on to daguerreotype surface. Ethyl alcohol absorbs moisture directly from the air which will be deposited on the daguerreotype surface. This problem can be minimized by initially rebottling ethyl alcohol in 1 ounce bottles for one-time use only. Use clean bottle caps with unwaxed liners. If spotting does occur, assume the alcohol has been contaminated, rinse daguerreotype again in new, just opened alcohol.

Ambrotypes

Ambrotypes were made in the United States from 1854 until about 1881, and were at the height of their popularity in 1856 and 1857. Relatively few of them are exterior views—almost

Here are the components of a daguerreotype or ambrotype from left to right in order: the hinged case, the soft brass binder, the image-bearing plate, the stiff brass cut-out mat and a clear glass cover. It may be disassembled as shown and reassembled with care. (Photograph by Larry Booth)

all the examples we have today are portraits. An *ambrotype* is a wet collodion negative on glass with a black paper, cloth or black paint background. The backing makes the negative image appear positive when viewed with reflected light. The change of the image from negative to positive is an illusion. As lighter areas of an original subject result in *more* densely deposited areas of silver on the negative, they appear *light* when viewed by reflected light. Darker areas of an original subject, represented by clear, *less* dense deposits

of silver on the negative, will allow the ambrotype's black backing to show through the near-transparent glass as dark areas.

An ambrotype was made by exposing a wet collodion plate in a camera—and producing a rather thin negative. After developing, fixing and drying, the glass negative with its black backing was then fronted with a thin metal cutout mat and a protective cover glass. Many different materials were used as backing. The most common were paint on the back of the glass plate, or a piece of dull black paper, cloth

or metal surface in the case to lie against the nonimage side. The back of the glass is sometimes tinted a strong red; this tinted plate is called coral glass. Tinting acts as an adequate light deterrent by prohibiting the passage of light through the negative. This multi-layer sandwich was sealed around the edges with paper tape and bound with a decorative soft metal frame. The complete assemblage was put into a case similar to those used for daguerreotypes. Ambrotypes were made in the same sizes as daguerreotypes and the protective materials and cases could be used interchangeably. The cover glass of some ambrotypes were cemented to the negative with balsam. If you encounter such an ambrotype in your collection, do not attempt to take it apart. If refurbishing of this ambrotype is necessary, it is a task for a technician.

An ambrotype can be assembled so that the image is viewed through its glass base (collodion side away from the viewer), showing it as right-reading, not reversed left to right. However, most of them are mounted with the collodion surface of the negative facing the viewer, (image reversed left to right) as the image then appears brighter and more detailed. Many ambrotypes were tinted delicately by hand, the color being applied to the collodion side of the negative, thus making viewing from the collodion side necessary.

Since an ambrotype is a wet collodion negative, chemical restoration of a stained or deteriorating image should be left to a qualified technician. However, what looks like a deteriorating image may only be damaged black backing or dirt and grime on the cover glass. With care and patience, an ambrotype can be disassembled, the cover glass cleaned, new black backing substituted for the old one, and all parts assembled. Gently pry the frame-bound sandwich out of its case as in disassembling a daguerreotype. Bend the binding frame away from the back at one end enough to permit removal of all the layers held to-

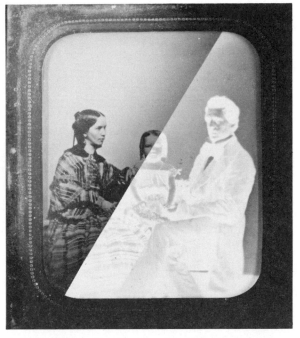

An ambrotype showing its simultaneous negative and positive characteristics. Half the normal black paper backing has been removed for this photograph to reveal the negative portion of the ambrotype. (Photograph by Larry Booth)

gether. Slit the paper tape with a blade and separate the layers by lifting off first the cover glass, then the mat, and then remove the backing. Do not allow the mat to slide around on the collodion's surface. Before attempting to clean the back side of the image plate, determine which is the collodion surface, since you want to avoid cleaning the image by mistake.

Clean only the glass side of the image with a clean dry cloth; the cover glass can be cleaned with mild, soapy water, rinsed *very* well and dried with clean cloth. The metal mat may be brightened with gentle brushing with a jeweler's soft brass bristle brush. This brushing should be done some distance away from the ambrotype refurbishing area to avoid con-

162 tamination of the plates. Wipe the mat thoroughly with a clean cloth before replacing it on the ambrotype. Do not use chemical cleaners or cleansers, as it is imperative that the entire ambrotype multi-layer sandwich be reassembled without harmful residues or fumes that could cause further deterioration.

Before reassembling the parts, examine each of them for any identifying marks. Photographers sometimes wrote names of the sitters and dates on the borders of the collodion side of the plates. If no notations are found, that fact should be stated in your files to prevent further disassembly by someone searching for identifying marks on the ambrotype.

If the ambrotype was formerly assembled with emulsion side away from the viewer, check for evidence that might indicate it was done incorrectly. The only reason for putting the sandwich together with the emulsion facing the black backing is to retain its original authenticity. If the ambrotype is reassembled in this way, use a new mat between the collodion and the backing to prevent direct contact. If there is no such definite reason, reassemble an ambrotype with its collodion side facing the viewer. A new black backing can be cut to size of the cover glass. The replacement backing should not introduce a new source of chemical contamination. New backing materials such as black paper, cardboard or paint might be handy, but are unknown quantities as far as introducing harmful chemicals is concerned. A safe backing material could be a sheet of high contrast polyester-base film which has been exposed to light, developed, fixed, treated in a hypo clearing agent and washed enough to remove all residual chemicals to meet archival standards. Polyethylene is inert, without harmful chemicals according to lab reports we have seen, and should be satisfactory backing material. One source of black polyethylene is the light-seal wrapping used for photographic paper currently made by duPont. Note that the blackest black backing will make the image appear brightest. If you find the backing too limp when reassembling the ambrotype sandwich, the black polyethylene could be reinforced with a sheet of 0.005 polyester film so that it will slide into the preserver frame easily. However, a more authentic black backing for ambrotypes can be made of acrylic resin B-72 (Rohm and Haas) mixed with lampblack. Apply this mixture to the glass back with a brush and allow to dry thoroughly before remounting. Reassemble ambrotype sandwich and seal with Permalife paper strips and Jade 403 adhesive using techniques described in preceding section on daguerreotypes.

Tintypes

Tintypes, which became popular about 1856, were made of black japanned sheet-iron coated with collodion, sensitized, and then exposed in the camera. Photographers called them *ferrotypes (ferro* is Latin for iron) or *melainotypes (melaino* is Greek for black or dark-colored); but tintype, its popular name, has persisted. Technically a tintype is a modification of an ambrotype using the chemistry and process of a wet collodion negative, the difference being that an ambrotype is on a glass base backed with black material while a tintype incorporates its own black backing on a thin sheet of iron painted black. Identical to the black backing of an ambrotype, the black enamel of a tintype makes the image appear positive. After exposure, the tintype was developed, fixed and washed—a developing-out process. To protect the image on its surface, a coating of varnish was usually applied over the whole surface. In some cases the varnish has deteriorated; if it could be removed without damaging the emulsion, the appearance of the photograph would be improved. So far as we know, a suitable remover that does not also remove parts of the image as well has not yet been found. In removing old varnish from a

Many tintypes found without frame or enclosure as shown in the typical portrait on the left. The clipped corners of the plate are common on tintypes intended for insertion into a cheap paper receptacle. The paper design on the right, featuring an oval opening and embossed patriotic motif, was one of many styles and sizes.

painting, a restorer may try as many as ten different solvents in varying strengths before determining which works best for a particular job. The innovative photo restorer may yet find a group of solvents that will work on tintypes.

Unlike an ambrotype, which can fairly easily be turned to an angle at which its negative image is visible, the tintype is difficult to see as a negative image, and then only if the luster of the protective varnish is not too shiny. If a tintype is mounted under glass, it can be confused with an ambrotype, because the grayish tones and muddy whites that can be seen are characteristic of both kinds of photographs.

We have seen only few tintypes of exterior views as the process was used almost exclusively for portraits. About 1870 the tintype was also made on brown japanned metal which photographers called "chocolate tinting"—this warm colored background was more pleasing for portraits. All tintypes, however, suffer from a lack of contrast, the whites never being a sparkling white, but rather a dull gray. "Tintypes" have been made on several other materials such as black cloth, patent leather, black cardboard and enameled paper. Like ambrotypes, many tintypes are also colored with

An effective, on-the-spot test to determine whether an image that may not be removed from its case is an ambrotype or a daguerreotype. Stand it upon a sheet of light paper as shown here. If the image is positive, as shown on the right, it is an ambrotype; if it looks like a negative as shown on the left, it is a daguerreotype. (Photograph by Larry Booth)

transparent pigments. They were made in all sizes from full plate, 6½" x 8½", to very small ones ¾" x 1", called tintype "gems." They are often found loose, although in their original state they were slipped into a small paper sleeve with an oval diecut opening in its face for the tintype image. Earlier ones were sometimes mounted in cases like those used for daguerreotypes and ambrotypes . . . do not con-

fuse them. Paper mounts were used later on. Tintypes were sometimes trimmed to special shapes and sizes and mounted in pins and rings.

Tintypes continued popular for many years. When the gelatin emulsion dry plate replaced wet collodion plates, it was also used to make tintypes. Chemical restoration of tintypes is not usually attempted as good copies made by

the proper techniques will perpetuate tintype images. Tintypes can be cleaned by a bath in a mild soap solution (Ivory Flakes) followed by a rinse in distilled water. Dry thoroughly to prevent rust. Bent tintypes can be improved by bonding to a same size sheet of Hollinger Museum Board with Jade 403 adhesive using a press for flatting and even glue adhesion.

How To Identify Daguerreotypes, Ambrotypes, Tintypes

With the knowledge gained from the sections on cleaning and handling of these three kinds of photographs, there should be no difficulty in identifying any of them when they are removed from their cases and accompanying layers. However, it is important to know how to distinguish among the three in their cases especially if the cover glass is dirty—a common situation. Occasions arise when this information is useful, at auctions, in antique shops, wherever and whenever it is not practical to remove the images from their mountings or cases. Frequently one type of photograph has been exchanged for another in a case, so while it is valuable to make a study of cases, it is unwise to assume that all images have remained in their original ones. Perhaps previous owners have changed them, and perhaps dealers have done so to make the pieces more salable.

The daguerreotype image has a shiny, metallic quality and is the only one of these three kinds of photograph that lies on a true mirror surface. The image will be seen as a positive at only a few angles and only when a dark area is reflected in the daguerreotype's surface. It will be seen as a negative image when a light area is reflected on its mirror surface. A good daguerreotype will appear bright and clear with fine detail. No other type of photograph matched these qualities.

An ambrotype never has a great contrast range. Shadows or dark areas are without fine detail, and the highlights never appear clear white. A close examination of the shadow areas will show the presence of a black backing behind the image by a distance equivalent to the thickness of the glass plate (provided that it has been mounted with the collodion surface facing the viewer.)

A tintype image is always seen as a positive image except when viewed at a particular angle with the light reflecting directly from its surface. If a tintype has been coated with a shiny varnish, the negative image will not be seen at all. This type of photograph cannot be produced a second time except by rephotographing it and producing a printable copy negative. Tintypes usually have less contrast than ambrotypes and have less detail in shadow or dark areas. Highlights are dull and other tones are muddy.

Calotypes

Calotypes marked the beginning of the negative-positive system which allowed the making of multiple positive prints from an original negative image. This negative-positive system became the foundation of most photographic processes.

Calotypes, also called *Talbotypes*, after William Henry Fox Talbot who first described them in England in January of 1839, are paper negatives and paper positive prints. A sheet of hand-made writing or drawing paper was dipped into a solution of ordinary salt, sodium chloride, and wiped dry; thus they are sometimes called "salted prints." A solution of silver nitrate was then brushed on one side of the paper, this action converting the sodium chloride to light-sensitive silver chloride. When dry, this sensitized paper was ready for use. Speed of this material was so slow that camera subjects were limited at first to immobile objects. When exposed in a camera, the light-sensitive silver chloride produced an image visible as a negative during exposure.

166 Talbot's first cameras had a peep hole through which the photographer could judge whether this visible negative image was sufficiently exposed.

By 1841, Talbot had made a paper negative material fast enough to be used for portraits by using potassium iodide instead of sodium chloride, and by adding gallic acid to the silver nitrate solution. When this negative paper material was exposed in a camera, a latent negative image was formed which was then developed, fixed, washed and dried—a developing-out process.

By both processes a negative image was produced on paper, which was waxed for greater transparency, then contact-printed on similarly sensitized paper to achieve a positive print in the same size. Fibers in the paper stock of calotype negatives imparted a grainy quality in printing. Since metallic silver is also imbedded in the surface fibers of the print paper, there is further breaking up of the image sharpness—giving calotype prints a characteristically soft quality without the fine resolution or great detail of prints made by other photographic processes. A calotype print has a warm brown color, often with somewhat red or purple tones. The surface of a calotype print, being the surface of the paper itself, is dull. The very thin paper used for a calotype print has a smooth surface, without any coating or sheen. During their brief life the moving eloquence of the calotype prints created great excitement and some critics believe their beauty has never been surpassed.

Widespread use of the calotype was restricted in the United States and England because the process was patented by Talbot in 1841. He sold licenses for the process at rates which most photographers resisted. In America the calotype method did not enjoy extensive use. In 1849 the Langenheim Brothers of Philadelphia purchased American rights to the patent. In spite of their promotional efforts, not a single license was sold; only a few photographers ever tried the process. Even though professional photographers preferred the daguerreotype process, some amateurs were enthusiastic about exploring the use of calotypes. Later improvements in 1851 involved a more transparent calotype negative material made by a different waxing method. The calotype process was never in widespread use in America; by about 1855 most photographers were using the newer collodion wet-plate negative. However, about 1885 there was a renewed interest in paper negatives for about three years, triggered by the search for a flexible film base for roll film cameras. We have seen a number of 5" x 8" prints made from paper negatives of this time period, some taken at the Kodak Works in Rochester. These paper negatives were made in a view camera equipped with an Eastman-Walker Roller Holder. The negatives were made transparent with castor oil. Should you find one of these paper negatives in a collection, try to track down others. There were a large number of exposures in a roll, so many other related negatives may have survived.

Calotypes deteriorate from inadequate fixing, that is, from hypo or other fixing compounds not completely washed out of the paper; the result is an overall yellowing and fading of the image. The image is also more susceptible to fading with exposure to light. Sulphur gases in the air accelerate this deterioration. Chemical restoration is possible, but should be done only by a technician familiar with calotype problems.

Faded prints can be restored chemically, but it is important to understand that restoration is chancy; calotypes were made by several formulas and developed and fixed with various chemicals during the fifteen-year period they were used. Because of their rarity, loss or damage would be especially unfortunate. This is a job for an experienced conservator.

The calotype process involves paper negatives and paper prints of a particular kind. However, before albumen paper was available, (1849 to about 1860,) the printing paper used to make calotype prints was also used to make prints from both albumen glass plate negatives and wet collodion negatives. These paper prints have the calotype print's characteristic warm brown color and smooth surface without gloss or sheen; they are without signs of fiber grain common to prints made on this paper from paper negatives.

Albumen Negatives

In the continuing search to find a more transparent base material for negatives than the heavy waxed paper of calotype negatives, photographers began to use sheet glass as a support base for an albumen coating binding silver halides to the glass. From 1849 to about 1854, this process was used in America, but the number of glass-plate albumen negatives produced was small. The speed of albumen negative plates was so slow, i.e., their sensitivity to light so reduced, that their use was principally limited to photographic views and to copy work. With the announcement of the wet collodion process in 1851, experimenters began to switch over; because in comparison, the albumen plate negatives were *less transparent* and *less stable* than collodion. By 1854 albumen plates were no longer used. Prints made from albumen negatives on paper were essentially the same as calotype print paper, the light-sensitive halides being imbedded in the fibers of the paper. The finished print had a warm brown tone with a smooth surface without gloss or sheen.

It is unlikely that albumen negatives will come to your attention because of their rarity. As we have never dealt with such a plate, we would welcome correspondence on suitable methods for their care and preservation.

Care and Repair of
Cracked and Broken Plates

When you suspect that an envelope contains a cracked or broken glass plate, immediately support it without further bending on a clean piece of same-size single weight glass. With plate and its envelope lying on the support glass, slit edges of the paper with a razor or scalpel and lift freed half of the envelope off. Make a sandwich by laying a second piece of glass over the damaged plate, flip sandwich over carefully and lift off first support glass to remove remaining half of old envelope. Save any information from the old envelope by transferring to the photograph's new record. Inspect the plate to see if it is cracked or broken.

Cracked Plates. Most cracked plates will have only one crack as those with multiple cracks seldom survive with emulsion intact. Clean the glass back of the damaged plate with clean, lintless cloth dampened with water. If dirt is stuck on this side, use a razor blade to remove it. When the plate's glass back is clean, lay over it a same-size second sheet of clean and dusted glass and flip the sandwich over again. Remove the now top sheet of glass so that the emulsion of the damaged plate is face up, lying on its new glass support.

Fasten the cracked plate, emulsion side up, to its new support backing with 3M Acrylic tape no. 850. Tape is placed on a 1/8-inch border of emulsion side, bridging the crack with gentle tension to keep it closed. Apply only on borders that are crossed by crack. It is essential to understand that applying subtle tension closes the crack firmly; unnecessary taping on borders uncrossed by a crack would tend to pull the crack open. The object is to apply take to pull the cracked pieces together. Press remaining tape down over edges of cracked plate and support glass and under edge of support.

A Selection of Nineteenth-Century Faces

The daguerreotype camera was the chosen instrument to retake loving memory from death once more into life. The daguerreotype plate bore this burden with suitable elegance forever. (Robert Weinstein Collection)

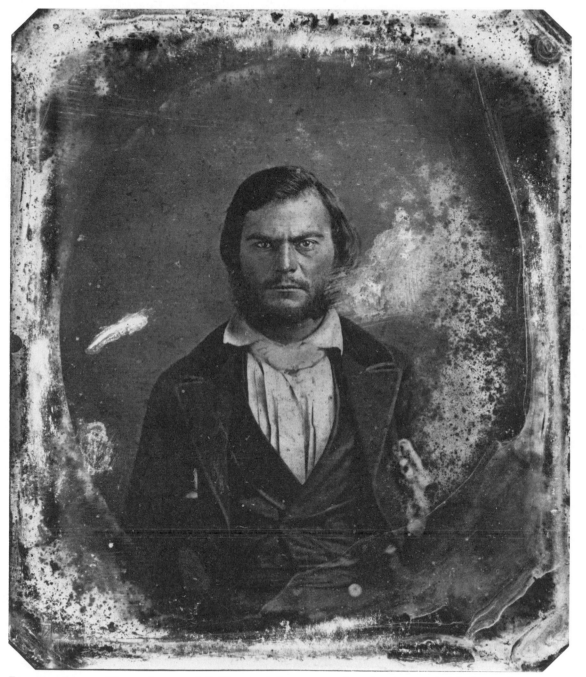

Francisco Lugo, citizen of pastoral California, is best remembered as an unpunished murderer. Determined and unrepentant, he faces his viewers now—and the daguerreotypist then—as a representative, unabashed witness of his time. (Courtesy, Natural History Museum of Los Angeles County)

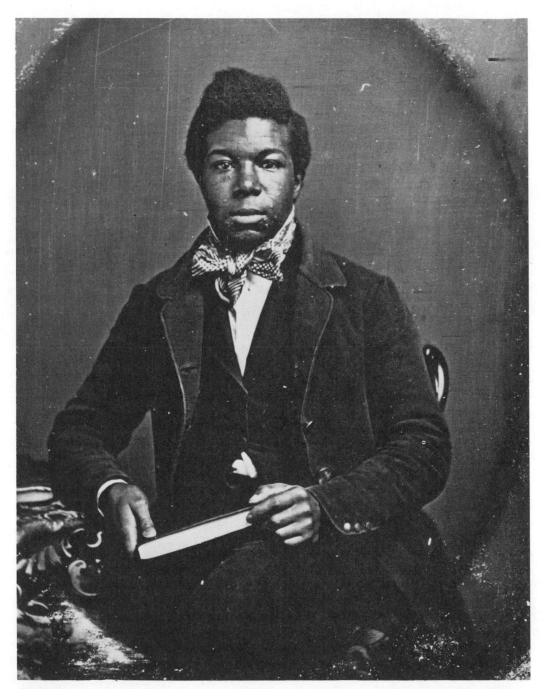

Of all the nineteenth-century images we look for now, those of black people or their lives seem the most difficult to recover. The few surviving daguerreotype portraits intrigue us, refusing to yield satisfactory answers to questions that still puzzle us. (Robert Weinstein Collection)

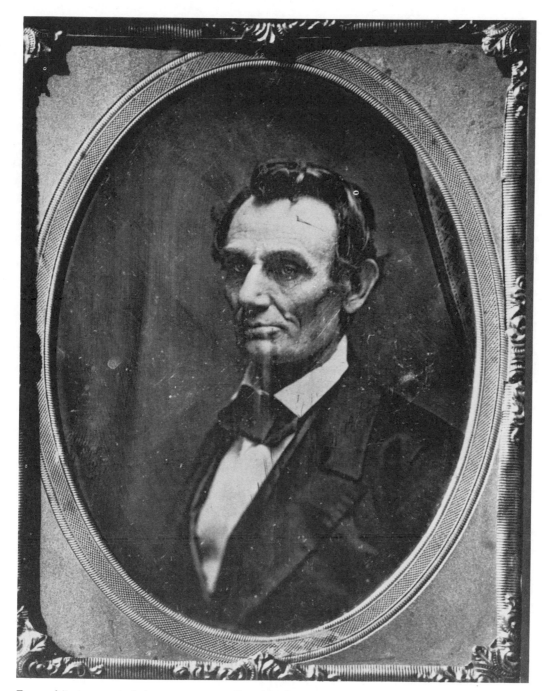

Few subjects accepted the camera so well as Abraham Lincoln. He seems to trust it as a friend, offering its impersonal lens his homely visage, his troubled feelings and his carefully hidden heart. (Courtesy, International Museum of Photography)

172

They all wanted their pictures taken: the solidly successful, the nearly successful, the posturing poseurs, even the out-and-out con men. In different dress and demeanor they have each assembled here, democratically, for the local photographer . . . and for immortality. (Courtesy, Title Insurance and Trust Company of San Diego)

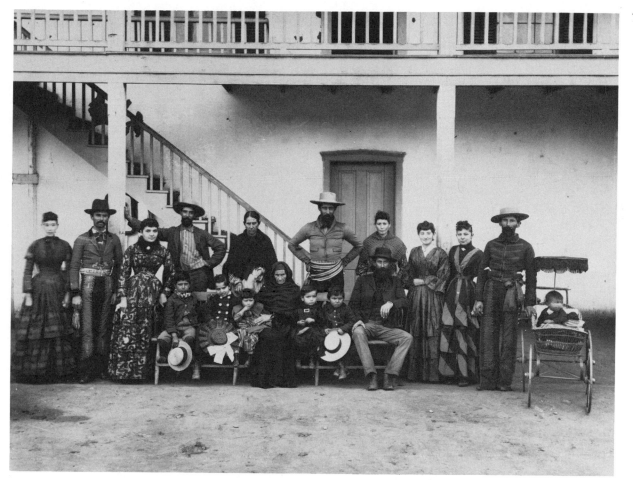

Three generations of the Lugo family assembled at their large adobe, Rancho San Antonio, in the summer of 1892. Descendants of a past already long gone, they survive in this image as a major visual artifact of the Mexican frontier in Alta California. (Courtesy, Natural History Museum of Los Angeles County)

174 If the tape overlap is wider than ⅛ inch on the support glass, trim off excess, taking care not to damage emulsion of the cracked plate in the process.

When a plate is only cracked, not broken, with its emulsion intact, you have a chance to save the image by making a duplicate negative without reproducing the crack line. Once the emulsion breaks, there is no way to reproduce it without evidence of the line except by retouching at some stage of the duplicating process. Fastened to its new glass support and slipped into a new, properly marked envelope, the cracked plate is ready to have a duplicate negative made of its image. This can be done by contact printing. A cracked plate is placed in a contact printing frame with unexposed film and rotated on a turn table during exposure by highly diffused light. A diffusion sheet of tissue, silk, matt plastic or ground glass can be used. The matt diffusion sheet is interposed between the light source and film about 3 inches from surface of the film for maximum effect. An interpositive or a direct duplicate negative can be made by this method.

Broken Plates. Lay the cleaned broken pieces emulsion side up on a cleaned surface. Select the largest piece with a right angle, hopefully with two right angles. Tape piece down, emulsion side up, on cleaned same-size support glass. Tape ⅛-inch border on emulsion face of glass plate. Press tape down over edges of plate and support glass and onto the back side of support. To this fixed piece of the plate, add other pieces one by one, fitting each firmly against previously anchored neighbor, taping each piece at its own ⅛-inch border, bridging the break with gentle tension.

This system works reasonably well for plates broken into only two to four parts. If there are more fragments, it is difficult to exert pressure effectively to hold them snugly together; larger gaps occur between the sections. It may not be possible for the taped border to confine all fragments. In this event, tape a cover glass over assembled pieces to contain them.

An alternate procedure involves use of minute dots of a cyano-acrylate instant glue such as Eastman Kodak's no. 910 to tack pieces together. Very tiny dots of the instant glue can be put on broken edges (only on glass—not on emulsion). Use a right angle such as a square as a fence to assemble pieces correctly. Tape to same-size support glass.

It is also possible to use clear epoxy glue with a refractive index similar to that of glass, such as Hydrosol 0.0151, available from chemical supply houses. These glues in close proximity to the emulsion are thought to be safe for the purpose; but we do not have long-term experience with them or information that proves they will not affect emulsion. We suggest that a high quality duplicate negative be made from such repaired plates soon as a related step of the procedure. If you cannot tape the broken plate immediately, store the broken pieces in individual envelopes to protect the edges from damage.

Duplicate negatives can be made from cracked or broken plates either using an optical system in an enlarger or camera or by contact printing. In order to subdue the reproduction of break lines in the duplicate negative, a diffused light source should be used in all cases. The ultimate technique in minimizing these lines is the turn-table method described in the preceding section.

Old-time photographers often dealt with broken plates by cementing them together with Canadian balsam which has a refractive index similar to that of glass. Unfortunately their technique involved heating the broken pieces so they accepted the balsam; and the final step of the procedure was to bake the repaired plate in a warm oven for 2 hours!

Wet Collodion Negatives

The collodion wet plate process was announced in England by Fredrick Scott Archer

in 1851, and in a few years replaced almost all other photographic processes. In America it had pushed aside the daguerreotype as the number-one process by 1857 and held its popularity until gelatin dry plates proved their superiority and convenience in about 1881. Because of superior results for copy work and for lantern slides and other positives, some photographers still made their own collodion plates, wet and dry, as late as 1908. The *wet-plate negative* is a silver image lying on the surface of a layer of collodion coated on a sheet of glass. *Collodion* was a thick, syrupy liquid made by dissolving gun cotton, cellulose nitrate, in a mixture of alcohol and ether. Soluble iodide and bromide was added to the collodion. The viscous liquid was poured out on a sheet of glass, flowed evenly over the plate by rocking it, while the ether and alcohol solvents were allowed to evaporate. This left a thin, tacky, reasonably even transparent film on the glass. The plate was then sensitized in a solution of silver nitrate. The chemical action formed a light-sensitive compound of silver iodide/bromide upon the surface of the collodion film.

As this type of sensitized plate dried, it lost most of its speed; thus the plate had to be exposed in the camera while still wet and developed, fixed, washed and dried, all within about an hour. The fixer used was a solution of potassium cyanide, instead of hypo. The necessity for this speed in using collodion wet-plate negatives was a fact of photographic life that led to construction of portable darkrooms. During the twenty-five years the process was used almost exclusively, some strange and ingeniously designed traveling darkrooms were designed which included collapsible tripod tents, two-wheeled push carts and horse-drawn darkroom wagons.

Wet collodion negatives can be distinguished from gelatin emulsion dry plates quite easily; the glass of collodion plates is usually thicker and less uniformly sized than that used for dry plates. The surface of a wet plate shows patterns where the collodion swirled around, missing corners and leaving heavy areas. The collodion image, when viewed by reflected light, appears light tan or gray and of medium density. With a black area behind it, the image will appear as a positive. The image can appear slightly dull, without high gloss or sheen, unless it has been varnished—a frequently practiced procedure. As the silver image lies *on* the surface of the collodion, so that even a small scratch will go through the silver layer, many photographers used varnish over the silver to give the image some protection. If the image side of a collodion plate is shiny with varnish, it can appear much like the plain glass side. Take care to determine which is the collodion side of a plate so you will not damage it by trying to clean it by mistake. A good way to be certain is to remember that the plain glass side is clear, there should be *nothing* on it while the emulsion side can show, nicks, scratches and breaks in the emulsion surface through which the clear glass *will* show. One other telltale is that on the emulsion side everything reads backwards, including signs and names. On the clear glass side everything reads properly, as it should. There were variations in collodion wet plates. For example, in the early 1870s, a thin albumen layer was first poured on the glass before application of the collodion to prevent curling and slipping of the collodion layer around the edges. Negatives of portraits made after about 1868 usually show signs of retouching on the emulsion side.

Collodion plates are much less affected by residual chemicals than are gelatin emulsion plates. The collodion is relatively impervious to aqueous solutions; and as fixing solutions in the original processing did not penetrate beyond the surface, they were easily removed in the original washing. The silver image of a collodion plate is sensitive to contamination from the common causes—impure envelopes,

176 pollutants in the atmosphere and deterioration gases from nearby nitrate-base film.

Collodion plates that have been varnished constitute a special problem. In the same manner that collodion had been poured onto a plate and spread over the surface by tilting, an amount of varnish was poured on over the collodion. The resulting varnish coating is not always smooth and often does not extend entirely over all of the corners. As the varnish ages and deteriorates, it frequently fractures into tiny segments, flaking off and taking the collodion with it.

To prevent loss of flakes (bits of image) when the varnish fractures, tape a cover glass the same size as original over the emulsion side with 3M acrylic polyester tape no. 850. Use 1-inch lengths of tape on each of the four edges of the sandwich to hold the cover glass firmly but allow future deterioration gases to escape.

A spray coating of Krylon or gelatin is a way of dealing with fractured collodion, but violates most conservators' philosophy that whatever remedial work is done to historical photographs should not be irrevocable—but should be capable of being undone. Collodion probably would not survive removal of Krylon.

The negative should not be handled, touched or moved any more than absolutely necessary. Maintain even temperature and humidity if possible. Each one should be placed in a separate Permalife paper envelope and stored loosely enough to allow the collodion to breathe. Under some conditions the varnish may soften and stick to envelopes, again removing some of the collodion. The cellulose nitrate in collodion also decays, giving off gases as does deteriorating nitrate-base film. Small gas bubbles, about pin-head size, are formed under the varnish often all over the surface of a collodion negative, contributing to further disintegration of both collodion and varnish.

It would seem an obvious remedy to remove the varnish coating before disastrous bubbles materialize or before the varnish deteriorates. However, during the long period collodion plates were used, over twenty-five years, formulas for collodion varied, especially at the end of their popularity. And the varnish was of many different types, some even had collodion mixed in it! Solvents that have been experimented with thus far to remove the varnish have also destroyed the collodion. Hopefully, future study will provide us with a variety of solvents that will work successfully.

The foregoing procedures are all simply delaying tactics, because eventually the negative will no longer be usable or be capable of being restored. To save the image, the best possible duplicate negative should be made while the original negative is still in good enough condition to permit doing so. Especially important original negatives should be copied twice, one direct duplicate negative made as a working negative and a film interpositive made as a master to be stored separately. A new working negative could be made from the master interpositive for any future need.

The collodion process produced images of remarkably high resolution and sharpness. Because the water-resistant collodion plate was sensitized in an aqueous solution of silver nitrate, an extremely thin silver layer was formed on the surface of the collodion capable of producing images of incredible sharpness and fine grain. See 18x enlargement of the Transcontinental Hotel on p. 37.

Negatives of such unusual quality deserve to be duplicated full size. Making a reduced 4 x 5 duplicate negative from a beautiful 8 x 10 wet plate collodion negative would represent a severe loss of potential use.

Dry Plates

Practical dry plates became available in 1881, and because of their convenience were the choice of most photographers by 1883. A *dry*

A gelatin dry plate. This type of glass plate negative, introduced in the United States in 1880–1882, successfully replaced the wet-collodion negative, the standby of most photographers for thirty years previously. (Courtesy, Title Insurance and Turst Company of San Diego)

plate negative is a silver image carried in a layer of gelatin on a sheet of glass, capable of maintaining its chemical sensitivity to light over long storage periods before use. The glass plate, coated with the gelatin containing light-sensitive silver bromide, was sold to photographers ready for use. In the darkroom an unexposed plate was loaded into a plate holder to be exposed in the camera as needed. Exposed plates were brought back to the darkroom to be developed, fixed, washed and dried.

The factory-produced dry plates are easily distinguished from the older collodion wet plates. Dry plate glass is thinner and has factory-cut even edges. The gelatin coating is smooth and uniform. The emulsion side of a

dry plate negative has a dark gray-black appearance in reflected light. In transmitted light the gradations in tone range from clear to black. It is easy to determine which side has the emulsion coating because it appears dull. The plain side of the plate will be a glossy, reflecting surface.

Deterioration of the silver image is much like that of other photographs. It is caused mainly by residual processing chemicals, contaminants in storage paper envelopes and by destructive gases in the atmosphere. Many of the older dry plate negatives show staining of the emulsion, particularly around the edges. In reflected light, a stained emulsion will have a silvery, metallic sheen, sometimes with coppery tones mixed in; but in transmitted light

178 the same stain area may appear yellow. Original negatives should not be restored chemically so long as they are in reasonably acceptable condition. Some negatives with silver stains—a shiny metallic appearance when viewed by reflected light—can still be printed satisfactorily. Because of the danger of damage during restoration, premature chemical restoration is not prudent. Dry plate negatives can be reprocessed to remove old residual chemicals that are still soluble from the emulsion. Stained or faded negatives usually can be restored successfully by various chemical processes even though the possibility always exists of ruining or damaging the negative in any of these procedures. Simply immersing an old gelatin dry plate in any liquid, such as a hardening bath, even at room temperature, can cause gelatin shock to the emulsion; this results in a mass of tiny fractures resembling a screen pattern—and ruins the negative. Restoration should be attempted by a technician only. Conservation is usually limited to cleaning the glass side of the dry plate with a clean damp cloth and drying it with a clean lint-free one. Stubborn spots on the *glass* side can be dislodged with a razor blade but be certain to clean *only* the glass side of a dry plate.

Generally the gelatin of a dry plate negative is reasonably stable, but its bond with the glass breaks down on some old ones. This fracturing and lifting of the gelatin can sometimes be remedied by recementing with emulsion-quality gelatin. The new gelatin is painted on to the base and the loose pieces gently pressed down on to it. This is a tedious job requiring skill and experience. Plates with emulsion that has fractured but not lifted can be given a super coating of gelatin to keep the emulsion intact.

Gelatin Adhesive. Gelatin adhesive is very useful for mounting or repairing photographs. It is hygroscopic, but less so than starch paste. Here are two basic formulas.

Formula I—from Eastman Kodak pamphlet no. E-34:

1 tablespoon gelatin (Knox Plain Gelatin or emulsion-quality gelatin)
¼ teaspoon ammonium hydroxide
¼ teaspoon Kodak Photo-Flo (1:200 dilution)
¼ cup warm distilled water (120°F) for thinner mixture use ½ cup water.

Dissolve gelatin in warm water, cool, then add ammonium hydroxide and Photo-Flo. Strain warm gelatin solution through absorbent cotton pad. Keeps for only two or three days at room temperature. Mix fresh or keep in refrigerator. For use, warm the gel solution slightly to liquify. This formula can be used in many ways.

1. As an adhesive for mounting prints.
2. To adhere fractured gelatin emulsion which has lifted from dry plates.
3. To clean and "heal" abraded gelatin print surfaces.

Formula II: This formula found in several early photographic encyclopedias is an update of the classic formula for the substratum (subbing) used in the manufacture of gelatin dry plates.
5 g emulsion-quality gelatin
0.5 g chrome alum
500 ml distilled water 130°F
5 ml Kodak Photo-Flo (1:200 dilution)
Dissolve gelatin in warm water, cool, add chrome alum and Photo-Flo. Strain through a cotton pad. Use soon while still warm and liquid. This formula is best for adhering emulsion which has loosened and lifted from old dry plate negatives. The chrome alum hardener makes the adhesive less soluble in warm water and may have superior long-term adhesion.

Emulsion-quality gelatin is available from Eastman Organic Chemical Co, (see your local chemical supply dealer or Van Waters and Rogers) or order from Peter Cooper Corporation, Camden Gelatin Division, 1000 North 5th Street, Camden, N.J. 08102. We have used their photographic gelatin type 331. Ask for a

A glass lantern slide by the Langenheim Brothers of the early Tombs prison in lower New York City. Their slides are rare and are often the only surviving photographic images of certain subjects. (Robert Weinstein Collection)

minimum order; as one pound of gelatin will go a long way. If the adhesive is not to be used in direct contact with the emulsion, Knox Plain Gelatin is satisfactory; but some technical authorities we have talked to say Knox Plain Gelatin should be just as satisfactory as emulsion quality gelatin.

Lantern Slides

The *magic lantern*, a system to project transparent drawings onto a flat surface screen, was in use quite some time before the first daguerreotype was made in 1839. In America, photographic slides were being made for use with this system from albumen-coated glass negatives and albumen glass positives by 1850. By 1860, the Langenheim Brothers of Philadelphia were engaged in full-time production of lantern slides they called stereopticon slides. The similarity of the names sometimes has resulted

in confusing these slides with the twin opaque prints of a stereograph. Lantern slides became a popular home entertainment event and enjoyed a long life as popular images for the "illustrated lecture of the day."

It was not until about 1900 that lantern slides reached their greatest popularity, continuing to be used for lectures and study up to the time that more convenient 35-mm slides replaced them, starting in the 1930s. Even as late as 1945, Bausch and Lomb were making and selling a "Stereopticon" slide projector. The typical lantern slide is a photographic image on a glass plate, 3¼" x 4", although British lantern slides measured 3¼" x 4". Continental or European slides measured approximately 85 x 100 mm or 3⅜" x 4". Both British and European slides may be found in many collections. They were black and white, toned or colored by hand with transparent oils. Beginning in 1907, natural color lantern slides were also made in quantity. These early color processes were Lumiere, Autochrome, Finlay color, Paget color, Dufaycolor, Afgacolor, etc. See Color Photography section for more information concerning their care and use. For use, the slide was protected with a cover glass bound on four sides with black paper tape. Often a cutout mask was sandwiched in between the slide and cover glass and frequently a title was printed in an appropriate place in the image area. Lantern slides were never as popular as stereographs because of the greater expense and necessity for subdued viewing light. Like stereographs, lantern slides may often be the only photographs of a particular subject or area that have survived. Copy negatives can be made from lantern slides, although as a rule lantern slides are less dense and of higher contrast. This characteristic makes good reproduction a little more difficult.

Many lantern slides have survived in remarkably good condition compared to the glass plate negatives from which they were made. Most of them have received limited use

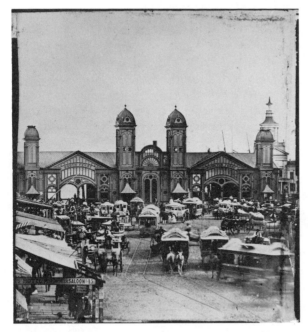

This view of the Cortlandt Street Ferry in New York City in the early 1850s is reproduced from a glass slide by the Langenheim Brothers, among the earliest known producers of lantern slides in the United States. (Robert Weinstein Collection)

The typical American 3¼″ x 4″ lantern slide. Produced in great quantities and frequently sold in sets, these slides identified as shown, served as warmly received forerunners of moving pictures and television. (Courtesy, Title Insurance and Trust Company of San Diego)

and have been kept in grooved storage cases. This avoided the usual abrasions, dirt, finger prints and direct contamination from a variety of sources so often seen on negatives. The cutout mask and the adhesive and paper binding which seal the slide are suspect as contaminants; but as they are not in direct contact with the viewed image emulsion, possible deterioration from those sources is diminished.

Types of care applicable to lantern slides are these:

1. If binding tape and cover glass are in good condition and the interior surfaces are not noticeably contaminated, cleaning the exterior glass surfaces and storing in the original grooved boxes may be all that is necessary.

2. If a slide's binding is damaged—cover glass cracked, interior surfaces dirty or image affected—the slide should be taken apart and cleaned. Broken cover glass should be replaced. The image plate can be given archival reprocessing treatment to remove residual chemicals. If it is stained or faded, a conservator can restore it chemically. The paper cutout mask can be deacidified. Reassemble, using rice paper or 20 lb. Permalife paper as binding tape with a good polyvinyl adhesive such as Promatco Jade 403. We do not know of a safe black tape similar in appearance to that used originally on old slides.

If reassembly is delayed for any reason, store the image plate separately in a Permalife envelope and the cutout mask and cover glass in another, coding the two envelopes so that original parts can eventually be reassembled. Another safe way to hold slides for final, more authentic reassembly, is to use modern aluminum slide binders which are available in lantern slide size, 3¼ x 4. These consist of an

aluminum frame, aluminum cutout mask and new cover glass. This gives good physical protection with safe materials.

The large lantern slides in a good projector with a fan and a heat-absorbing filter can produce slide programs of unusually good quality although the intense projection light and accompanying heat can be harmful to life of the slides. Projection time per slide should be limited to 15 seconds. On an occasional basis, they can be used with great care and their use justified as much as the occasional showing of original prints with care can be similarly justified. As a safety measure copy negatives should be made of the lantern slide images to preserve them.

Printing Paper Care

Albumen Paper

Albumen paper was introduced about 1855 and generally used in America from about 1860 to 1890. A coating of albumen (egg whites) containing sodium chloride (salt) was applied to a thin, smooth surfaced paper. The coating was sensitized by an application of silver nitrate which reacted chemically with the sodium chloride, forming light-sensitive silver chloride. After drying, the paper was ready for use in making prints.

Photographers generally purchased the paper already coated with albumen and sodium chloride. On a daily basis or as it was needed, the paper was sensitized by the individual photographer who floated it face down on top of a solution of silver nitrate, hanging it up afterwards to dry under yellow subdued light. During the course of the paper's popularity, millions of eggs annually were required for their whites, forcing some manufacturers to point out in their advertising that no blood eggs were used in the making of their paper. The albumen gave a luster to the surface of prints on this paper, though this quality var-

ied among different manufacturers' paper.

To make a print, the photographer placed a sheet of albumen paper in contact with a negative in a printing frame and exposed it in sunlight. It is referred to as a "printing-out process." This process made a visible image which was then washed in water and toned a pleasing warm brown (sometimes with a purple tint) in a solution of gold chloride, fixed in hypo, washed and dried. As the paper was very thin, most prints were sold mounted on cardboard. The mounts were of different sizes to match the various sizes of prints and each size had its own distinctive trade name. Some of the most popular mounts in use in the United States were:

Carte-de-visite	4¼ x 2½
Cabinet	4½ x 6½
Victoria	3¼ x 5
Promenade	4 x 7
Boudoir	5¼ x 8½
Imperial	6⅞ x 9⅞
panel	8¼ x 4

A small, wallet-sized card was popularly used to mount portraits and certain views, and as it was presented either with or in lieu of a calling card, was known as a *carte-de-visite*. Enjoying instant popularity, it was produced in the millions; you will find many examples in your collection.

All of these mounts were a form of successful advertising for the photographer, as cards were printed or embossed with the name of the photographer and the address of his gallery. Surprisingly in many cases the name and address on these mounts *can be* the name of the merchant who sold the photo, *not* the original photographer, so be careful! Often the mount will have printed on its face, or its back, identifying information about the photographer as well as a negative number identifying the person or the location shown in the photo.

Albumen prints deteriorate in the classic

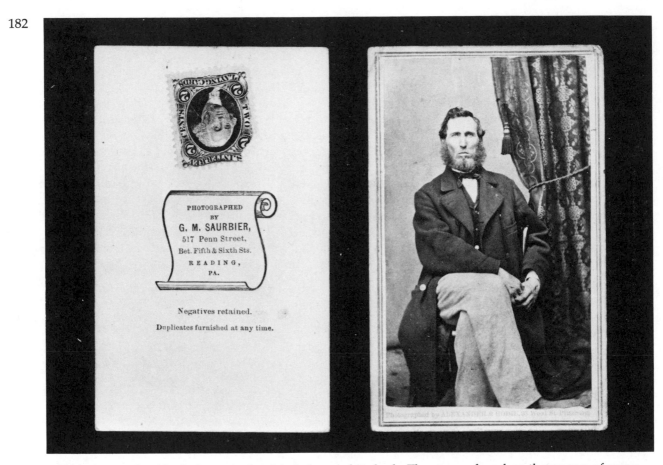

A typical example of both the carte-de-visite's face and its back. The stamp, found on the reverse of many carte-de-visites, is a U.S. tax stamp required from 1864 to 1866. (Courtesy, Title Insurance and Trust Company of San Diego)

ways of metallic silver images. Residual hypo stains and fades the silver image. Sulphur gases in the air and impurities in storage envelopes react with the silver, also causing fading and staining. Chemicals in the cardboard mounts and in the print paper base, together with moisture and chemicals in the adhesive used, can also stain the silver image and the paper base.

Our examination of albumen prints in quantities indicates that fading, a bleached appearance most noticeable in the highlights from residual hypo's attack on the silver, is the most common of all deterioration problems. Other common problems are over-all yellowing from exhausted hypo (silver thiosulphate stain) and spots and blotchy stains probably caused by adhesive and certain impurities in the cardboard. Abrasions on the picture surface, together with accumulations of dirt, are more common symptoms of deterioration.

What can be done without undue risk to the image of the print? Cleaning the surface with Kodak Film Cleaner applied with a clean cotton ball followed by a swabbing with denatured alcohol to remove any streaking caused

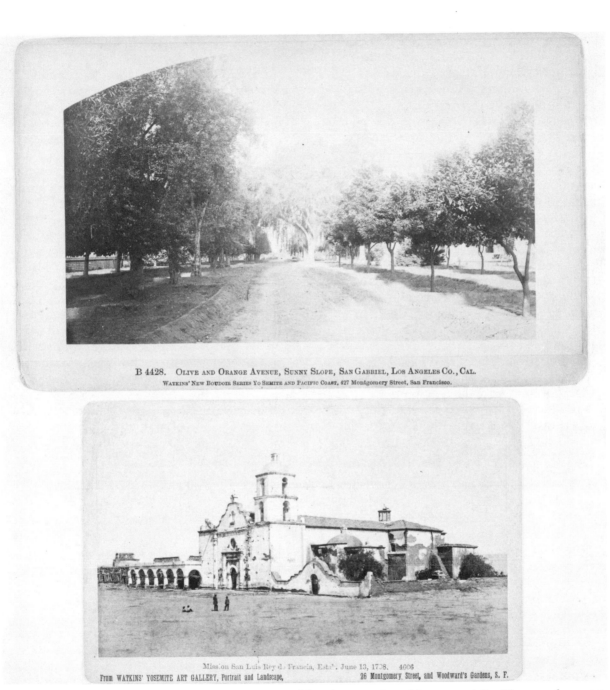

B 4428. OLIVE AND ORANGE AVENUE, SUNNY SLOPE, SAN GABRIEL, LOS ANGELES CO., CAL.
WATKINS' NEW BOUDOIR SERIES YO SEMITE AND PACIFIC COAST, 427 Montgomery Street, San Francisco.

Mission San Luis Rey de Francia, Esta'. June 13, 1798. 4606
From WATKINS' YOSEMITE ART GALLERY, Portrait and Landscape, 26 Montgomery Street, and Woodward's Gardens, S. F.

Two examples of the many contemporary mounts used for photographs sold commercially. The round corners and the imprinted information about the photographer as shown here were customary. (Courtesy of Wayne Fabert)

184 by the film cleaner. Water-soluble dirt can be removed with distilled water and Photo-Flo (200 to 1 dilution) applied gently with Q-tips.

Before cleaning an albumen paper print, make a high-quality copy negative 4 " x 5 " or larger. In addition albumen prints *can* be removed from their old mounting board and processed to remove residual chemicals. The process of parting the print from its mount, depending on the tenacity of the adhesive and the size of the print can be very difficult and is a high physical damage risk. Chemical restoration is not usually attempted because the gold toning makes restoration extremely uncertain. Gold-toned prints are ruined by the bleach and redevelopment process.

About 1880 most professional photographers adopted a system of burnishing albumen prints. This was done by applying a patented glaze to the surface of the finished print and running it through a burnishing roller machine, resembling an old-fashioned hand-operated clothes wringer. The burnishing process produced a fairly high gloss on the surface of the print. This information is a dependable aid in identifying and dating albumen prints from that time period 1879 to about 1892.

Printing-Out Papers

Printing-out papers, collodion or gelatin emulsion papers, known as P.O.P., were introduced about 1891. They were a manufactured product, sold ready for use. P.O.P. was a beautiful photographic printing paper with a tone that ranged from maroon, plum, brown to sepia. The paper base was a little thicker than albumen paper and slightly more opaque. The paper was exposed in contact with a negative in a print frame by sunlight or high actenic artificial light. The visible image formed directly by this exposure was then washed, toned, fixed in hypo, washed and dried like earlier albumen paper. In addition to gold toners,

other toners were used, such as platinum, uranium, and palladium.

The formation of a visible image on the paper as it was exposed acted as a built-in-mask for the shadow areas; this resulted in greater detail in both shadows and highlights. This was true because while the image was forming, silver chloride was transformed into pure silver, which acted as a physical barrier or shield to limit further exposure beneath the surface of the shadow areas. The highlight areas not having this shield continued to expose for greater detail. Negatives made for printing by this wide tonal scale process are difficult to print as well on the shorter scale developing-out papers used after 1900.

Printing-out paper can usually be distinguished from albumen paper by its slightly thicker, more opaque base and its high gloss. It is not always easy to use these criteria to distinguish between them, however, because the later albumen paper had a glossy surface produced by burnishing the finished print with a patented glaze. The color tone of many P.O.P. prints is a shade of maroon which is different from print tones of albumen paper.

Deterioration of P.O.P. prints follows the usual familiar pattern, principally fading from residual chemicals and harmful gases in the atmosphere. Reprocessing to remove residual chemicals is practical. Kodak hardener SH-1 must be used on this unhardened gelatin first. Chemical restoration is not practical, because the toning limits the restoration techniques. There are two types of printing-out papers, gelatino-chloride paper and collodion chloride paper.

Collodion Chloride Paper. The surface was coated with collodion emulsion used as a vehicle to support light-sensitive silver chloride. It was made in the late 1860s, but not used in volume until the early 1890s. Although it is difficult to see the differences between collodion and gelatino printing-out papers, the col-

lodion emulsions can be recognized as more brittle and likely to show tiny cracks. Collodion emulsions have less tolerance to heat without cracking. One important difference between collodion and gelatino is their reaction to solvents used in remedial work. For example, acetone and other solvents that can be used to remove scotch tape or stamp-pad ink from gelatino emulsion may dissolve a collodion emulsion. Because of collodion's reaction to heat, dry mounting can make many hairline cracks in such an emulsion. One of the popular collodion paper trade names was Aristotype. We have seen many mounted prints with the preprinted words "Aristotype Print" on the reverse side of the mounting.

Gelatino-Chloride Paper. This printing out paper has a gelatin emulsion and usually a high gloss. The trade name of Eastman Kodak's P.O.P. was Solio Paper, a name so well known that photographers of that day frequently referred to printing-out paper prints as Solio prints. P.O.P. has been made continuously since about 1891 and is still available today. Portrait photographers have long used unfixed P.O.P. prints as proofs. The emulsion of gelatin P.O.P. prints, when wet, is soft and easily damaged. Any reprocessing of these prints should be preceded by hardening in Kodak SH-1 hardening bath.

Most printing out-prints, albumen and gelatin, were gold-toned as part of the finishing-fixing process. A fixed but untoned printing-out print has an unpleasant brownish-yellow appearance. The gold-toning strengthened and beautified the print, changing it to a color ranging from warm brown to maroon. The effect of the gold-toning process was similar to plating. The outside surface of the grains of silver forming the image were coated with gold. The gold, having a greater resistance to chemical change than the silver, gave additional permanence to the image by protecting it from fading.

Developing-out paper, introduced about 1880, possessed greatly improved printing speed, though it was not until about 1886 that developing out papers were popularized through effective promotion by Eastman Kodak. By 1900 this faster, more versatile photographic paper had superseded the two well-known printing-out papers of that day, gelatino-chloride and collodion. Since 1900 until today, developing-out paper in one form or another has been the standard printing paper for black and white photographs. Instead of requiring several minutes of exposure in bright sun to expose a contact print correctly, this new paper required only a few seconds of strong artificial light. The paper, ready for use as purchased, was factory-coated with a layer of light-sensitive gelatin emulsion. After exposure, the paper was developed, fixed, washed and dried in the darkroom. The processing time from exposure to ready-to-dry print was about thirty minutes. These two advantages—shorter exposure times with artificial light and shorter processing time—led to increased volume of production and greater use of enlargements. With albumen printing-out paper, exposure times using the sun as a light source for the enlarger might be as long as an hour. The relative ease of enlarging with developing-out papers ultimately led to use of smaller size negatives and cameras. The paper base of the early developing-out prints before about 1915 was a little thicker and more opaque than printing-out papers, but still quite thin compared to today's single-weight paper. Developing out papers were made in three basic types, bromide paper, chloride paper, and chlorobromide paper.

Bromide Paper. Bromide paper was introduced in England in 1880, but was not produced in large quantity in this country until 1886, when Eastman Kodak Company set up

186 machinery to coat paper with emulsions. Professional photographers generally used bromide paper for portraits when it was first available, but usually used printing-out paper for views until about 1900.

Early bromide prints have a soft slate-black image color. Compared to albumen and gelatin printing-out paper prints, early bromide paper's shadow detail is less and the highlight areas are less brilliant. Early bromide prints had smooth surface and were not generally toned. Later the paper was made in smooth, glossy and matt surfaces. The paper weight is slightly thicker and more opaque than albumen paper. Bromide paper became increasingly popular; by 1940 it was dominant in popularity and remains so today.

Chloride Paper. This paper was introduced earlier, but was not generally available until about 1890. Photographers were slow to give up their printing-out papers for contact printing until about 1898. Chloride paper with its blue-black image was first called gaslight paper, because it could be exposed by gaslight. The first trade name for gaslight paper was Velox which became a household word. (Eastman Kodak Company still uses the name Velox for one of its contact printing papers.) While the paper could be exposed with gaslight, it was slow enough to be handled and processed in subdued light and did not require a light-tight darkroom equipped with safe lights.

Because Velox could be exposed and processed faster than printing-out prints, it became the standard paper for photo finishing companies developing and printing snapshots for the amateur. Family albums from the 1890s and early 1900s are filled with Velox prints.

The surface of early Velox prints was smooth; and later gloss and matt surfaces were popular. Modifications in printing speed were made in this paper over the years, but the basic, slow chloride contact print paper was used until about 1946.

Chloro-Bromide Paper. This type paper was manufactured early, about 1884, but did not become popular until about 1920. Being a combination of bromide and chloride, it contained some characteristics of both papers. It was slower than bromide paper. Its tone was brown-black, but could be changed by different developers and/or toning from red to brown to black to blue. These papers were widely used for both contact and enlarging until about 1950. Two of the beautiful classic chloro-bromide papers were Kodak Opal and Ansco India-tone.

It is not easy to distinguish one developing-out print from another, but the preservation procedures are the same for all three types. The prints usually deteriorate in the familiar manner of fading and staining from residual chemicals, harmful adhesives and mounting board, and the action of sulphur gases in the atmosphere. Developing-out paper can be reprocessed to remove residual chemicals; however, the gelatin emulsion should first be hardened in Eastman Kodak SH-1 Hardener to prevent softening and help to prevent damage to the print surface. Hardening the gelatin before any liquid immersion is especially important in the earlier prints.

Unmounted glossy prints with abraded gelatin surface can be healed and cleaned by ferrotyping. Wash the print in running water for about ten minutes, then squeegee it to a photographer's ferrotype plate. Dry without heat, using a fiberglass screen to hold the print in continuous contact with the ferrotype plate to ensure an even glazing of the gelatin print surface. Faded and stained developing-out prints which were not originally toned, usually respond to the conservator's chemical restoration treatment.

Stereographs

The popular nineteenth-century parlor pas-

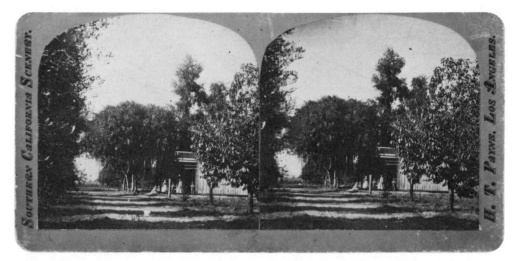

One of the earlier flat stereographs with machine-rounded corners. Many such cards had imprinted somewhere on their faces the photographer's name, address and the series title of which an individual card was a part. (Courtesy, Title Insurance and Trust Company of San Diego)

time of looking at stereograph views of scenes from all over the world on a stereoscope viewer was perhaps equivalent to watching travelogues on television for the current generation. Stereographs were popular from about 1858 until about 1920 in an up-and-down cycle from one generation to the next. They were made in America as early as 1850, but large volume sales of stereographs did not begin until about 1858 when the wet collodion negative replaced other processes. Photographers were sent to many parts of the world to supply photographs for this demand; stereographs by the millions were made annually as their popularity increased. It was no passing fancy. The stereograph has the longest history of popularity of any form of photograph, creating a tremendous business affecting photographers in all areas. Great quantities of such photographs have survived. Many times the only photographs we have of particular subjects or areas are stereograph views.

A stereograph is a pair of photographic prints of the same scene mounted adjacent to each other on a 3½" x 7" card. The early cards are flat, whereas cards manufactured later are sometimes slightly curved across the vertical axis, from top to bottom. The cards almost always have hand-written or printed information on both sides of the card, and thus, self-identified, are especially useful. Originally they were issued by individual photographers in hand-numbered sets; later they were issued in printed sets by publishing or view companies.

As the stereograph is viewed through a stereoscope, the two-dimensional scene of the prints is transformed into a single three-dimensional photograph with the realistic effect of depth and distance that binocular vision gives the viewer. The photographs were taken by a stereoscopic camera which had two lenses mounted 2½" apart (the average distance, center to center, between human eyes). A thin septum separates the two lenses from the lens board to the film plane. It is like two cameras with a single common back, each lens forming an image equivalent to what would be seen by

188 one eye. Both images are recorded on a single plate or film separated by a dividing line formed by the septum.

The negative is processed and a contact print of the two images is made from it. The two vertical prints, each 2¾" x 3¼", are cut apart at the dividing line and mounted on the 3½" x 7" card. The position of the prints on the cardboard mount is opposite to their position as printed from the negative: the left-hand print mounted on the right side of the card and the right-hand print mounted on the left side. This switching is necessary in the negative-positive process because while a reversed negative image (mirror image) is corrected left to right in each print, the two images themselves are laterally reversed. To proved this to yourself, look at a stereograph and assume it was printed from the negative as exposed in the camera, the prints not cut apart. Turn the card upside down. The two inverted pictures represent the images as formed by the camera (a lens forms an upside-down image). The picture on the right was made by the right lens, but when you turn the card right side up, you will see that the right lens picture is now on the left. This lateral inversion of the pictures is corrected by cutting the prints apart and reversing their position. Some photographers cut the negatives apart, interchanging the positions of the images before printing. In this case, the two stereographic prints could be on one continuous piece of photographic paper. Knowing about the methods of interchanging stereographic prints is important because it could help in identifying the work of one photographer from another.

Stereographs were viewed with a stereoscope, a device originally made in several forms. The most popular model was a lightweight board with a sliding rack attached at one end to hold the stereograph. At the other end was a fixed cross piece holding a pair of magnifying lenses with a thin septum between the lenses to help separate the images. A handle was attached to hold the instrument up to the viewers eyes. As the stereograph was popular over a long time period, the type of print used represented the type of printing process in vogue at any particular time. Therefore, the range of prints on stereographs covers albumen prints, printing-out prints, to developing-out prints. There were even a few calotypes and daguerreotypes used as stereograph experiments in the time before card stereographs became popular. Some early stereographs were positives printed on glass and viewed by transmitted light.

Stereographs deteriorate in the usual ways of silver image prints, from the action of harmful residual hypo, adhesives, chemicals in cardboard, storage envelopes and from gases in the atmosphere. Because the prints were often handled in viewing, there may be more damage than usual from dirt and abrasions on the print surface. Remedial techniques are limited to cleaning the print surface with film cleaner and cotton pads. To preserve the images, make the highest quality photographic copies of both prints because each print covers a slightly different area.

Reprocessing stereographs to archival standards to remove old residual chemicals is possible, and restoring them chemically is possible, but each process necessitates removing the prints from their mounting. Because of the danger of damage to the prints from either of these operations, this is proper work for a technician. If stereo prints are removed for treatment, the original card remount should be deacidified and the prints mounted on original card using a polyvinyl resin adhesive such as Promatco Jade 403. If the prints are remounted to a new card, transfer all information from the old card and the date of remounting—making certain you record the photographer's imprint.

Occasionally we have seen early stereograph cards with two sets of prints mounted one on top of the other. Apparently the photographer ran short of card stock and used an older card

that had not sold well. In these cases, because of the possibility of discovering a picture of importance underneath, we think the top prints should be removed in spite of the risks involved. Fortunately, the adhesive does not stick so well to the smooth albumen surfaces of the bottom prints, thus the top prints will come off far more easily than prints mounted directly on the cardboard.

Film Care

Nitrate-Base Film

Nitrate-base film is the most troublesome of photographic material in any collection. It is highly combustible and under certain rare conditions, the film will ignite spontaneously.

High temperatures over an extended period of time, coupled with inadequate ventilation of large amounts of film caused some famous nitrate film fires in earlier days. An example of this dangerous characteristic is illustrated by a story of special effects achieved in a scene from the movie, *Elmer Gantry*. The Revival Tent fire scene was shot several times using various flammable materials that failed to satisfy the director until they tried stringing lengths of 35-mm nitrate-base film around the tent. When ignited, it burned so rapidly it created an instant, and satisfactory, holocaust. Every useful step *must* be taken to avoid such dangers. Check with your local fire department for regulations concerning disposal of nitrate film. For example, in San Diego the fire department rules are that the film should be submerged under water in metal containers and transported to the area of the sanitary dump set aside for the safe disposal of dangerous chemicals.

Cellulose nitrate, from which nitrate-base film was made, is relatively unstable chemically. Even under normal storage conditions, the material will slowly decompose, giving off powerful gases, nitrogen dioxide and others.

As these gases form they *will* react with the base of the film and the emulsion, accelerating further chemical disintegration in a continually intensifying cycle of destruction. Not only do these gases react chemically with the film base from which they are produced, but they also destroy negative envelopes. These gases will create the same chain-like reaction with other nitrate-base film nearby, ruining images of any other kinds of photographs in the immediate storage area.

Given this somewhat frightening introduction to the hazards inherent in nitrate-base film, it is essential that a curator responsible for a collection of this material know some of the chronology of its use, methods to determine whether a negative is indeed on nitrate-base film, what its particular storage requirements are, and the inevitability of the necessity for duplicating nitrate negatives.

Chronology. In 1889, Eastman Kodak began to produce nitrate-base film, the first really practical, transparent flexible-base film for roll camera use—which made photography practical for the amateur. This roll film was produced from 1889 to about 1903. It is very thin and curls easily. A slightly thicker noncurl nitrate-base roll film was introduced in 1903. It had a coating of gelatin on the back surface to prevent curling. Safety-base roll film started to replace nitrate-base roll film in 1939, but nitrate-base roll film was produced until 1950. Nitrate-base sheet film was introduced in 1913, but professional photographers made the switch from glass plates gradually; some continued to use glass plates until about 1929. Safety-base sheet film was introduced in 1934, but nitrate-base sheet film continued to be produced until 1939.

While some forms of safety-base film were produced sporadically beginning as early as 1912, it did not start to replace nitrate-base film in sheets until about 1934. Film companies were producing roll film on nitrate-base as late as 1950. While this 1950 film was made

190

A print from a badly stained nitrate-base film negative. The degree of nonreversable damage revealed here marks a stage in the continuing deterioration and ultimate disintegration of this negative. (Courtesy, Title Insurance and Trust Company of San Diego)

in very small quantities, it does demonstrate that chronology clues cannot always be conclusive. Production of nitrate-base film for movies continued until about 1951. It is helpful to know something of the history of the use of nitrate-base film as a clue to its identification. (See accompanying table).

Deterioration. Among nitrate-base films there is great variation of life expectancy from one film to another, some films lasting for 75 years or more in reasonably good condition while others have decomposed in only 20 or 30 years. Usually the early roll film has lasted better than later sheet film. Wide differences in

life expectancy of nitrate-base films can probably be explained by some of the following conditions. Variation in the manufacture of the cellulose nitrate could affect purity and stability. Good ventilation during storage, allowing escape of nitrogen dioxide fumes, will prolong the film's life. Generally very thin roll film keeps better than thicker sheet film for the same basic reason, gases can escape more readily; differences in manufacture, however, still could probably affect its stability. Storage temperature is very important. Rate of decomposition has been estimated to double for every 10°F increase in temperature above 70°F.

High humidity accelerates decomposition because nitrogen dioxide converts to corrosive nitric acid in the presence of moisture. As nitrate-base film deteriorates it passes through several states. A description of the five stages of deterioration, written by Cummings, Hutton and Selfin for the *Journal of the Society of Motion Picture and Television Engineers* in March, 1950, is paraphrased here to apply to sheet and roll film.

First, the film base discolors to a yellow-brown, usually uniformly, generally accompanied by staining and fading of the picture image. Second, the emulsion becomes soft and tacky, the film will adhere to other film or paper and the film base may also become brittle. Third, the base then becomes soft, contains gas bubbles and emits a noxious odor of nitric acid, an unmistakable clue. Fourth, the entire film softens and becomes a sticky misshapen mass, still emitting the same strong odor. At this stage, the mass can actually run down onto the drawer bottom and damage paint. Fifth, the film mass degenerates partially or entirely into a brownish powder.

Recognition. Recognizing nitrate-base film can be reasonably easy. For original negatives, the chronology (time period from accompanying information or from the image) is a clue. For example, sheet film pictures taken between 1913 and about 1939 are on nitrate-base film. Most original negatives on sheet film before 1935 are on nitrate-base film. The deterioration characteristics already defined will indicate which negatives existing in your collection are on nitrate-base film. The characteristic and unmistakable odor from a drawer or box containing both nitrate-base and safety-base film is evidence that noxious gases are present, permeating all of the film. Nitrate-base film is frequently identified "nitrate film" along the border. As long as you are dealing with an original negative, this is valid identification. Safety-base film is usually identified similarly

Date of Last Nitrate Film Manufactured**	Type of Film
1933	X-ray film
1938	Roll film in size 135
1939	Portrait and commercial sheet film
1942	Aerial film
1949	Film pack
1950	Roll film in sizes 616, 620, 828, etc.
1951	Motion picture film (35mm)*

*16mm motion picture film was never made on nitrate base.
**This refers to films made by the Eastman Kodak Company. From Calhoun, J. M. "Storage of Nitrate Amateur Still-Camera Film Negatives". *Journal of the Biological Photographic Association*, 1953, *21*, 1–13

on its edges, both on roll film and sheet film. However, it would be possible for an original nitrate-base negative to be duplicated on safety-base film, resulting in the transfer of the border identification to the new negative, so that *both* identifications could be found on the same negative border.

Most nitrate sheet-film negatives are at least forty years old now so they will probably show at least some sign of deterioration that will aid you in positive identification. If doubts persist, the following described float test is conclusive. Snip off about ¼" corner from the film in question, place it in a small bottle of trichloroethylene, available from a chemical supplier. Shake the bottle to make sure the film clip is completely immersed. If the sample sinks, it is nitrate-base film. If it floats, it is safety-base, cellulose acetate or polyester film. Care should be taken to be sure the test sample should not be accidentally wet with water before testing, as nitrate film wet with water will not sink. While trichloroethylene is not inflammable, the vapors should not be breathed. There are other more complex lab tests for identifying nitrate film.

Once nitrate-base films are identified, they (with their envelopes) should be removed from

192 the storage area of other films immediately and isolated in the best temporary storage conditions possible until they can be duplicated. After duplication, the copies should be checked against the originals for quality, then the originals and their envelopes disposed of. Any films that have deteriorated so far that they are not reproducible should be thrown away as soon as they are discovered, after notes are made of any historical image content.

Storage. Since it may not always be possible to duplicate all nitrate-base film negatives immediately as they are separated, special precautions should be exercised in their storage. The negatives should be placed separately in paper negative preservers. Only porous paper should be used to allow gases to escape freely. The negatives should then be stored loosely in vented file cabinets or boxes with changing air in the storage room. Temperature should be low, ideally below 50 °F and humidity 30–40 R.H. Use frost-free refrigerator for small quantities. Air conditioning is desirable, but if it is not available, select the most suitable temperature storage area and use automatic dehumidifier. Avoid hot attics and damp basements. Even under good storage conditions, nitrate-base film will continue to deteriorate.

Duplication. Because of its dangerous effects on all photographic images nearby, periodic inspection about every six months should be made to locate negatives deteriorating to the point of making immediate copying imperative. Remove and dispose of any negatives that have deteriorated beyond the point of copying. High quality duplicate negatives can readily be made from the nitrate-base negatives, though some precautions must be observed. Since many of these negatives are likely to have yellowish stains on the image, pay special attention to the techniques of removing stains optically through the use of colored filters during the duplicating procedure. Because of the combustibility of nitrate-base film, caution your photo-technician to use heat absorbing glass between the film and light source if an enlarger is used in the duplication. As already noted, emulsion can become sticky at some stages. If this condition is encountered, keep negatives in a dry atmosphere for a while before they are duplicated by contact printing. As all negatives cannot be duplicated instantly, the ones in the worst condition and those most valuable historically should have high priority on the duplication schedule. Thin roll film negatives can be duplicated last.

Old envelopes of nitrate-base negatives must be disposed of, *never reused*, as they could contaminate any material subsequently stored in or near them. Be sure to record any information from old envelopes and negatives before disposal. Duplicate negatives should receive archival processing, be placed separately in approved envelopes, and be given the advantage of the best archival procedures. They should *never* be placed with the originals, even temporarily.

Some early roll film of the 1900 period had no anticurl coating on the back. Many times these negatives are found curled into tight little rolls about the diameter of cigarettes. Usually the film base is brittle, making unrolling it for viewing or printing very difficult. Our philosophy is that the best possible print and the best possible duplicate negative should be made from these nitrate-base negatives—and the original then destroyed, as it is a safety hazard and harmful to other photographs. Insert a thin, smooth edge blade in the edge of the curled negative to start unrolling it. Tape the negative edge to a sheet of glass. Insert a thin glass rod into the rolled negative and carefully force it to unroll, fastening its two side edges to the glass as you go with little tabs of tape. Finally, tape the last edge down to the glass. Adjust the taped edges so the negative lies smoothly on the glass. A curled negative always has the emulsion side on the inside of the roll. When it is unrolled and taped to the glass by this method, the film side of the nega-

Contact print from deteriorating diacetate safety-base film negative of 1936 to 1950 period. As film shrinks, emulsion separates in meandering channels (sharp random pattern); and gelatin backing separates (out-of-focus horizontal lighter streaks). Small white dots are gas bubbles from deteriorating cellulose-nitrate adhesive sublayer. (Courtesy, Natural History Museum of Los Angeles County)

tive is against the glass and the emulsion side is up, fortunately in the correct position for making a duplicate negative and for printing.

Safety-Base Film

It has been widely assumed that nitrate-base film is the only problem child of the flexible film-base family. We now know that some safety-base film also will deteriorate slowly. Thanks to José Orraca's study of deteriorating safety-base film samples from collections in various parts of the country, this new danger has been identified.

Chronology. Safety-base sheet film began to replace nitrate-base film in about 1934. The first safety-base film was made from cellulose acetate. In 1937 an improved safety film was made from cellulose diacetate, and in about 1947 cellulose triacetate film was introduced. Cellulose nitrate was used as the adhesive sublayer (called subbing in the trade) between the gelatin emulsion and the film base. In the aging process, cellulose acetate and cellulose diacetate shrink as plasticizers volatilize from the film base. We have seen hundreds of 5 x 7 and 8 x 10 films that have decreased as much as ⅜ of an inch in each dimension. As this

194 film-base shrinkage takes place, edges curl and ruffle.

Deterioration. Deterioration is evident in three different ways: (1) film base shrinks drastically; (2) gelatin emulsion and anticurl gelatin backing separate from the film base in channels sort of like river tributaries, and (3) cellulose nitrate adhesive, which is used to hold emulsion on the film base deteriorates (much like nitrate-base negatives and collodion negatives), making tiny gas bubbles trapped between emulsion and base. All three of these deterioration signs can be seen while the image still remains unstained. However, as the distintegration continues, yellow stains appear and decomposition continues, spurred on by nitrous oxide gases.

High temperature accelerates the entire process. Examination of similar negatives from 1939, some stored in air-conditioned rooms and some stored in an attic room where they were exposed to summer heat and humid winters, show how important storage conditions are in the preservation of such films. *All* of the diacetate negatives stored in attic conditions showed advanced deterioration as previously described. Those negatives stored in the air-conditioned room showed only a small dimensional shrinkage and curling.

Restoration. Care and possible treatment for these negatives include storage at lower temperature and constant humidity to slow the deterioration process, and making prints and copy negatives or duplicate negatives—although the bubbles and channels will show in advanced stages. It is possible for a conservator to remove the emulsion membrane and adhere it to a sheet of glass or sheet of film. The emulsion is floated off its deteriorating base by soaking in water diluted with Eastman Kodak Photo-Flo. A negative's emulsion (especially one in an advanced state with many bubbles and channels) comes off the base surprisingly quickly. Once free from the old base, the emulsion is coaxed into a single plane as it floats on the water. A sheet of glass with coating of gelatin (see section on Glass Plates, Lifted Emulsion, for formula) is placed under the membrane and lifted up to capture the emulsion. The membrane is teased into position with a Q-tip and the plate is dried in a horizontal position. A piece of unexposed film, fixed and washed to archival standards, can be used instead of gelatin-coated glass. While still wet, the film's emulsion acts as the adhesive to hold the membrane. When an image is floated off its original film base, it expands. Before adhering it to a new base of glass or film, help the image to shrink to its original size by soaking membrane in a bath of alcohol and water mixed 1:1.

There are many, many deteriorating early safety-base films. Hopefully more study will develop quicker and more successful ways of doing the delicate job of saving them.

7

Modern Photographic Processes

Modern Black and White Prints

Stabilization Process Prints

The newly developed stabilization processed prints are a great hazard when used near historical photographs. These are prints which have been stabilized with special chemicals instead of being developed, fixed and washed in the usual way we have already described. Stabilization prints, after exposure, are fed immediately into a quick processing machine where two solutions activate the developer (built into the emulsion) and stabilize the developed image. A finished, damp-dry print is produced in about ten seconds. These prints, loaded with extra strong hypo, are not only unstable in themselves, but will ruin any photograph placed in contact with them. Since chemicals can migrate through paper, there is real danger of contamination during storage even though the prints may be in separate envelopes. Because of this danger of accidental contamination from stabilized prints to *any* kind of photograph, old or new, we suggest that stabilized prints not be accepted into your collection or allowed anywhere near your archives or workrooms.

Special care must be exercised in screening incoming prints for your collection. This is a problem because not all stabilized print manufacturers identify their products. The only positive identification of unmarked stabilized prints is made by using the Kodak ST-1 test. This involves placing a drop of the test fluid on the border of a suspect print. Instructions and formula can be found in Kodak Data Book-

let J-19. These prints, when first made, have a strong hypo odor, and a sensitive nose might detect candidates for the ST-1 test. Stabilized prints are rarely ferrotyped, helping to narrow the criteria of their suspicious characteristics.

Stabilized prints *can* be given treatment to make them permanent, any time after these prints come from their processing machine. The sooner they can be fixed and processed to make them permanent, and incapable of contaminating other photographs, the better. Starting with the fixer, archival processing procedures should be followed as for all other prints—two fixing baths, hypo clearing agent, washing, etc. See archival processing. Envelopes, folders, and separators, that have been used with these stabilizing process prints should *not* be used or reused for photographs or other valuable materials.

Polyethylene-Coated Papers (Resin-Coated Papers)

Polyethylene-coated papers represent a new generation of photographic printing papers that have captured a major portion of most segments of the consumer market because of their speed and convenience of processing and drying. Both sides of the paper base are coated with a thin sheet of polyethylene film. The photographic emulsion is applied on the outside surface of this moisture resistant coating. Processing times for developing, fixing and washing have been reduced to about eight minutes to produce a damp-dry print. Compared with the thirty-five minutes (plus drying time) required to process a regular paper print for commercial quality permanence, the time saved by using polyethylene-coated papers explains why they are becoming universally popular.

Manufacturers of polyethylene coated papers are promoting it for commercial use. They are recommending their regular photographic papers for *archival* permanent records. In one

196 of Eastman Kodak's recent publications (Kodak Studio Light, Issue No. 1, 1976) the life expectancy of polyethelene-coated photographic paper, called resin-coated paper, is discussed in comparison to conventional photographic paper. It also outlines precautions necessary to assure the longest life for polyethelene-coated paper. Its study indicates that both resin-coated paper and conventional noncoated paper, when stored in the dark with only occasional viewing, and kept at 70°F and 50% RH, can be expected to have equally long and useful life.

When prints made on these two papers are displayed at normal levels of illumination in home or office, those on resin-coated papers may not last so long as those on conventional paper. When the storage or display conditions pemit relative humidity to vary between 30% and 60%, the useful life of coated paper will be less than that of conventional paper. Kodak also points out, "Until extensive testing and natural aging data indicate that prints on resin-coated paper base can be expected to last as long as prints on nonresin-coated base, black-and-white photographic papers without resin coat will be produced by Eastman Kodak Company for those customers requiring long-term keeping under adverse storage or display conditions."

Polyethylene-coated papers do have some advantages over other papers besides speed of processing. For work prints and commercial prints other than photographs for permanent archival storage, polyethylene-coated paper is easier to handle, is stiffer and tends to dog-ear less. These prints cannot be dry-mounted at high temperatures. Use low temperature Kodak Dry Mounting Tissue Type II.

Historical societies or museums that receive photograph albums, commercial prints or newspaper file prints that are made on polyethylene-coated paper may have fewer deterioration problems with these photographs than with ones made on regular photographic papers which are likely to be poorly processed, inadequately washed and dried on a cloth belt dryer contagiously contaminated through continued use.

Raw edges of the paper base absorb some processing chemicals and may contribute to chemical contamination of other photographs if stored in direct contact. This problem could be alleviated if all four edges of a polyethylene-coated print are trimmed. Henry Wilhelm of the East Street Gallery suggests all edges be trimmed ⅛ of an inch. He adds "at present, polyethylene-coated papers are not recommended for museum use or other applications requiring long-term stability."

Since polyethylene-coated papers have become universally popular for most photographic purposes, the demand for regular photographic papers has decreased dramatically. As a result, manufacturers now offer regular photographic paper in fewer sizes, fewer surfaces and emulsions. Should this trend continue, it is possible that regular photographic paper may not be manufactured at all some years from now. Partly with this possibility in mind, Henry Wilhelm of the East Street Gallery has proposed that a special photographic print material be manufactured to better meet archival standards for permanence. He suggests, (1) a white opaque base of triacetate that should be more permanent, resist contamination and process more easily than regular photographic paper; (2) a coarse-grain print emulsion for better resistance to fading and staining than fine-grain emulsion of photographic printing paper; (3) texturing on the reverse side to permit pencil writing.

Archival Processing

In general, the procedures that have been detailed for the handling, displaying, filing and storing of gelatin emulsion historical photographs for long life, are the same for modern black and white gelatin emulsion negatives

and prints. The remedial processes and precautions given for gelatin emulsion historical photographs apply as well.

In cases where you want maximum permanence for current photographs, the starting point for their long life is the use of *archival processing* methods when the photographs are developed. Here is a checklist to insure that the photographs you make or order are processed for optimum permanence.

Prints.

1. Do not use or accept "stabilization" prints or resin-coated prints.
2. Use fresh, not overworked chemicals. There is a useful capacity limit for developer, stop, hypo and hypo eliminator. The number of pieces processed should be counted to avoid the possibility of using the chemicals to process too many pieces before changing to fresh chemicals.
3. Use two fixing baths with adequate agitation.
4. Use a washing aid such as Kodak Hypo Clearing Agent.
5. Use protective toning, either selenium or gold toning to protect prints from sulphur gases. (Optional for extra protection)
6. Wash adequately, determined by testing, using a type of print washer that separates the prints, such as the print washer from East Street Gallery, and be sure at least two gallons of water change per minute. This usually means about one hour at a rate of flow of one complete change in the washer every 5 minutes with water temperature at 65 to 75 °F.
7. For maximum permanence, use Kodak HE-1, hypo eliminator, to remove 100% of residual hypo.
8. Finished prints should be checked frequently for residual hypo content with Kodak HT-2 formula and Kodak Hypo Estimator Stain Sample.
9. Dry prints without contaminating them. We

recommend air drying on fiberglass drying screens in an uncontaminated area.

Negatives

1. Use fresh chemicals; capacity for use is noted on their packaging. Discard tired solutions.
2. Use a washing aid such as Kodak Hypo Clearing Agent.
3. Wash with an efficient washer using a water flow sufficient to provide at least a complete change every five minutes for about thirty minutes. Testing will determine the time required for your equipment.
4. Check residual hypo content with Kodak HT-2 formula to be sure all hypo is removed in washing.
5. Dry without heat in uncontaminated area.

Commercial Processing

It costs extra time, work and money to give photographs complete archival quality processing. Recognize that not all of today's photographs can be or need to be saved for posterity. Sometimes a print only has a one time use. For example, often prints are made just for publication in books, magazines or newspapers. After screened reproductions are made from them, the photographs may even be discarded. To spend extra money and time on archival processing under these circumstances is not realistic.

For purposes other than archival use, what is needed is a print processed to high quality commercial standards. This includes many of the requirements for optimum permanence, fresh chemicals used only so long as they work completely and well, two hypo solutions, washing aid (clearing agent), and effective washing and drying. Here too, random tests should be made occasionally to determine residual hypo content. The standards of test tolerance would be lower for commercial proces-

198 sing than for archival processing for maximum permanence.

Summing up, when you need prints and negatives to last as long as possible, they must have been processed for maximum permanence. The way to be sure that photographs meet this requirement is to specify in detail what "archival processing for maximum permanence" means; check the effectiveness of processing to see you are actually getting what has been specified, and make random tests to determine the residual hypo content of the processed photographs. When archival processing is not required, you need to pay only for high quality commercial standards. Know what you want and check to see that you are getting it.

Color Photographs

Almost from the beginning of photography there was a quest for color; it was added to photographs very soon. It was first applied by hand using dyes, pigments and metal compounds. We have already noted the application of color in this way on daguerreotypes, ambrotypes, tintypes, paper prints and lantern slides.

Modern color photography's basic principles were first demonstrated in an experiment related to the theory of color vision by James C. Maxwell in 1861. A scene was photographed as a positive black and white silver image through three primary color filters, red, green, and blue; when these three images were viewed by projection through the same three filters simultaneously and in register, the image appeared in color.

The first commercially successful natural color process was the Lumiere Autochrome process introduced in 1907, a method used for almost thirty years. Lumiere's process used the same basic theory of color photography as described in the Maxwell experiment; but instead of using three separate images that had

to be viewed in register, Lumiere used the screen unit principle. A screen of small-particle primary color filters (in the form of red, blue, and green starch grains) was laid down on a single glass plate, then coated with a panchromatic emulsion. After exposure through the screen, the image was developed as a positive, which when projected or viewed by transmitted light, appeared as a natural color photograph. The Autochrome process was soon followed by other types, Finlay Color, Paget Color (from England), Dufaycolor, Agfacolor and other. In Dufaycolor, the screen was laid down on the film support base in the form of a dyed grid pattern over which the emulsion was coated. The film was exposed through this base. A separate plate containing the tri-color dyed screen grid was used in front of the film during exposure in the Finlay and Paget Color processes. From the developed negative a positive was made and placed in contact with and in register with a screen identical to the one used during exposure to produce a color transparency. The advantage of the separate screen plate system, Finlay and Paget processes, was that multiple transparencies could be made from a single negative. The screen pattern used in these color processes can be seen easily with the aid of a low power magnifying glass. It is easy to distinguish between the random starch grain pattern of Autochrome and the regular screen grids of Paget and Finlay Color. Black and white lantern slides colored by hand are identified by the inevitable inaccuracy of manual applications of the transparent pigments.

The stability of the color transparencies produced by these early processes was quite good. As the dye layer was simply superimposed over the photographic image and not involved chemically in the developing of that image as it is in modern color photographs, the permanence of these dyes is remarkably good. We have seen Autochromes, Paget Color and Finlay Color transparencies of such bril-

liance and saturation now, that little fading can have occurred in the sixty years since they were produced. Unfortunately most modern color processes *do not* possess similar color stability.

While many natural color slides have survived showing little evidence of fading, a great many others show serious signs of fading, particularly the blue areas. The permanence of the dyes does vary with the process and with conditions of storage and use. These faded examples point up the need for protection from heat and strong light. For this reason, they should be stored away from light and heat and should *not* be viewed by use of an ordinary projector. At the time of their popularity, they were of course, projected; but they were also viewed by a hand viewer called a Diascope. This was a small collapsible case which held the slide and a same-size mirror. With the case open and the slide in an erect position, one could hold the slide toward any light source and view the image from the mirror. The method was quite effective with just normal room light level. For limited display purposes, this diascope principle could be used with weak tungsten light; although any viewing of these fine old color slides must be undertaken with great care so as not to fade them. In display, limit the exhibition time and light intensity.

For those who insist on projecting these natural color slides in spite of the obvious dangers, use a projector with a blower and a heat-absorbing glass and limit the projection time to ten seconds or less per slide.

In the color systems described above, the black and white silver image remained a part of the photograph after development. In the more complex color methods that came later, the silver images were bleached out and replaced by dyed images; they produced color photographs of great brilliance and high optical resolution (extremely sharpness.)

With this type of color process, beginning with Kodachrome in 1935 and other color films that followed, modern color photography was on its way to widespread general acceptance. From the 1930s to early 1950s a high point was reached in natural color prints. Three-color processes, called dye transfer and carbro color prints, were capable of producing exquisite color prints. These became the standard by which prints from other processes were compared. Both of these types of prints were made by superimposing on paper the dye images made from separation negatives. Separation negatives were made either in a one-shot color camera or from a color transparency. Dye transfer prints were made by transferring in register three dyed images, magenta, cyan and yellow, (formed on the gelatin of three film positives) to the gelatin surface of a special paper. Carbro color prints were made by superimposing three dyed pigment image layers on to a specially prepared paper base.

Color stability of the dye transfer and carbro color prints is remarkably good. We have seen many examples about thirty years old which show no apparent fading. Display time of such prints should always be by tungsten light and limited; display illumination should be protected by polyester sleeves and kept at 70°F or lower, and at a relative humidity of 40 to 45%.

Autochromes, Agfacolor and later processes, wash off relief and carbro color prints, are remarkably stable when compared to color processes used today. One reason why most of today's color photographs have a fairly short life expectancy compared to some earlier processes is that the dyes must be selected for their *chemical* suitability for a particular process instead of for permanence.

One thing these color processes have in common, whether transparency, negative or print, is that the color image is formed by dyes. Unfortunately *all dyes*, given time, will undergo changes in hue and saturation, meaning they fade severely. The dyes are more sensitive to light, temperature, humidity and certain gases than black and white film and under

200 comparable storage conditions; deterioration of dyes in color films will be greater and will occur sooner.

While these changes vary with the color process and conditions of use and storage, none of the color processes is permanent enough to be suitable for archival records and should not be used as the *only* photographic record of any important project meant to be permanent.

Thus far, the only proven way to perpetuate color images of transparencies (or negatives) for posterity is to have three color separation negatives (or positives) made on black and white film including a gray scale and have them processed to archival standards. If these separation films are given optimum storage conditions, good color images could be produced from them as needed for the next couple of hundred years or so. Since such separations or color images produced from them are expensive, five to ten times more than a black and white copy negative would cost, most institutions have to reserve this procedure for relatively few color photographs. From an archivist's point of view, the transient nature of dyes is a dismal situation when you consider the thousands and thousands of color photographs that have been taken of historical events. Consider all the color photographs of the great historical treasures of the world and the millions of research study slides made from them, all of which will have relatively short lives from an archival point of view.

In 1955 we took 4 x 5 color transparencies of San Diego, street scenes, historic homes and buildings, and events. Over a period of about a year many hundreds of color photographs were made as a portrait of the city. At the same time, black and white photographs of the same subjects were taken with the same camera. Both types of photographs have been stored in an air-conditioned environment. Now, twenty years later, all of the color early Ektachrome transparencies have faded drastically, leaving pale magenta images suitable

only for limited informational use, while the black and white photographs have survived in good condition.

Protecting Color Film

The principal factors affecting the permanence of color photographs are light, heat and humidity, dangers from which they must be protected. Also, they need protection against physical dangers, dirt and finger prints, insects, pollution gases and fungus. Keep color photographs cool, dry and dark.

Light. Color photographs need protection from light in storage and in use. In use there are many things that can be done to limit the damaging effects of light. In slide projectors, be sure to use the correct wattage bulb for the projector. *Never* use a higher wattage bulb than is recommended for the projector. With projectors that have two bulb brightnesses, high and low, use lower light level. Make sure the projector is functioning properly, that the fan works and the air intake is not obstructed. Do not use a projector without heat-absorbing glass. Make a rule to limit projection time to no more than thirty seconds per slide. When important slides are to be projected on a heavy use basis, such as in continuous or repeated projection, *duplicate slides* should be made from the original, and these duplicate stand-ins replaced with new duplicates when they show signs of fading. Remember that heat and light from a projector, and the amount of time a slide is subjected to them, will determine how long a slide's color will last before fading.

Heat and Humidity. Color photographs should not be kept in damp basements or hot attics or other places where heat and dampness can affect them. Temperature should be 70°F or below. Relative humidity should be between 15% and 40%. *Metal storage boxes with baked enamel finish are best.* See the section under long term storage conditions for additional in-

formation on temperature and humidity requirements.

Insects. Do not store color photographs near old carpets, books and stuffed furniture. Carpet beetles and other insects that are likely to infest such things also eat the gelatin of a photograph's emulsion. If you suspect that color slides are being damaged by insects, the mounts should be discarded, the films remounted using new mounts. Both sides of the film should be cleaned with Kodak film cleaner. Slides should be stored in an uncontaminated container. Do not use moth balls in the storage area because the fumes they give off will damage the slides. Excrement from all insects can also damage the emulsion of color photographs. If you find evidence of it, dust with clean camel's hair brush and clean with Kodak Film Cleaner.

Polluting Gases. Industrial gases such as nitrous oxide, hydrogen sulphide and sulphur dioxide will cause the dyes in color photographs to fade. Fresh air coming into the storage should be filtered with activated charcoal filters especially if you are in an area of strong pollution.

Physical Protection. Color transparencies and negatives should be kept clean and free of dust and handled by their edges only. If they are accidentally marked with finger prints, remove them as soon as possible with Kodak Film Cleaner gently applied with absorbent cotton pad. For storage of mounted slides we like the Saf-T-Stor slide page from Franklin Distributors Corporation, P. O. Box 320, Denville, New Jersey 07834, which was produced with the encouragement of Library of Congress Restoration Officer, Peter Waters. A variety of similar plastic pages are sold for holding slides. Ones made from polyethylene and polypropylene should be satisfactory. If they are called vinyl, be sure they are not polyvinyl chloride which may produce traces of hydrochloric acid during storage.

Unmounted sheet and roll film color photographs should be kept in transparent triacetate or polyester sleeves. Do not use Permalife envelopes because their buffering compounds are thought to be harmful to the film dyes. Storage boxes of metal with baked enamel finish are best; although boxes made from "inert" plastics should be satisfactory. Polyvinyl chloride plastics are not safe.

Fungus. Fungus spores are in the air everywhere, regardless of temperature and humidity. These spores will germinate and grow wherever conditions are favorable, such as in atmosphere in which the relative humidity is 60% or above. The best preventive measure against fungus growth is to store color photographs in cabinets or containers in which the relative humidity is 60% or below. As fungus grows on color photographs, it will damage the gelatin of the emulsion or the anticurl gelatin of the back of the film. As growth progresses, it will physically etch and distort the gelatin. It also liberates substances which affect permanence of the dyes. If you are lucky enough to have mechanical air-conditioning with automatic relative humidity control, there should be no problems with fungus on color films. Lacking this, the next best environment can be created in a small room with a comparatively inexpensive refrigeration type dehumidifier controlled with a humidistat to keep relative humidity below 50%. Another alternative is to dessicate films with silica gel and seal them in moisture proof containers. Keeping the relative humidity below 50% is a sure way of preventing growth of fungus. There are some other procedures that can help prevent growth of fungus at least temporarily; avoid any sort of surface contamination to the film such as dirt, dust and fingerprints and use transparent sleeves. Coating transparencies, positive and negative, with film lacquer also offers considerable *temporary* protection. The lacquer acts as a fungicide and forms a physical barrier protecting the emulsion from attacking the surface of the film for some time.

202 Another procedure for protecting color slides against fungus growth on emulsion involves cementing or laminating the slide to a single piece of slide glass with gelatin. This unusual process is described in Eastman Kodak Bulletin E-34. Eastman Kodak reports in Bulletin AE-22 that experience with large numbers of glass mounted, tape-bound slides used in the tropics indicates very little fungus growth. When binding the slides, it is important to have both film and glass very dry. This can be done with individual slides by warming film and slide about 10° above room temperature for about five minutes before encasing the film. Be sure that the slide glass has been cleaned before using and the cleaning solution completely removed from the glass. Cases have been noted where minute quantities of commercial glass cleaning solution left on the glass have caused tiny spots of fading like measles on the transparencies. A final rinse of the glass in distilled water and complete drying with clean lintless cotton cloth is recommended before putting the glass in contact with film.

Once fungus attacks the gelatin emulsion, with black and white or color films, the gelatin will become soluble in water. Therefore, *water or water solutions cannot be used in the removal of fungus*. If the growth of fungus has gone far enough to actually etch the emulsion, the film may be beyond any remedial treatment. If the fungus is only on the surface, it can be removed with Kodak Film Cleaner on an absorbent cotton pad. After cleaning, the slides should be remounted in new mounts. If the film has been coated previously with lacquer, it will be necessary to remove the lacquer as part of the process of removing the fungus growth. The lacquer can be removed from slides and negatives by treating it with a solution of denatured alcohol and household ammonia. The formula is one tablespoon of ammonia to one cup of alcohol. The film should be removed from the slide mounting, placed emulsion side up on a sheet of glass to avoid scratching or marking the film base, and the surface gently wiped with the alcohol/ammonia solution on absorbent cotton. Film lacquer can be removed from color negatives by dipping and agitating them in the solution for no longer than two minutes, than hanging to dry. Use new slide mounts after cleaning operation is completed. Fungus can eventually penetrate through protective film lacquer and through the emulsion; the success of the cleaning operation depends on the extent of the fungus growth. While black and white prints can be treated with a fungicide to protect against the growth of fungus, there is no satisfactory fungicidal treatment for color photographs.

Long-Term Archival Storage of Color Photographs

Dyes in all color photographs eventually will change and fade. At present the best method for delaying dye changes is to store color photographs at low temperatures and keep the relative humidity at 25% to 30%. In an article in the *Journal of SYMPTE*, vol. 79, Nov. 1970, Peter Adelstein, C. Loren Graham and Lloyd E. West reported on the effects of temperature and humidity on dye stability of processed motion picture film and made recommendations. The significance of these findings is now being seen in Eastman Kodak technical information. For example, their Pamphlet E-36, 12-74-BX, indicates that storage of properly processed Vericolor II negatives stored at 70°F and 40% RH should make satisfactory prints for two to four years. Such negatives stored at 35°F and 25% to 30% RH should make satisfactory prints at least ten times longer. Those negatives stored at 0°F to 10°F and 25% to 30% RH should "provide maximum stability of the dye images, enabling properly processed negatives to print satisfactorily for a very long, indefinite period of time.

When stored at these low temperatures, the negatives must be protected to maintain the proper moisture content." This projected life expectancy approaches ours for archival life.

Life expectancy of other color materials will be different from the examples given for Kodak negative color film; but the ratio of increased life for other materials between room storage conditions and low temperature, low RH conditions should be similar. Actual experience with Kodachrome at room storage conditions, 70°F and 50% RH, established that many transparencies have lasted thirty years without serious fading. Though we have not seen results of tests projecting the life of Kodachrome stored in low temperature and humidity, it seems certain that such conditions will prolong the life of this film greatly.

One development that helps make storage at lower temperatures more practical is the Kodak Storage Envelope, a heat-seal moisture proof packaging now available from Eastman Kodak which allows humidity control to be established while film is stored in a household refrigerator. With this moisture proof package, film can be stored in any container capable of maintaining constant low temperature without additional humidity control.

Another important development is the result of work by Henry Wilhelm of the East Street Gallery in testing temperature and humidity levels of household frost-free refrigerators which indicates that the food sections of some frost-free models are capable of maintaining desirable levels of humidity for storing color films, one Sear Roebuck model in particular. There are fluctuations during the defrost cycles for short times; so simple packaging is necessary but sufficient protection against these minor variations of relative humidity. Such a refrigerator is reasonably modest in cost and can store as many as 18,000 mounted 35-mm slides without the necessity of sealing the film in moisture-proof packages. Whatever indi-

vidual refrigerator one actually chooses to use for color film storage should be checked out with a humidity gauge, as manufacturers' specifications often are changed without notice to the consumer. For additional details, see *Preservation of Contemporary Photographic Materials* by Henry Wilhelm.

Kodak Storage Envelopes—moisture-proof, heat-seal aluminum foil envelopes—can be ordered from photographic stores. The envelopes currently are available in two sizes, 4 x 5 and 8 x 10, and will hold about fifty sheets of film or other materials up to one half inch in combined thickness. To use these envelopes, insert color film, press out most of the air and seal the open end with an electric iron at 250° to 300°F (cotton setting). Check for complete seal and reiron if necessary. Seal can be checked by pressing the remaining air in the envelope toward the ironed seal to see if air escapes. Heat seal foil wrapping material is made by manufacturers such as Reynolds Metals, Dow Chemical and Continental Can Companies. Inquiry to these companies can be made for names of distributors and fabricators if you wish to explore the possibility of using different size packages. After packages are sealed, they should be boxed to prevent punctures during handling, then placed in refrigerator or deep freeze for indefinite storage.

For future color photograph projects, choose the color film best suited to the purpose, one that offers the longest life in dark storage or one with longest life when exposed to light as for slide projection or display. To insure maximum permanence, (1) select camera film for best dark storage; (2) make duplicate films and or third generation films for work use, choosing film for this purpose which has the greatest resistance to fading when exposed to light; (3) store originals in dark in best low temperature and low humidity conditions you can afford; and (4) have all film processing done by a lab with proven reliability.

204 *Current Color Photographic Materials*

Color Developed Photographs. In this type of color film the dyes forming the color image are created in the film during the processing. Most of today's color photographs are made by this process. Reversal color developed films, such as Kodachrome, which have the color forming agents in the processing chemicals have a proven dark storage life longer than other color developed films. For example, many Koda-chromes stored in moderate room conditions from the 1945 period have not deteriorated substantially. Other color developed films have color forming agents incorporated in the film during manufacture, and are not so stable in dark storage.

Silver Dye Bleach. Cibachrome is a darkroom-speed reversal material for display type transparencies or prints. Test conducted by manufacturer and Giles, et al., indicates that Cibachrome has a higher resistance to image fading from exposure to light than conventional color developed images by a ratio of 3 to 10.

Instant Color Prints. The new Polaroid SX-70 prints and Polorcolor II prints use metallized dyes which have superior light fastness properties. Test information supplied by the manufacturer indicates these prints have somewhat greater resistance to exposure to light than conventional color developed prints.

Accelerated age testing with various types of color film reported in "The Keeping Properties of Some Colour Photographs" by C. H. Giles and R. Haslam in *The Journal of Photographic Science*, Vol. 22, 1974, also indicates that slow speed color films have longer life in exposure to light than high speed films do. Their projections of limited dark storage testing also indicate slow speed color films have longer life than high speed films do.

There is much activity in testing and evaluating various types of color photographs; we can expect new guide lines for selecting material for best life in dark storage and in exposure to light. Manufacturers have a new interest in producing more stable color film, and new products are to be expected in the near future. There is the happy promise that eventually faded color photographs can be saved, in some form, by new technology in image restoration. Do not throw away your historically significant color photographs. In the meantime, give them cool, dry, dark storage.

Appendix A

Where Do We Turn for Help

Information

The quality and quantity of published material on care and preservation of historical photographs continue to improve and increase. A look at the bibliography of this book will prove the point. We believe that some of the more comprehensive work on the care of historical photographs has been published by Eugene Ostroff of the Smithsonian Institution. Eugene Ostroff and Walter Clark, of the Center for Conservation of Photographic Materials, have recently conducted important preservation seminars at the Smithsonian Institution. José Orraca has authored several papers on the conservation of historical photographs and has conducted many valuable, well balanced workshops. Henry Wilhelm, of East Street Gallery, has written a worthwhile and popular booklet, *Procedures for Processing and Storing Black and White Photographs for Maximum Possible Permanence*, and just published a large, comprehensive book, *Preservation of Contemporary Photographic Materials.*

Much more information will be available in the future about conservation of historical photographs. We believe the following listed sources will provide useful information on conservation and on evaluation of materials and procedures.

Dr. Walter Clark, Consultant on Conservation
Center for the Conservation of Photographic Materials
International Museum of Photography
George Eastman House
900 East Avenue
Rochester, New York 14607

The following information quoted from *Kodakery,* July 17, 1975, outlines the functions of this new center.

"The preservation and protection of the museum's collections. The evaluation of new materials and techniques used in conservation of photographs.

The dissemination of information and advice regarding the proper storage and care of photographic materials. Limited research toward the solution of new and unsolved problems relating to photographic conservation."

We hope the Conservation Center will offer some short term, concentrated training programs that deal with specific preservation problems.

Dr. Clark says that at the present, notes from their testing, evaluating and other actions will probably be published in *Image,* at IMP, a GEH publication for Associate Members for whom the regular membership fee is $16.00 per year.

Assistant Director of Preservation
Administrative Department
Library of Congress
Washington, D.C. 20540

The Restoration Office of the Library of Congress offers a number of Preservation Leaflets. They encourage individuals or institutions needing technical information or with special problems to write. Information usually concerns conservation of books and documents, but preservation of photographic materials is included. Related subjects can be very helpful, for example plastic enclosures, adhesives, etc. The Library of Congress, Restoration Office publishes sources of supplies for the conservator.

Eastman Kodak Company
Rochester, New York 14650
or your nearest Eastman Kodak Dealer

Eastman Kodak Company has published many pamphlets and books that apply to the subject of photographic conservation. We understand there is a major new book on preservation of photographic materials is in preparation and is due in 1976. We look forward with great interest to seeing this publication. We suggest you obtain the 1976 Index to Kodak Information L-5, which lists all of their publications and that you reorder yearly to keep informed about new subjects and revisions.

American National Standards Institute
1430 Broadway
New York, N.Y. 10018

ANSI publications represent a good source of information, specifications for many materials, items and techniques used in standard practice for care and preservation of photographs.

Royal Photographic Society of Great Britain
14 South Audley Street
London W1Y 5DP
England

The Royal Photographic Society has published many important papers in the *Journal of Photographic Science* and in the *Photographic Journal*. We assume these publications will continue to be valuable sources of information pertaining to our field.

American Association for State and Local History
1400 Eighth Avenue South
Nashville, Tennessee 37203

AASLH has published many leaflets and bulletins on the subject of conservation. We suggest you write to them requesting their publications catalogue.

National Conservation Advisory Council
Mrs. Gretchen Gayle, Executive Secretary
S.I. 356
Smithsonian Institution,
Washington, D.C. 20560

We believe formation of the National Conservation Advisory Council is an ambitious and worthy endeavor. Its objective, establishment of a National Institute for Conservation, possibly with regional centers, could be of great value in educating and training conservators, technicians and scientists, promotion of coordination and research, and "diffusion of knowledge through strengthening existing programs and developing a data storage and retrieval system for current information on conservation research, practices, and materials." We hope that photographic conservation will receive adequate attention from this future organization.

Many of the products and materials now used in the photographic conservation field have not been well tested and evaluated. Specifications of even the ones we believe to be safe can be changed by the manufacturers without notification. There are several products which should be manufactured to meet our specific photographic needs. We believe there should be some cooperative organization that would take on the task of testing, periodic re-evaluating, and *offering for purchase* suitable materials of dependable quality for use in our field. Many of the conservation techniques used on photographic prints and negatives could be performed by a dedicated worker with specific on-the-job training in these methods. This is especially true for large collections in which there are many thousands of photographs of the same type, all suffering the same symptoms of deterioration. There are, of course, other procedures requiring more skill and training than is possible to acquire in a concentrated training course. We hope there will be specialized training programs to prepare people to do a better job in preserving photographic collections. We believe we can look for leadership in this matter to the Conservation Center, International Museum of Photography, George Eastman House, the Library of Congress, or to the proposed National Conservation Center.

Sources

The materials we have recommended may be obtained from the following sources mentioned below:

Hollinger Corporation
3810 So. Four Mile Run Drive
Arlington, Virginia 22206
Tel. 703 671-6600

Permalife Negative Envelopes
Permalife Document Cases
Permalife Storage Boxes
Permalife File Folders
Permalife Museum Mounting Board
Permalife Bond Paper
Permalife Map Folders
0.008 Permatan Lightweight Carboard
 write for catalogs and price lists

TALAS (Technical Library Assoc.) 104 Fifth Avenue New York, New York 10011	All Hollinger (Permalife) products in smaller quantities UP Plexiglas Filters UF3 Mylar in sheets and rolls Polyvinyl Resin AF3
Rohm and Haas Plastics Division Independence Mall West Philadelphia, Penna. 19105	Manufactures UV Plexiglas UF3 write for names and addresses of distributors in your area
Process Materials Co. 329 Veterans Boulevard Carlstadt, New Jersey 07072	Jade Adhesive Promatco Heat Set Tissue
From your local photographic supply store	3M Seal M-5 tape White Cotton Gloves Glassine Envelopes Kraft Negative Envelopes
Eastman Kodak Company Rochester, New York 14650	Triacetate Envelopes and Folders Prepared Chemical Solutions Technical Literature
Bausch and Lomb Optical Co. Rochester, New York	Hand magnifiers, head loops
S. Schweitzer Company 660 West Lake Street Chicago, Illinois	Dry Paste No. 6 (Wheat Flour Paste)
J.L.N. Smythe Company 2301 Cherry Street Philadelphis, Pa. 19103	Verigood Blotting Paper 125 SHS, 24" x 38"-48OM, Sub 120, Wh.
Fisher Scientific Company 711 Forbes Avenue Pittsburgh, Pa. 15219	Dry Chemicals. Use Reagent Grade only
Your Local Glass Supply store	Plate Glass in sizes required
Your Local Drafting Supply Shop	Light Tables, Steel Map Cabinets

Appendix B

George Eastman House Rochester, New York

MATERIAL	TECHNIQUE	PERIOD	REMARKS
I. DIRECT POSITIVES			
Metal-			
Copper, silver-plated.	Daguerreotype	1839–c.1855	Silver tone, before 1842; brown tone, after 1841.
Iron, japanned black.	Tintype (Ferrotype, Melainotype)	1854–c.1900	Chocolate colored, after 1870.
Glass	Ambrotype	1854–c.1870	Earliest have black velvet backing. Later colored glass.
Leather and Oilcloth	Pannotype	1854(?)1860	Extremely rare.
II. NEGATIVES			
Paper-			
Uncoated, often waxed or oiled.	Calotype	1841–c.1855	Extremely rare in America.
With gelatin surface.	Eastman paper negative	1884–c.1895	Rare, usually of poor quality.
Glass-			
Thick, edges often ground, coating grayish, uneven.	Collodion	1851–c.1880	Not used to any extent in America until c.1855. By c.1860 universal.
Thin, edges sharply cut, coating black, very smooth and even.	Gelatin dry plate	c.1880–c.1920	Occasionally used today.
Gelatin-			
Looks like "film", but completely gelatin; brittle; edges uneven.	Eastman American film	1884–c.1890	Used in Kodak No. 1 (1888): circular image 2½", Kodak No. 2 (1889),cirular image 3½".
Clear plastic (nitro-cellulose)			
Extremely thin, curls up and wrinkles easily.	Roll film	1889–1903	CAUTION: FLAMMABLE.

N.C. (non-curl). Somewhat thicker, coated on both sides with gelatin to prevent curling.	Roll film	1903–1939	Test by cutting small piece from corner, put in ash tray, touch with lighted match. If it flares, base is nitrate.
Machine cut sheets, exactly rectangular, edges stamped with name of manufacturer.	Sheet film or Cut film	1913–1939	
Clear plastic (cellulose acetate) Marked SAFETY on edge.	Roll film Sheet film	1939 to present.	

III. PRINTS
Paper

Uncoated, brown to yellow-brown tone.	Silver print	1839–c.1860	Also called salted paper.
Coated paper, extremely thin, brown image, high gloss, usually on mount.	Albumen print	1850–c.1895	"Printing upon al-bumenised paper seems to be dying a slow but natural death." *Amateur Photographer*, August 3, 1894.

Sizes of Mounts

Carte-de-visite, 4¼ x 2½		Introduced to U.S. c.1859	
Cabinet, 4½ x 6½		Introduced to U.S. 1866	
Victoria, 3¼ x 5		Introduced, 1870	
Promenade, 4 x 7		Introduced 1875	
Boudoir, 5¼ x 8½		Date intro-duced unknown	
Imperial 6⅞ x 9⅞		Date intro-duced unknown	
Panel 8¼ x 4		Date intro-duced unknown	
Stereo approx. 3 x 7		Introduced to U.S. 1859	(Rounded corners.)
"Artiste", "Cabi-net", "Deluxe" Stereo, approx. 4½ x 7 or 5 x 7		Introduced to U.S. 1873	

210

Paper (continued)			
Coated, thickness of writing paper, yellow-brown to purple image.	Collodio-Chloride, Gelatino-Chloride, Aristotype Solio P.O.P. Proof	1888–c.1910	"Aristotype introduced a year ago." *American Amateur Photographer,* October, 1889.
Uncoated, usually drawing paper, often pebbly surface, delicate gray image.	Platinotype	1880–c.1930	Became popular with art photographers upon its commercial introduction in 1880 by the Platinotype Company.
Similar	Palladiotype	c.1914–c.1930	Similar in all respects to platinotype, except salts of palladium used.
Uncoated, brilliant blue.	Cyanotype; blue print.	c.1885–c.1910	Invented 1840 but rarely used until c.1885 when its ease of processing appealed to amateurs.
Uncoated, usually drawing paper; various colors; resembles a wash drawing.	Gum bichromate	1884–c.1920	Used only for "artistic" photography.
Smooth, usually heavy paper; rich image in various tones.	Carbon	1864–c.1900	Although invented earlier, first widespread use followed introduction of the transfer process in 1864.
Coated, semi-mat or smooth, black-gray-white	Velox Azo D.O.P.	1893–to present	All present day printing processes are based on this so-called "gaslight" paper. Old prints often "bronzed" or with metallic silver sheen.

Appendix C:

Information Update

In order to include the latest technical information, the following paragraphs were added to *Collection, Use, and Care of Historical Photographs* in March, 1978.

Sleeves and Envelopes

The best sleeves for negatives and original prints are either triacetate or uncoated polyester. Polyester sleeves are available in a large variety of sizes and will not tear. National Plastic Company, 4400 Santa Ana St., Cudahay, California 90201 will make sleeves (folded flap, unsealed) at fairly reasonable cost, but one must agree to take the entire run. For example, a run of 2-mil Mylar sleeves in 8¼ × 10¼ size to fit 8 × 10 glass plate negatives yields about 5800 at about $80.00 per thousand sleeves.

Henry Wilhelm reports that most commercial grades of polyethylene of the type used for negative envelopes are coated with an antiblocking and/or slip agent intended to prevent the polyethylene from sticking to itself. Since composition of these coatings is unknown and can vary (some coatings contain silica gel which absorbs moisture) polyethylene envelopes are not recommended for archival storage until a thorough study of them has been made.

Retrieval of Images (p. 151)

Microfilm

Eastman Kodak has combined a microfilm reader with a minicomputer using microfilm cassettes in its new Kodak Oracle microfilmer and Oracle retrieval terminal. Once the images are coded on the microfilm, the computer-reader will search out requested images and display them on the screen.

Microfiche

Many institutions are converting parts of their photographic collections to 4 × 6 microfiche. Cataloging is usually by subject. With 60 images per

card, one file drawer can hold an enormous number of images. With cataloging done by subject, retrieval by browsing is extremely convenient and saves wear and tear on original negatives and prints.

Daguerreotypes (pp. 155-159)

There have been reports of small black spots appearing on some daguerreotypes after cleaning with the thiourea formulae. A thorough study of the spots on one daguerreotype by Jacobson and Leyshon indicates that the spots appear to result from inadequate washing after treatment in a thiourea solution. A number of technicians are now using formulae containing much less thiourea and phosphoric acid. Some have reduced the amounts of both ingredients to as little as one tenth as much required in the original formulae.

Irving Pobboravsky's "The Daguerreotype: A Summary of our Present Knowledge on Identification, Tarnish Removal and the Process" (Graphic Arts Research Center, R.I.T.) suggests that currently popular daguerreotype cleaning formulae (thiourea/phosphoric acid) require further study. He recommends we refrain from chemical cleaning (tarnish removal) because of present lack of knowledge of the side effects. There is no urgency in restoring a daguerreotype to prevent irreversible deterioration, so waiting for more information is suggested.

Tintypes (p. 165)

On page 165 it was suggested that tintypes could be cleaned with soap and water. This treatment should not be used on unvarnished tintypes, because the collodion might be removed. Tintypes with rusty spots on the front or back should be treated to prevent further rusting damage. Carefully scrape away rust spots down to the bare metal with a fine implement. Seal the cleaned area with a nonyellowing acrylic resin such as Rohm and Haas B-67 or F-10. Test a small corner to be certain the resin is compatible with the collodion and any previously applied protective coating. After rust is removed

212 from unvarnished tintypes, the entire front surface probably should be coated with sealer.

Gelatin Dry Plates (p. 178)

This procedure for cementing loosened emulsion in place with gelatin was based on experience with edges of plates where expansion of fragments was no problem. The authors agree with Siegfried Rempel, conservator at the Canadian Conservation Institute, National Museums of Canada, that this procedure is not satisfactory, because the aqueous gelatin causes so much expansion of some fragments that they do not fit their former positions properly.

A new solution will have to be found that either prevents expansion of emulsion in contact with aqueous gelatin or else employs a safe, non-aqueous adhesive. Rempel has experimented with soluble nylon as an adhesive, but these experiments are not complete.

It is possible that the emulsion stripping techniques of Mrs. Vilia Reed can be adapted to re-adhere fractured and lifted emulsions in the future. At the present time making a high-quality copy negative of the affected plates and storing the plates carefully—until new techniques can be devised—is suggested.

Deteriorating Safety-Base and Nitrate-Base Negatives (pp. 192-194)

One of the most exciting breakthroughs in the field of photographic preservation is the very promising experimental work being done by Mrs. Vilia Reed of Eastman Kodak in Rochester. At the March 1978 preservation conference at Rochester Institute of Technology, Mrs. Reed demonstrated stripping of emulsions from deteriorating early safety-base negatives and nitrate-base negatives and adhering them to a new support base. This is a reasonably fast process (10 to 15 minutes) that frees emulsions from their old backing and sandwiches them between a Kodak Estar film support (cleared, fixed and processed to archival standards) and a prepared stripping film.

These procedures were originally intended to smooth out and salvage early safety-base negatives to permit duplication by copying. The emulsion on its new support can be dried, handled, copied and stored for a long time, although tests for aging have not been made yet.

While it is still recommended that high quality duplicate negatives be made of deteriorating nitrate-base negatives, and the destructing nitrates then be destroyed safely, Mrs. Reed's stripping/sandwiching procedures promise a way of preserving some original image emulsions from especially valuable nitrate-base negatives.

Color Films (p. 202)

Both testing and actual experience prove that Kodachrome has the longest dark storage life of all camera speed color films. Ektachrome has greater resistance to fading when exposed to light. For longest life, original slides should be shot on Kodachrome, then duplicated on Ektachrome duplicating film for projection. The original Kodachromes should be kept in dark storage with low humidity and low temperatures. See Henry Wilhelm's book *Preservation of Contemporary Photographic Materials* for more details.

Suggested Reading

Technical Material

Adams, A. *The Print (Basic Photo Book 3)*, New York, Morgan and Morgan, 1950.

American National Standards Institute, Inc. "Methods for the Determination of Silver in Photographic Films, Papers, Fixing Baths or Residues," PH4.33-1969.

American National Standards Institute, Inc. "Methods for Manual Processing of Black-and-White Photographic Paper," PH4.29-1962 (R1969), ANSI, 1430 Broadway, New York 10018.

American National Standards Institute, Inc. "Practice for Storage of Black and White Photographic Paper Prints, PH1.48-1974.

American National Standards Institute, Inc. "Practice for Storage of Processed Photographic Plates," PH1.45-1972.

American National Standards Institute, Inc. "Practice for Storage of Processed Safety Photographic Film Other than Microfilm," PH1.43-1971.

American National Standards Institute, Inc. "Requirements for Photographic Filing Enclosures for Storing Processed Photographic Film, Plates and Papers," PH4.20-1958 (R1970).

American National Standards Institute, Inc. "Specifications for Photographic Film for Archival Records, Silver-gelatin Type, on Cellulose Ester Base," PH1.23-1969.

Baker, W. S. and A. G. Hoshovsky, "The Storage and Retrieval of Visuals", *Graphic Science*, March 1968.

Barrow, W. J. *Manuscripts and Documents, Their Deterioration and Restoration*, 2nd ed. Charlottesville, University Press of Virginia, 1972.

Bermane, D. "On the Resistance to Fading of Silver-Dye-Bleach Transparencies", *The Conservation of Colour Photographic Records*, The Royal Photographic Society of Great Britain, London 1974.

Brian, C. "The Early Paper Processes, The Recognition of Early Photographic Processes, Their Care and Conservation", A Royal Photographic Society Symposium, Mar. 16, 1974, London.

The British Journal of Photography *Annual* 1975, U.S. Distributor, Amphoto, New York, N.Y.

Calhoun, J. M. "Storage of Nitrate Amateur Still-Camera Film Negatives," *Journal of the Biological Photographic Association*, 21: 3, Aug. 1953.

Clerc, L. P. *Photography Theory and Practice*, 1st ed. New York, 1930.

"The Conservation of Colour Photographic Records", Monograph No. 1, Royal Photographic Society of Great Britain, 14 South Audley Street, London W1Y 5DP, 1974.

Eastman Kodak Company, *B/W Processing for Permanence*, Kodak Publication J—19, Eastman Kodak Company, Rochester, New York, 14650, 54-3-73-AX

Eastman Kodak Company, *Basic Chemistry of Photographic Processing* (2 vols.), Kodak Publication No. Z-23-ED, 1971

Eastman Kodak Company, *Cementing Kodachrome and Ektachrome Transparencies to Glass*, Kodak Pamphlet No. E-34, Major revision 116-5-72-D

Eastman Kodak Company, *Copying*, Kodak Data Book No. M-1, 1968

Eastman Kodak Company, *Hazard in Handling and Storage of Nitrate and Safety Motion Picture Film*, Feb. 1951

Eastman Kodak Company, *Kodak Vericolor II Professional Films*, Kodak Pamphlet No. E-36, new pamphlet 12-74-BX

Eastman Kodak Company, *Notes on Tropical Photography*, Kodak Pamphlet No. C-24, Major revision 6-70-AX.

Eastman Kodak Company, *Prevention and Removal of Fungus on Prints and Films*, Kodak Pamphlet AE-22, Minor revision 128-6-71-BX

Eastman Kodak Company, *Processing Chemicals and Formulas (For Black and White Photography)*, Kodak Publication No. J-1, 1966

Eastman Kodak Company, *Stains on Negatives and Prints*, Kodak Pamphlet J-18, 1952, 6-52E-KP

Eastman Kodak Company, *Storage and Care of Kodak Color Films*, Kodak Pamphlet No. E-30, Major revision 3-73-CX

Eastman Kodak Company, *Storage and Care of Kodak Films in Rolls*, Kodak Publication No. AF-7, reprint 5-73-AE

Eastman Kodak Company, *Storage and Preservation of Microfilms*, Kodak Pamphlet P-108, 1965

Eastman Kodak Company, *Storage and Preservation*

Suggested Reading

214 *of Motion Picture Films*, Kodak Data Book No. H-8, 1957

Eaton, George T. "Preservation, Deterioration, Restoration of Photographic Images", *Library Quarterly* 40, January 1970

Eder, Josef Maria, *History of Photography*, New York, Columbia University Press, 1945.

Focal Press, Ltd. *The Focal Encyclopedia of Photography*, rev. ed., New York, McGraw-Hill, 1969.

Friedman, J. S. *History of Color Photography*, Focal Press, 1968.

Giles, C. H. and R. Haslam, "The Keeping Properties of Some Colour Photographs," *The Conservation of Colour Photographic Records*, The Royal Photographic Society of Great Britain, London 1974.

Hamner, M. F. *History of Kodak and its Continuations*, New York, The House of Little Books, 1940.

Harker, M. F. "Gelatin Silver Halide Processes," *The Recognition of Early Photographic Processes, Their Care and Conservation*, A Royal Photographic Society Symposium, Mar. 16, 1974 London.

Henn, R. W. and I. A. Olivares, "Tropical Storage of Processed Negatives," *Photographic Scientists and Engineers* 4, July-Aug. 1960, pp. 229-233.

Jones, B. E. *Encylopedia of Photography*, Waverley Book Company, London, 1911.

Mees, C. E. K. *From Dry Plates to Kodachrome Film*, New York, Ziff and Davis, 1961.

Neblette, C. B. *Photography, Its Materials and Processes*, 1st ed., New York, Van Nostrand, 1927.

Neblette, C. B. *Photography, Its Principles and Practices*, 1st ed. New York, Van Nostrand, 1927.

Newhall, B. "Ambrotype", *Image* 7:8, October 1958, pp. 171-177.

Newhall, B. *Latent Image*, New York, Doubleday, 1967.

Orraca, J. "The Conservation of Photographic Materials", *Bulletin of the American Institute for Conservations of Historic and Artistic Works*, 13: 2, 1973.

Orraca, J. "Philosophy of Conservation", address to Society of American Archivists, Toronto, Canada, October 1, 1974.

Ostroff, E. "Conserving and Restoring Photographic Collections", *Museum News*, May 1974, 2233 Wisconsin Ave., N.W., Washington, D.C. 20007.

Ostroff, E. Photographic Preservation: Modern Techniques, *The Recognition of Early Photographic Processes, Their Care and Conservation*, A Royal Photographic Society Symposium, Mar. 16, 1974, London.

Ostroff, E. "Preservation of Photographs", *The Photographic Journal*, 107:10, October 1967. The Royal Photographic Society of Great Britain, Maddox House 1, Maddox Street, London W1, England.

"P Stands for Permanent", *The Laboratory*, Fisher Scientific, 711 Forbes Avenue, Pittsburgh, Pa. 15219, 1964.

Rice, S. "Picture Retrieval by Concept Coordination, A Self-Interpreting Model File at Harcourt, Brace and World, Inc.", *Special Libraries*, December, 1969.

Rodgers, H. G., M. Idelson, R.F.W. Ciecuch, and S. M. Bloom, "The Light Stability of New Polaroid Color Prints," *The Conservation of Colour Photographic Records*, The Royal Photographic Society of Great Britain, London 1974.

Sargent, Ralph N. *Preserving the Moving Image*, Published jointly by Corporation for Public Broadcasting and National Endowment for the Arts, 1974.

Simons, Wendell W. and Luraine C. Tansey, "A Universal Slide Classification System with Automatic Indexing,"The University Library, University of California, Santa Cruz, California, January 1969.

Snelling, H. H. *The History and Practice of the Art of Photography*, Introduction by Beaumont Newhall, Morgan and Morgan, Inc., Hastings-on-Hudson, New York, 1970.

Stellman, Jeanne M., and Susan Daum, *Work is Dangerous to Your Health*, Pantheon Books, Div. of Random House, New York, 1973.

Time-Life Books, *Caring for Photographs, Display, Storage and Restoration*, Life Library of Photography, Time-Life Books, New York, 1972.

van Altena, W. F. "Envelopes for Archival Storage of Processed Astronomical Photographs," *American Astronomical Society Photo Bulletin*, No. 1, 1975.

Vanderbilt, P. "Filing Your Photographs: Some Basic Procedures", Technical Leaflet #36, American Association for State and Local History, Nashville.

Vanderbilt, P., "Picture Collections and the Local Historical Society", *History News*, 11:5, May 1958.

American Association for State and Local History, Nashville.

Wilhelm, Henry, *Preservation of Contemporary Photographic Materials*, East Street Gallery, Box 775, Grinnell, Iowa, 50112, 1978.

Wilhelm, H. *Procedures for Processing and Storing Black and White Photographs for Maximum Possible Permanence*, rev. ed., East Street Gallery, 723 State Street, Box 775, Grinnell, Iowa 50112, 1970.

Wilson, W. K. "Record Papers and Their Preservation", *Chemistry*, Vol. 43, March 1970.

Winger, H. W. and R. D. Smith, ed. *Deterioration and Preservation of Library Materials*, Chicago, University of Chicago Press, 1970.

Nontechnical Reading

Abbott, B. *Changing New York*, New York, Dutton, 1939

Ackerman, C. W. *George Eastman*, Boston, Houghton Mifflin Company, 1930

Andrist, R. *American Century*, New York, American Heritage Press, 1972

Angle, R. M. and M. F. Rhymer, *The Chicago Fire*, Chicago, Chicago Historical Society, 1971.

Baer, M. and A. Fink, *Abodes in the Sun*, San Francisco, Chronicle Books, 1971

Betjeman, J. *London From Old Photographs*, London, Batsford, 1969

Bohn, D. and R. Minick, *Delta West*, San Francisco, Scrimshaw Press, 1969

Boni, A. *Photographic Literature*, New York, Morgan and Morgan, 1962 and 1972 (2 vols.)

Brown, M. H. and W. R. Felton, *Before Barbed Wire*, New York, Doubleday, 1956

Brown, M. H. and W. R. Felton, *The Frontier Years*, New York, Bramhall House, 1954

Braive, M. F. *The Photograph: A Social History*, New York, McGraw Hill, 1966

Bridaham, L. B. *New Orleans and Bayou Country*, Barre, Mass., Barre Pub., 1972

Bruce, D. *Sun Pictures—The Hill-Adamson Calotypes*, New York, New York Graphic Society, 1973

Buckland, G. *Reality Recorded*, London, New York Graphic Society, 1974

Caldwell, E. and M. Bourke-White, *Say, Is This the USA?*, New York, Duell, Sloan and Pearce, 1941

Caldwell, E. and M. Bourke-White, *You Have Seen Their Faces*, New York, Modern Age Books, 1937

Cancian, F. *Another Place*, San Francisco, Scrimshaw Press, 1974

Capa, C. *The Concerned Photographer*, (2 vols.), New York, Grossman, 1968 and 1973

Cato, J. *The Story of the Camera in Australia*, Melbourne, Georgian House, 1955

Conrat, R. and M. *Executive Order 9066*, San Francisco, California Historical Society, 1972

Coombs, B. *Westward to Promontory*, Palo Alto, Calif., American West Publishing Co., 1967

Cunningham, R. E. *Indian Territory*, Norman, University of Oklahoma Press, 1957

Dabbs, E. M. *Face of an Island*, New York, Grossman, 1971

Daniel, P. and R. Smock, *A Talent for Detail*, New York, Harmony Books, 1974

Darrah, W. C. *Stereo Views*, Gettysburg, 1964

Davidson, B. *East 100th Street*, Cambridge, Harvard University Press, 1970

De Sarmo, M. C. *Seneca Ray Stoddard*, New York, Adirondack Yesteryears, 1972

Gernsheim, H. *Creative Photography*, London, Faber and Faber, 1962

Gernsheim, H. *The History of Photography*, London, Oxford University Press, 1955

Gorham, M. *Ireland Yesterday*, New York, Avenel, 1971

Green, J. *The Snapshot*, New York, Aperture, 1974

Greenhill, R. *Early Photography in Canada*, Toronto, Oxford University Press, 1965

Gutman, J. M. *Lewis W. Hine and the American Social Conscience*, New York, Grossman, 1967

Hafen, L. *The Diaries of William Henry Jackson*, Glendale, Arthur Clark Co., 1959

Haley, J. E. *Life on the Texas Range*, Austin, University of Texas Press, 1952

Hamilton, C. and L. Ostendorf, *Lincoln in Photographs*, Norman, University of Oklahoma, 1963

Harper, R. J. and S. Triggs, *Portrait of a Period*, Montreal, McGill University Press, 1967

Hiley, M. *Frank Sutcliffe*, London, David R. Godine, 1974

Homer, R. J. *The Legacy of Josiah Johnson Hawes*, Barre, Mass., Barre Publications, 1972

Horan, J. D. *The Great American West*, New York, Crown, 1959

Horan, J. D. *Mathew Brady, History With a Camera*, New York, Crown, 1955

Suggested Reading

216 Horan, J. D. *Timothy O'Sullivan, America's Forgotten Photographer*, New York, Doubleday, 1966

Hurt, W. R. and W. E. Lass, *Frontier Photographer*, Lincoln, University of Nebraska Press, 1956

Image (Journal of the International Museum of Photography), Vols. 1-13, 1952-1965

Ivins, W. M., Jr., *Prints and Visual Communication*, Cambridge, Harvard University Press, 1953.

Jackson, C. *Picture Maker of the Old West*, New York, Scribners, 1947

Jackson, W. H. *Time Exposure*, New York, G. P. Putnam and Sons, 1940

Jammes, A. *William Henry Fox Talbot*, New York, Collier Books, 1972

Jensen, O. *Carrier War*, New York, Simon and Schuster, 1945

Jensen, O. and J. P. Kerr, *American Album*, New York, American Heritage Publishing Co., 1968

Kunhardt, D. M. and P. B. *Twenty Days*, New York, Harper and Row, 1965

Lesy, M. *Wisconsin Death Trip*, New York, Pantheon Books, 1973

Lewis, S., J., McQuaid, D. Tait, *Photography, Source and Resource*, Rochester, Turnip Press, 1973

Mahood, R. I. *Photographer of the Southwest, A. C. Vroman, 1856-1916*, Los Angeles, Ward Ritchie Press, 1961

Martin, P. *Victorian Snapshots*, London, Country Life, Ltd., 1939

Mayer, G. *Once Upon a City*, New York, Macmillan, 1958

McGhee, R., and L. De Cock, *James Vander Zee*, New York, Morgan and Morgan, 1973

Meredith, R. *Mr. Lincoln's Contemporaries*, New York, Scribners, 1951

Meserve, F. H. *The Photographs of Abraham Lincoln*, New York, Harcourt, Brace, 1944

Michaelson, K. *David Octavius Hill 1802-1870 and Robert Adamson 1821-1848*, Edinburgh, The Scottish Arts Council, 1970

Milhollen, H., M. Kaplan, and D. Donal, *Divided We Fought*, New York, Macmillan, 1961

Miller, N. H. *Shutters West*, Denver, Sage Books, 1962

Minto, C. S. *Scotland in Old Photographs*, London, Batsford, 1970

Morgan, M. *One Man's Gold Rush*, Seattle, University of Washington Press, 1967

Newhall, B. *The Daguerreotype in America*, New York, Duell, Sloan and Pierce, 1961

Newhall, B. *The History of Photography*, New York, Museum of Modern Art, 1964

Newhall, B. *Masters of Photography*, New York, Bonanza Books, 1958

Newhall, B. *Photography, A Short Critical History*, New York, Museum of Modern Art, 1938

Newhall, B. and N. *On Photography: A Source Book*, Watkins Glen, 1956

Newhall, B. and N. *The Pencil of Nature*, New York, Da Capo, 1969

Newhall, B. and D. Edkins, *William H. Jackson*, New York, Morgan and Morgan, 1974

Phillips, D. and R. A. Weinstein, *The Taming of the West*, Chicago, Henry Regnery, 1974

Phillips, D. and R. A. Weinstein, *The West: An American Experience*, Chicago, Henry Regnery, 1973

Pollack, P. *The Picture History of Photography*, New York, Harry Abrams, 1958 and 1970

Plowden, D. *Commonplace*, New York, Dutton, 1974

Plowden, D. *The Hand of Man on America*, Riverside, N.Y., Chatham Press, 1971

Plowden, D. *Lincoln and His America*, New York, Viking Press, 1970

Portrait of the Past, Madison, Wis., Wisconsin Trails, (2 vols.), 1973

Reid, W. and A. DeMenil, *Out of the Silence*, Fort Worth, Outerbridge and Diemstfrey, 1971

Reisenberg, F. and A. Alland, *Portrait of New York*, New York, Macmillan, 1939

Riis, J. A. *How The Other Half Lives*, New York, Dover, 1971

Rinhart, F. and M. *American Daguerrian Art*, New York, Clarkson Potter, 1967

Rinhart, F. and M. *American Miniature Case Art*, New York, Barnes, 1969

Root, M. *The Camera and the Pencil*, 1864, reprinted, Pawlet, Vermont, 1971

Schmitt, M. and D. Brown, *Fighting Indians of the West*, New York, Bonanza, 1958

Schmitt, M. and D. Brown, *The Settler's West*, New York, Scribners, 1955

Schmitt, M. and D. Brown, *Trail Driving Days*, New York, Bonanza, 1952

Schoener, A. *Portal to America-The Lower East Side of New York*, New York, Holt, Rinehart and Winston, 1967

Science Museum Photography Collection, London, D. B. Thomas, 1965

Shelton, C. E. *Photo Album of Yesterday's Southwest*, Palm Desert, Desert Magazine, 1961

Simpson, G. *The Way Life Was*, New York, Praeger, 1974

Smith, A. and Thompson, J. *Street Life in London*, New York, 1969

Sobieszek, R., et al., *French Primitive Photography*, New York, Aperture, Inc., 1970

Steichen, E. *The Family of Man*, New York, Museum of Modern Art, 1955

Strand, P. and Newhall, N. *Time in New England*, New York, Oxford Press, 1950

Szarkowski, J. *E. J. Bellocq: Storyville Portraits*, New York, Museum of Modern Art, 1970

Szarkowski, J. *The Face of Minnesota*, St. Paul, Minnesota Press, 1958

Szarkowski, J. *The Photographer and the American Landscape*, New York, Museum of Modern Art, 1963

Taft, R. *Photography and the American Scene, A Social History, 1839-1889*, New York, Dover Publications, 1964

Taft, R. R. *Artists and Illustrators of the Old West*, New York, Scribners, 1953

Thomas, S. *Views of Louisville Since 1776*, Louisville, Louisville Times, 1972

Tilden, F. *Following the Frontier*, New York, Alfred Knopf, 1964

Turner, P. and R. Wood, *Peter Emerson*, Boston, David R. Godine, 1974

Ullman, D. *Appalachian Photographs*, Aragon Society, North Carolina, 1971

Webb, W. and R. A. Weinstein, *Dwellers at the Source*, New York, Grossman, 1973

Weinstein, R. A. *San Francisco, 1853-The Golden City as the Argonauts Saw It* . . . California Historical Society, 47:1, March, 1968

Weinstein, R. A. and R. Belous, *Will Soule, Indian Photographer at Fort Sill, 1869-1874*, Los Angeles, Ward Ritchie Press, 1969

Whitman, W. *Leaves of Grass, Photographs by Edward Weston*, New York, Limited Editions Club, 1942

Winter, G. *A Country Camera, 1844-1914*, London, Penguin Books, 1966

Index

Index

Index

Index